Everyone *Can* Draw

Barrington Barber

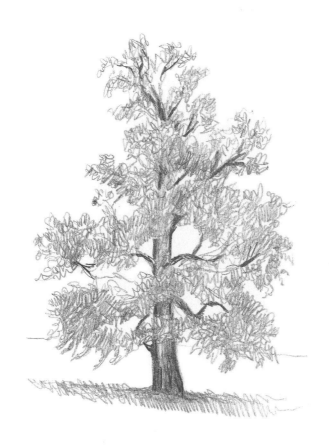

ARCTURUS

ARCTURUS

This edition published in 2014 by Arcturus Publishing Limited
26/27 Bickels Yard, 151–153 Bermondsey Street,
London SE1 3HA

ISBN: 978-1-78212-624-9
AD003867UK

Printed in China

Contents

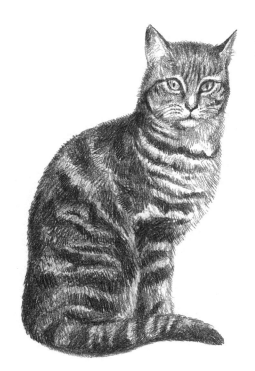

INTRODUCTION

It's not uncommon to hear people saying they would like to try their hand at art, adding, 'But I can't draw,' as if this were an immutable fact that rules them out from the start. Yet being able to draw isn't a rare and special quality. It does help if you have some innate talent, of course, but that isn't the main thing; in my long career as an art teacher I've often seen students with talent but not much will to work overtaken by much less naturally gifted students who were prepared to put in the groundwork and persevere. I've taught people from five years of age to 70 and have never come across anyone I couldn't teach to draw adequately if they really wanted to learn. So the first step is to feel confident that it's only a matter of how much work you are prepared to put into drawing that decides how well you will do, and that confidence will carry you through the small failures that occur whenever you try to learn a new skill.

This book follows a particular plan that has been designed to make the learning process easier for you. It begins by describing the most useful mediums for a beginner before moving on to the basics of line drawing, which is the simplest and most obvious method of drawing. Once you have gained some proficiency with that you will then tackle the use of tone and texture in order to flesh out your line drawings and make them look three-dimensional.

These exercises will teach you about observation, which is the most important thing for an artist to practise. It is particularly vital when drawing the human figure, because our familiarity with it means that mistakes in proportion are easily spotted. From this book you'll learn the classic proportions, so that if you do need to diverge from them to show an individual's particular characteristics you will be able to do so convincingly – many of us, let's face it, don't fit the classical norm.

There's also a section on perspective that will help you to assess how to draw larger objects such as buildings without being too intimidated by the size and complexity of their structure; after all, you can't draw a scene that looks three-dimensional without knowing how to convey the sense of objects receding from the viewer.

Next, the composition of your picture is a useful thing to consider, although you may not want to think about this until you've been drawing for a while. However, to make your drawings work on a formal scale some understanding of how to compose a picture will enhance your artistic skill.

Finally, we'll look at some useful practices that all artists need to know in order to improve their ability. Learning to draw on the move, for instance, enables an artist to act on impulse and forces them to respond creatively to different situations. The great thing about drawing is that there's always another skill you can add to your repertoire, and that's one of the things that keeps artists working happily into their later years.

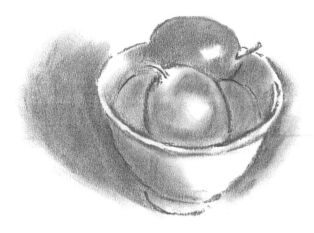

Subject matter

In this book we'll look at all types of subject matter as you build up your skills. The easiest things to draw are simple still-life objects because you can arrange them as you like. Some more complex objects, such as a tricycle and rucksack, are next in line of difficulty; after that come plants and, when you have mastered those, the whole landscape genre. Here you have to cope with the light constantly changing and creating different shadows and highlights, both in rural settings and in town and cities.

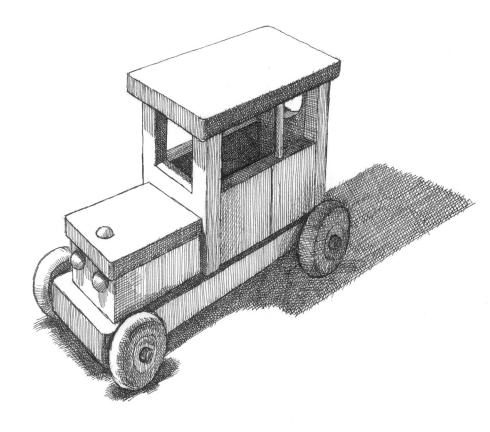

Animals are tricky to draw because they rarely keep still and generally have no inclination to do what you want. You'll often have to take photographs to work from in order to become more familiar with their shapes. When it comes to humans, for a portrait drawing you do have the advantage that the model probably wants to be drawn well and will pose for you – but we pick up many subtle distinctions in the human face, and if you miss them out it reduces the likeness of the portrait. It takes a while to achieve portraits that are convincing, showing not only the features realistically but also the person's character.

Probably the hardest subject matter for drawing is the human body as a whole. It's so complex that I believe even the most accomplished artists never achieve perfection in their works, so don't worry too much if your first attempts aren't great works of art. Drawing groups of figures is even more complex, but the challenges are very satisfying as well – and as soon as you have a little success you'll begin to see why artists find it impossible to stop drawing.

Equipment

When you first start to draw the most obvious tools to use are pencils, since you will have used these since you were a child and will be very comfortable with them. Later on, when you are feeling more confident and preparing to take your drawing skills further, you will want to try a variety of mediums to see the different marks they make, enjoying the way you can expand your range of techniques. You will find drawing implements described on pages 14–29, with exercises to try them out on.

For your surfaces, you will need medium-weight cartridge paper, which you can buy in sheets or in a sketchbook. The latter will be most versatile, because you can take it around with you as well as using it at home. The sizes you will find convenient for travelling with are A5, A4 and A3 – anything larger is unwieldy.

A drawing board to use at home can be bought ready-made from an art supplies shop, but it's easy enough to make one cheaply by sawing it from a piece of MDF or thick plywood; an A2 size is most useful. Sand the edges to smooth them out and, if you wish, paint the board with either primer or a white emulsion to protect the surface against wear and tear. To attach your cartridge paper to the board, traditional clips or drawing pins can be used, but I prefer masking tape, which is light, easy to adjust and doesn't seem to damage the paper if it is used carefully.

Whether you draw sitting down or standing up, you will need to have your paper surface at a reasonably steep angle. If you want to draw standing up, which is usually the most accurate way to draw from life, you will need an easel to support your drawing board unless you are working with a small sketchbook. You can buy small folding easels or larger radial easels – I prefer the latter. If you like to draw sitting down and haven't got an easel, you can support an A2 drawing board on your knees and lean it on the edge of a table or the back of another chair.

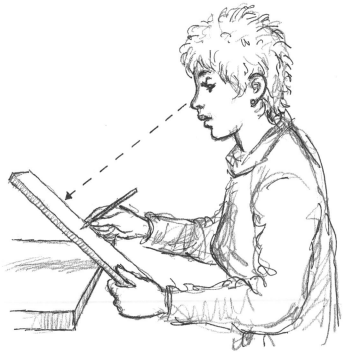

No matter whether you are using an easel or more informal support, your sight line should be such that the part of the drawing you are working on is directly facing your gaze. If you are looking at the surface from an angle oblique to the paper, you will draw slight distortions without realizing it until you step back and see the drawing more objectively. Keep your grip on the pencil, or whatever implement you are using, fairly light and relaxed – you don't need to hold it forcefully. Also try different ways of drawing with the pencil, both in the normal pen grip and also in the stick grip (see p.10), especially when you are drawing standing up – the more vertical your surface, the easier it is to use the stick grip.

Keep relaxing your shoulders, arm and wrist – a smooth, easy action is more conducive to good drawing. If you realize your movement is becoming anxious and constricted, stand back from the easel a little and work with sweeping strokes until you feel your action loosening again. As a beginner it's all too easy to become tense, perhaps through worrying that you are about to spoil a drawing that has been going well so far, but remember you are doing this for pleasure! The exercises in this book should help you to enjoy the learning process and concentrate on your progress rather than your mistakes.

THE BASICS

When you start to draw you need to know a few basics about how to handle your equipment and draw to size. Later you will begin to develop a personal style of working with which you feel comfortable.

Holding a pencil

You may think advice on how to hold a pencil seems rather unnecessary, but I assure you that an artist must learn how to handle the instruments of drawing properly in order to get the best results. You don't have to grasp the pencil in a vice-like grip, which it's easy to do without being aware of it if you're feeling a bit tense about tackling something difficult. Hold it loosely, so that you can manoeuvre it easily. Then practise different ways of handling it, as shown.

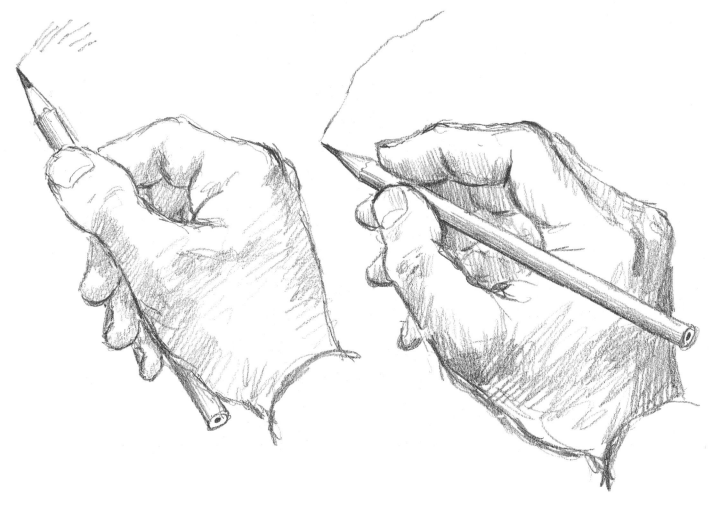

Hold your pencil as you would a stick, with your thumb on top, and see how well you can control your strokes. Don't grip it tightly. This method is ideal for drawing at an easel with the drawing board upright.

Then hold the pencil as you might usually hold it for writing, but again without gripping it tightly. Keep altering the way that you hold the pencil until you feel comfortable with different methods.

Sizing your drawing

It's all too easy to fall into the habit of always drawing your subjects at the same size. This rather limits your ability to improve, as an artist should be able to draw at any size that is needed.

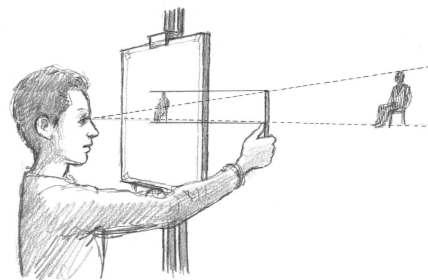

Making your drawing the same size that the subject appears to be from your viewpoint is a very good exercise. The drawing board and paper must be vertical for you to do this effectively, and you'll need a long pencil or a straight stick of some sort to measure with. Here we take the example of a human figure.

First place yourself so that you can see the model clearly, and extend your arm out until it is straight. This is essential because otherwise you will get varying measurements, which defeats the object. Then hold your pencil or stick upright so that the top is level with the top of your model's head and your thumb is at their feet. Mark this distance on your paper. If your model is too far away they will appear too small to be drawn properly, while if they are too close you will need a very long measuring device to cover the distance from head to feet. If need be, just move them to a reasonable distance, at which you will have a size that you can handle.

Draw everything to this size as carefully as you can; you'll probably be surprised by how small the drawing is, but if you get all the measurements right it will be very accurate. Don't forget to extend your arm to its full length each time you measure anything so that you get the proportionate measure each time.

Now try drawing on as large a sheet of paper as you can, perhaps A2 or A1 size. Draw the model with the top of the head touching the edge of the paper at the top, and the feet right at the bottom of the paper. It doesn't matter what the pose is but ask your model to stretch out as much as possible, as long as they will be able to hold the pose. Now everything has to fit into this much larger format and you'll soon notice how easy it is to get the proportions wrong. Don't worry about this – look on it as a challenge, and just keep on correcting the drawing until you've made as good a job as you're able to in the time available.

The next time you draw anyone try the same trick but with a smaller format, such as a sketchbook, but working as large as is possible on the page. This practice of trying different sizes is important for you to extend your drawing abilities, even if you eventually settle on a preferred scale. Every now and again draw much larger than you usually do, just to test your ability.

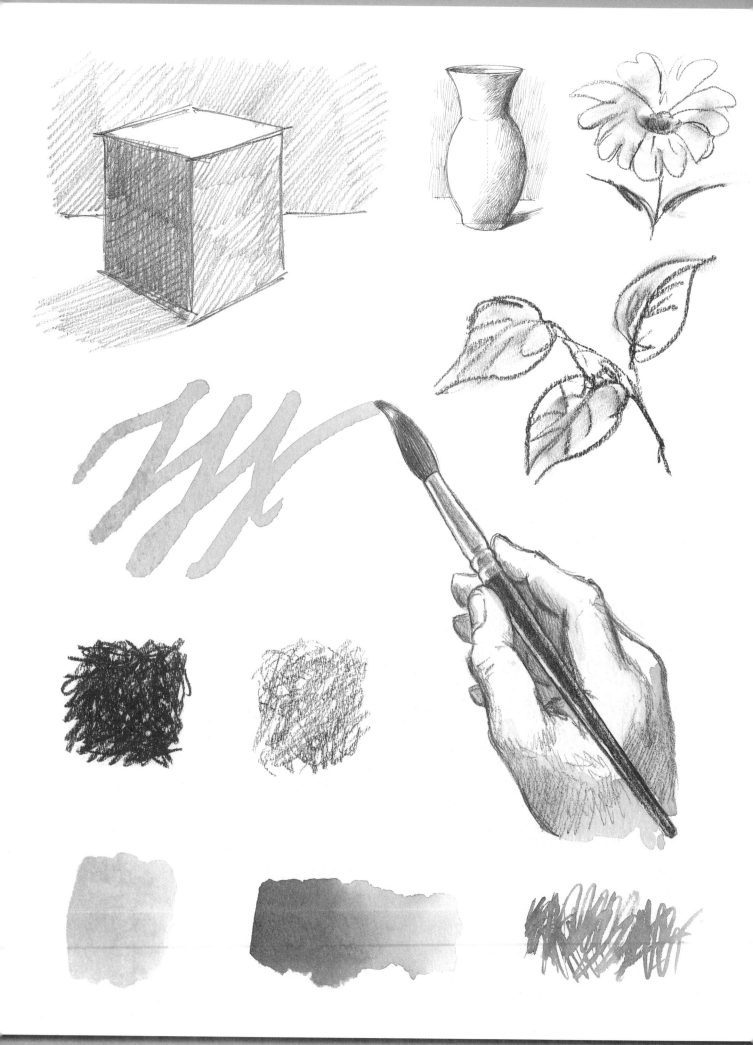

MARKS AND MATERIALS

The classic materials for drawing are pencil, pen and ink, charcoal in its various forms and brush and wash. Each of these has its own characteristic marks, and which you choose for any particular drawing will depend on your own preference and also what will best suit the subject. Experiment with other tools, too – a twig or the quill of a feather you see lying on the ground will give you new and exciting marks when dipped in ink, for example.

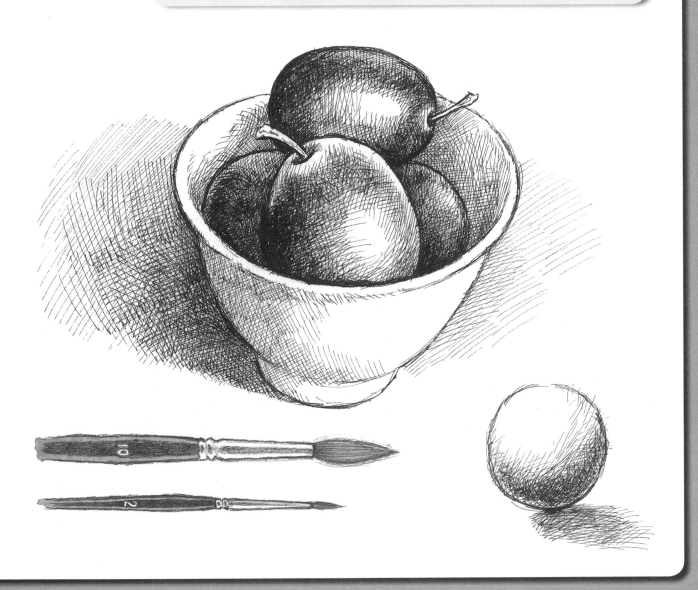

PENCIL

The most common medium for drawing is pencil. Use B-grade pencils as they make a darker mark with less pressure required than the harder H pencils. Ideally you should have B, 2B, 4B, 6B and 8B as a range.

B-grade pencils are soft and wear down quite fast, so have several sharp pencils to hand. It will interrupt the flow of your work if you have to keep stopping to sharpen your pencil.

1 When you're ready, start drawing a wavy line in any direction just to get the feel of the pencil on the paper. This is more important than it may seem, because experiencing through your hand the way the pencil meets the paper gives your drawing greater sensitivity.

2 Scribble lines in all directions to make a patch of dark tone.

3 Then try a series of quickly made lines, all in the same direction and as close together as you can, to make a patch of tone.

4 Next, draw a number of lines in all directions, but shorter and spaced around to build up like a layer of twigs.

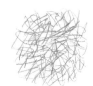

5 Draw a tonal patch with all the lines going in one direction in vertical strokes.

6 Next, draw horizontal strokes in the same manner.

7 Now combine horizontal and vertical lines with diagonals to produce a very dark patch of tone.

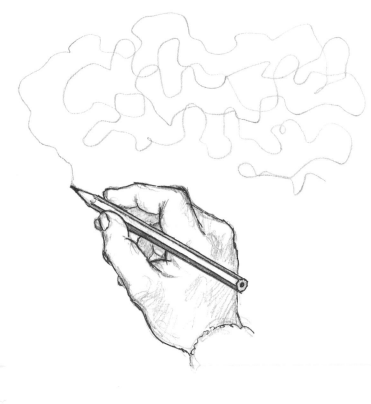

8 Draw a circle as accurately as you can. Although it's easy enough to imagine a perfect circle, drawing one takes careful work and yours will probably look like the one shown.

9 Now add a bit of tone to one side of your circle to give the impression of a three-dimensional sphere. Put a patch of tone underneath the sphere to look like a cast shadow.

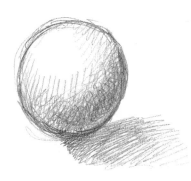

10 Now try a drawing of a group of leaves, keeping it simple and just aiming to express the feel of the plant's growth.

11 Similarly, draw a flower shape – don't try to be too exact at this stage.

Now we are taking a further step towards picture-making, because you are going to attempt a shape that resembles something that you might want to draw.

12 First draw a diamond shape that is flatter horizontally than vertically.

13 Then draw three vertical lines down from the left corner, the lower centre corner and the right corner. All the lines should be parallel to each other, with the outer two about the same length and the central one a little longer.

14 Now draw lines from the lower ends of the verticals, similar to the lower sides of the original diamond shape. This now looks like a cube shape.

15 To increase the illusion of three dimensions, make a light tone across the background space to about halfway down the cube, then put tone over the two lower surfaces of the cube. Make the tone on one of the lower sides even darker. To finish off the illusion, draw a tone from the bottom of the darkest side of the cube across the surface that the cube is standing on. The final result looks like a box standing on a surface.

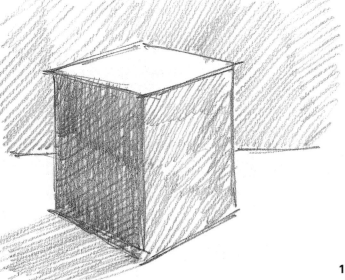

PEN AND INK

To draw with pen and ink, the most obvious tool to go for is a graphic pen. These are available in several sizes, and you will need an 0.1, an 0.3 and an 0.8 to give you a fine line and two rather thicker lines. You can buy them in any stationery or art supplies shop. There's no variation in the line from these pens, so if variation is what you want, use a push pen with a fine nib and a bottle of black Indian ink. If the pen nib is flexible enough you can vary the thickness of the line at will, by exerting or releasing a little more pressure on the pen. These pens are available from a good art shop or a specialist pen shop.

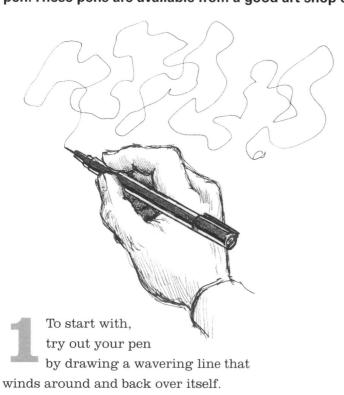

1 To start with, try out your pen by drawing a wavering line that winds around and back over itself.

2 Now, as with the pencil, make a fairly rough scribbled area as shown – don't worry about the direction or length of the lines drawn.

3 This time make your lines more deliberate, all in the same direction and as close together as you can without them touching.

4 Now have a go at short marks that go in all directions and overlay each other. Keep the texture as even as you can so that there are no obvious gaps showing.

5 The next stage is to draw patches of tone with the pen as I have shown in the examples, first vertically then horizontally.

6 Then draw all the lines in four directions, overlaying them to build up a texture that can be read as a tone.

7 Next, draw a circle in ink, in the same way as you did with your pencil.

8 Now, using textured marks, as in the example, try to make a convincing sphere shape out of it.

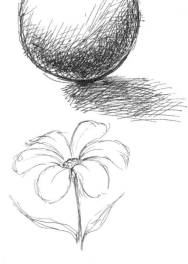

9 Now draw a spray of leaves. Because the pen is so much more definite than the pencil you will have to draw lightly and finely, or else the lines will become too clumsy.

10 Then draw a flower head on a stalk. Treat your drawing loosely, as if using a pencil, and the marks will look attractive.

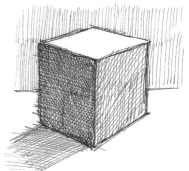

11 Now have a go at drawing the same cube shape as before, but this time in ink. Note how in the last stage the lines are quite carefully drawn in one direction and then overlaid with other lines in contrary directions to build up the tone.

12 Now you can start to draw a real object in ink. First draw a line with a ruler, vertically and of a definite length.

13 Each side of this central line, draw freehand the simple curves of a vase. Mark the top and bottom of the shape with short horizontal lines.

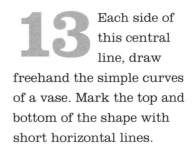

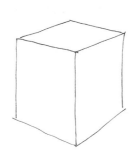

14 Around the upper and lower edges, give the impression of depth by drawing an upper lip to the vase as an ellipse and a lower edge as a half ellipse.

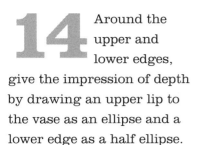

15 With light lines overlapping each other, produce an effect of shading as I have done in the example shown. Don't forget to add the cast shadow as well.

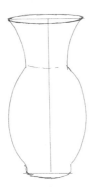

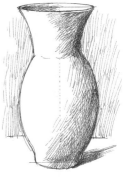

17

CHARCOAL AND CONTÉ

These mediums are favoured by many artists as they give a quicker result in terms of tone and flexibility. Charcoal comes in sticks of varying thickness, of which you will only need about two. It is very brittle and breaks easily, so you really have to use a light touch with this; it always makes a dark mark so you don't need to press at all. For something stronger and less easily smudged, try conté sticks, made of charcoal compressed with a binder. Either way you will need to buy some fixative to spray your drawings with to make sure that they don't smudge; do this outside your house if possible as the fumes can be unpleasant.

1 Try making a series of scribbles with these two mediums to get the feel of them on the paper.

2 Next make a series of vertical strokes that become softer and fainter as you work to the right, as shown.

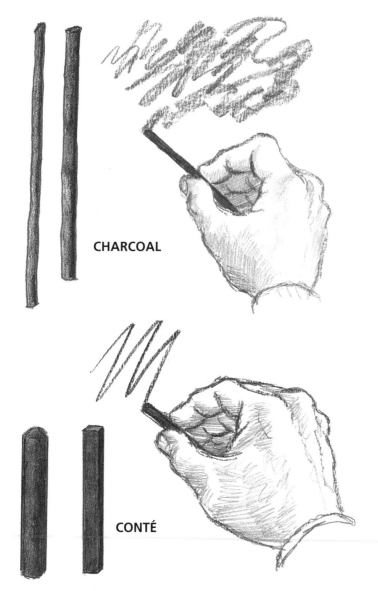

CHARCOAL

3 Now do the same thing but this time smudge the result with your fingers as you move to the right, gradually letting the marks get softer and smokier until they fade out to nothing. This is where your fingers get dirty.

CONTÉ

4 Now try a rounded shape with a dark centre becoming soft and smudgy all around the outside. It should look like a ball of smoke.

Now go through a similar set of exercises with the charcoal or conté stick, but this time using slightly different marks. Finger smudging helps you to give a softer edge to the tones.

5 First, create a scribble that gets darker and darker, overlapping the marks to give more density.

6 Next, make a series of scribbly lines to produce a much lighter tone. Keep your touch on the paper quite soft, with no pressure.

7 Now make a series of dark lines then smudge them until you have something that looks like a dark cloud with no defined edges.

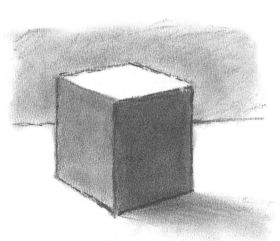

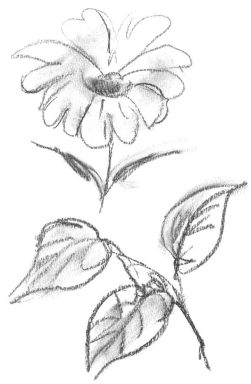

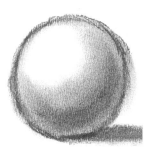

8 Now draw a circle. Draw in the areas of shadow, leaving a white highlight to give the sphere volume. Your circles will be getting better as you've done a few now!

9 Next try a cube. Build up the tone on two sides, being careful to leave the top surface white. Use your finger to create a smudged shadow to the front of the cube.

10 Finally, make some quick drawings of leaves and a flower, smudging parts with your finger to give some hint of shadows or texture.

BRUSH AND WASH

This form of drawing uses a brush instead of a pencil and is a useful technique. You will need two watercolour brushes, sizes 10 and 2, and some dark watercolour paint or soluble ink. Buy round brushes, which come to a point when they are wet – the best type for this are those made of sable hair. Watercolour paper is the ideal surface, but if you prefer to use cheaper cartridge paper you should buy a fairly heavy one or the water will make it cockle.

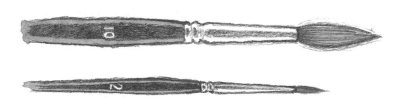

Using brushes of radically different sizes gives you plenty of choice for mark-making.

3 Now try a darker tone, gradually making it lighter as you progress to the right by adding more water for each stroke.

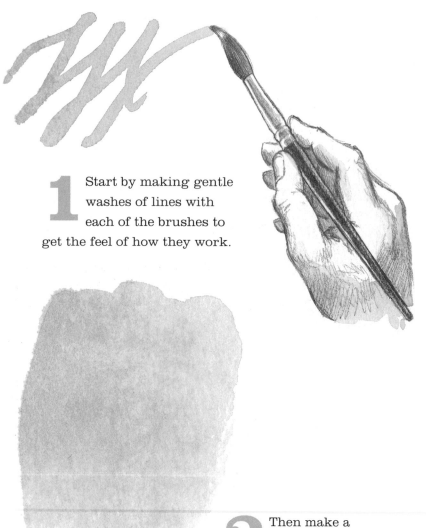

1 Start by making gentle washes of lines with each of the brushes to get the feel of how they work.

4 Now, with the smaller brush, swish a few lines of tone without taking the brush off the paper.

2 Then make a patch of tone – quite a light one.

5 Starting with a very dark tone, dilute it down as you move to the right until it seems to disappear into nothing. Ideally you should be able to go from the very darkest tone to almost white by this method, but don't worry if at first you can't achieve it – more practice will improve your efforts.

6 Now try painting a few leaf-shapes like the ones you did with your dry mediums, only this time it will be much easier to get the shape in one stroke. When it is dry, paint in a few darker lines to show the veins on the leaves.

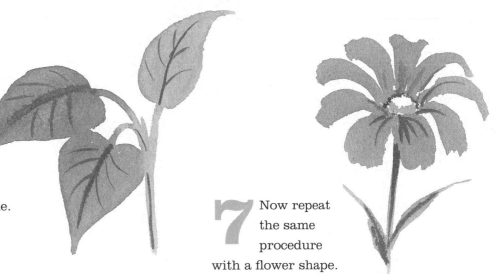

7 Now repeat the same procedure with a flower shape.

8 Again try to draw a perfect circle.

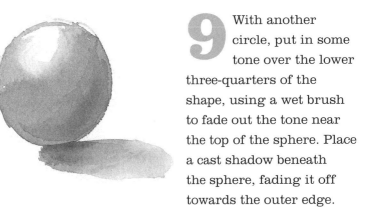

9 With another circle, put in some tone over the lower three-quarters of the shape, using a wet brush to fade out the tone near the top of the sphere. Place a cast shadow beneath the sphere, fading it off towards the outer edge.

10 Now you can draw a cube shape as before, but this time using a brush. In the first stages of drawing the cube, use the small pointed brush to make as fine a line as you can. You'll have to wait for the paint to dry before you do the next step, but if you're using watercolour paper it won't take long.

11 Paint a wash as carefully as you can with your large brush, giving a tonal background halfway down the cube and covering the two lower sides in the same tone. Also put in a cast shadow, washing it away to nothing at the far end of the shadow.

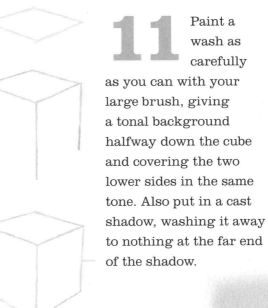

12 Now just darken one side and the adjacent shadow to complete the picture. You may want to strengthen the lines a little around the cube as I did to make it more positive.

PENCIL STILL LIFE

In the examples on the following pages I have drawn the same simple still life in different mediums to give you an idea of the effects you can achieve with each. The exercises on the previous pages will have given you valuable experience in handling these mediums, so you may now be ready to have a go at reproducing these yourself. I encourage you to draw from life as often as you can, as it will quickly improve your drawing and will also teach you to see more accurately and perceptively.

For this still life I placed a bowl of plums on the table in front of me and lit them from one side, without any particular background. This made a series of clear shapes without any complicated drawing to be done.

1 First make a very rough pencil sketch of the main shape of the objects to make sure that you are seeing it accurately. Once the result pleases you, draw it up more carefully, using an eraser to correct any mistakes.

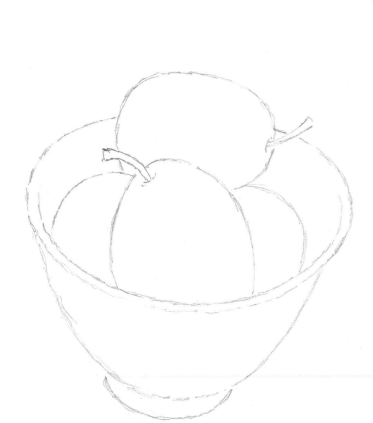

2 When you are drawing the objects with more defined lines you should make as many corrections as you need to, because this is the time when it's relatively easy to do. Later on it becomes more difficult.

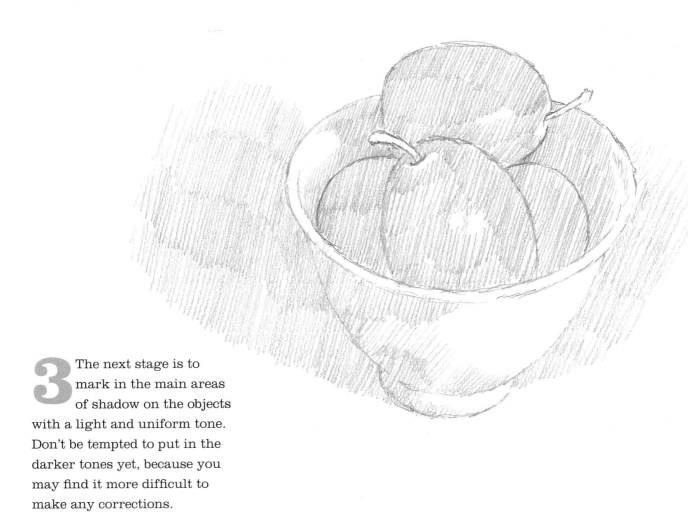

3 The next stage is to mark in the main areas of shadow on the objects with a light and uniform tone. Don't be tempted to put in the darker tones yet, because you may find it more difficult to make any corrections.

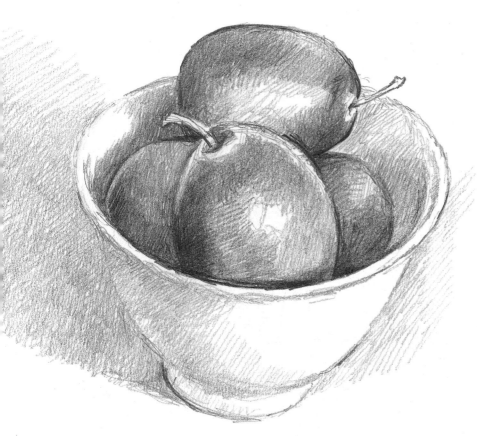

4 When you're satisfied that all the areas of shade have been covered by your light tones, put in the darker ones. A good way to do this is to put in the very darkest first and then work in all the mid-tones afterwards, but you may prefer to tackle it another way. However you do it, keep checking the whole drawing to see how the effect is progressing.

PEN STILL LIFE

Drawing up the same still life in ink is rather like working with a pencil, except that you can't merge the marks so easily to make the tone. However, the principle is exactly the same in that you build up the tone after you have drawn the outline of the main shapes.

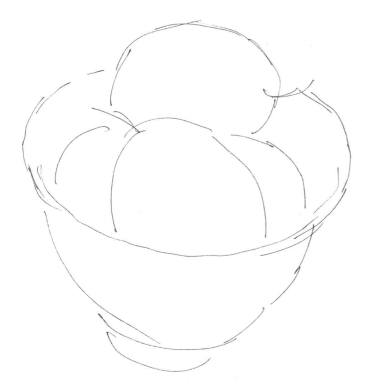

1 Sketching in a rough outline should be done very lightly, because you will not be able to lose the marks. Make them very fine in thickness and rather broken in line.

2 When you're firming up your outline drawing, take as much time as you need to make the image as accurate as you can.

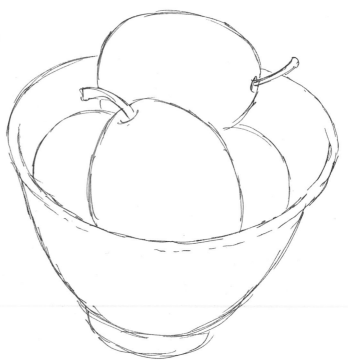

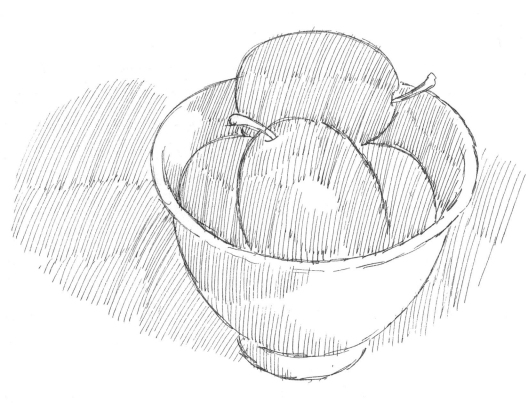

3 Then, as in the pencil image, you'll need to put in the overall area of tone with light strokes, not too close together. It doesn't matter if the strokes don't all go in the same direction – just don't make the tone too heavy at this stage.

4 In the final stage you'll need to build up the marks in the darker areas as before, judging the weight of tones in the image as you go along. This layering of strokes, one set over another to make a sort of lattice-work, is called crosshatching. In this way the tone can become darker and darker as you add each layer of closely drawn lines.

CHARCOAL STILL LIFE

As you can probably guess, when you draw the still life in charcoal the same rules apply as with pencil and pen. The main difference is that you have the smudge factor to make the job quicker, if not quite so precise. My advice is to draw in charcoal on a bigger scale, when the slightly chalky line seems to be more effective.

1 With this softer drawing medium the first lines aren't so crucial as it's quite easy to alter them. However, keep them light and sketchy at this stage, making alterations as you go along. The process of correcting your drawing is never a waste of time because this is how you learn to improve your skills.

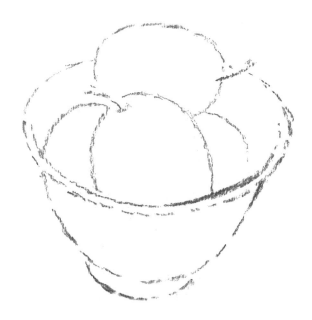

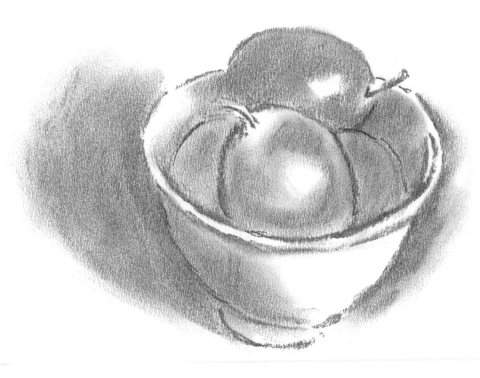

2 Put in the main area of tone as with the other techniques, but this time you can smudge the tones a bit to keep them light and soft-edged. Don't go over any area where the light is strongest, as white paper helps to give the highlights impact.

3 Then build up the darker tones, smudging only lightly to avoid smoothing out the texture of the drawing too much, which can make it look a little too glossy.

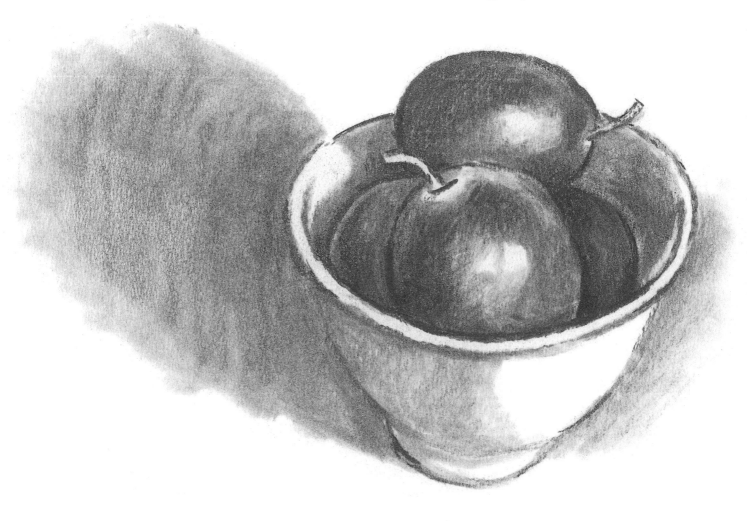

BRUSH AND WASH STILL LIFE

With the brush and wash version you can lend the surface of the objects a very realistic look, which is the great advantage of paint over pencil. Of course it's not quite so easy to control, but you'll soon become good at it if you keep practising. The convincing effect of this method makes learning to handle it well worth while.

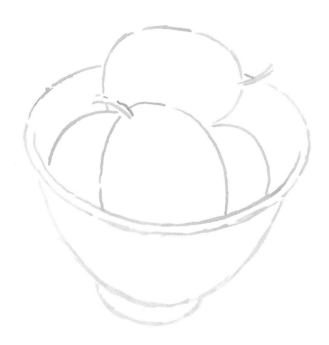

1 The first outline drawing, rather like the pen drawing, needs to be done fairly carefully, although it is easier to change than the ink version. However, if you can keep it very spare it helps for the later stages. Don't have the brush loaded with too dark a tone – keep it light.

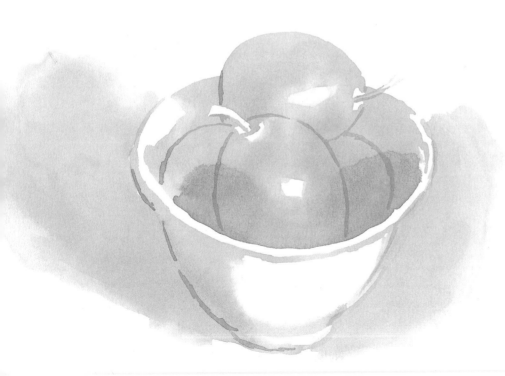

2 In the second stage the laying on of the single light tone can only be carried out when the first marks are dry, otherwise you will find the area flooding with too much tone.

3 In the third step, lay on the darker tones when the light tone has dried – you may have to soften some of the edges by watering down the colour sometimes. This in a way is the hardest part of the brush technique, so don't be too upset if it doesn't always work. This is where practice comes into force; the more you try it out the better you will get.

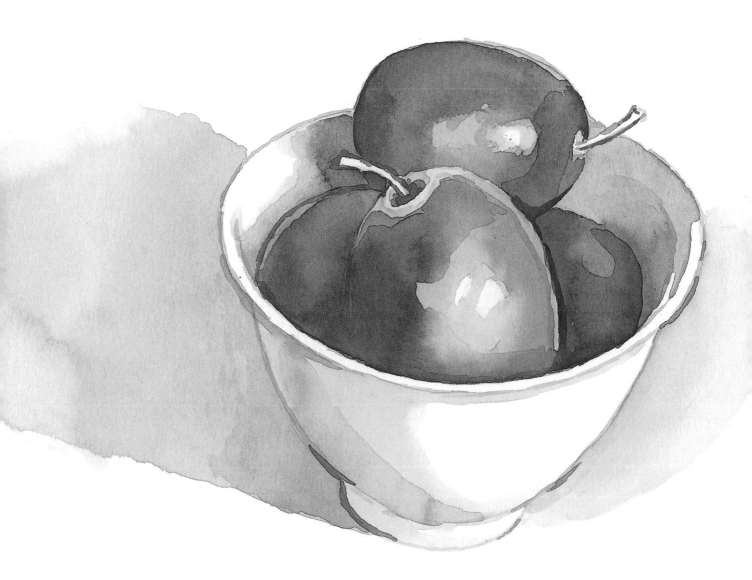

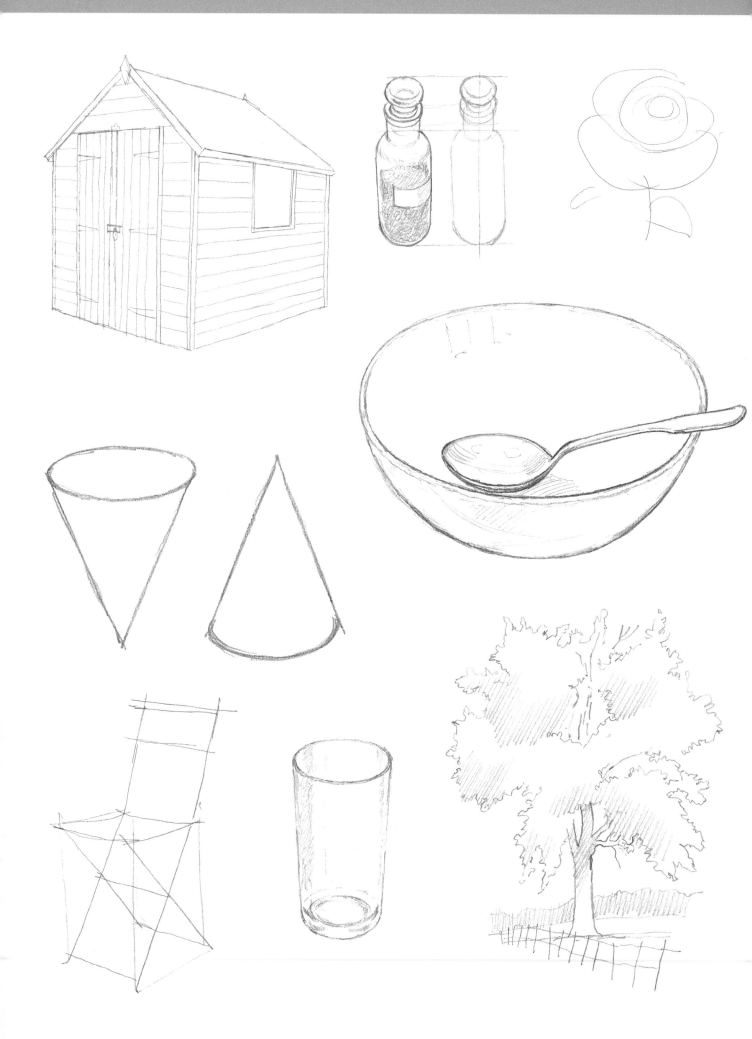

Chapter 2

LINE DRAWING

Once you have become familiar with the marks that different drawing materials make you can really get going on drawing from life, and anything is useful for your practices. In this chapter we shall concentrate on making line drawings of a range of subjects without worrying too much about tonal detail at this stage. You may like to follow my own drawings on the following pages, but do choose some objects of your own as well so that you are working out for yourself how best to describe them.

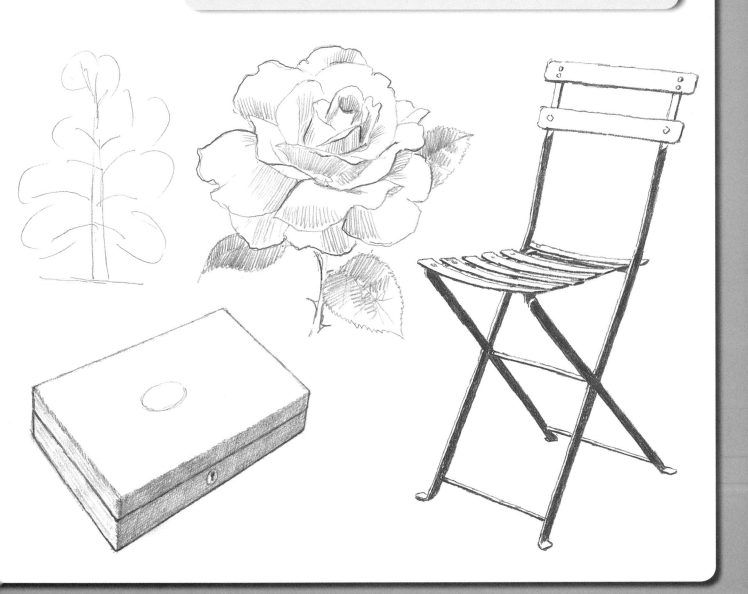

SIMPLE SHAPES FROM EVERYDAY THINGS

Starting with a circle drawn using a compass, test your efforts to draw a freehand circle accurately. Draw them side by side for comparison and keep rubbing out any obvious mistakes until the hand-drawn circle looks as effective as the compass-drawn one.

Then try out these figures by copying them – a cube, a cylinder and a cone in two positions.

Now find an ordinary wooden box and do your best to reproduce some form of the shape as shown here, with its perspective effect. Notice how the far end of the box appears to be slightly smaller than the closer end. We'll be looking at the laws of perspective on pages 66–89, but for now just rely on observation.

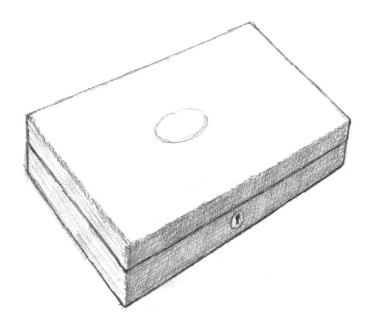

For your next practice, find a series of ordinary objects from around the house and have a go at drawing them in a very simple way. There's no need to look for items with an inherent beauty – this is just about learning to draw things accurately.

Here's a little glass bottle containing some pigment that I found in my studio. It's based on a circular shape, so, as you can see in the drawing next to it, the sides show as mirror images each side of a central line.

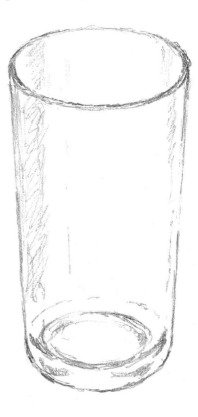

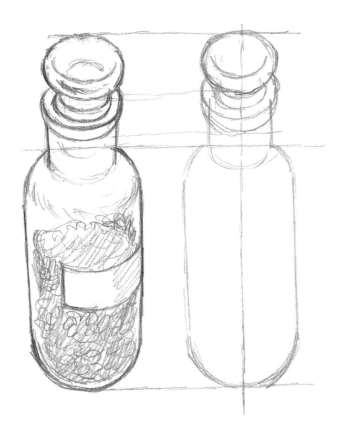

This is also true of the next object, a glass tumbler. Many of the objects you will find in your kitchen are based on circles or squares.

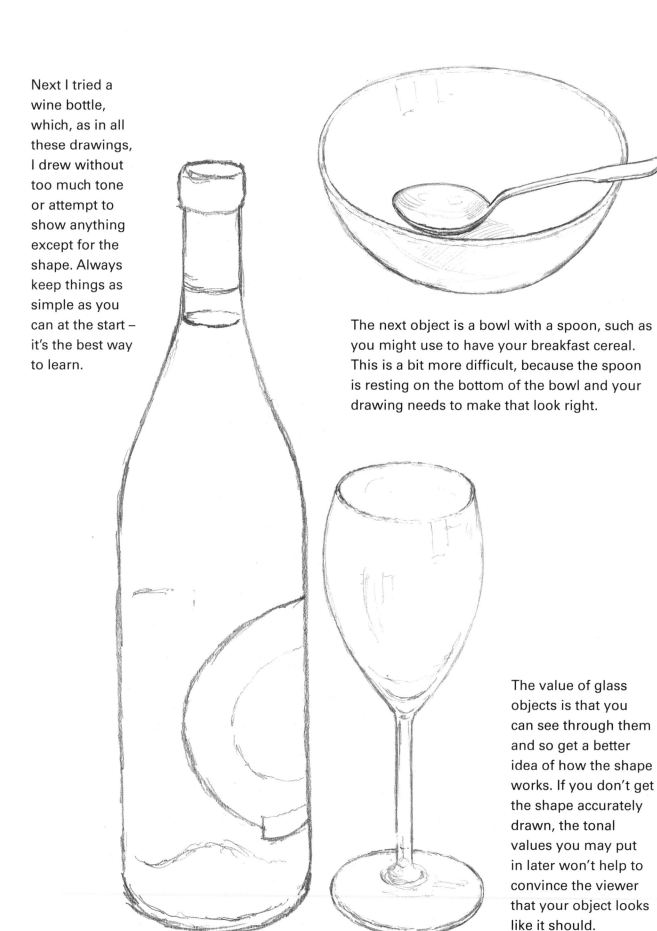

Next I tried a wine bottle, which, as in all these drawings, I drew without too much tone or attempt to show anything except for the shape. Always keep things as simple as you can at the start – it's the best way to learn.

The next object is a bowl with a spoon, such as you might use to have your breakfast cereal. This is a bit more difficult, because the spoon is resting on the bottom of the bowl and your drawing needs to make that look right.

The value of glass objects is that you can see through them and so get a better idea of how the shape works. If you don't get the shape accurately drawn, the tonal values you may put in later won't help to convince the viewer that your object looks like it should.

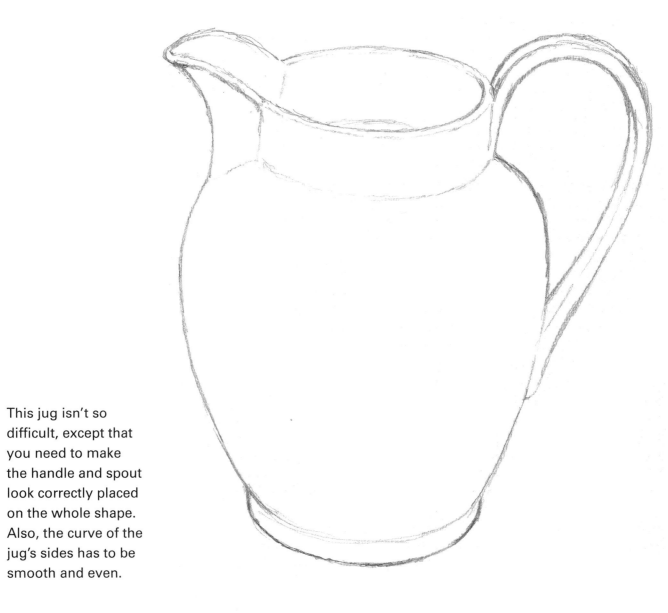

This jug isn't so difficult, except that you need to make the handle and spout look correctly placed on the whole shape. Also, the curve of the jug's sides has to be smooth and even.

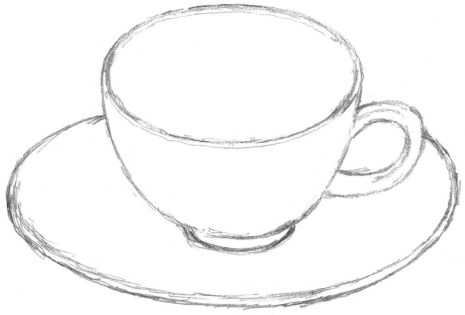

The cup and saucer will enable you to practise the techniques you learnt in the previous drawings, because the cup has to rest on the saucer convincingly and the handle must look firmly attached.

TREES AND FLOWERS

Even if you live in a town, you probably have some vegetation near you in a garden or a park. Go and have a look at some trees, and notice how complex they are, with their myriad leaves and branches. One student of mine, when confronted with a tree to draw, said, 'Do I have to draw every leaf?' Of course, the answer is no – but you do have to make a tree look as though it has leaves en masse.

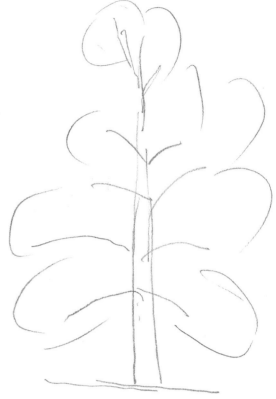

As you can see, these first sketches help to establish the proportion and overall look of the trees without much drawing.

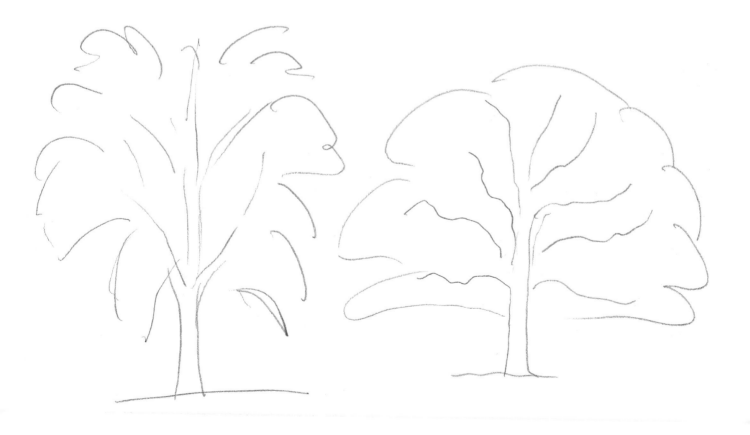

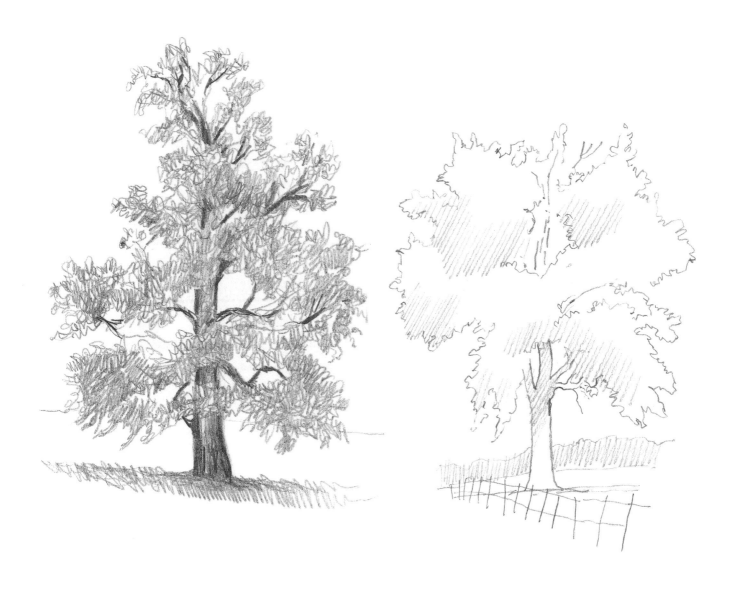

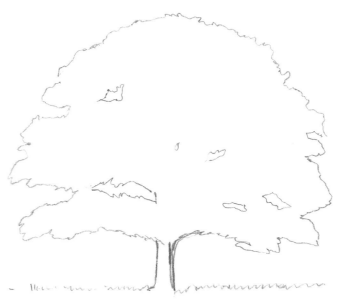

In the three drawings on this page, I've shown how you can indicate leaves with a sort of scribble technique so that they look softer and less definite than the trunk and branches; or you can outline whole masses of leaves and just put a tone over the areas where the shadow is deep. Alternatively, you can simply outline the whole shape of the tree without worrying about the different parts.

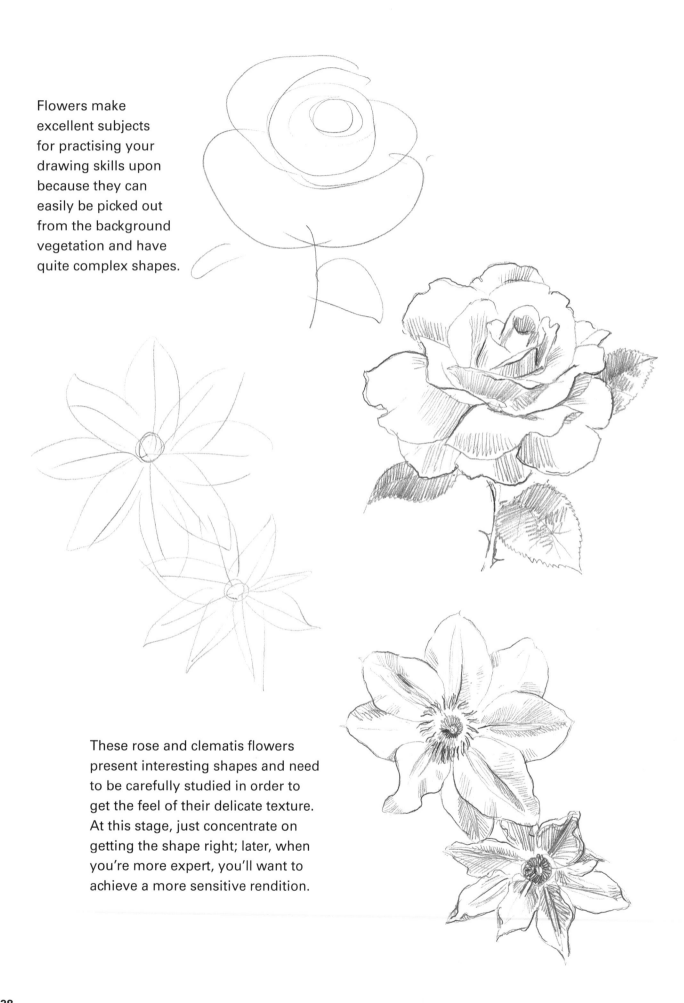

Flowers make excellent subjects for practising your drawing skills upon because they can easily be picked out from the background vegetation and have quite complex shapes.

These rose and clematis flowers present interesting shapes and need to be carefully studied in order to get the feel of their delicate texture. At this stage, just concentrate on getting the shape right; later, when you're more expert, you'll want to achieve a more sensitive rendition.

LARGER SHAPES

Now let's look at something bigger and man-made. This is an ordinary iron garden chair that's not only very traditional, but in this case fairly old and worn – it's a chair from my own garden, in fact. Because of its linear shape it's ideal for this practice.

1 First draw a skeleton of lines that gives you the main shape of the chair without any detail. At this stage, get the basic cubic shape right by projecting lines down from the seat to the points where the legs meet the ground. The crossed side pieces that make up the legs of the chair meet at about the middle of this cube.

2 Now carefully draw up a more three-dimensional shape, showing the pieces of flat metal that the chair is constructed from. At this stage, use an eraser as much as you need to in order to get the shapes correct.

3 Now make the darker sides of the strips of metal quite black and sharply defined with your pencil, leaving the lighter edges of the side facing the light drawn less strongly. The effect of this is to give more solidity to the form of the chair.

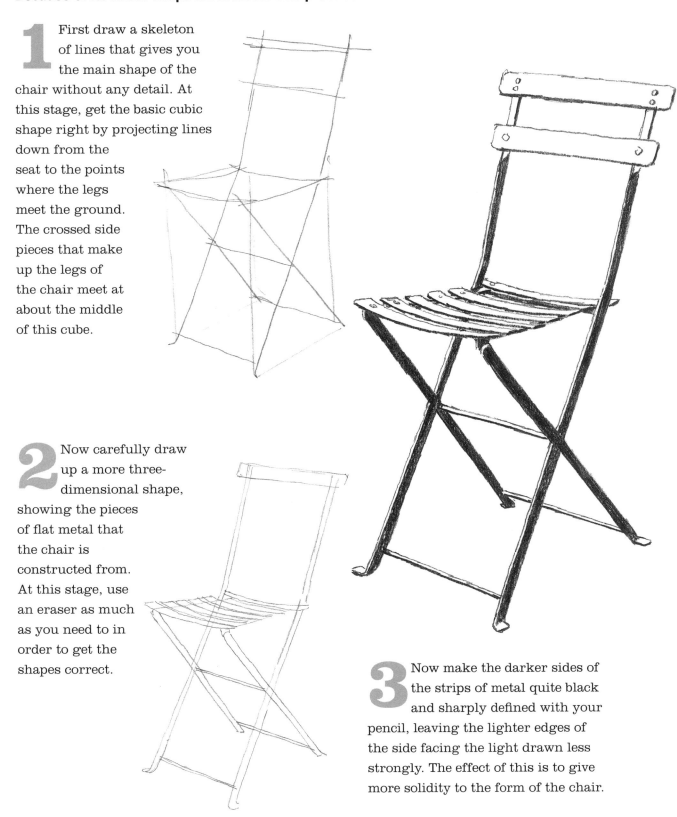

1 Now we'll go even larger. I've chosen a garden shed, but if you haven't got one just draw any small wooden hut you can find. The first thing to concentrate on is successfully giving a three-dimensional effect to the hut by using perspective. This is fully explained on pages 66–89, but all you need to know here is that once you've drawn the nearest corner first as a vertical line, all the horizontal lines of the building going away from you should converge so that if they were extended they would meet at your eye level.

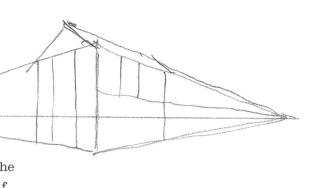

2 To start with, put in only the outline of the building, leaving the details until you're confident you've got the shape right. You can see how the use of perspective immediately conveys the sense of a three-dimensional structure.

3 Now put in as much detail as you can, working carefully, but only in line at this stage. Take as much time as you need and use an eraser to correct any parts that don't look right to you.

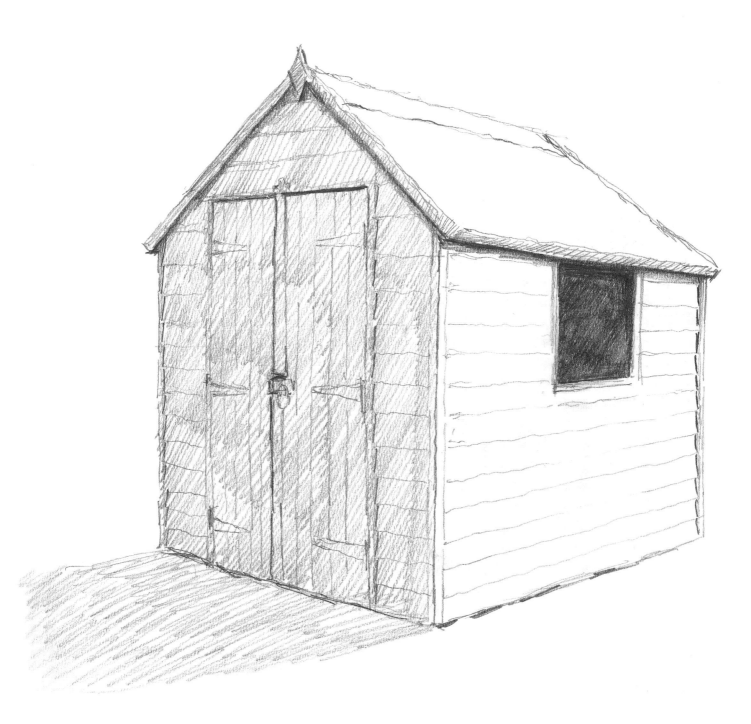

4 When you have done this just try a little tone by putting one side in shadow and darkening any windows to give them a feeling of depth. As you can see, even with quite minimal tonal areas the hut looks more substantial.

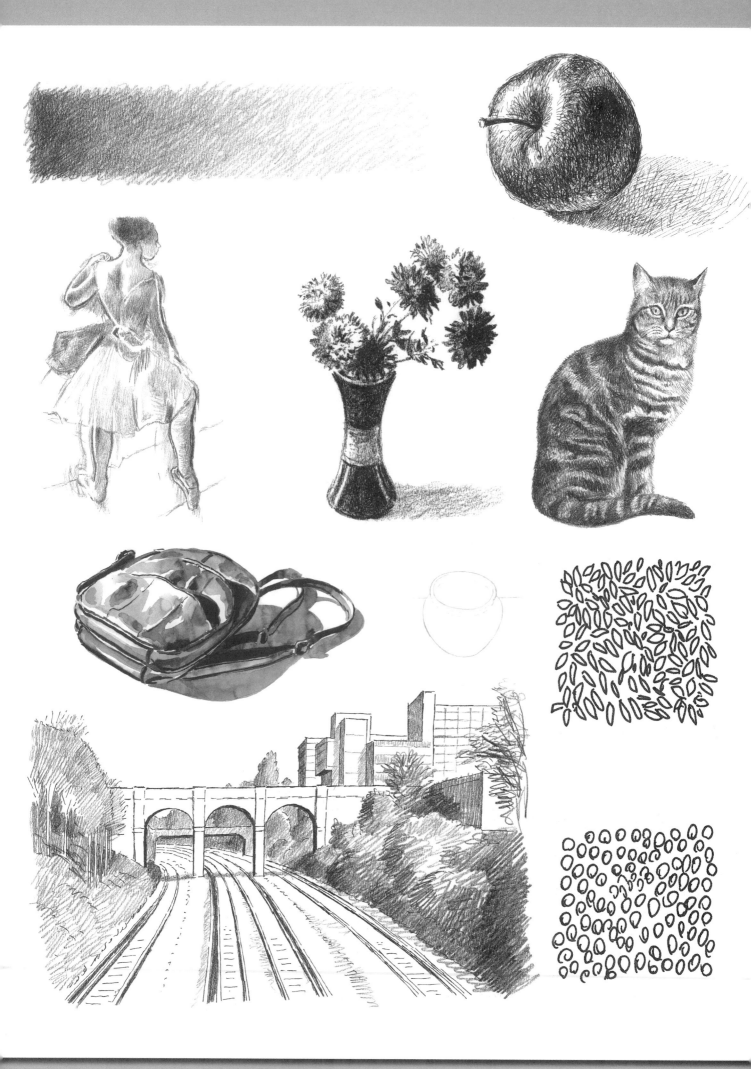

TONE AND TEXTURE

Once you have drawn your subjects, you need to add tone to give them solidity and show their texture too so that the viewer can recognize their surface. This takes quite a bit of practice, so I have chosen a wide variation in the subjects I have given you to draw. You will soon begin to see how the methods you use for one drawing can easily be adapted for other objects that at first glance seem quite different. Of course, the more you practise the better you will become.

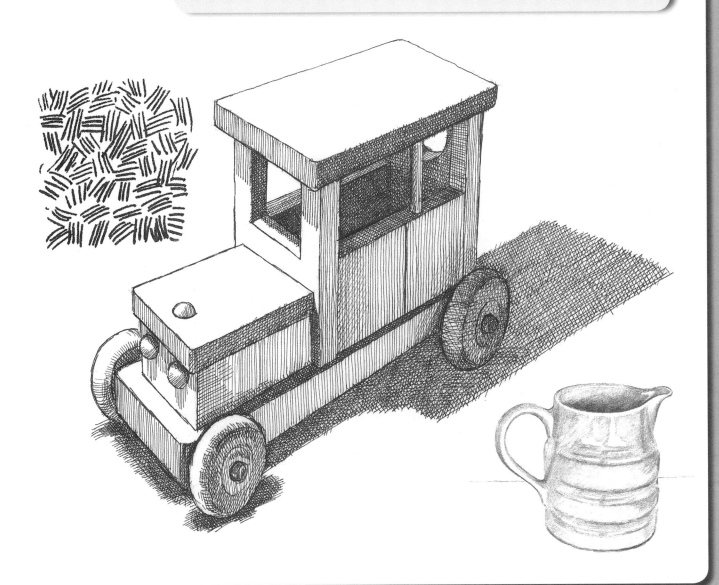

EXERCISES IN TONE

As a start, I've given you some patches of texture or tone just to get the idea across. If you draw a series of five squares alongside each other as shown, you can then proceed to fill them in with your different mediums.

The first square on the left should be filled in with the darkest area of tone that you can manage with pencil, pen, charcoal and brush and wash. As you can see, the square at the far end is in all cases completely white, with no tone or texture in it at all.

Next you have to try to balance your tones so that the remaining three squares in each panel give a very dark but not black tone, a mid-tone and a very light tone. The effect should be to see a natural change in tone from dark to light as your eye wanders across the five squares. If any of them seem to blend too much with the adjacent ones or, conversely, jump out too much, you haven't got it right yet. You may need to have several goes before you come up with the ideal graduation of tone from black to white.

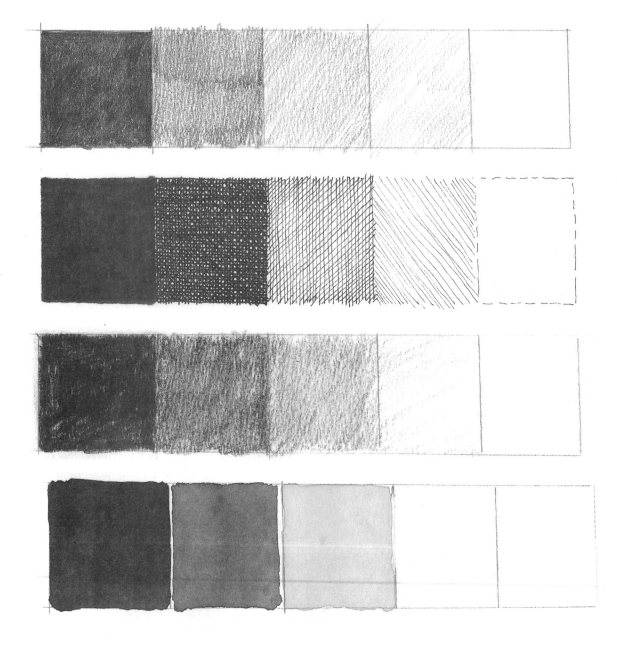

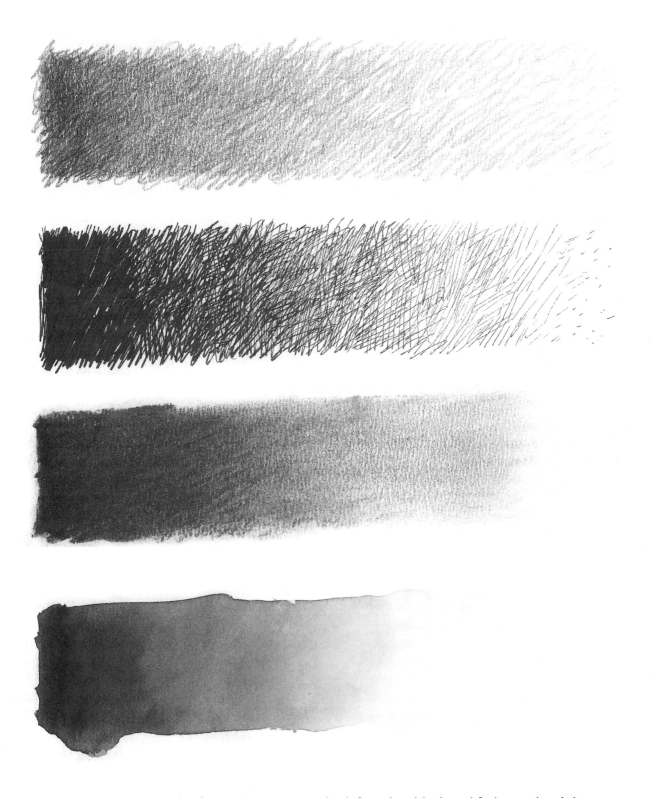

Then try doing a swatch of tone that starts at the left end as black and fades to the right until it's white. In the pencil and charcoal versions you'll be able to smudge the tone a bit to make it work more effectively, but with the ink and the brush and wash you can't do that. Adding water to the wash version is the key, but the ink just has to be done with careful working over the texture of lines, gradually ending up with hardly any.

TEXTURE USING PEN AND INK

Texture is another way of defining the objects you're drawing, and as pen and ink is such a definite medium, using texture is the only way that you can express tonal values. So here I have drawn a whole group of textures that you may need when you come to do any drawing in this medium.

Short marks in
various directions.

Longer marks.

Very long marks.

A texture rather like
woodgrain, with no
lines overlapping.

A wiry scribble that
goes back and forth
across itself.

An endless wiry line
that doesn't ever cross
over itself.

Much heavier short
lines with an 0.8 pen.

Longer lines with
an 0.8 pen.

The woodgrain look
with an 0.8. pen.

A dotted technique.

Groups of short
lines in clusters.

A wiry line with
an 0.8 pen.

A series of small leaf
shapes covering the area.

A layer of zigzag lines
across the area.

A net of horizontals
and verticals.

A series of tiny
blob shapes.

Shapes like a series
of fish scales.

Very light lines like a
series of fine scratches
overlaying each other.

TONE ON AN OBJECT

It is only once tone has been added that an object begins to look like something three-dimensional that you can handle and use. The following drawings show just how important it is to be able to use tone to describe the substance of objects.

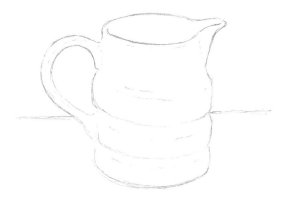

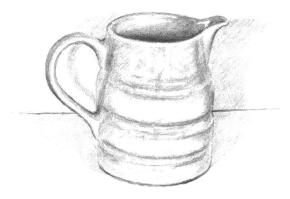

1 Here I've drawn a light-coloured jug, first in outline to show how the shape alone, if well described, will give you quite a lot of information about the jug. You can see that it must be round and that it has a lip and a handle, and it appears to be on a surface, the limit of which you can see behind it.

2 In the next drawing all the tone has been put in to show the difference that this makes to our knowledge about the object. The space is more defined and the quality of the curve of the jug is more clearly seen so you get some feeling of its solidity.

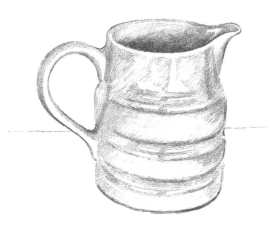

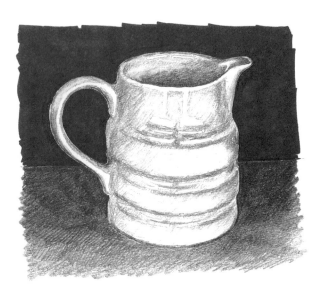

3 In the next drawing I have put in all the tone on the jug but have left out the tonal background. This has the effect of making the jug appear to float in space, because it hasn't any real connection with the background.

4 The last drawing of the jug does the opposite, making the dimensions of the object loom out of the darkness of the background, so that it's very clearly defined as light against dark. This isn't in fact realistic, but it's a good way of bringing our attention to the jug shape jumping out of the space. So you can see that tone can add or subtract quite a bit from your drawing.

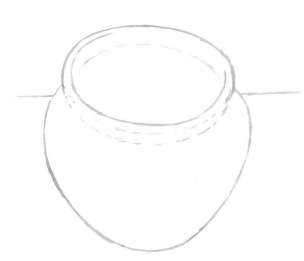

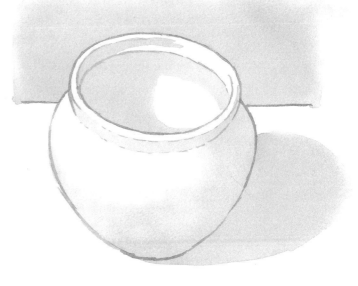

1 Here I've drawn a simple brush and wash version of a white pot against a white background as an exercise in producing shade with this medium. It is in three stages, the first being an outline drawn in with a fine-pointed brush.

2 Next I put in the whole area of shadow on the pot, the surface it's resting on and the background, using one light tone only.

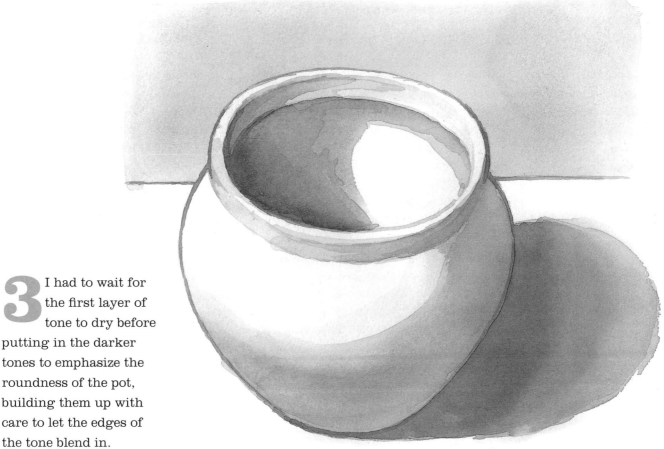

3 I had to wait for the first layer of tone to dry before putting in the darker tones to emphasize the roundness of the pot, building them up with care to let the edges of the tone blend in.

EXPLORATIONS OF TONE

Once you've tried using tone on simple household objects you'll be ready to tackle tone on more complicated subjects. It's not more difficult – you just need to observe where the light is coming from and be consistent with where you place your shadows.

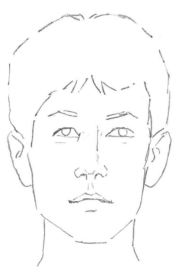

1 The first stage is an outline drawing of a head – at this stage the only requirement is for a clear and correctly proportioned shape that includes the position of the features and the area of the hair.

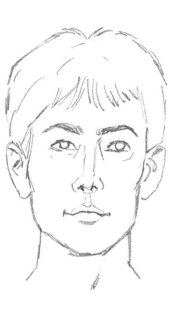

2 In the second drawing the shapes of the features are more clearly described and you can gain some idea of the solidity of the head without yet seeing any of the form defined by tone.

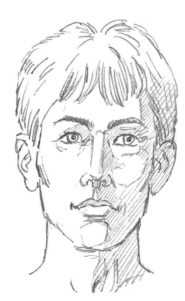

3 The next drawing shows the head with the first main areas of tone put on uniformly and quite strongly. Of course you might not want to use tone quite so boldly as you may be aiming for more subtle areas of shade, but this gets the idea across.

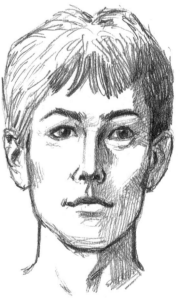

4 In the final stage you can go full tilt at the tonal area and show some parts darker to give the most convincing feel of dimension and depth. At this stage you might decide to soften some edges of tone as well.

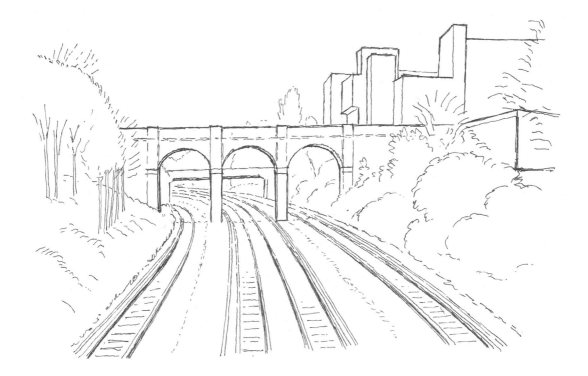

1 Now an example of the tonal work in a landscape picture. This view from a bridge over the railway near Putney, in London, gives a good example of perspective, which is emphasized by the railway lines curving from under two bridges towards the viewer. This in itself will give a sense of depth even without any tonal work. The drawing at this stage needs to be accurate and well-defined to show the various buildings and vegetation in proportion.

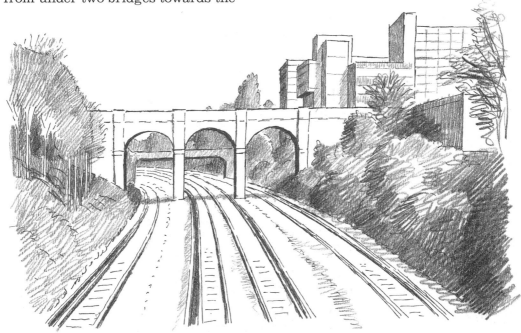

2 Quite a lot of the tone that is put in next is on the vegetation, which always tends to look darker than the surrounding buildings unless the building is in deep shadow or the sunlight is very strong on the leaves. As you can see, the tonal work emphasizes the depth and space in the picture, especially around the bridge area, where the shadows under the arches are very strong, and along the length of the railway lines, which stand out in the foreground.

TONAL DRAWING PRACTICE

Having looked at some of the possibilities of tone, we can now turn our attention to some straightforward objects for you to practise your technique on.

First, a drawing in ink of an apple. The build-up of tonal texture is done in a scribble technique, which seems to work well with rounded objects.

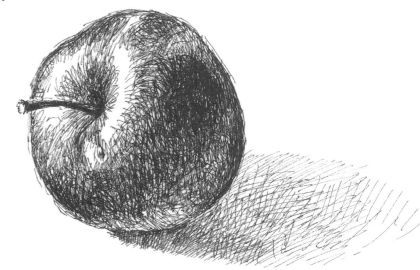

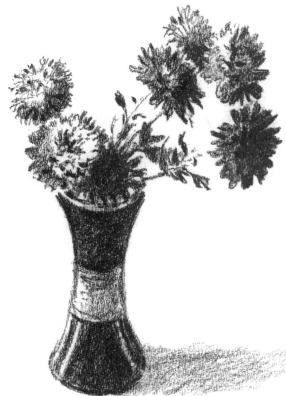

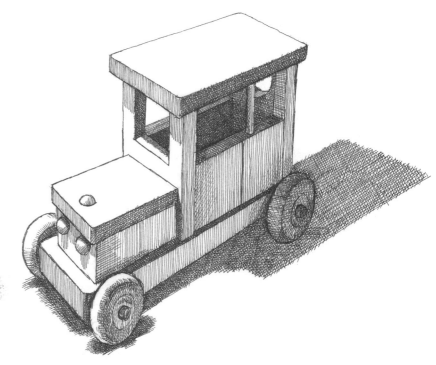

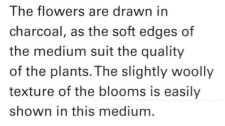

The flowers are drawn in charcoal, as the soft edges of the medium suit the quality of the plants. The slightly woolly texture of the blooms is easily shown in this medium.

Because of its straight-edged manufacture, this toy seems a good subject for using pen and ink. You can draw most of the main tone in lines that echo the lines of the form, so lots of verticals and horizontals to start with, and then a few diagonals to deepen some areas in tone and texture.

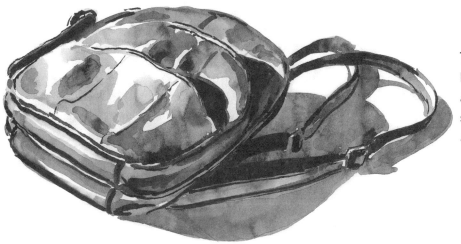

The brush and wash technique helps with the drawing of a leather bag, its slightly squashy look being easily adapted to this technique.

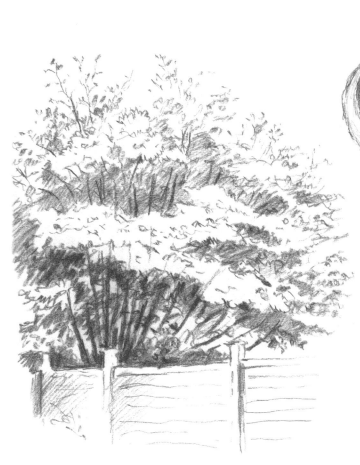

A careful pencil drawing suits a white pestle and mortar, with the shadows put in as pale tones, since a light-coloured object would only have dark tones if it were subjected to very dramatic lighting.

Some trees seen over a fence are easiest to draw in charcoal, because this medium is sympathetic to the soft clumps of leaves.

Here are two examples of how to put together a drawing which largely relies on tone for its effect. One is of a girl sitting in front of a fire in the evening, and the other is of a large tabby cat. Both are mostly made up of changes in tonal density rather than definite lines to show their substance; in neither of them are lines much in evidence.

1 In the one of the girl fire-gazing, a very simple outline is all that can be drawn, showing the areas of differing tones. The only point of the outlines is to make sure the proportions are correct.

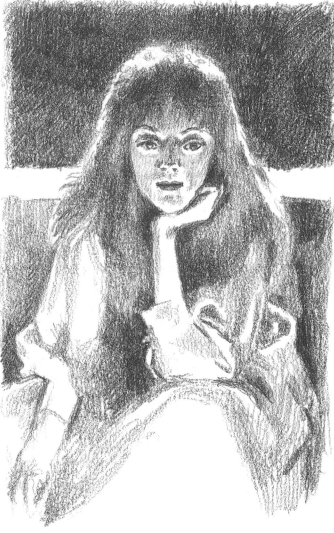

2 Then put in the shaded areas all as one tone, leaving white paper for the highlights.

3 Carefully darken the areas that need to be stronger until you are satisfied that the picture is strong and convincing.

1 Drawing the cat is a similar exercise, except that the tone is much more descriptive of the pattern on its fur. Start with an outline of its body and loosely indicate its face and stripes.

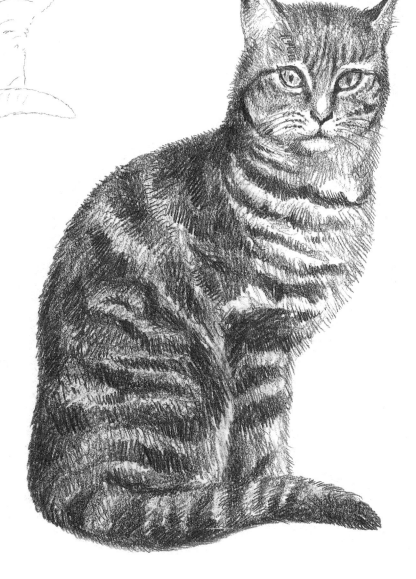

2 Cover nearly all of the cat with a simple tone – there are very few areas of white in this picture, and they appear mainly on the face and chest.

3 Finally, draw into the main areas of darker tone to bring out the stripey appearance of the fur.

SHOWING MATERIALITY

As you become more proficient, you will find that the marks you make when you draw any object give an effect of the material that it is made of. On these pages there are two examples to help you to explore this. The first is an exercise often given to art students to test their ability to observe shape and texture, and that is to take a piece of paper, crumple it up, and then put it down and draw it as accurately as you can. The second exercise is to draw a piece of woollen, cotton or silk clothing, showing its texture clearly. When you have finished these exercises you will have managed to draw many very different objects and you will know how to tackle a range of shapes and surfaces in the future.

Exercise 1

Start by drawing the crumpled paper in outline so that you have got the whole shape down. Keep the line light and as smooth as you can. When you think your drawing is close enough to the shape in front of you, make any corrections you need to.

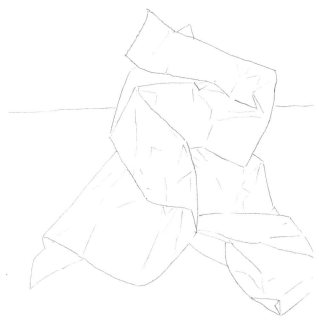

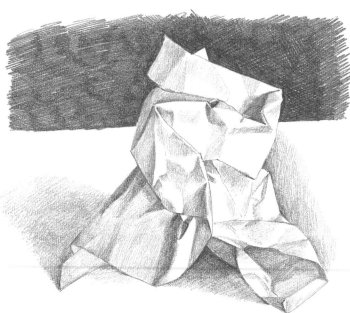

Now carefully put in as much of the tonal areas as you can – it is a bit difficult with white paper, because some of the tones are so similar. When all the tones on the paper are done, put in the background tones. As you can see in my example, the wall behind is quite dark, but the paper is resting on a white surface. The dark wall helps to throw the mass of paper forward in space a little, and gives contrast to the rest of the tonal areas.

Exercise 2

1 For the piece of clothing, try this knitted cotton sweater draped across the back of a wood and canvas chair. First draw a rough sketch to make sure you have got the mass and bulk of the subject right.

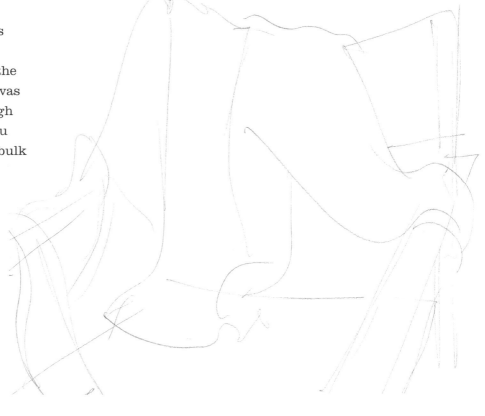

2 Now make a careful outline drawing, allowing the lines to suggest the soft edges of the material as well as the shape of it. Make sure that the hard, smooth lines of the chair contrast with the texture of the sweater's outline.

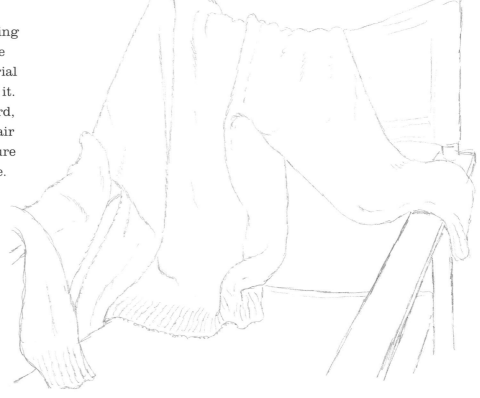

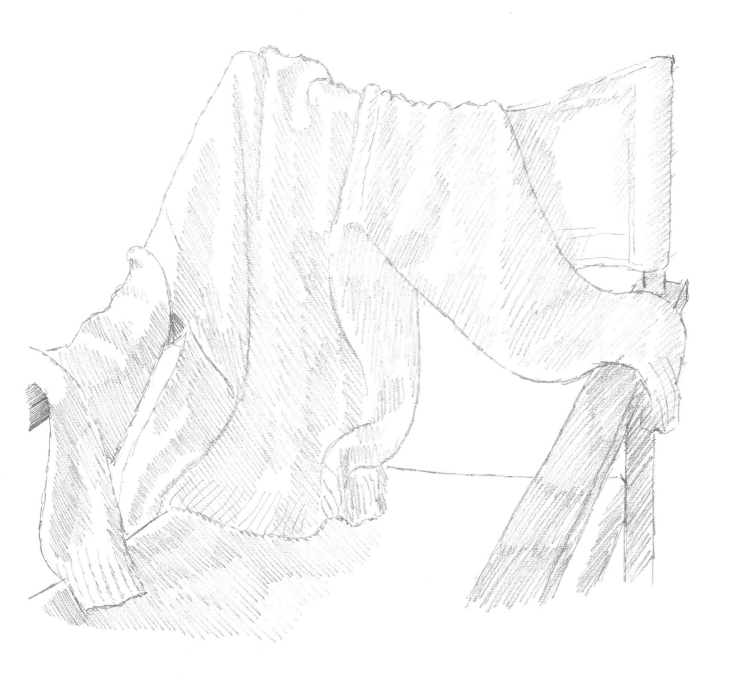

3 Next make a careful all-over rendering of the main tone, not differentiating between dark and light tones at this stage.

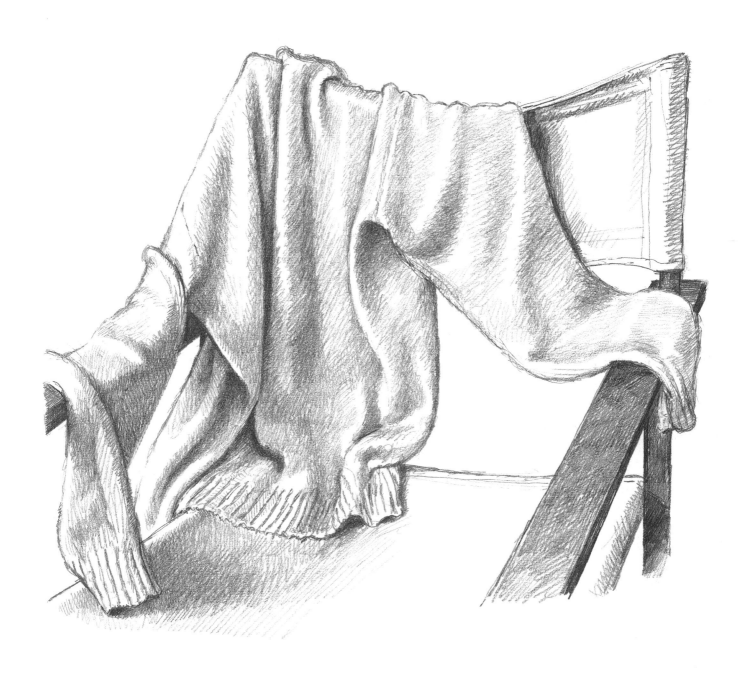

4 Lastly, build up the tonal values to give an effect of the texture and soft drape of the garment, taking care to make the chair look harder and sharper-edged than the cloth.

HOW THE MASTERS HAVE USED TONE

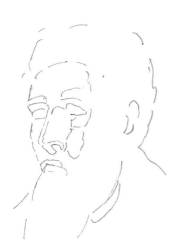

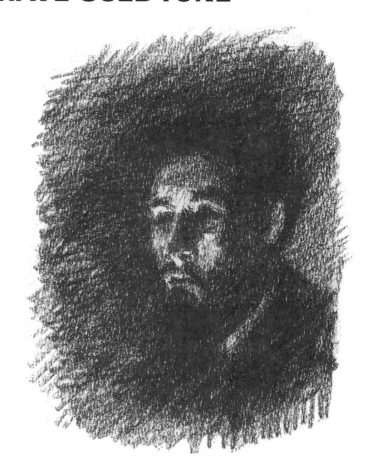

Ernest Laurent drew the face of fellow-painter Georges Seurat in very low light (probably from a candle), which demonstrates how much can be implied by so little. I've drawn an outline of the actual amount of definition shown, but we read a lot more into his drawing in terms of depth and form.

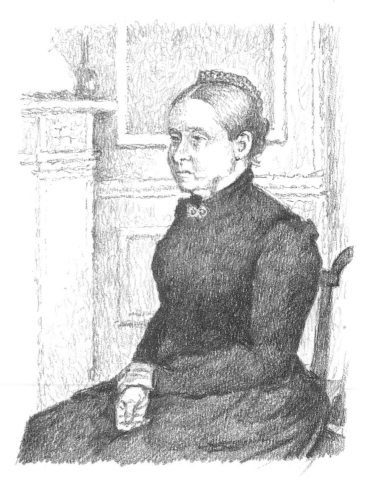

In Théo Van Rysselberghe's drawing, the main shape of the figure is shown with much denser texture and tone than the background and this helps to give her a dramatic intensity in the space. I've drawn an outline as before to show the main shape of the figure. This way of separating the foreground from the background can work very well.

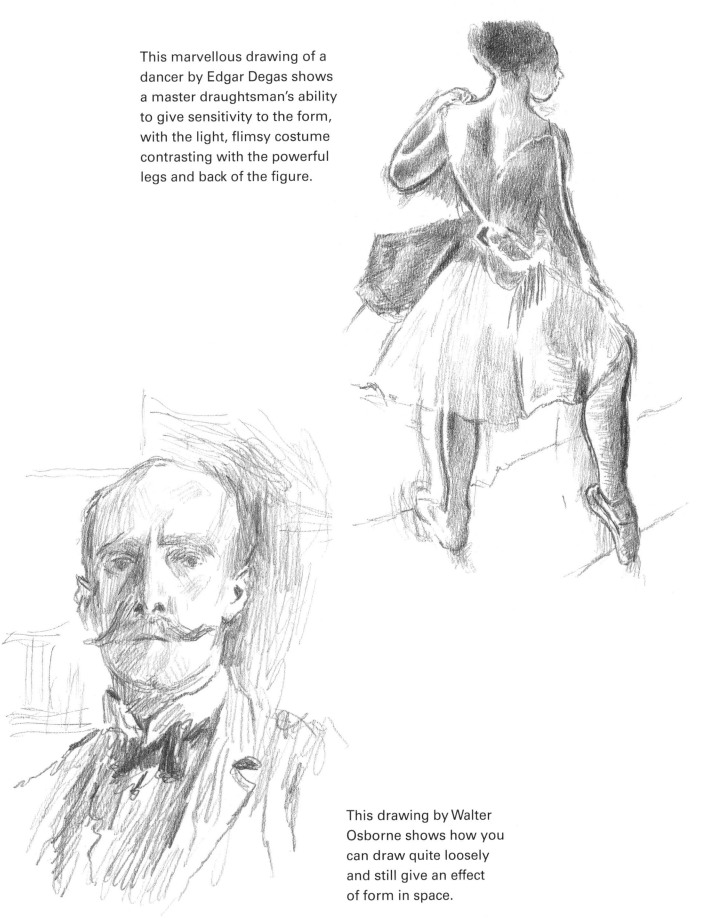

This marvellous drawing of a dancer by Edgar Degas shows a master draughtsman's ability to give sensitivity to the form, with the light, flimsy costume contrasting with the powerful legs and back of the figure.

This drawing by Walter Osborne shows how you can draw quite loosely and still give an effect of form in space.

The drawing of ruins by Herman van Swanevelt gives an impression of the weight and solidity of the chunks of masonry against the light with the use of finely drawn lines. Notice how the nearer stone is much denser in texture than the arches, although just as clearly defined.

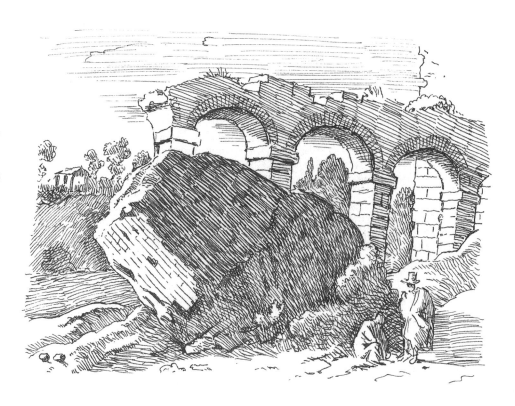

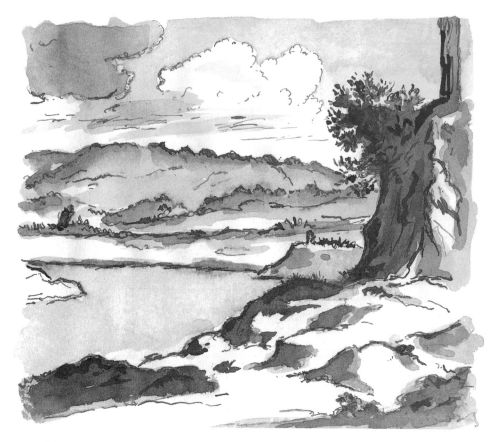

Claude Lorrain's view of the Tiber gives a good lesson in the use of brush and wash, with the addition of some inked lines. Notice how the nearer areas are in darker tones and have stronger texture than the farther landscape.

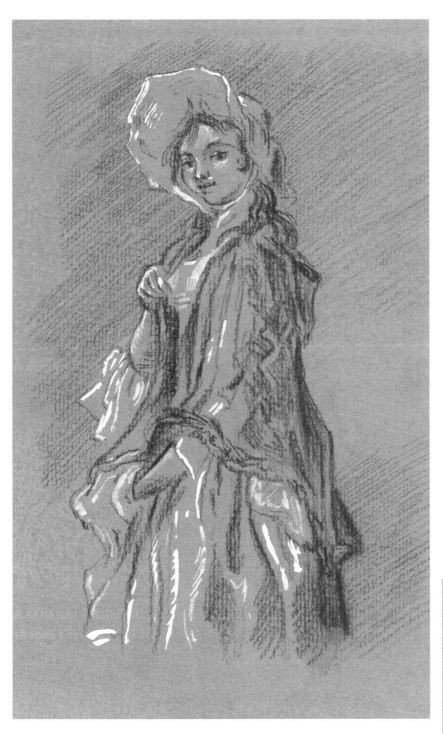

Using toned paper allows the artist to eliminate one area of tonal work as the paper acts as the mid-tone, leaving only the dark and light tones to be drawn. Thomas Gainsborough's approach is very subtle, using quite a lot of the darkest tones and applying the lightest tones only sparingly.

In this modern version of the Gainsborough that I have done myself, the dark and light tones are strong but the colour of the paper does most of the work.

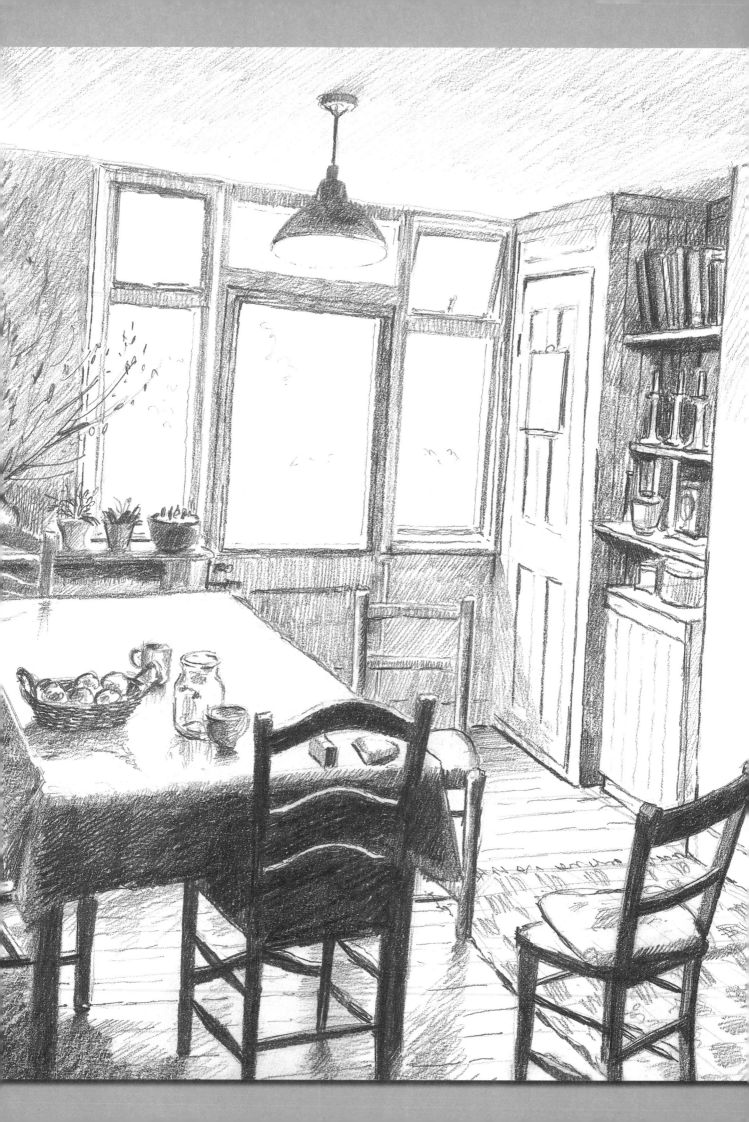

PERSPECTIVE

As yet we have only considered perspective very briefly, so this lesson deals with it in more detail as it's an essential part of drawing visually believable pictures. The first stages of learning about perspective are very theoretical and until you begin to apply it in practice you may find it rather confusing. However, the principles are not too difficult to understand, and with a bit of practice at drawing perspective you'll soon begin to see how it works in real life and you'll be able to make all the subtle adjustments that help to make your drawings more convincing.

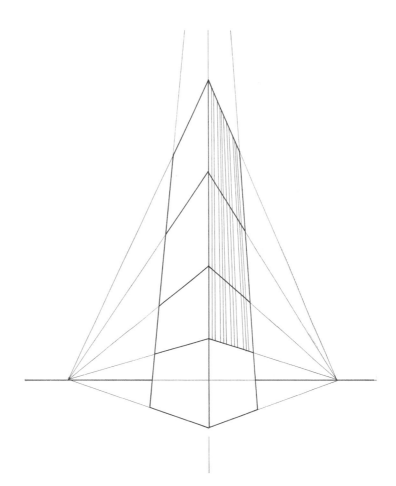

ONE-POINT PERSPECTIVE

One-point perspective is the simplest form of perspective and often the only one you need to know when you're drawing subjects from close quarters.

To start a one-point perspective drawing, for example of a room, you first need to establish a horizon line, or eye level. Perpendicular to that, near the middle of the horizon, a vertical line represents your viewing point. Then, to construct the room, you need a rectangle with the two lines crossing near the centre of it – don't place them exactly in the middle, or it will look a bit too contrived. Now draw lines from the centre point where the horizon and vertical meet to pass through the corners of your rectangle.

From this point you can now construct lines as shown, to place the position of a door on one side wall and two windows on the opposite wall.

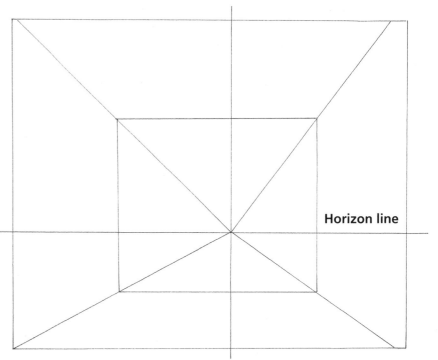

Horizon line

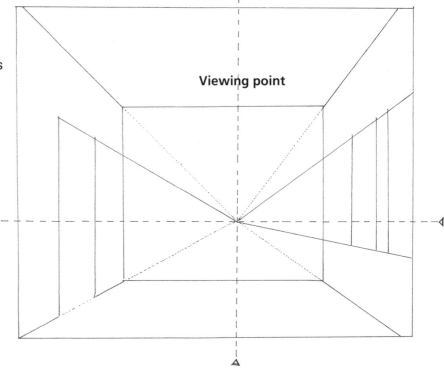

Viewing point

If you imagine yourself in an empty room, standing not quite in the middle, you might see something like this diagram, based on the perspective lines you've just established. Here there's a low eye level, which must mean that you're sitting down, and the room has a door to your left and two windows to your right. It has bare floorboards and strip lighting on the ceiling. There's a large picture frame hanging on the far wall.

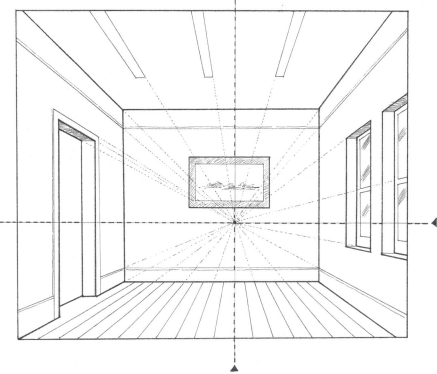

Notice how the vertical line indicates your viewing position and the horizontal one your eye level. All the floorboards seem to slope towards the centre point, known as the vanishing point. The lines of the skirting boards and the cornice rail on the walls to each side all slope towards this centre point also, as do the tops and bottoms of the door and the windows. In other words, except for the lines which are vertical or horizontal, all lines slope towards the centre point – which is why it is called one-point perspective.

This diagram gives a good idea of how you can set about constructing a room that appears to have depth and space. Now stand or sit in a room of your home and see if you can envisage where imaginary horizontal and vertical lines representing your eye level and viewing position cross; this is the vanishing point for the perspective, to which all the lines that aren't vertical or horizontal will slope. Even the furniture is included in this as long as it's square on to the outlines of the room.

Here's a vast interior of a medieval church that shows how one-point perspective works, even with an unusual building such as this. I haven't included any furniture in the drawing so that you can see where the perspective lines of the roof, windows and columns all join at one point, showing our eye level and viewing point.

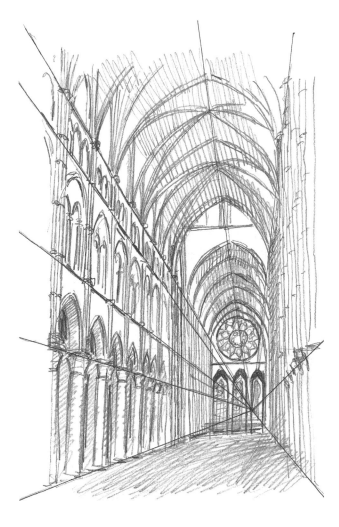

TWO-POINT PERSPECTIVE

When you draw outdoors you need an extra measure of perspective, because you're dealing with much bigger spaces and with large objects such as buildings and cars seen from various angles. This means that you need to use two-point perspective, which will enable you to construct buildings that look convincing.

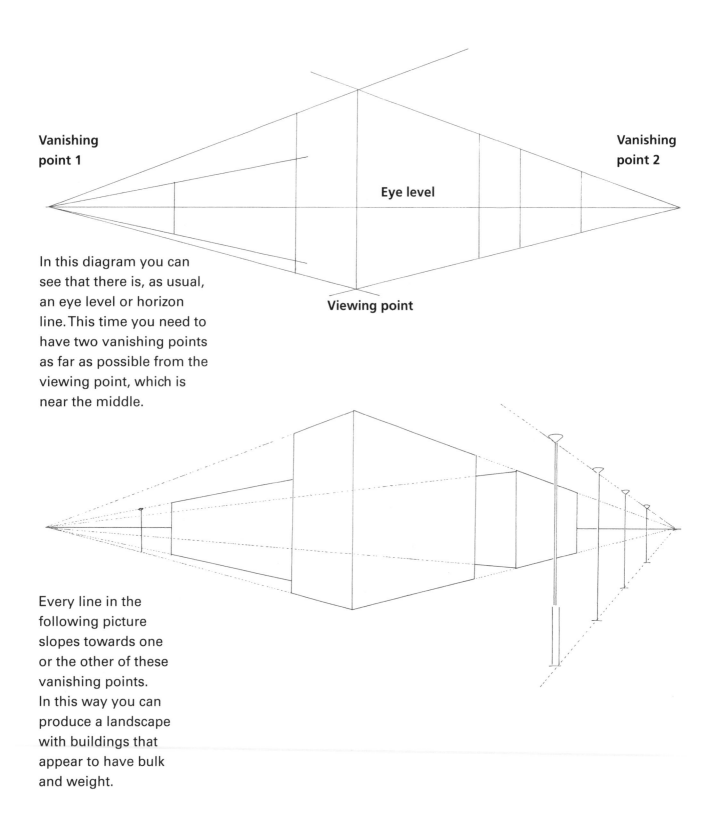

Vanishing point 1

Vanishing point 2

Eye level

Viewing point

In this diagram you can see that there is, as usual, an eye level or horizon line. This time you need to have two vanishing points as far as possible from the viewing point, which is near the middle.

Every line in the following picture slopes towards one or the other of these vanishing points. In this way you can produce a landscape with buildings that appear to have bulk and weight.

Notice how the lamp-posts appear to become smaller as they recede from your point of view. The tops and bottoms of the posts are in line, and all the rooflines of the buildings can be joined in straight lines to one of the vanishing points. The same applies to all the windows, doorways and pavements. The corner of the nearest building is on the viewing vertical and all the other parts of the buildings appear to diminish as they recede from this point.

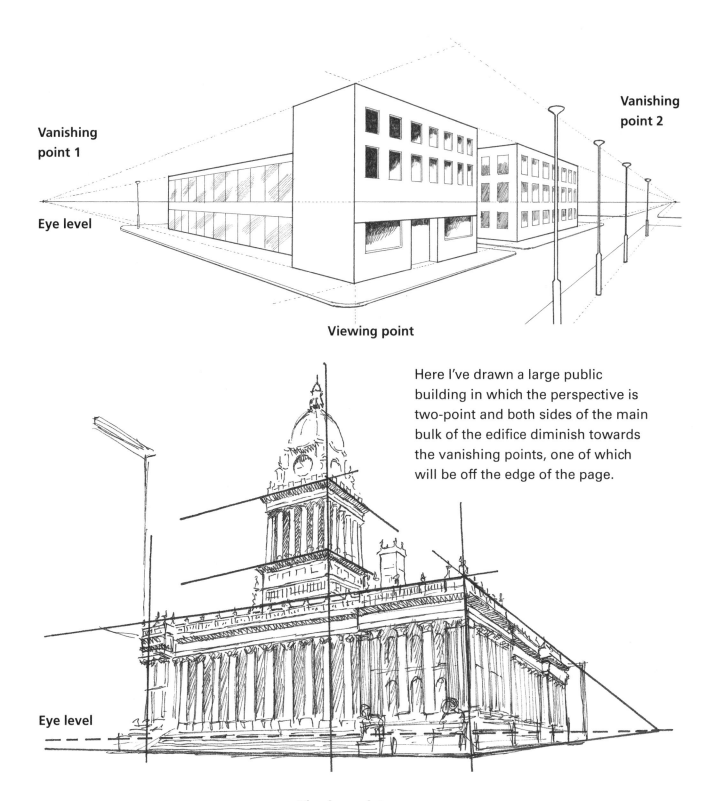

Vanishing point 2

Vanishing point 1

Eye level

Viewing point

Here I've drawn a large public building in which the perspective is two-point and both sides of the main bulk of the edifice diminish towards the vanishing points, one of which will be off the edge of the page.

Eye level

Viewing point

A PERSPECTIVE DIAGRAM

This purely diagrammatic exercise is intended to give you practice in drawing perspective, so that eventually you will be able to draw it without all the construction lines because your mind has absorbed its principles. The co-ordination of the eye and mind is melded by repetition and practice.

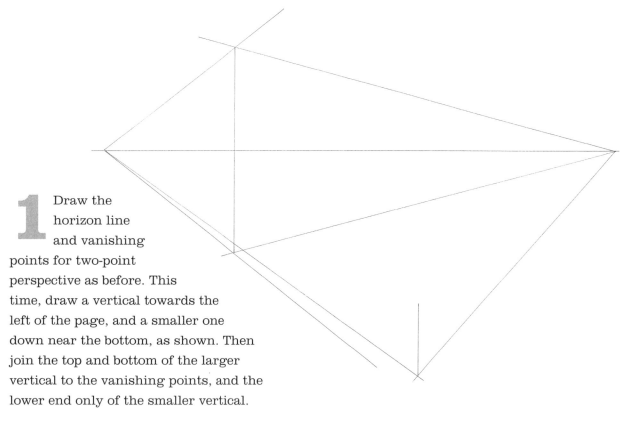

1 Draw the horizon line and vanishing points for two-point perspective as before. This time, draw a vertical towards the left of the page, and a smaller one down near the bottom, as shown. Then join the top and bottom of the larger vertical to the vanishing points, and the lower end only of the smaller vertical.

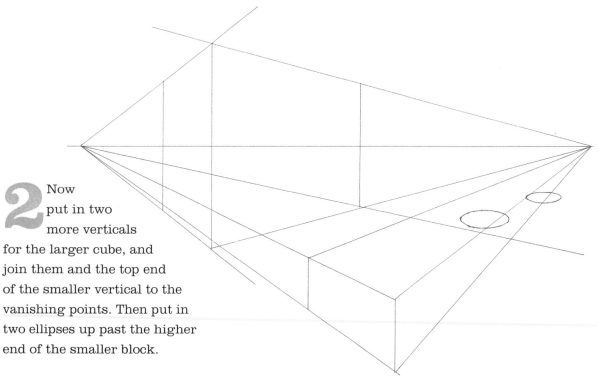

2 Now put in two more verticals for the larger cube, and join them and the top end of the smaller vertical to the vanishing points. Then put in two ellipses up past the higher end of the smaller block.

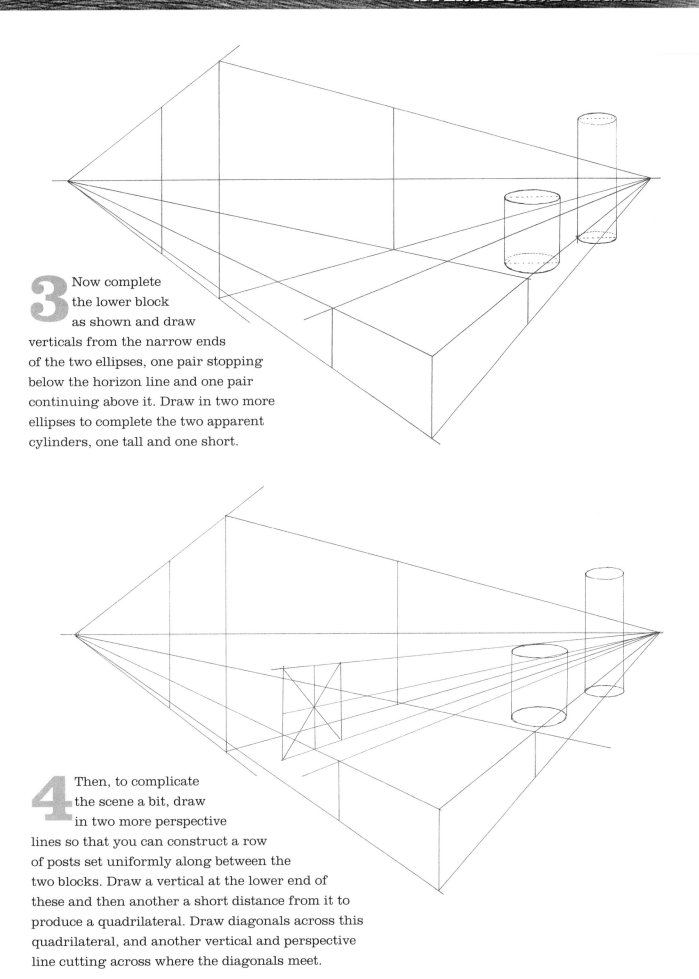

3 Now complete the lower block as shown and draw verticals from the narrow ends of the two ellipses, one pair stopping below the horizon line and one pair continuing above it. Draw in two more ellipses to complete the two apparent cylinders, one tall and one short.

4 Then, to complicate the scene a bit, draw in two more perspective lines so that you can construct a row of posts set uniformly along between the two blocks. Draw a vertical at the lower end of these and then another a short distance from it to produce a quadrilateral. Draw diagonals across this quadrilateral, and another vertical and perspective line cutting across where the diagonals meet.

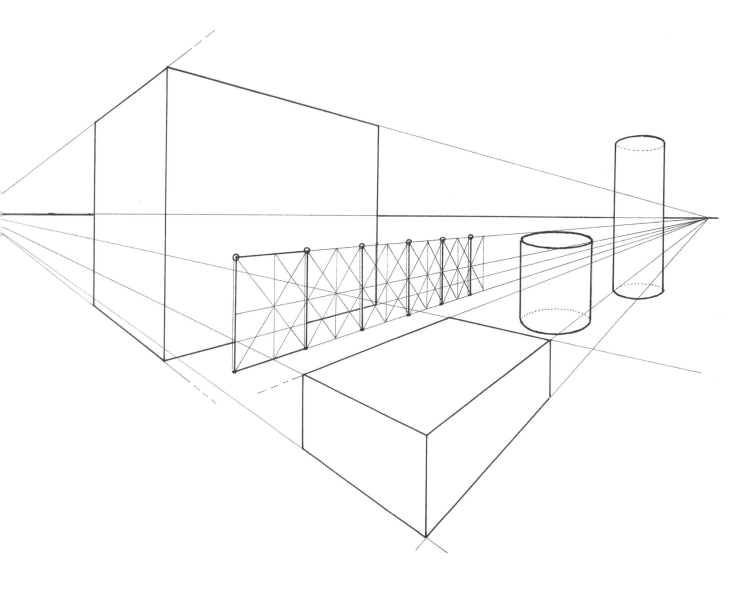

5 Using the method shown on page 71 to draw a row of posts in perspective, keep producing diagonals that use the next central point to construct another vertical until you have a whole row of them.

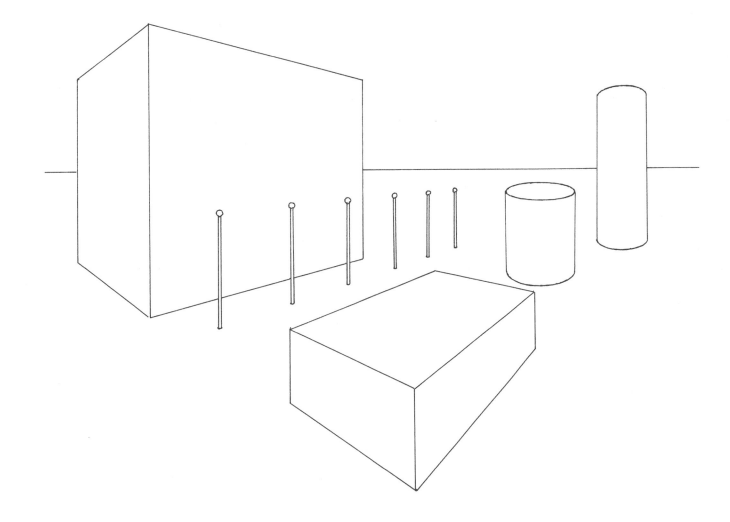

6 When you have erased your construction lines the diagram should look like this. The exercise takes time, but it is well worth doing to consolidate your perspective drawing skills. The result should be solid-looking and convince the eye.

THREE-POINT PERSPECTIVE

While one-point and two-point perspective are generally all you'll need, when you start to draw very tall buildings you may have to bring in a third point of perspective.

This enormous cathedral at Reims in France is a case for three-point perspective. Because of the great height of the building and the fact that the viewpoint is so close a third vanishing point is needed high up in the sky above the cathedral. All the vertically sloping lines along the sides of the building must eventually meet at a point somewhere above it that's off the paper.

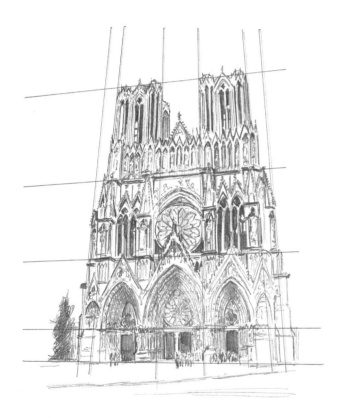

A very high vanishing point is of course much harder to judge, as there is nothing on which to fix your point. But you can see the way it would work, and if you ever have to draw a skyscraper from close to, you would have to use this method to make sense of it.

APPLYING PERSPECTIVE

Next we'll look at how you can apply perspective when drawing landscapes. There follow three views of the same scene along a road, each view taking you nearer to a bird sanctuary observation post.

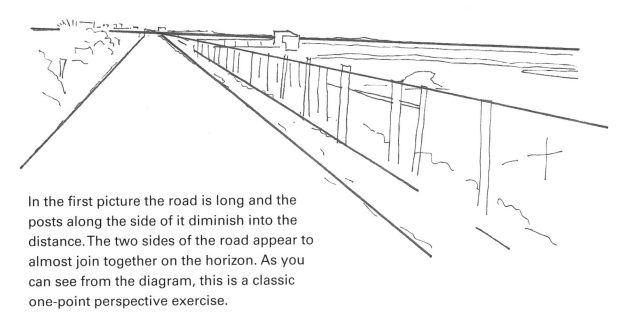

In the first picture the road is long and the posts along the side of it diminish into the distance. The two sides of the road appear to almost join together on the horizon. As you can see from the diagram, this is a classic one-point perspective exercise.

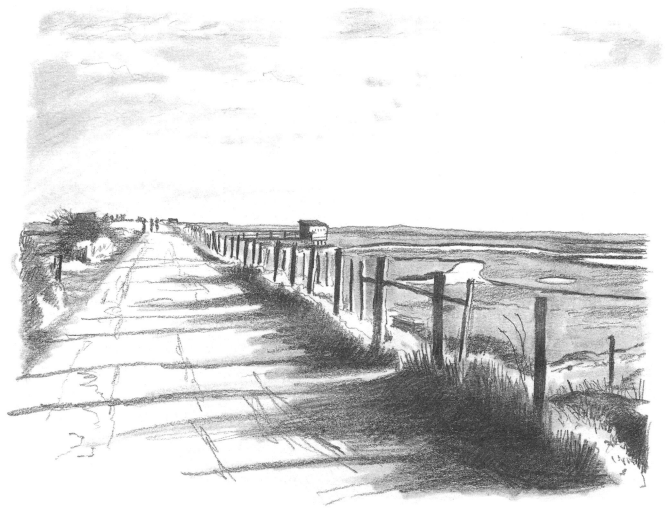

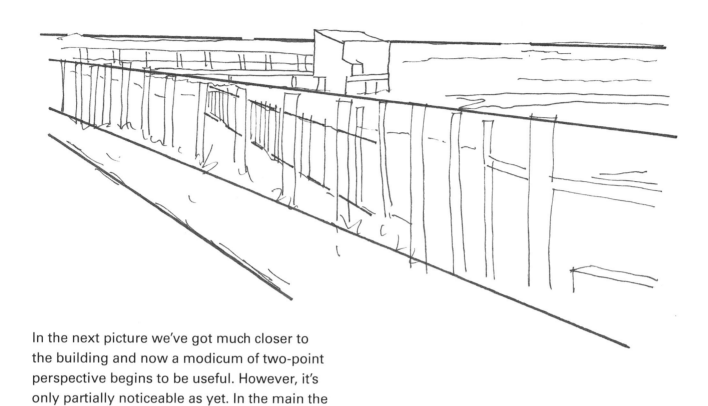

In the next picture we've got much closer to the building and now a modicum of two-point perspective begins to be useful. However, it's only partially noticeable as yet. In the main the line of posts still needs one-point perspective.

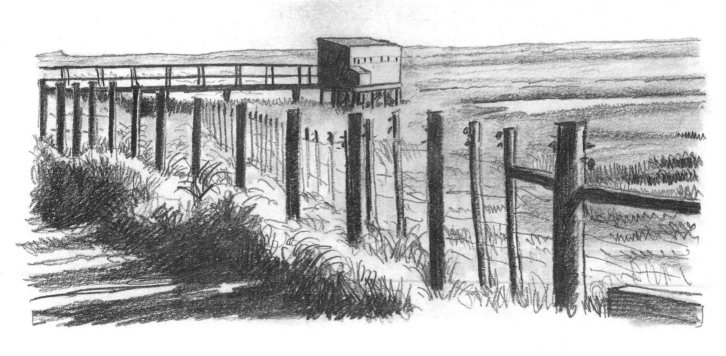

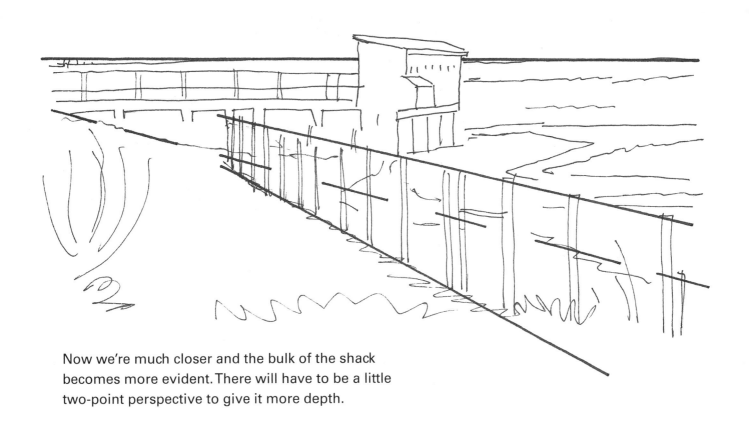

Now we're much closer and the bulk of the shack becomes more evident. There will have to be a little two-point perspective to give it more depth.

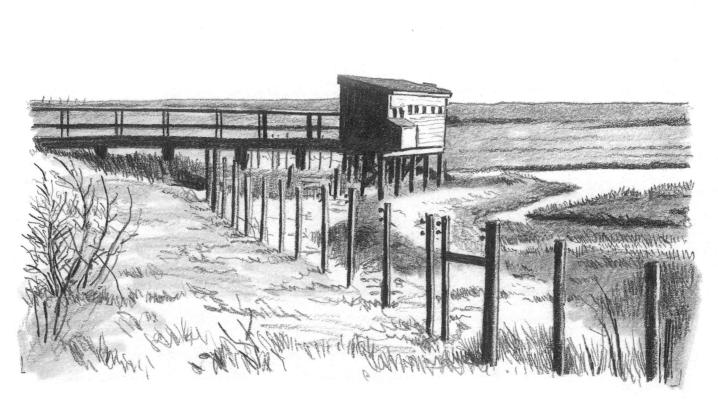

Here are two scenes in which it's easy to see how the effect of perspective is making itself felt in the drawing of objects that are set at different distances from us but are all of similar shape and form.

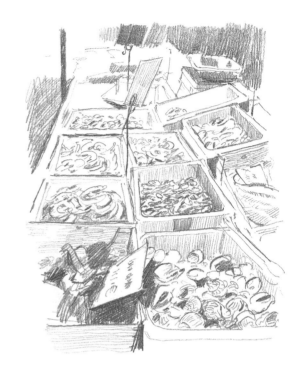

Perspective is used not just on the table but on all the boxes of fish and shellfish lined up in a French marketplace.

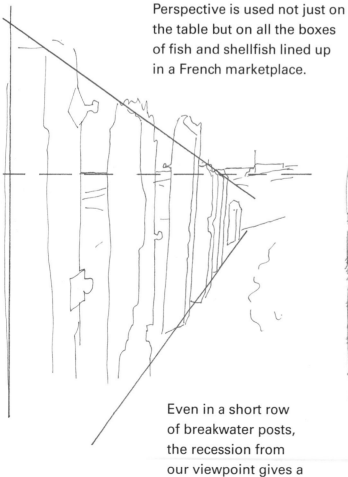

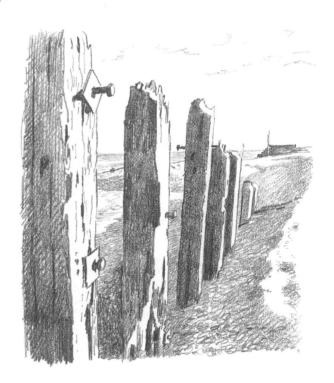

Even in a short row of breakwater posts, the recession from our viewpoint gives a strong sense of depth to the beach scene.

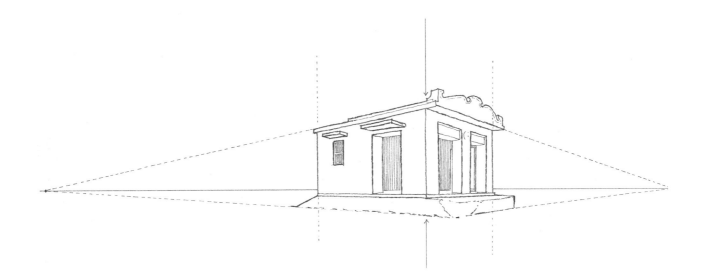

Now we look at a series of drawings which show how two-point perspective will help you to draw buildings more convincingly. It's most useful with architecture, although if you draw a still life large enough it can come into play there too.

This simple structure in India has been covered with painted advertisements. You can see the horizon line behind the building and the lines of perspective drawn from the highest and lowest points at the viewpoint edge. The viewpoint is at the nearest corner of the building. The two main lines of perspective from these points are drawn to the two vanishing points at each end of the horizon line. All the lines parallel with these two sides of the building should arrive at one of these two vanishing points. The other lines are all perpendicular to the horizon.

As you can see from the sketch and the more finished drawing, the method is quite simple. In the case of this drawing, one of the vanishing points is closer to the viewpoint vertical than the other, which means that you can see a bit more of the side of the building than you can the front.

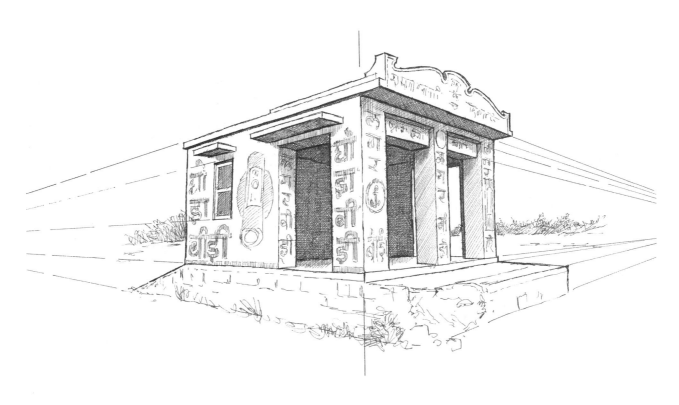

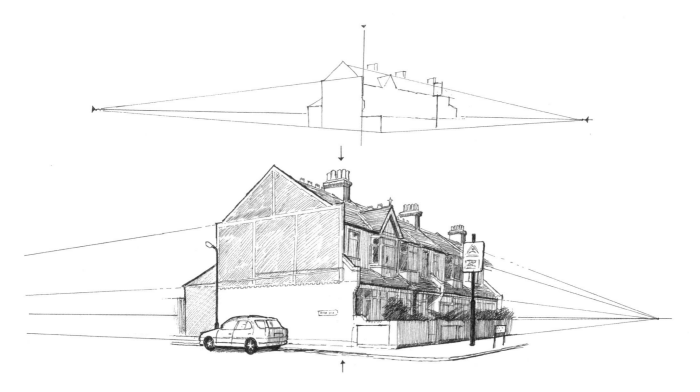

The next drawing is more complex, because it's of a block of suburban houses on the corner of a street and there are more details of the buildings to consider. But don't feel hesitant about tackling this because at the angle it's drawn a lot of the detail can be just suggested, with marks that aren't precise. The main bulk of the building is the critical part and if you get that right, the rest will look right too.

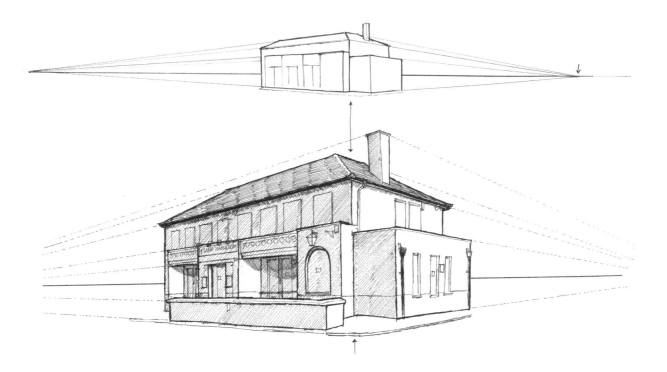

In the next drawing, of a boarded-up public house, the bulk of the building is fairly simple and there isn't much detail to get caught up in. Once again there are two vanishing points and the viewing point is the corner of the building nearest to the viewer.

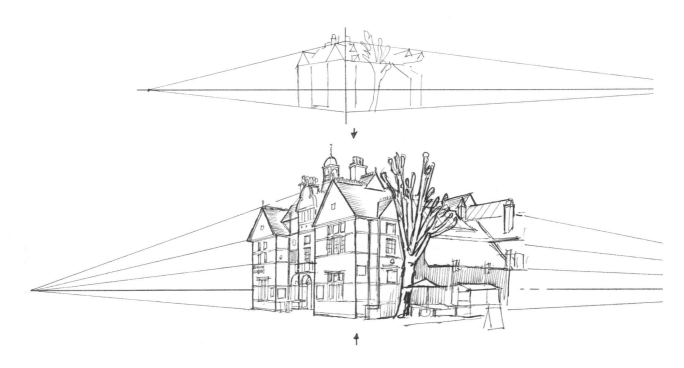

Now a complex building – a Victorian library that has a lot of detail in the construction. But the same rules still apply, and when you come to draw something like this don't be daunted – just remember the rules and adjust the drawing to your own impression of the building. You should never be too rigid about perspective unless you are drawing for an architect or engineer.

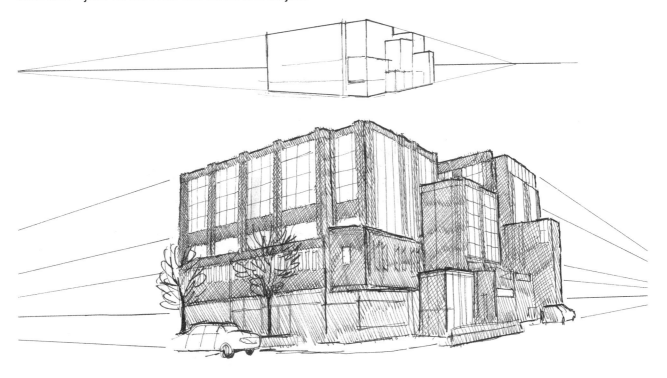

Here's an example of a modern structure on the corner of a high street, built in clearly defined blocks and with a lot of window space. Like the first drawing of the very simple building on page 79, this shows clearly how the rules of perspective can work to convey the bulk of the building.

DRAWING AROUND THE HOUSE

I started this exploration by walking around my own house and drawing small areas of the rooms from different angles and from both a standing and sitting position to give me different eye levels. Some views are quite restricted and others more expansive, but they demonstrate that even in your own house you'll find many possible subjects for a drawing. Don't worry too much if the results are rather uninteresting as pictures – the point is to practise drawing some larger objects and spaces, and also to introduce some perspective.

My first view was of an open sitting area at the back of our house. The perspective is shown mostly in the lines of the floorboards and in the shapes of the dresser and window. The cupboards and chairs give scope to achieve a three-dimensional effect to add to that given by the perspective.

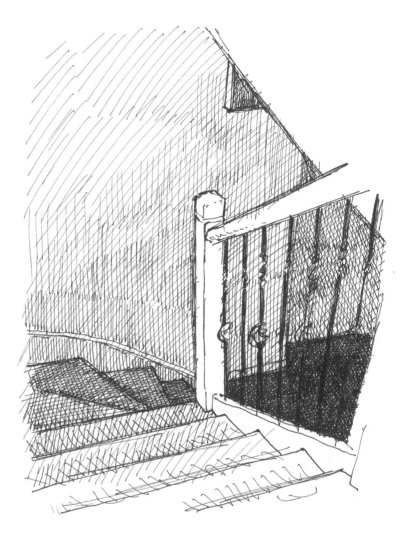

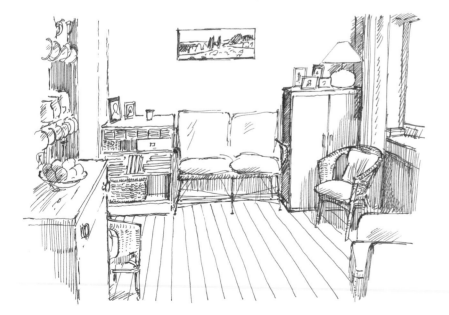

The next area I chose (above) was tricky because it was halfway up the stairs and the perspective view was slightly unusual. One way to check out your own basic drawing is to take a photograph with a digital camera and note the angles on the screen of the camera to check your drawing by. The top end of the stairs was well lit, while the bottom stairs in the hall were much darker in comparison. This helps to give some feeling of depth to the composition, with the banister rail sharply defined against the gloom.

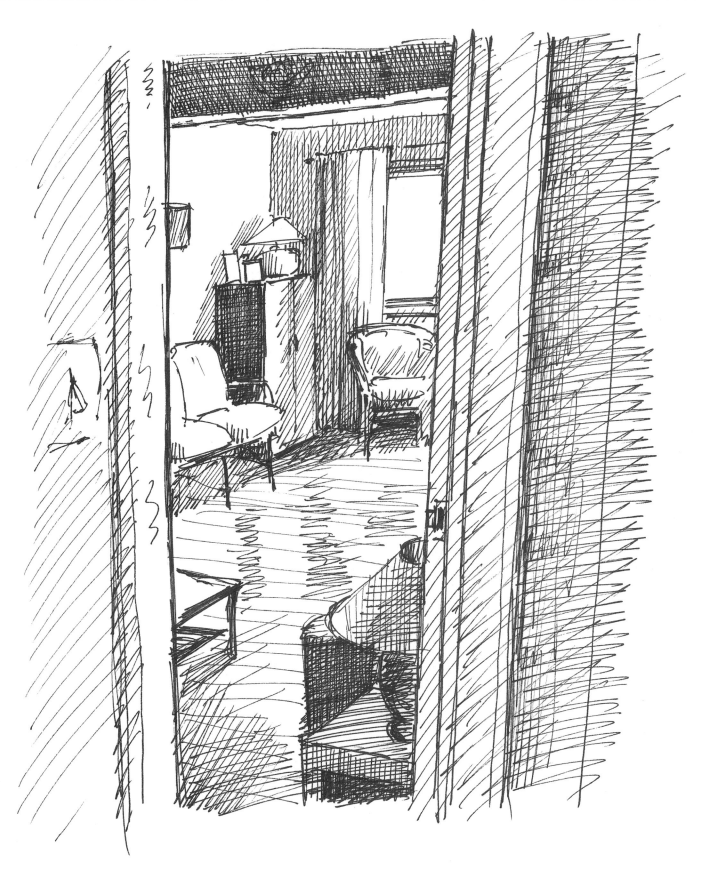

Then I took a view through an open door looking towards the windows
at the back of the house. I could mainly see bits of chairs and tables,
with the bright light of the window seen through the dark surround
of the door jamb. This always makes for an intriguing quality in the
picture because it seems to be revealing a secret view.

For the next view, I have done a perspective construction to give you some idea as to how the dynamics of the picture will work. This can be done with any interior, although some have more obvious perspective than others. This one, which gives us a view down the length of a table, does demand that perspective is taken into account.

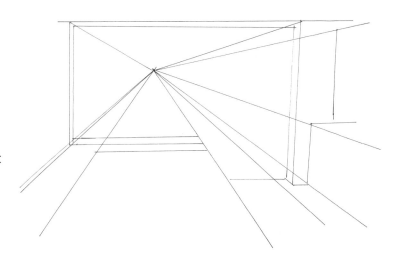

In the final drawing you can see how the perspective works, with the table cleared and the floorboards receding towards the windows. The light coming in from the windows and bouncing off the tabletop contrasts with the darker, shadowed areas of the walls.

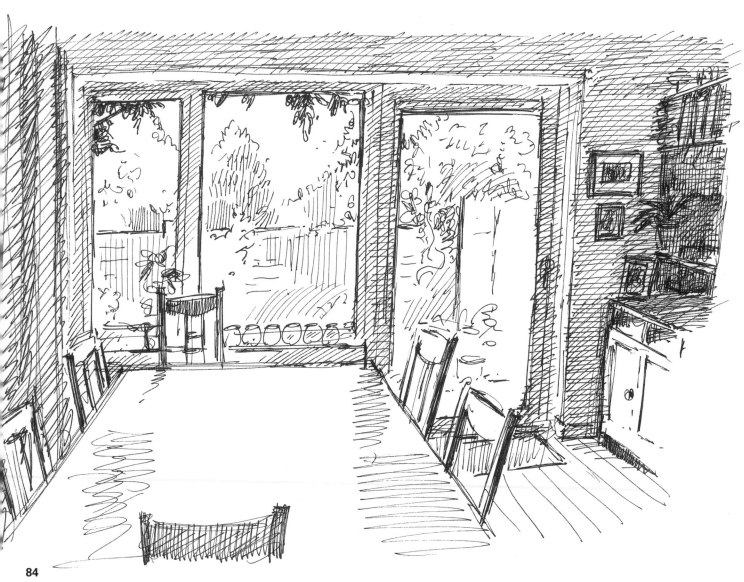

Here is another perspective diagram to show how the construction of the scene gives more depth to the finished picture of my kitchen – an area which is often the site of an interesting accidental still life.

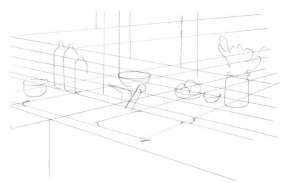

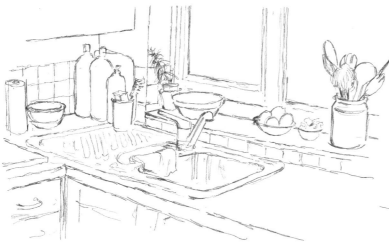

This is the view of the sink and all the paraphernalia surrounding it, as in most kitchens. It might have been even more interesting had there been some washing up piled up on the side of the sink.

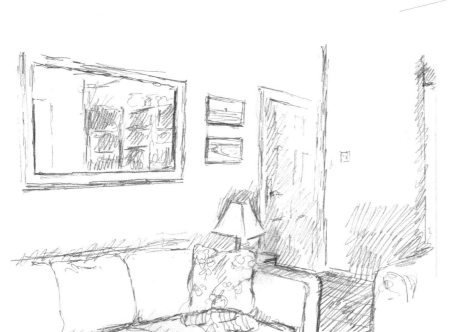

Here the perspective diagram shows how the construction of the drawing shown left is in fact relatively simple.

This drawing is a view of a sitting area with a mirror on the wall and the corner of a sofa with a door behind it. It isn't highly significant, but there is a small amount of perspective to be observed in the shapes of the mirror and the pictures on the wall.

AN INDOOR SCENE IN PERSPECTIVE

The final perspective exercise is simpler than the previous ones, because you only have to look around you at the room you are in to see your next subject. That doesn't mean that the task is any easier when it comes to drawing it, but at least you have now had quite a bit of practice at drawing in perspective, so you will be much more confident of tackling the problem.

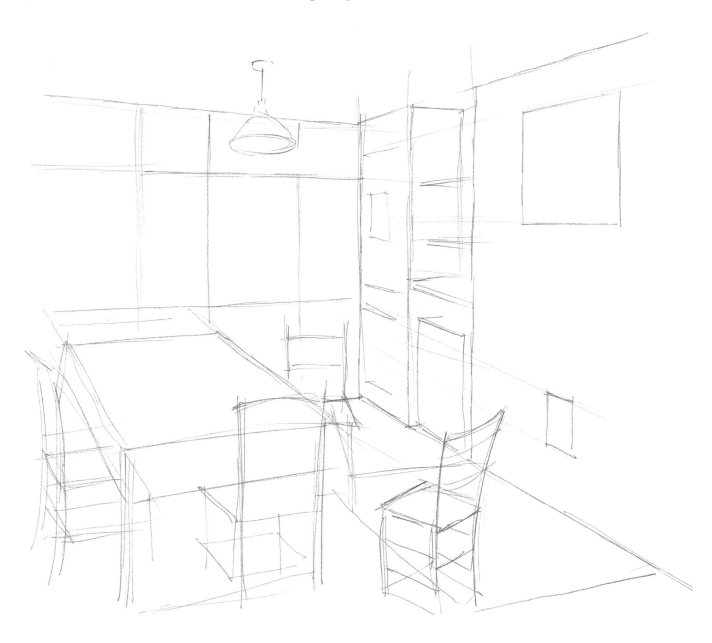

1 First of all, look at this initial sketch of an interior. It will be immediately obvious to you from your studies so far that this scene is using perspective lines to construct the drawing.

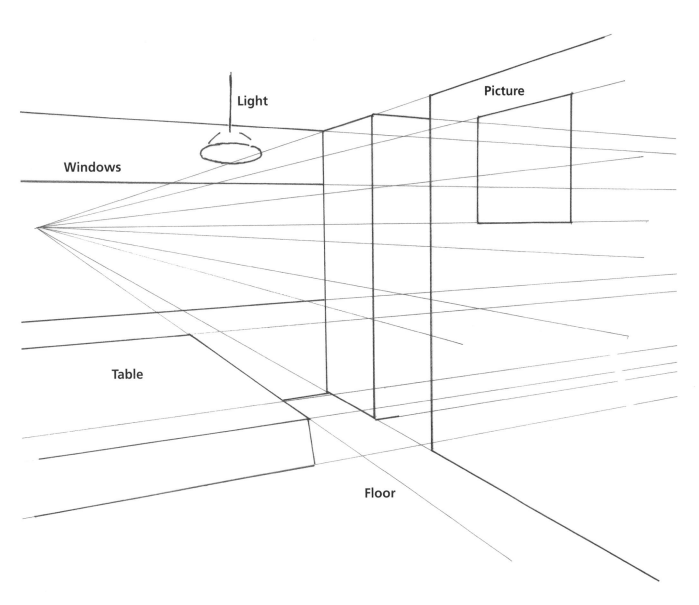

Light

Picture

Windows

Table

Floor

2 The next diagram shows perspective lines laid over the sketch to help verify my view of the room. You will find that the hardest parts of your own room to see properly are those at the periphery of your vision, in which there is often some slight distortion that would look odd in the drawing. You may have to correct or ignore some of the apparent image at the very edge of your vision.

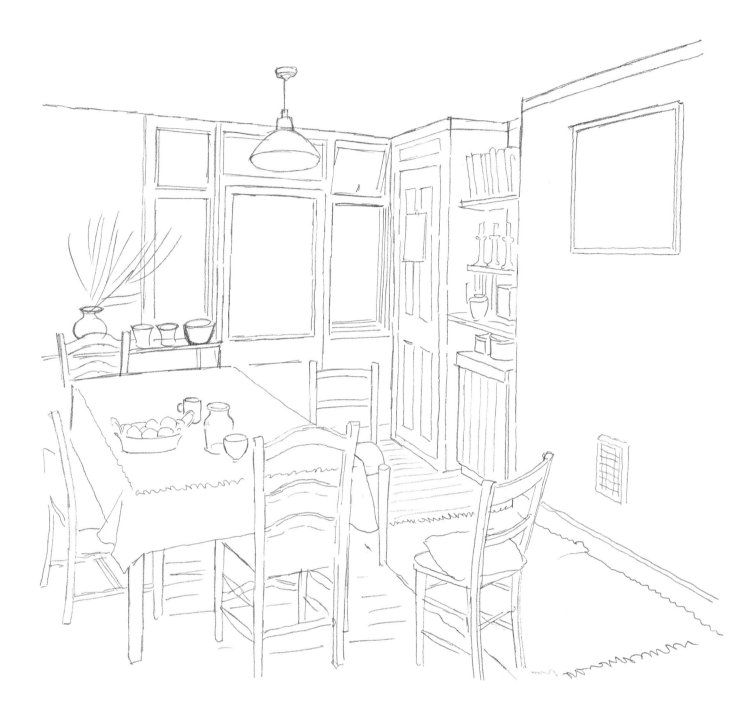

3 Once you've constructed a sketch that you think holds the image correctly, begin to put in the main outlines of the room and furniture within your field of vision. However, if there are any complicated pieces of furniture or objects that make things more difficult, remove them from view or simply leave them out of your drawing. All artists learn to adjust the scene in front of them in order to simplify it or make it more interesting and compositionally satisfying; you can see this in the topographical work of Turner, Canaletto or Guardi, for example. The lines of perspective should enable you to get the proportions of the objects in the scene accurate.

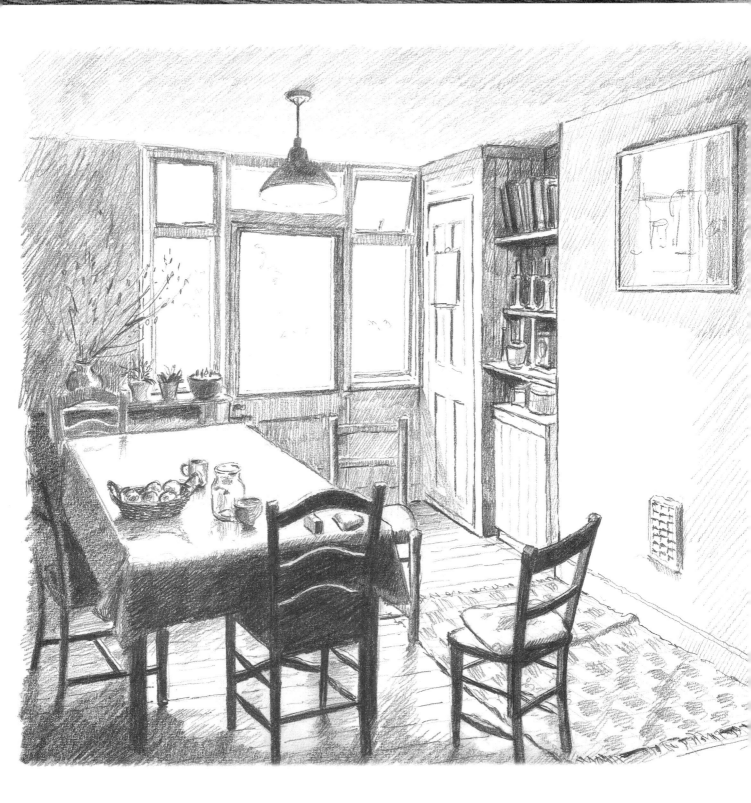

4 You can then work on the tonal values of the scene to give it atmosphere and depth. If you have to leave it and come back later, check that the furniture hasn't been moved and that the angle of light is similar to the time before – if the weather is sunny and you try to resume at a different time of day you will potentially find the lights and darks very differently placed. The lighting in my scene is partly from the windows and partly from the overhead electric light. Notice how I have built up the tone to a strong black in the chairs nearest to my viewpoint.

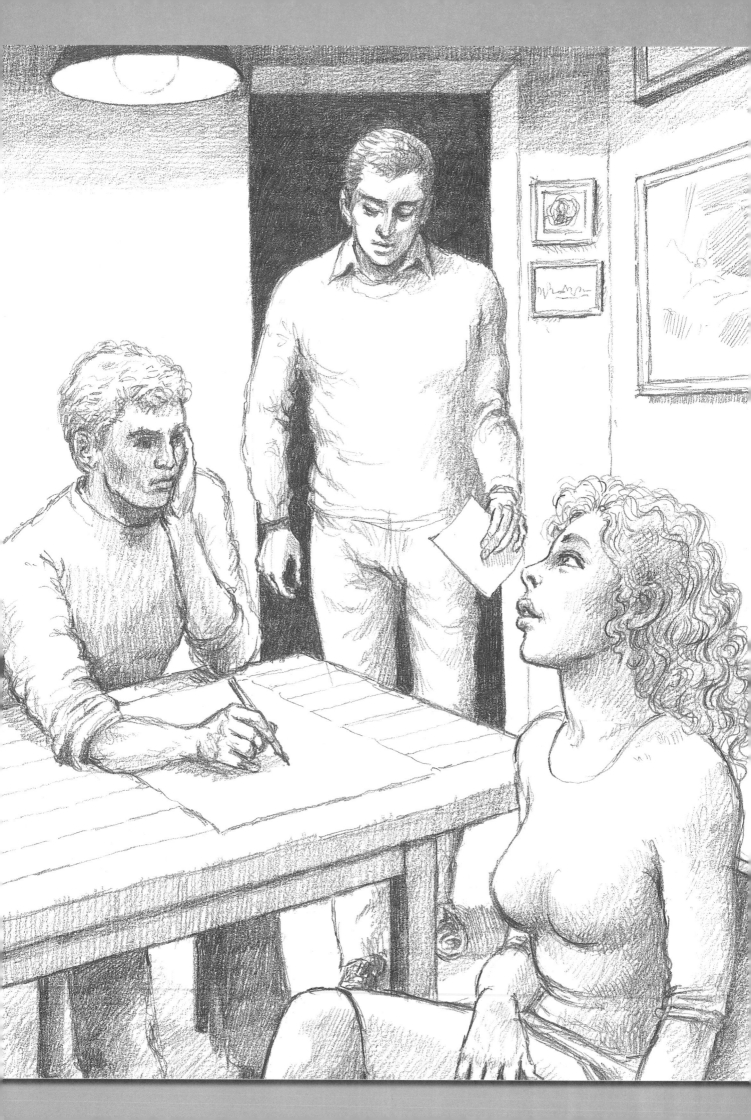

Chapter 5

COMPOSITION

No matter how well you learn to draw objects, animals, figures or landscapes, until you have considered the question of composition you have arrived at satisfying pictures only by accident. The intellectual process of determining how the individual elements of a picture hang together is what differentiates the accomplished artist from the beginner. There are many routes by which to arrive at a strong composition and this lesson will not by any means be exhausting all the possibilities, but you will discover several time-honoured methods of going about it.

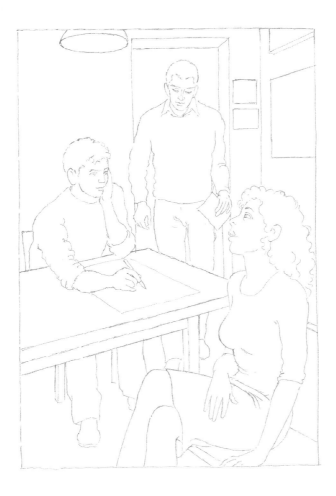

COMPOSITION DIAGRAMS

In the first diagram I have just divided the space into quarters, with one horizontal line halfway down and one vertical line halfway along. So if you place your main subjects at the centre of your page and try to balance out all the various parts of the drawing, you will arrive at a simple centrally placed image.

The next diagram shows how tilting this axis of lines and moving the crossing point over to one side gives a different balance of marks, which will be more dynamic and possibly dramatic. This slightly off-balance design is similar to many of the Impressionists' compositions, which they in turn derived from Japanese prints.

A centrally based composition with a raised horizon line will give you the effect of distance and of looking across a space from a higher position. This can help when producing a large open landscape.

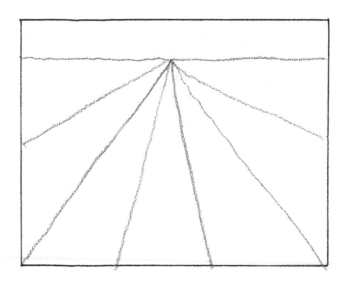

This diagram shows a more abstract design, with a spiralling inward effect caused by placing solid shapes in ever-decreasing sizes into the centre. If you are drawing numbers of people you might want to take an approach like this.

A composition such as this is useful for landscapes and figure groups, because it starts with something close to the viewer on one side and gradually sweeps away to a distant eye level at the opposite side. The obvious example of this could be a street scene with the buildings diminishing into the distance.

When you are working on an interior space, decide at the start where the far wall or end of the space will be placed. Here I've put it to the right of the scene, about in the middle horizontally. But the main thing is to make the decision before you start.

Using a triangular shape of figures in a picture can make a very stable composition, yet still imply motion.

COMPOSITION BY MASTER ARTISTS

Here are some compositions by the American painter John Singer Sargent. The first is of a seascape with a large fishing boat drawn up on the beach and, beyond that, another vessel floating on the water. The dark, closer boat makes a solid wedge of tone stretching halfway across the scene, and the beach and sky take up most of the rest of the space. The second vessel is squeezed into the small area

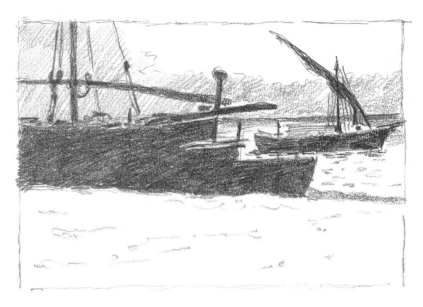

of water that can be seen past the beach and nearer boat. You gain a strong sense of what the scene must have been like when Sargent saw it. He obviously decided that he wouldn't include all of the closer boat, using it instead as a sort of frame for the vessel floating beyond. The light seems to indicate that this dramatic scene is either late or very early in the day.

This scene, again by Sargent, is of a beach in Morocco with fishing nets spread out along the length of the beach. He has used a strong diagonal composition, with the beach taking up half the picture and the line of nets and the waterline emphasizing the diagonal. Up in the top half the rocky shore juts into the rest of the picture, and the deep blue sky and sea contrast strongly with the white sandy beach. It's an unusual compositional device, but in his hands one that works very well.

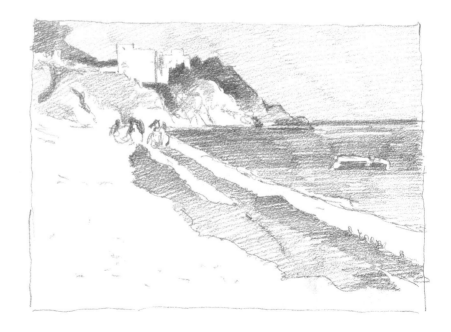

The next examples each have a small diagram to bring home the point of the composition. When you first look at a picture, it's sometimes easy to miss interesting compositions because there's so much to take in. In each of these examples the artist has made a decision to include some things and omit others in order to improve his picture.

The first one is by Sargent again, and it's another beach scene. However, this time there is human activity, with a group of fisherwomen walking across the scene towards the sea, probably to catch shellfish. The figures form the main part of the scene with, behind them, an open beach, a few figures in the distance and a lighthouse. There is a clear sense of the fisherwomen being distinct from any other activity. They are all going in the same direction

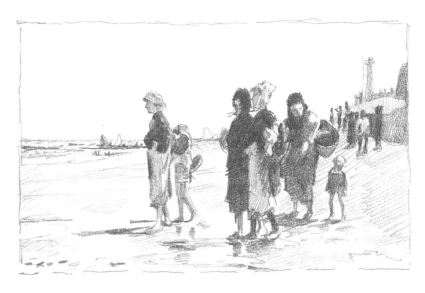

from the right side of the composition towards the open left side. The figures are strong and dark against the light and there are reflections of them in the pools of water on the beach. Notice how Sargent uses the different sizes of the two children accompanying the women to balance the mass.

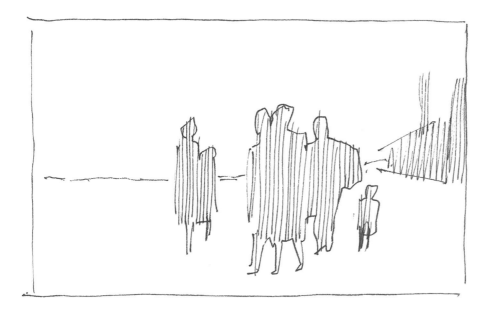

The diagram of the composition makes it very clear that the clump of figures is the main point of the scene and the rest is just background space.

In the next scene, by J.M.W. Turner, the main focus of interest is on the rugged castle at the edge of the sea. Turner uses the great sweep of dark clouds swirling around the sky in the background to almost frame the scene. He also gives you the close-up waves of the sea breaking on the near shore as a dramatic angle to pull your attention towards the distant castle. In terms of area the castle is quite small in the picture, but because of Turner's ability to compose the scene your eyes are drawn towards the building. He has placed it centrally, which helps, but it's remarkable how he has made the elements of the coastal scene emphasize the point of the picture.

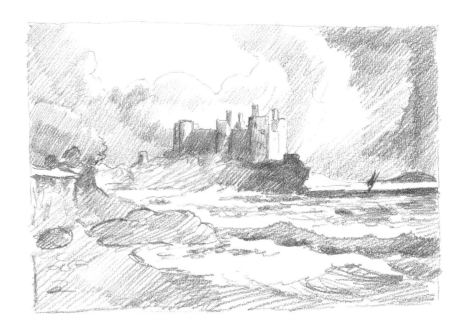

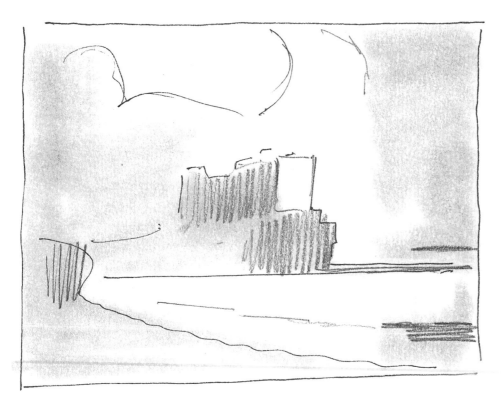

In the diagram you can see how small the area of the castle actually is, but the framing of it with the sky and sea brings our attention to where Turner wishes it to be.

Now we have a still life by Paul Cézanne of a couple of pots, a jug, some fruit and a cloth arranged on a table. He allows quite a lot of space around them and contrasts the white jug, pot and small cloth against the dark larger cloth, the fruit and the dark pot.

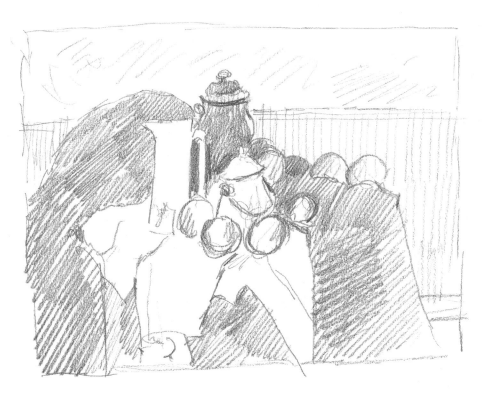

As you can see in the diagram, the white area is quite small, held in the middle of the dark mass of cloth, fruit and pot, which takes up about half the space, and the mid-toned background, which is almost as large. Consequently, the light objects attract our attention even though they take up quite a bit less space in the whole picture. This subtle understanding of composition is the reason why Cézanne is considered such a master.

MASS AND ISOLATION

In the two pictures on show next, I'm using examples of photographic compositions which work very well and could easily be used by an artist. They emphasize two different things – one the use of a large mass of details to make your point, and the other isolating one part of the scene to give it added emphasis.

The first picture is a close-up view of an ornate Russian Orthodox cathedral and is really a composite mass of decorative domes, towers, arches and doorways that seem to have been assembled almost indiscriminately. There is undoubtedly an architectural logic to the whole thing, but from our viewpoint we can't see this. What we can see is detail crowded upon detail, with just a bit of sky at the top to give us an idea of the architectural mass. The picture makes its point by being rich in detail and pushed up against our view so that it almost overwhelms us.

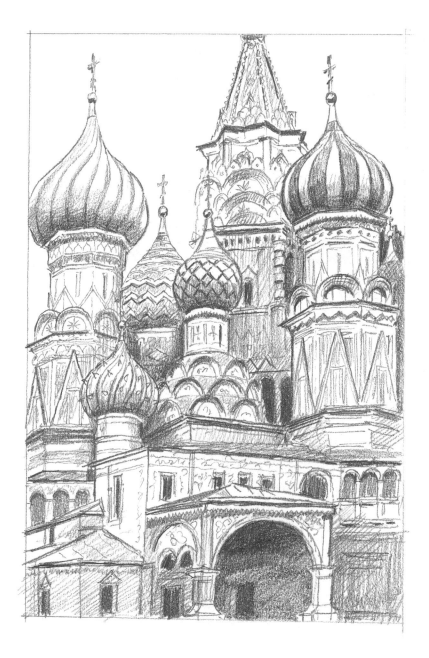

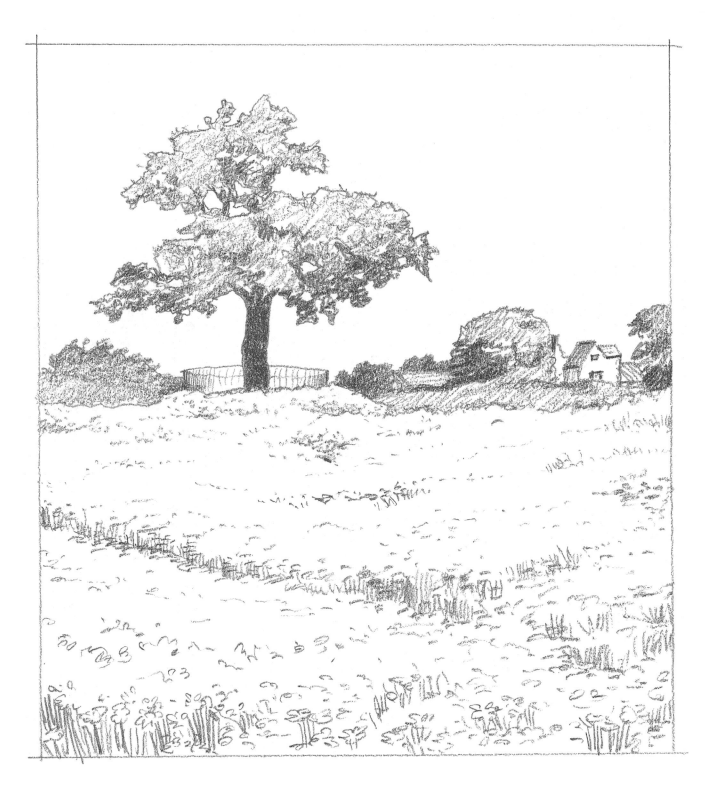

The second example is of an open meadow full of white flowers that creates a sort of carpet spreading away from our viewpoint and taking up half of the whole scene. Beyond this is the sky – we are obviously looking uphill – and a few indications of buildings and vegetation along the horizon. But at the centre-left of the upper half of the scene is a tree with a strong trunk and spreading branches. Isolating this tree gives it a grandeur and an importance in the composition that makes us remember the scene as dominated by the tree. Its placing makes it definitely the focal point of the scene and nothing else has quite so much personality as this object, although the flower-strewn field was probably the first thing that caught the photographer's eye.

DESIGNING A FIGURE COMPOSITION

Now we are going to have a go at producing a complete figure composition. This will be done in a very practical way, with me drawing up a composition that you may want to copy, or you may wish to do something similar without necessarily reproducing my picture. I will show you step by step how I might go about it, and you can then apply the same system to your own creation.

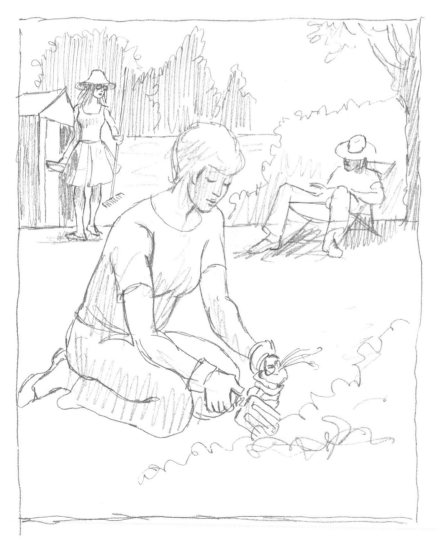

1 I've started by using two slightly different formats, imagining a simple scene that I know well. If you want to make your own picture, think of something familiar in your life because it will lend verisimilitude to the composition.

In one picture I've put three figures in a garden setting. The nearest figure is a woman kneeling by a flowerbed with a garden tool in her hand. She is almost central, but just off to the left to create some space on the right. In that space is a male figure sitting in a deckchair, rather far back in the scene. To the left of the main figure is another woman walking towards her. The trees in the next garden go across the picture at about a third of the way from the top.

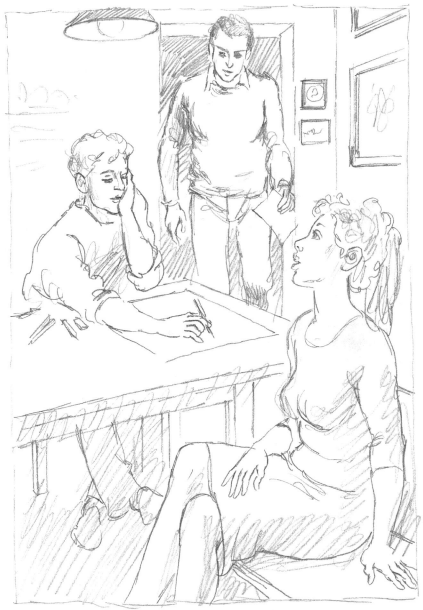

Again taking a familiar scene, I decided to draw an artist with a model, adding another figure to complicate the matter a little.

I placed the artist at a table which juts across the centre of the space, with him behind it and his model in front to the right. I made his model a girl and the other figure a male walking forward into the room.

The model is the largest figure, and her feet are not visible. She sits in the right-hand corner of the picture, taking up about one-third of the scene diagonally across the picture. The artist is the next nearest but he is hidden by the table from his waist up. The third figure is almost in the centre of the picture, but further back as though coming through a doorway. This is design number two.

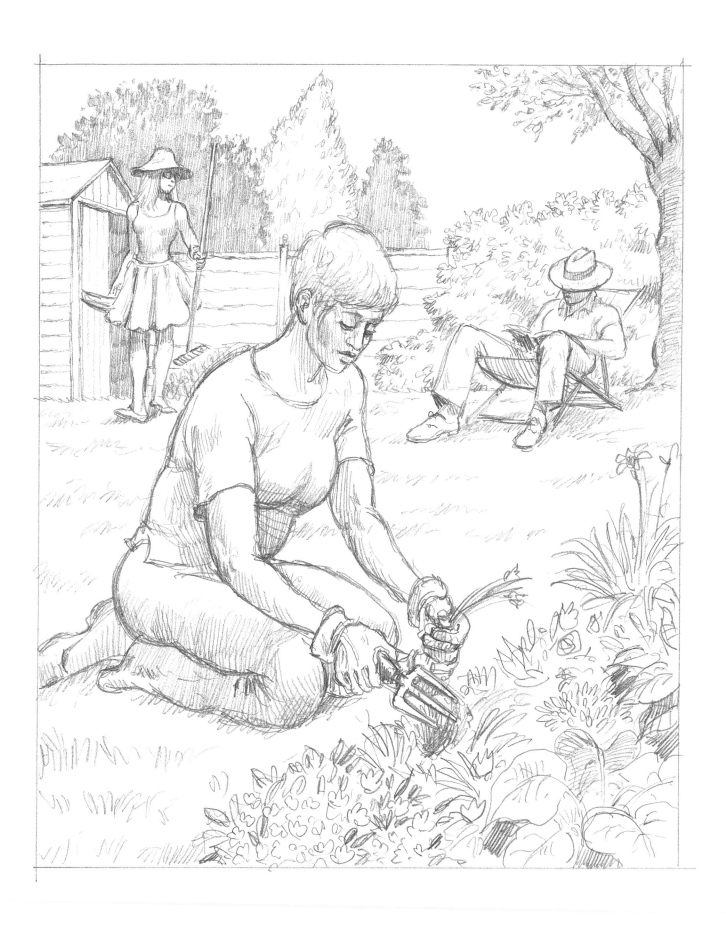

2 Having produced a rough draft of the pictures, I still couldn't make up my mind which one to follow, so I drew them both up more seriously in greater detail. This may take you some time, and it's the stage where you decide exactly what everything is going to look like. You may decide halfway through drawing one picture that you prefer the other one, and if so you can stop and just concentrate on the one of your choice. Stopping short with one of them doesn't matter – this is an exercise in coming to your final decision.

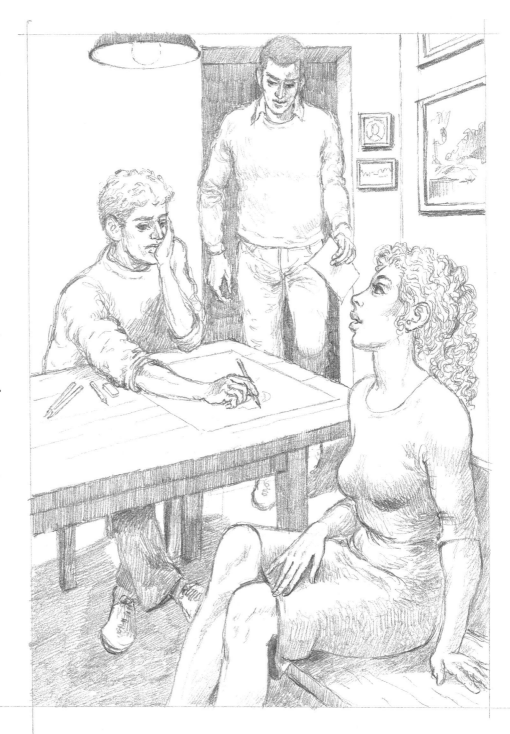

3 My decision was to go with the artist drawing the model, and now I needed to consider it in more detail.

First I decided what the main figure would really look like. Ideally I would find a person to model for me, and after getting her to sit in the correct pose for my composition I would carefully draw her from life. If that were not possible I would work from my own previous drawings or use photographic reference.

As you can see, I drew her head twice in different positions and also made a sketch of her nearest hand. All this acted as useful information for the final picture.

Then I moved on to the other two figures, getting some idea of how the artist would look and how the other man would actually approach the scene. I tried different positions for the head of the walking man.

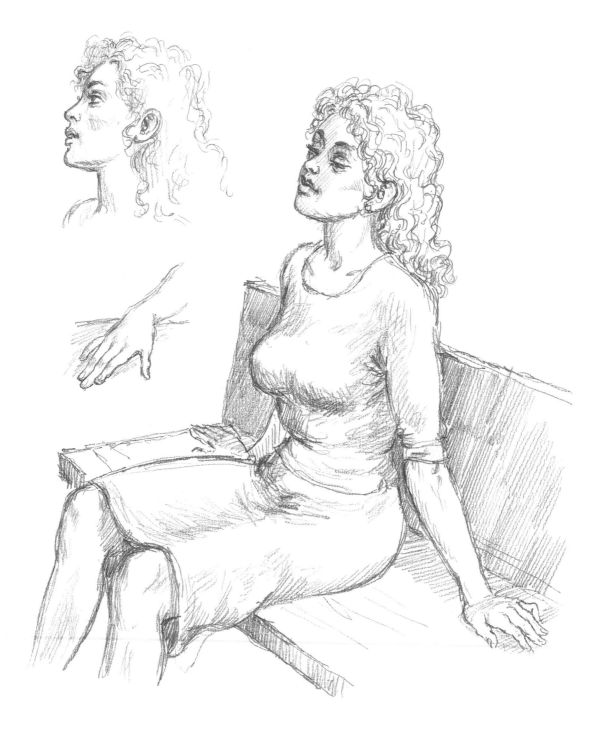

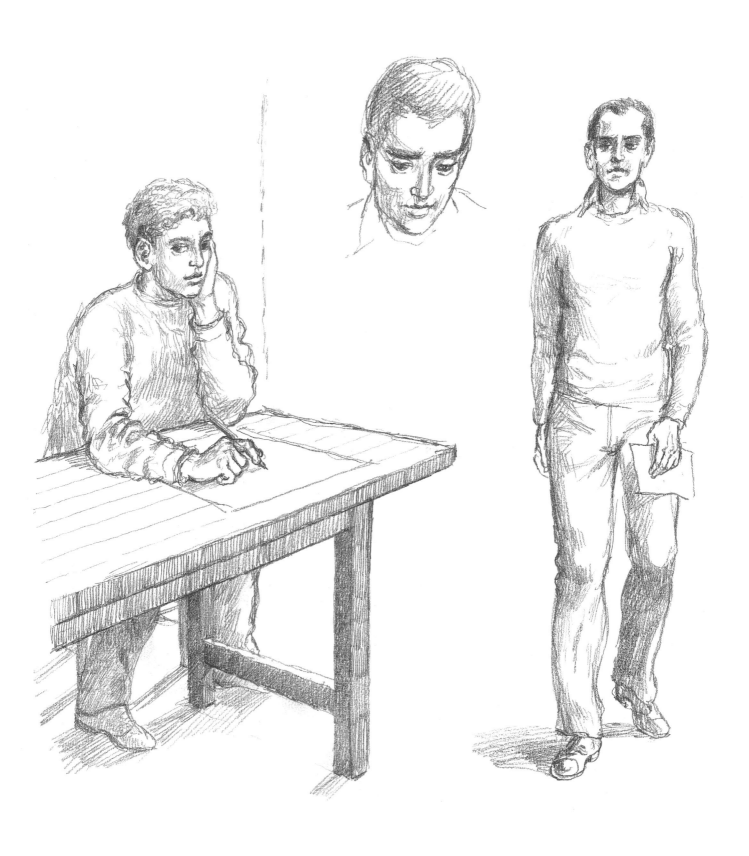

4 Having researched the figures, I now put them all into context by drawing up what is known as a cartoon, which is an outline of the complete picture. This was the last stage where I could alter the scene if required. Keep a version of this cartoon to enable you to correct any details when you have put in the tone.

Having got the full picture drawn up in line, I could now put in the main areas of tone or shadow in one light tone (opposite). At this stage don't overdo the weight of tone, because you will find it harder to get rid of it than to add more if you need to. It shows you where the light is coming from and gives you an idea as to how solid your figures may look.

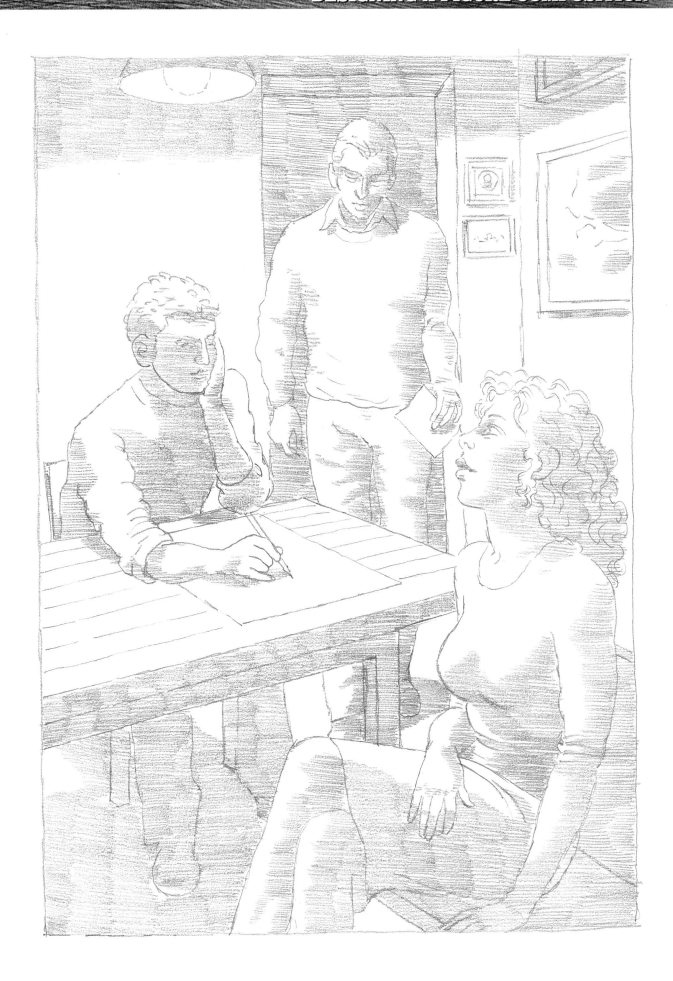

5 Now comes the final stage, where everything is put in with great detail. Using your copy of the cartoon to ensure that all the shapes remain correct, begin to build up the heaviest tones so that you can see how the depth of space works in your composition. Take your time, because the quality of your work depends on the care and attention that you give to this finishing stage.

So now you have your completed composition with all the preliminary drawings that you made. Keep these for a while, because they might be useful in later drawings. In the ateliers of old, the drawings made for pictures were always kept for quite a time to be used over and over again in other compositions.

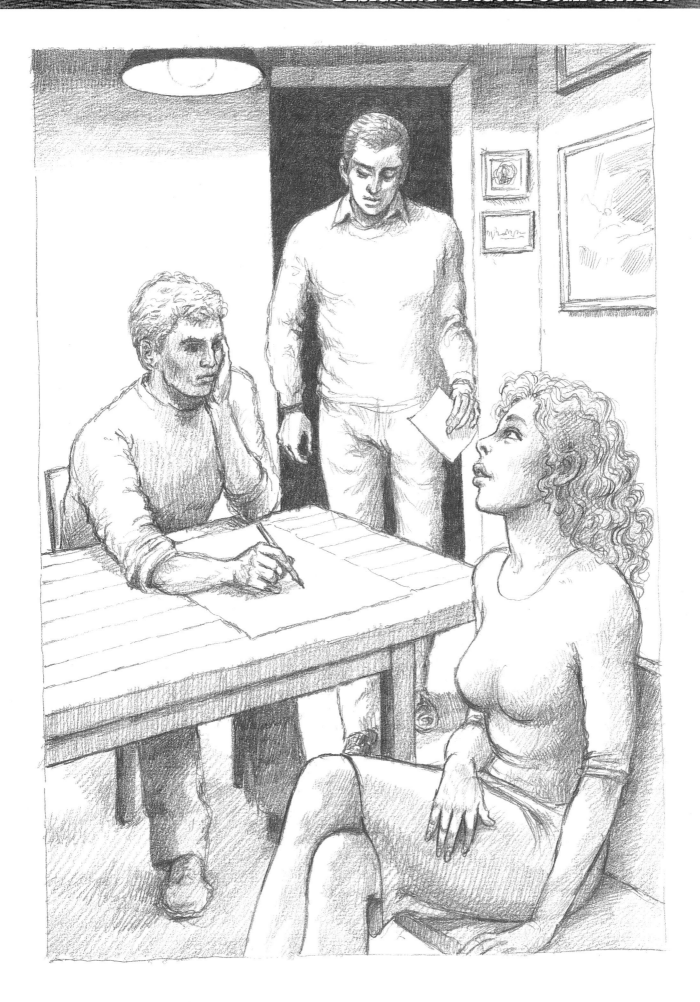

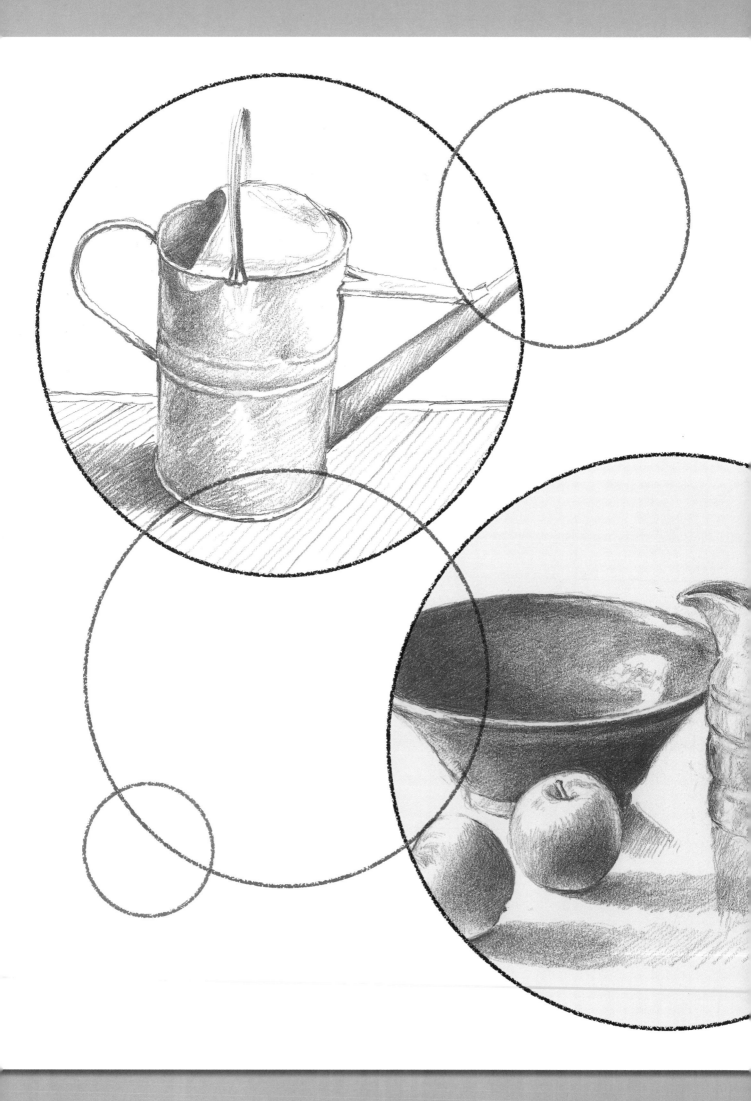

Chapter 6
STILL LIFE

This part of the book starts with straightforward drawings of mundane household objects so that you can practise your handling of shape, texture and tone. Many of the items around your house will have ordered, symmetrical forms and you need to be able to tackle those with confidence to make your interiors look convincing. Once you've mastered the drawing of everyday objects in isolation, the next easy step is to try out your skill at putting together a composition of several objects and producing a still-life drawing.

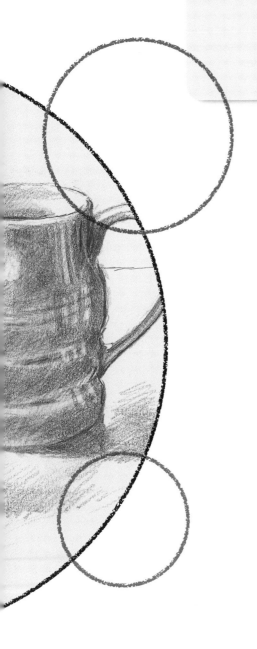

SIMPLE STILL-LIFE OBJECTS

Here we're going to build up to drawing a simple still-life composition, starting with some practice on straightforward household objects to help you tackle the problems that you'll discover. In these examples I've given you a variety of shapes, some easy and others more complex.

First I tried a tumbler and a wine glass, because they are easy to see through, and so you can see how the shape works. They are both centred on a central line, both sides being mirror images of each other. You could draw a vertical and draw each side of it, as I have done with the tumbler.

I've also drawn in all the tonal values, but before you embark on this do make sure that you have got the shape right.

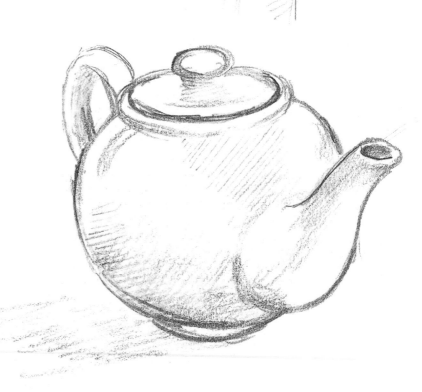

Next I moved on to two solid objects, which are a bit more complex because of the projections on them. The first is a teapot, which I have drawn with the spout turned slightly towards me. So although the middle part of the pot is based on a central line, the spout and the handle are angled projections off that more balanced shape.

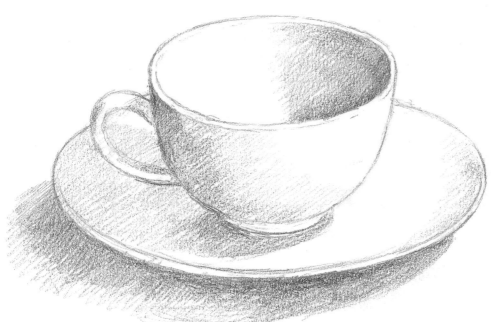

The next example is a cup and saucer, with the handle projecting to one side, and here you also have two objects that fit together to contend with.

Now a return to a glass tumbler – but this one has faceted sides in the lower half, which produces a more testing shape to draw. Again, as with all of these objects, the main thing is to get the shape right and only then go ahead with the shading.

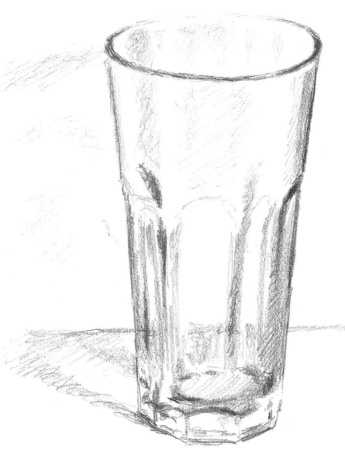

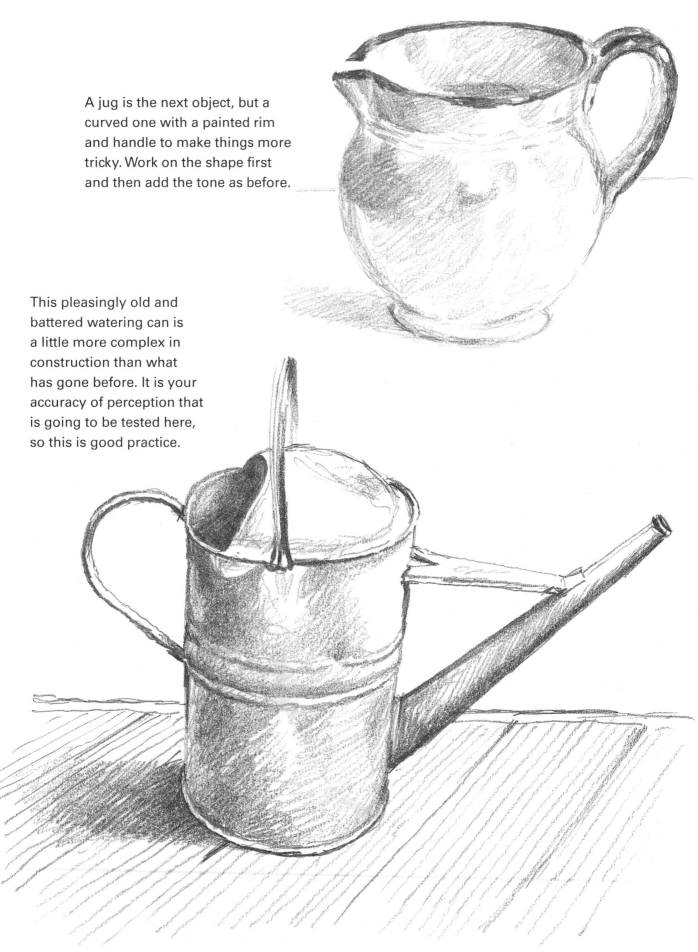

A jug is the next object, but a curved one with a painted rim and handle to make things more tricky. Work on the shape first and then add the tone as before.

This pleasingly old and battered watering can is a little more complex in construction than what has gone before. It is your accuracy of perception that is going to be tested here, so this is good practice.

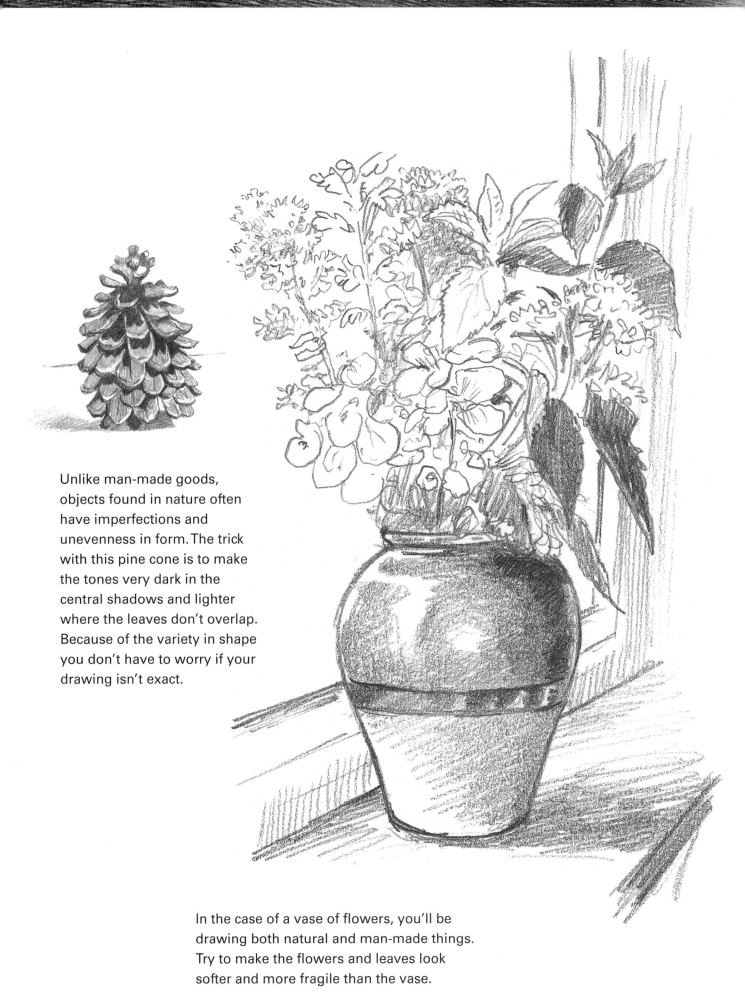

Unlike man-made goods, objects found in nature often have imperfections and unevenness in form. The trick with this pine cone is to make the tones very dark in the central shadows and lighter where the leaves don't overlap. Because of the variety in shape you don't have to worry if your drawing isn't exact.

In the case of a vase of flowers, you'll be drawing both natural and man-made things. Try to make the flowers and leaves look softer and more fragile than the vase.

GROUPING OBJECTS

Now we're going to move on to groups of objects – always trickier than single items as you have to consider their relationship to each other.

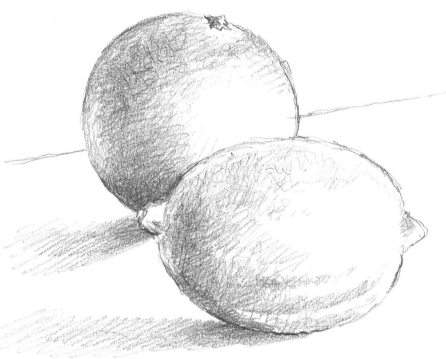

Start with an orange and lemon, placing them in such a way that one overlaps the other. This means that you have to consider the size of one compared with the other, as well as the different shapes. When you put in the tone, notice how the shading on the lower part of the orange helps to show up the shape of the lemon.

Now try three objects – two apples and a pear. The space between the apples is very narrow and causes a nice tension between their shapes. The front apple overlaps the pear and helps to contrast the two shapes. Here you are thinking in terms of a still-life composition.

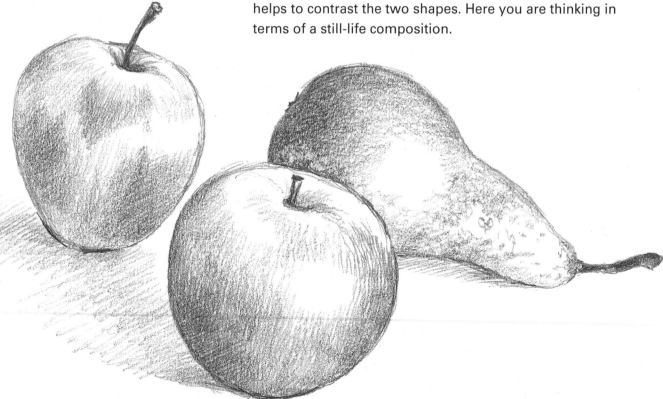

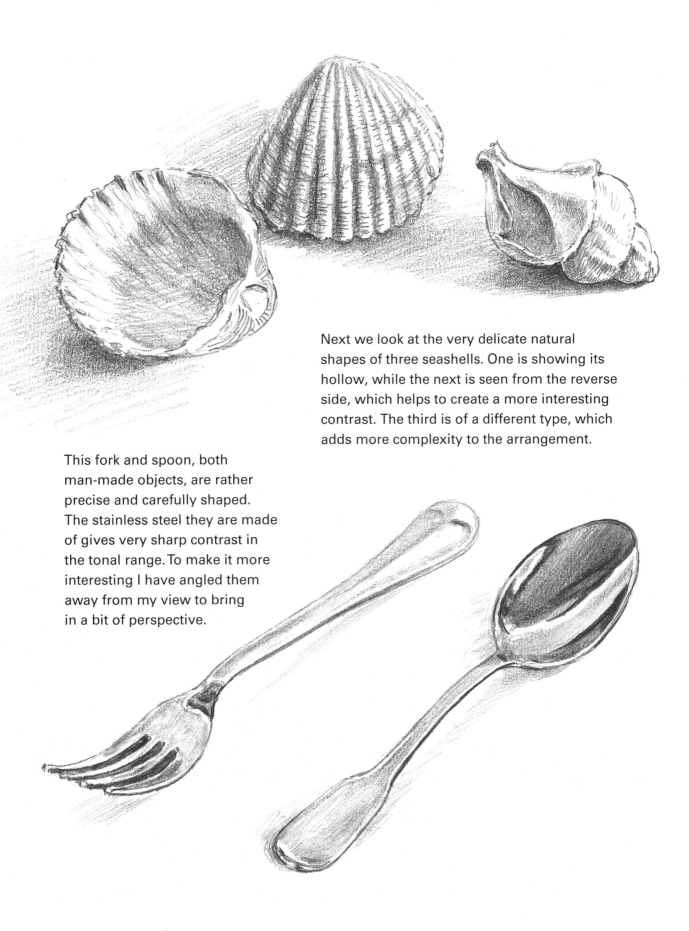

Next we look at the very delicate natural shapes of three seashells. One is showing its hollow, while the next is seen from the reverse side, which helps to create a more interesting contrast. The third is of a different type, which adds more complexity to the arrangement.

This fork and spoon, both man-made objects, are rather precise and carefully shaped. The stainless steel they are made of gives very sharp contrast in the tonal range. To make it more interesting I have angled them away from my view to bring in a bit of perspective.

SIMPLE STILL LIFE

You can decide for yourself what you want to draw for your own first still life or follow my example given here. To start with, I looked around my living room for likely objects and picked up a bowl with some fruit in it. I felt that including all the fruit might be rather complex, so I removed it except for two apples, which I placed on a table by the bowl. I placed a jug on the table to add a more vertical shape to the composition and started moving the pieces around to see what might look interesting.

The light was coming very strongly from the left-hand side of the composition, so it was relatively well lit. I put the jug in a position that just appeared to clip the edge of the bowl from where I was sitting. I moved the two apples so that they were very close together, but not quite overlapping. I thought that this would give some tension to the arrangement.

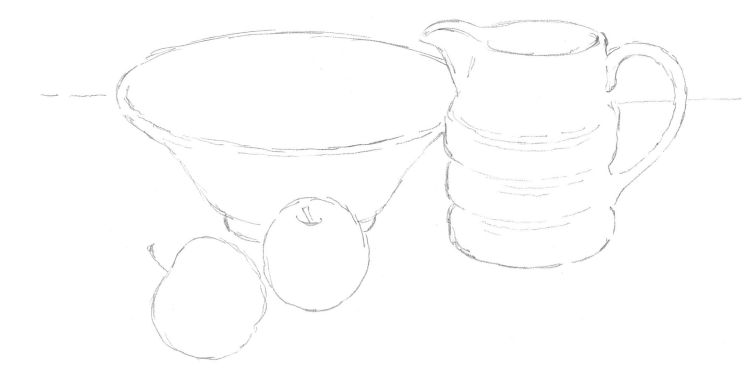

1 After assessing the relative sizes of the objects, draw a fairly loose outline of each one, making sure they are in the correct relation to each other and the main shapes are accurate. Use an eraser to correct any mistakes until you are satisfied that you have arrived at a good likeness. When you've had more experience you'll be able to take the accuracy of the drawing much further, but for the moment go by your own perception as to the quality of your drawing. The nice thing about drawing is that you never arrive at a point where you can't improve on your skill – that's what makes it so engrossing.

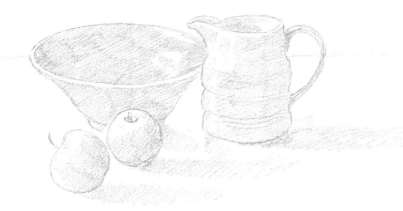

2 Now put in as much of the shading as you can, but all in a fairly light, even tone. This will train your eye to see the whole shaded area rather than doing each piece separately. While doing this I discovered that the light was in fact coming from two directions, most strongly from the left, but also from behind the objects. This meant I had to make a decision about where the emphasis would be when I put in the stronger tones; you can make things easier for yourself by making sure that the light is only from one direction.

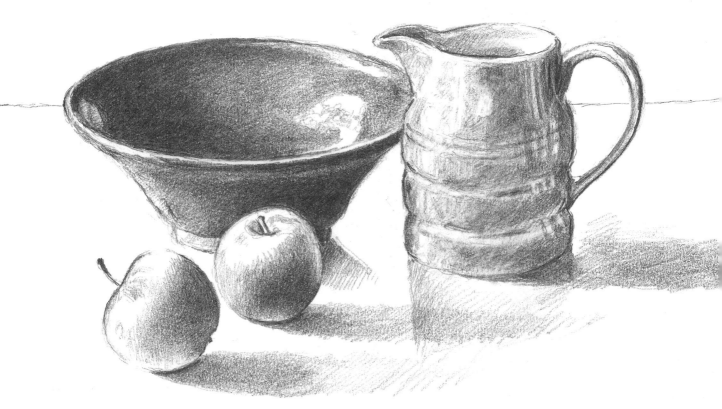

3 The next stage is where the whole composition starts to gain some feeling of convincing dimensions. Often the best way to proceed is to put in the very darkest tones over the general tone already there, so that you get some idea about how much you will have to grade the tones from darkest to lightest. All the in-between tones are variable, depending on how dramatic you want the drawing to look. With greater contrast there's more drama, and with gentler contrast there is a more subtle feeling of depth. In this drawing I've left a bit of drama in the lighting without exaggerating it.

EXPLORING THEMES

There are many themes which you can use in still life, and in this chapter I have suggested just a few of them to give you a starting point. Choosing a theme helps to focus the mind of the artist, because it limits the type of object that can be used. Also the viewer can find satisfaction in being able to recognize the connection between the objects. In a way a themed still life is like a narrative; it tells a story about a particular subject, which adds a point of interest that otherwise would not be there.

The first drawing shows the different forms of material that you can incorporate in a composition to show off your abilities in rendering texture. Here we have a basket with a wooden chopping board leaning against it, a ceramic jug, a wine glass, a tea towel and a metal saucepan. So in one still life you can show six or more materials, and if you are dextrous they will make an interesting picture.

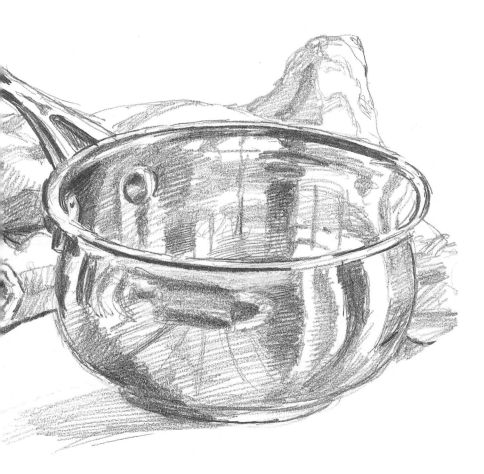

A sporting theme might be to your taste, and you can choose to illustrate a sport that you are interested in. I found all sorts of sports equipment at a local school: flippers and a snorkel, a cricket bat and ball, football shoes, boxing gloves and even fencing swords! Having made my drawing, I realized that I had become carried away and included too many objects, spacing them too far apart to make a good composition.

Next is a still life of children's toys, including a tricycle, a toy cat, a plastic duck, a toy car, a set of interlocking jars and a painted egg. There are many other toys that you could show in a composition like this. For example stuffed toys and dolls have a strong hold on the imagination, and the contrast between a large hard object like the tricycle and a woolly teddy bear would give a maximum textural range.

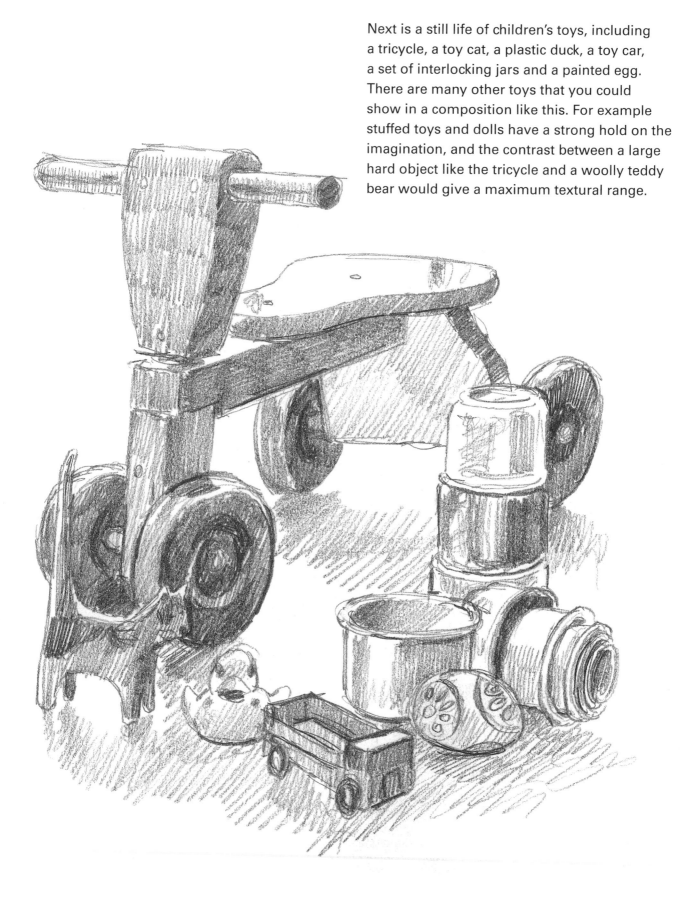

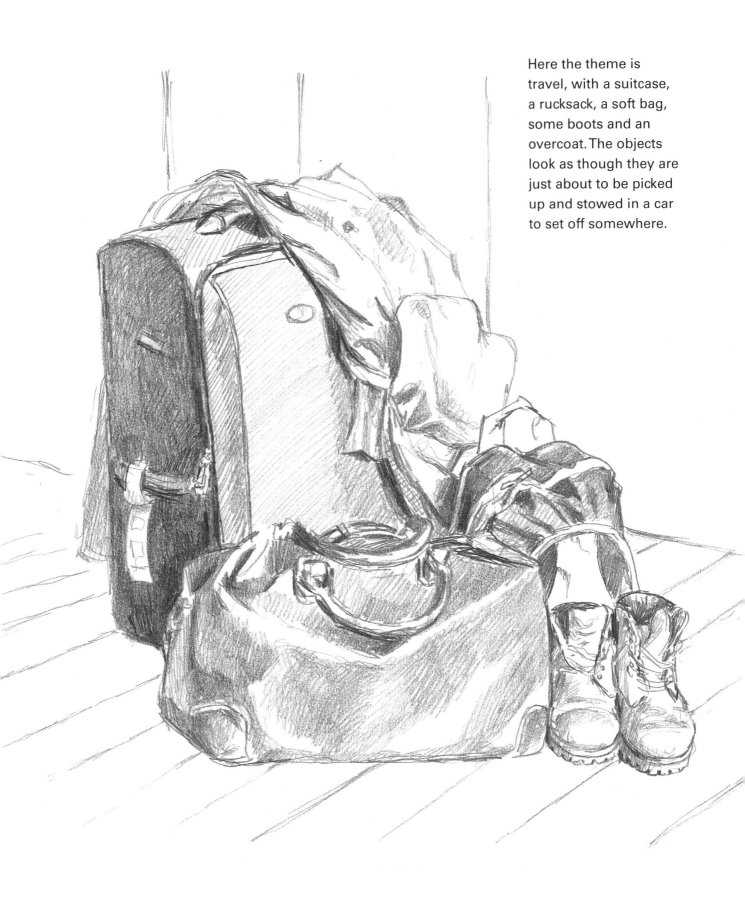

Here the theme is travel, with a suitcase, a rucksack, a soft bag, some boots and an overcoat. The objects look as though they are just about to be picked up and stowed in a car to set off somewhere.

A very popular theme for more traditional still-life artists is that of cooking. Here we see various items that may be used in the creation of a cake or pudding, or just as part of a larger meal. Again the variety of shapes and textures gives you a chance to show how well you can draw.

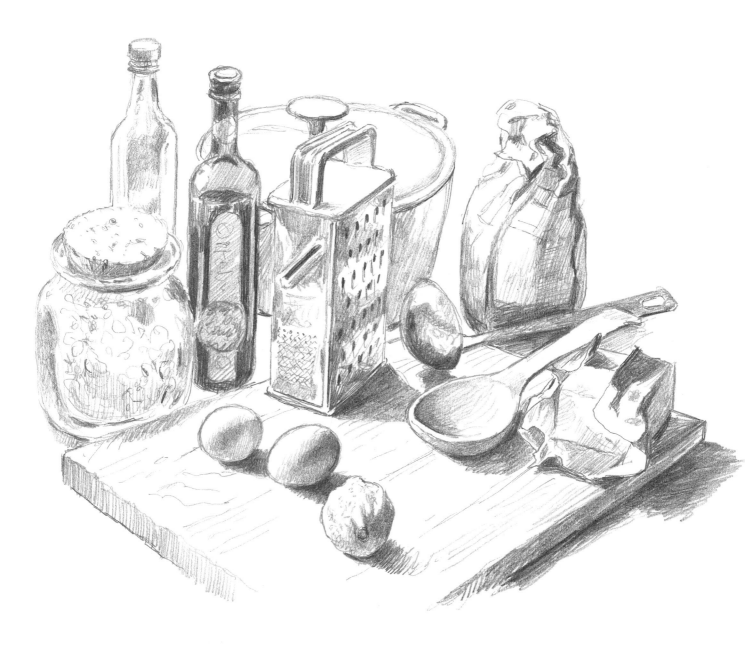

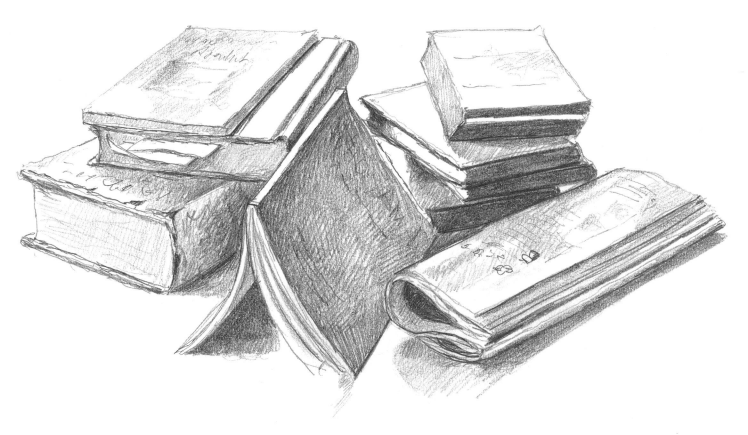

This still life consists of just books and paper and needed to be arranged quite carefully to make an interesting composition. It looks easy but in fact is quite difficult to draw convincingly.

THEMED STILL LIFE

My theme here is the end of a sumptuous meal, with objects such as a decanter, glasses of half-drunk wine, bread, a cheeseboard, nuts, plates and discarded napkins suggesting that a good time has been had by all.

1 This still life is one in which I could control my set-up easily, selecting just the end of a table and a couple of chairs that suggest a much larger expanse. The background could be quite dark, evoking a big room with the lights low, since all the diners have left. I began by putting down a rough idea of the sort of setting I had in mind.

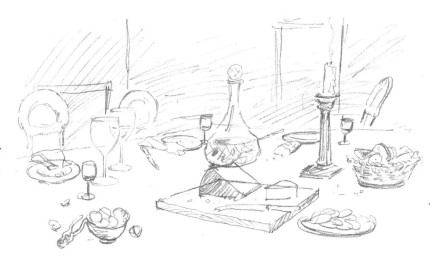

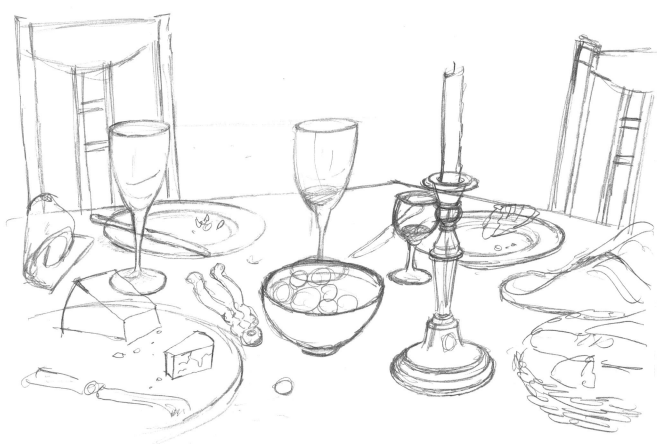

2 Next, I gathered the items to put on the table-top and made some preliminary set-ups to try different compositions. I made separate drawings of some of the objects to get an idea of how I would treat them, then drew up a fairly well-worked-out version of how my final composition would look.

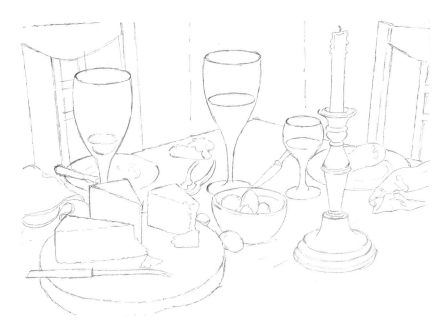

3 Having by now made up my mind as to the way I was going to draw the picture, I carefully produced a line drawing of the composition. It shows a close-up view of a corner of the table-top, covered with a cloth. On it are two side plates, some nuts and a nutcracker, a candlestick with a snuffed-out candle, glasses, knives, a cheeseboard and slices of bread. A couple of discarded napkins by the plates give the feeling that the diners have just left.

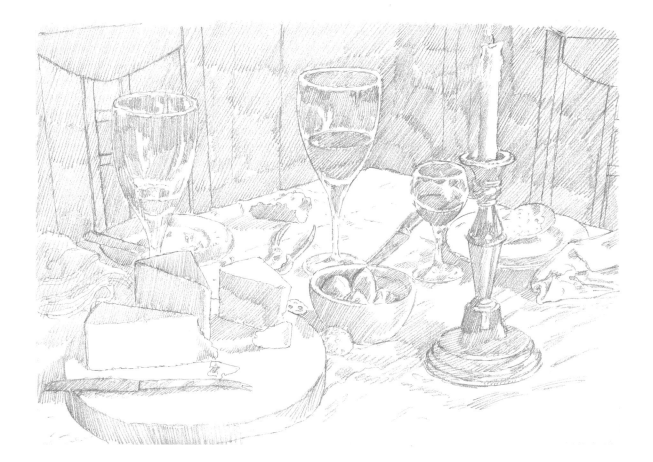

4 The next step was to work over the whole drawing, putting a basic layer of tone on all the areas where there would be some shadow. Most of the background would be quite dark in the finished drawing to help throw forward the objects on the table. I left the paper white for all the brighter edges of the glasses and metal objects, so that the highlights would provide tonal contrast.

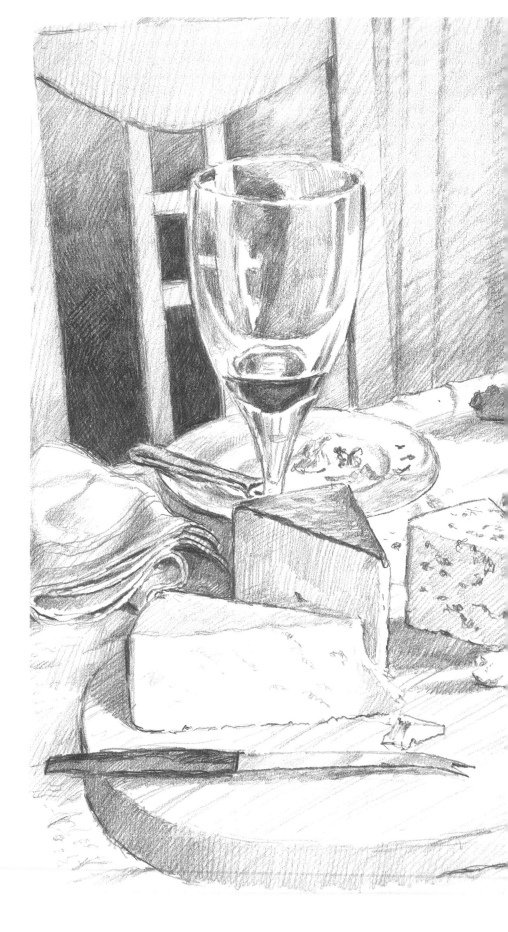

5 In the last stage, I worked up all the varieties of tone so that the solidity of the objects and their materiality can be seen. It is a good idea to put in the very darkest tones first and then work in the variations between the darkest and lightest, as this makes it easier to balance the tones to the best effect. In my example the darkest tones are in the background depths and the dark wine in the glasses, while the knives and candlestick also have very dark areas to contrast with the bright highlights. The overall tonal contrasts in the drawing help to give the objects and the composition depth and substance.

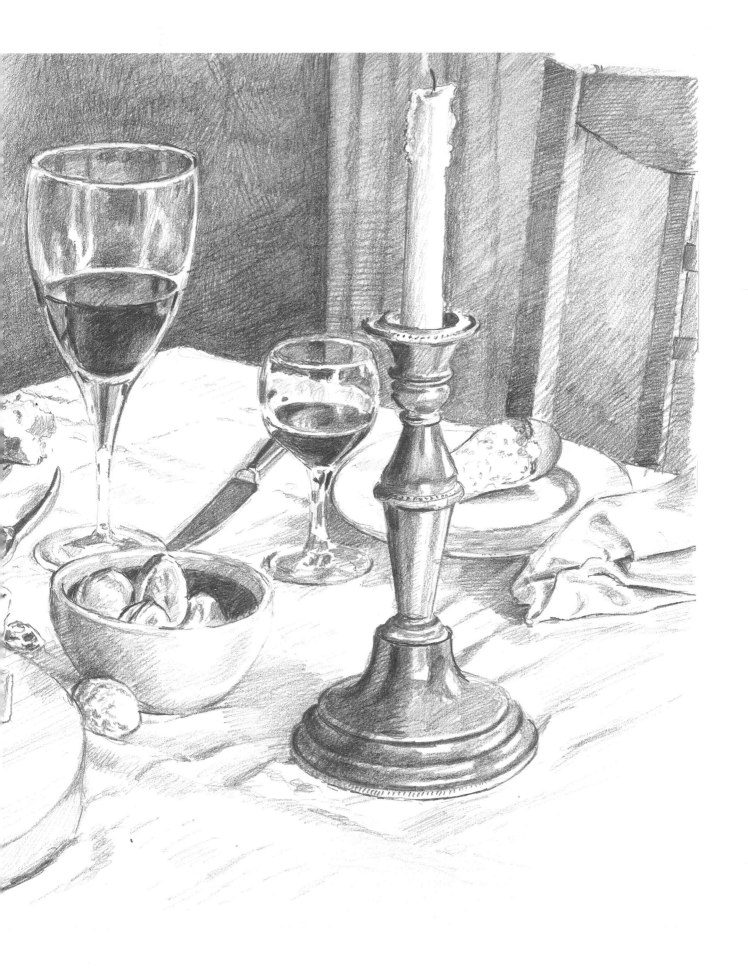

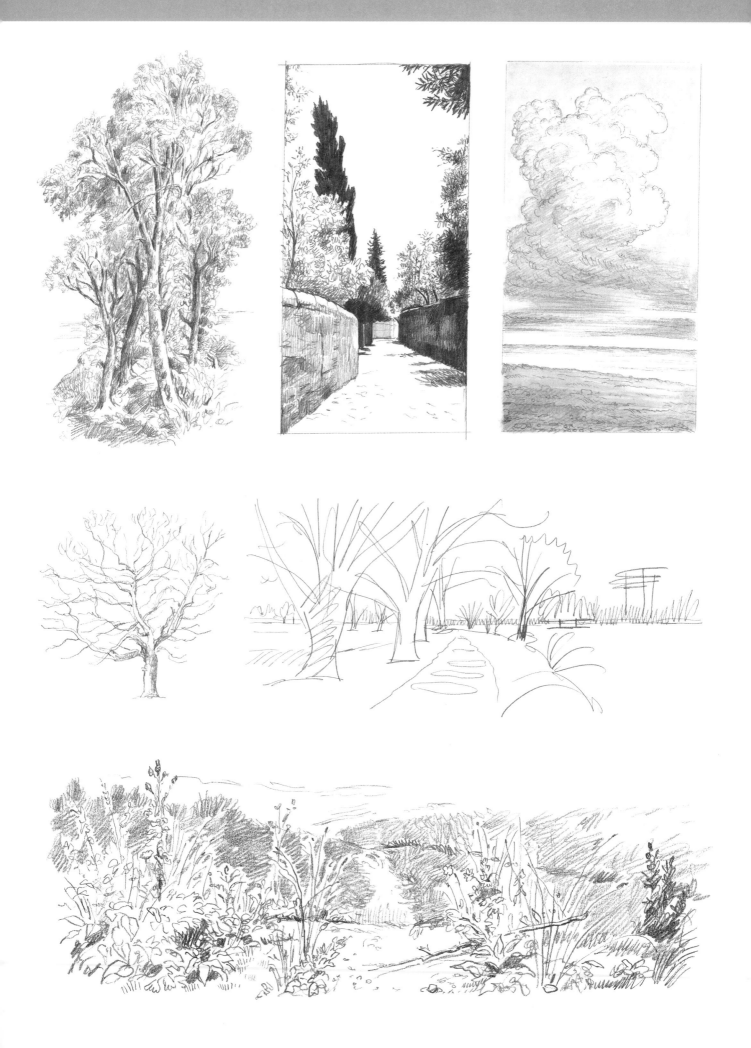

Chapter 7

LANDSCAPE

Now it's time to take a look at subjects outside
your house. To make the transition easy, step
out into your garden and then into your street
and draw what you see every day. To start with,
I suggest taking just one or two bits of the scene,
rather than trying to get a whole picture all at
once; little details can be quite fascinating to
draw once you start to study them. When you're
ready to try a whole scene, go for something
that's familiar, because it's gaining the ability to
render on paper the most ordinary sights that
gives you the best practice in this work.

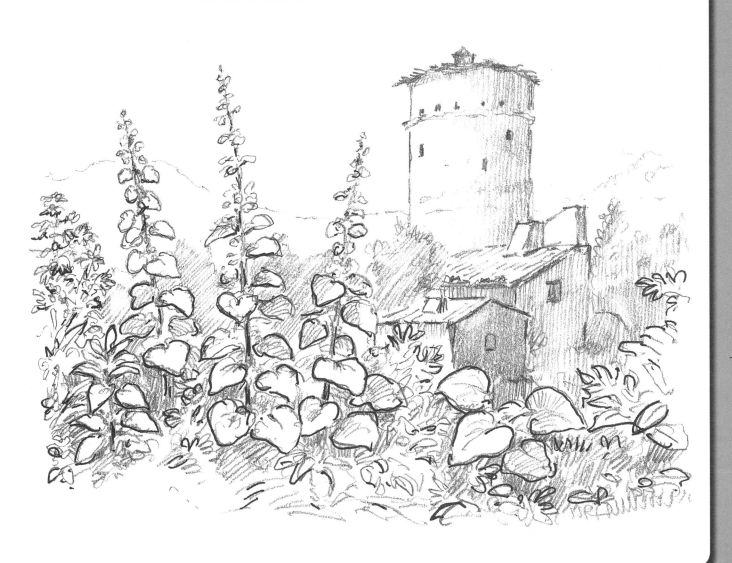

DRAWING IN YOUR LOCAL AREA

If you have a garden, this can act as the first step towards exploring your locality. It doesn't matter if it's small and not an area of great beauty – the important thing is to practise drawing out of doors. If you have never tried this, starting off by tackling a landscape panorama would be very daunting and might knock your confidence. Instead, draw garden chairs or tables, pots stacked up against a wall, some trellis – small, unimportant subjects that are easy to handle, so that you can then go out of the gate with optimism that the surrounding streets will be equally manageable.

In my garden in the summer a few garden chairs were scattered about on the grass, so it was simple to just draw them in context without worrying about the whole scene.

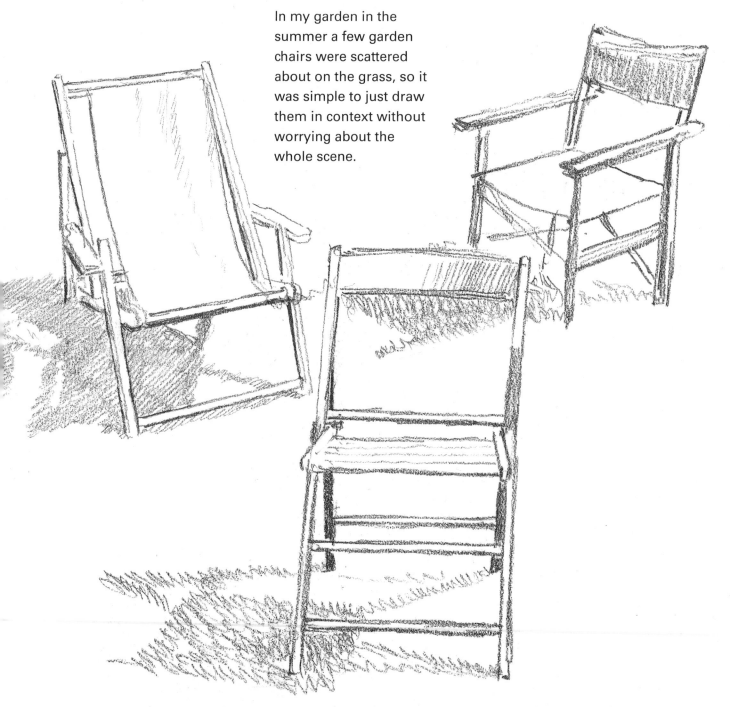

Not far from my house I drew some rooftops, a railway bridge and a group of cars parked along the road. Keeping the drawing simple, I immediately began to get a feel for the space and its general ambience – not at all neat and tidy, but rather haphazard.

On another outing I concentrated
on some street furniture, such
as this letterbox, and then drew
some roadside trees.

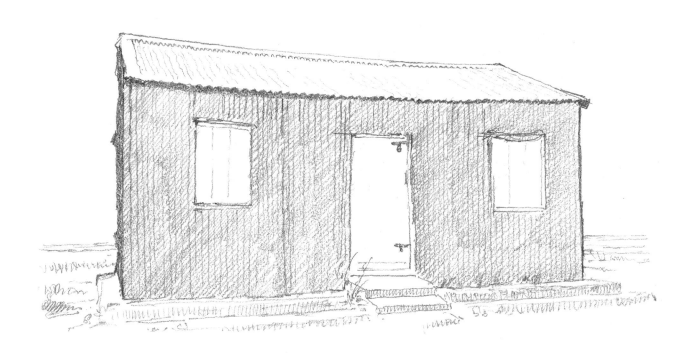

These drawings of a corrugated iron hut by the seashore and a railway bridge have a quality of emptiness, as though something were waiting to happen – for someone to enter or leave the hut, for example, or for a train to run under the bridge. In both of these drawings there is an indication of perspective giving depth.

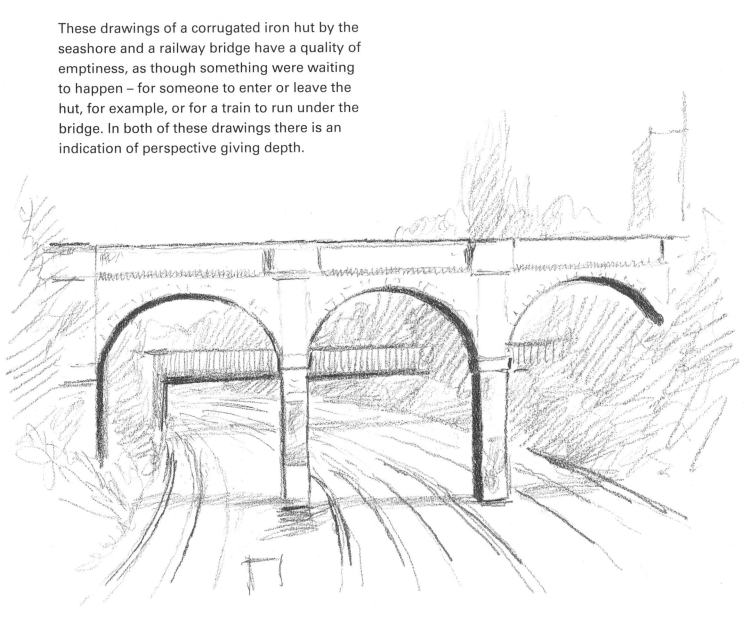

DRAWING A LOCAL SCENE

As I live in deepest suburbia, this seemed to be the right place to start finding ideas for a local scene since it is the type of area many of us inhabit. Of course, if you live out in the country or by the seaside, you can take advantage of your situation to bring in the greater glories of nature.

1 First, as always, I made a quick sketch to get the area that I was going to draw clear in my own mind. There was a patch of grass right in front of me with a road curving away and plenty of trees around.

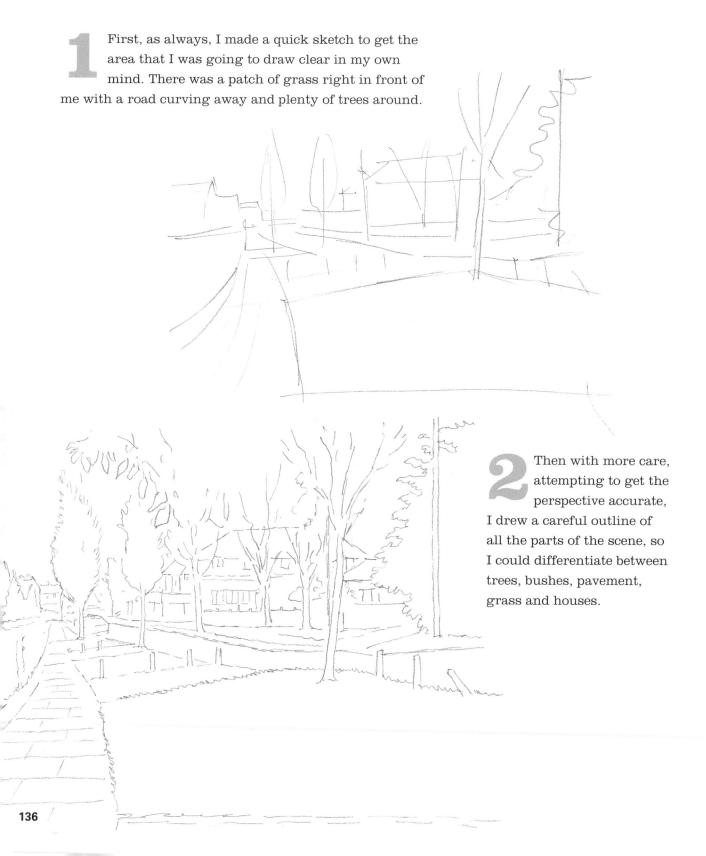

2 Then with more care, attempting to get the perspective accurate, I drew a careful outline of all the parts of the scene, so I could differentiate between trees, bushes, pavement, grass and houses.

3 I put in the main tone all over the picture, not yet differentiating between the darkest and lighter tones. This gave me a good idea as to where the greatest emphasis in the spatial qualities of the scene could be made.

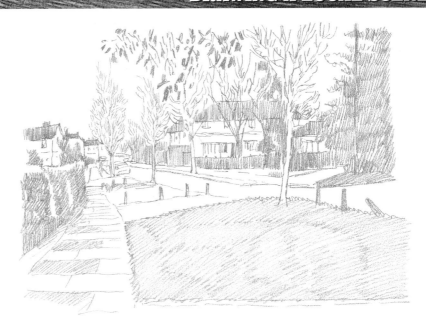

4 Next I built up the darkest areas with more and more tone. These were mostly parts of the houses and the evergreen trees. I was lucky to have a very dark yew tree on the right-hand side of the picture which acted as a framing device and I emphasized the overhanging leaves at the top of the picture a bit more to also help frame the scene. This is the sort of artistic licence that can greatly improve a drawing.

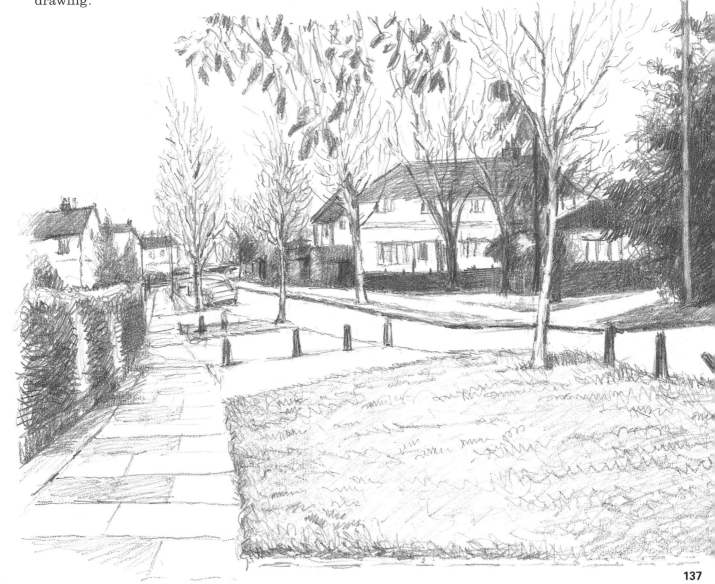

ELEMENTS OF LANDSCAPE: WATER

Water in a landscape always adds an extra dimension to a drawing, reflecting the sky and the scenery and bringing light into your work. You may be lucky enough to live near the sea, but a river or lake will be just as interesting for studies of water.

In this scene the water is in rapid movement and so reflects the light rather than the landscape and sky. The surrounding scenery is the side of a rocky hill and the stream flows down to a pool at the base of the picture. There is not much sky as the depth of the hillside needs to be shown, and there is little vegetation except for grass. It is in effect a portrait of a waterfall. Most of the water is the white of the paper, and to make it work the rest of the picture needs some pencil work to provide contrast.

The next picture is of the Suffolk coast, along a creek where fishing boats are moored. In the forefront of the scene are a couple of boats tied to a jetty, with the water behind and in the distance the other shore, also with moored boats. The sky is clear and the water reflects that light, with only small ripples of reflection shown where the boats are. The weather is calm and still, so there is almost nothing to see in the sky and the water.

This drawing of a part of the Niagara Falls, after W.H. Bartlett's *View from Table Rock* (1837), again shows a waterfall but here the dark rock face frames the right half of the picture and provides extreme contrast with the white of the water. While the waterfall on the facing page shows evidence of the rocky terrain over which it flows, the sheer drop of the Falls creates a dramatic sheet of water that gives the picture an entirely different mood.

This picture is of the River Thames at Hammersmith, in London. Here, the main feature is a row of houses curving away from the viewer, with dark reflections in the water below.

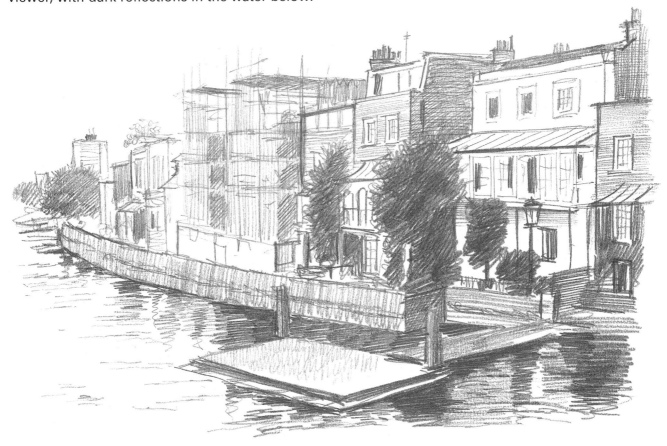

TREES

The next exercise is to make a study of trees, because they are present in most landscapes. Your earlier go at trees on pp.36–37 will have given you the basics, but now the task is to concentrate in more detail on two or three species – choose ones that grow close to where you live so that you can easily revisit them. Shown here are the works of three artists from the 19th century to give you some idea of the power and strength of skilfully drawn trees.

The first artist is Samuel Palmer, who portrayed the landscapes of southeast England. His drawing of oak and beech trees (below) is a magnificent example of the stature that the trunk of a large tree can give to a picture, if drawn expressively. This is an exercise that you could emulate and learn a lot about drawing in the process.

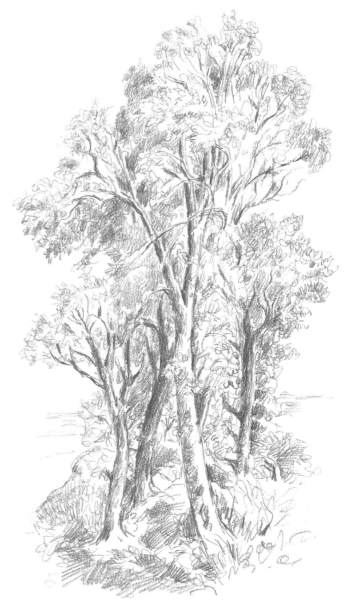

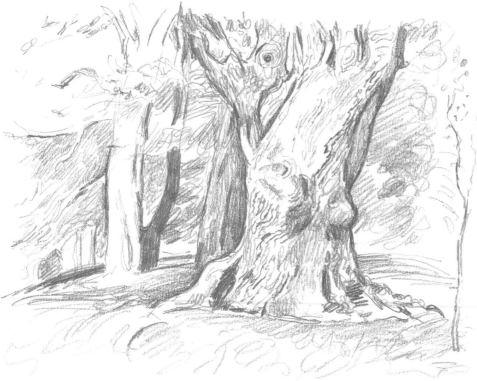

The second artist is John Constable, drawing in the Vale of Dedham in Suffolk. His beautifully realized clump of trees, with their intertwining branches and masses of leafy texture contrasting with the hardness of the wood, is a lesson in itself. Copy a Constable drawing of a tree to discover some of his methods, then have a go at drawing leaves in a similar fashion.

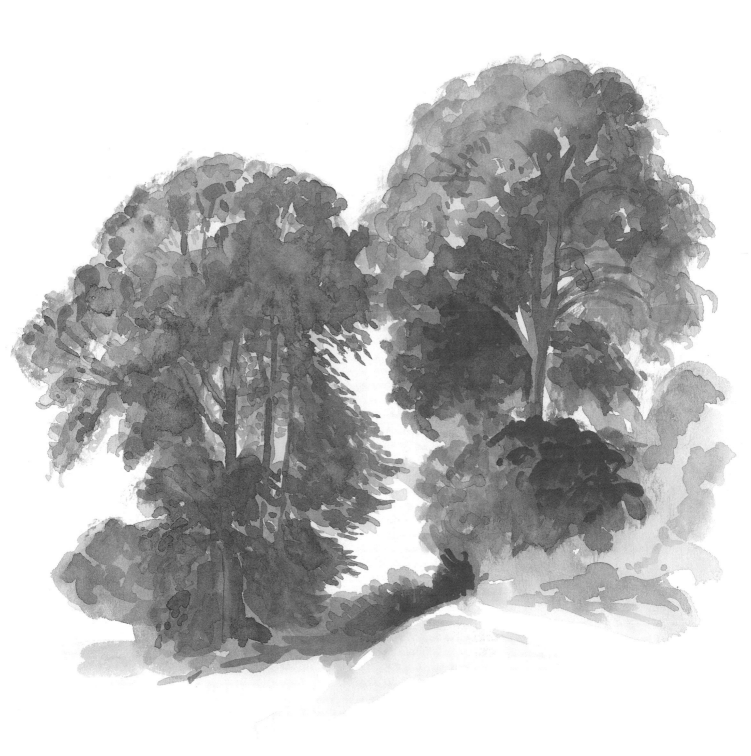

Now look at this Peter de Wint watercolour drawing
of trees near Oxford. He has built up a grey mass of
tone in rounded forms, then added darker and darker
tones to give some depth to the scene. Again the
best way to emulate this is to try copying him first,
then draw some real trees in a similar style.

141

PLANTS

While plants can be loosely indicated in the larger landscape you will sometimes want to draw them in more detail, perhaps in the foreground to add a sense of depth to a panoramic picture or in a more intimate, small-scale study.

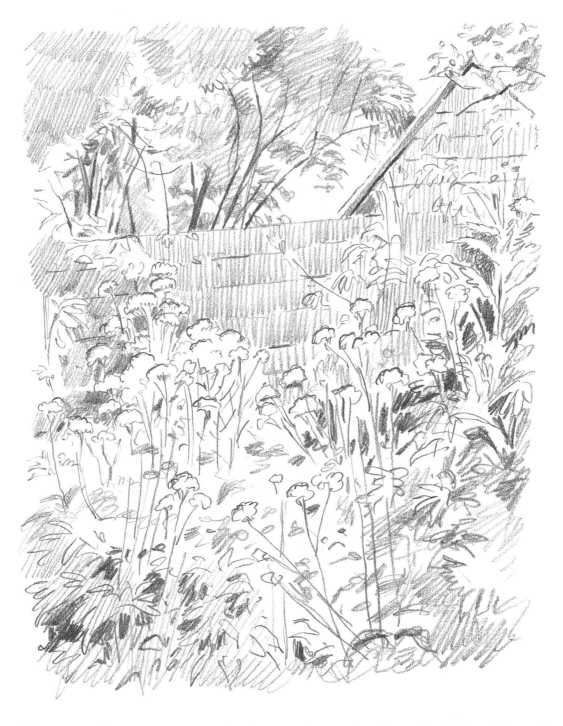

This corner of an overgrown garden is a good example of a study of plant life, which is essential for a landscape artist to practise. The whole landscape might not concentrate on these details, but if you don't get them right the overall picture will suffer. One exercise you should engage in is to make several attempts at just drawing plants in all their profusion – the more common and tangled, the better.

This view of a valley with a tower and other buildings is seen past the profusion of wild plants on the side of the hillside nearest to our viewpoint. The nearer plants are drawn more heavily in outline than the buildings in the background, which helps to bring the foreground plants forward and push the buildings back.

This edge of a countryside path has the usual mix of wild plants growing along it – a good test of your drawing ability, even if they never end up in a complete landscape.

LEADING THE EYE INTO THE PICTURE

The next three pictures show examples of scenes where a path or waterway draws the eye into the scene by leading away from the foreground into the distance. This very effective device is often used by artists to add interest to the picture.

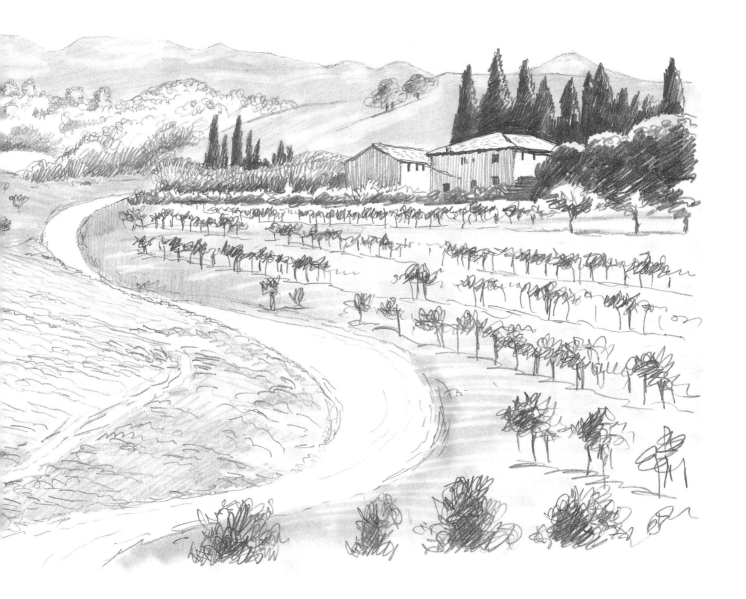

In this view of the Chianti countryside in Italy a path winds across the scene past the open vineyards and a farm, disappearing into the hills. Nearly all the main features are on the right side of the picture, but they create a horizontal thrust across the scene, counter to the direction of the path.

The next scene is from Venice, Italy – a canal on the island of Burano with boats cluttering the edges of the water and a church tower looming up in the distance. We appear to be looking along the canal and the row of houses alongside it.

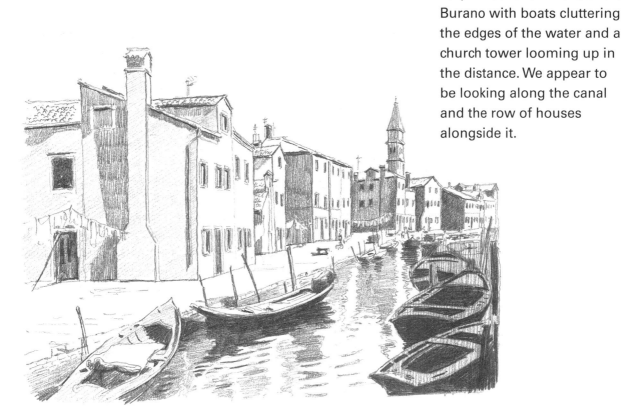

This watercolour by de Wint shows a lane dipping past a farmhouse in the Warwickshire countryside in England, where we appear to be on top of a slope. The large clumps of trees frame the whole picture in a satisfying way.

CHOOSING YOUR FORMAT

When it comes to drawing landscapes the usual tendency is to think in terms of a wide horizontal shape, which is indeed known as landscape format. However, a vertical shape (portrait format) can sometimes be an interesting variation that may suit your subject better. Here are three versions of portrait-format pictures that show how this way of selecting your scene can be useful.

The first scene is of a narrow walkway near Florence, Italy, which shows tall trees either side of a walled road. The whole interest of the picture is the perspective effect of the tunnel through the encroaching walls and trees. If you were standing in this spot it would be obvious that a portrait format is the way to draw the scene.

The next drawing is a more selective view, because the natural way to portray a beach scene without much in the way of foreground features is to show it in a wide horizontal format. Here, with the sides of the picture pulled in, the magnificent cloud is the main feature; the sea and beach have been reduced to the minimum so as not to distract from the view of the sky. This sort of landscape could be described as a skyscape instead.

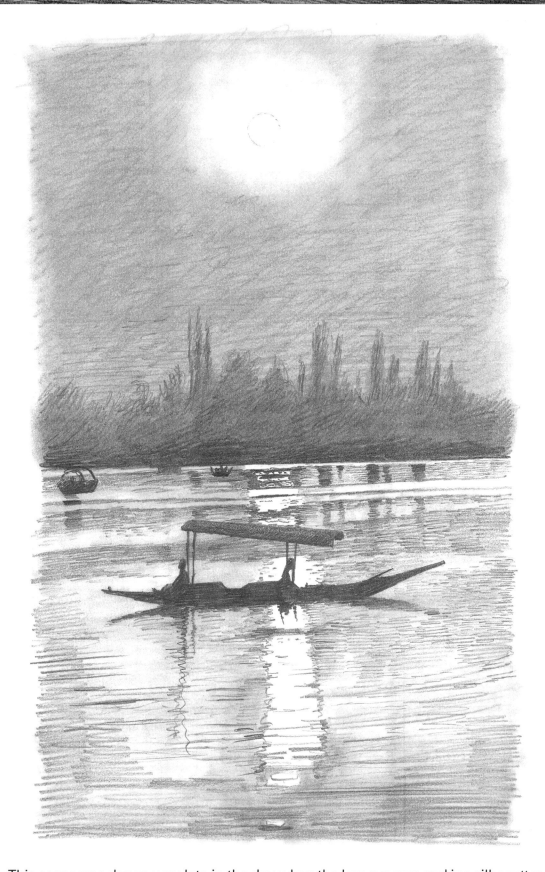

This scene was drawn very late in the day when the low sun was making silhouettes of the boats and trees. It's more a picture of the sun and its effect on the misty sky and the water rather than of the lake itself, so the portrait format was used to act as a window that selects the sun and its reflection. The passing boat in the centre of the scene is a bonus, only made possible by using photographs for information; a moment such as this doesn't allow time for detailed sketching.

A PANORAMIC VIEW

This picture of downland scenery to the south of London was drawn in the 18th century by George Lambert. He chose a wide format to include as much of the panorama as possible, positioning himself well back from the hill – he even shows another artist in front of him drawing the scene. It is clear he wanted to place the hill dead centre in the drawing, framing it with trees at each side of the picture. Many artists of the time would paint large panoramic views like this and then charge the public a small fee to see them.

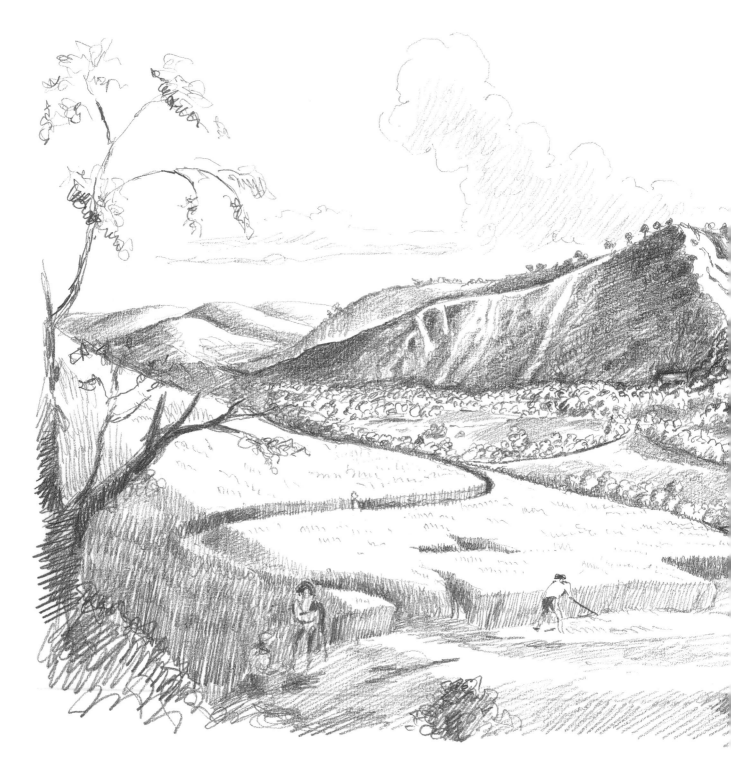

Tackling a panorama

When you feel ready to have a go at a complex large-scale picture such as this you will need to set it up carefully. You will obviously have to choose a day when the weather is going to be in your favour, and then you will have to find a spot to draw from that makes it easier for you to encompass the whole scene. It's a time-consuming subject, too, so you'll have to allot a good part of the day to your drawing, or else return several times in order to complete the picture. A good series of photographs will help to add extra information for completing the piece when you get it home.

Working on a piece this large is always a challenge, but if you have the courage to try it out you will probably learn a good deal about landscape drawing in quite a short time. If the view is local to you, visiting it repeatedly beforehand will tell you a lot about the times of day the light is most attractive and the best spots to place yourself. It will also help you to regard the scene as a familiar one, making the moment you arrive with your paper and pencils less daunting.

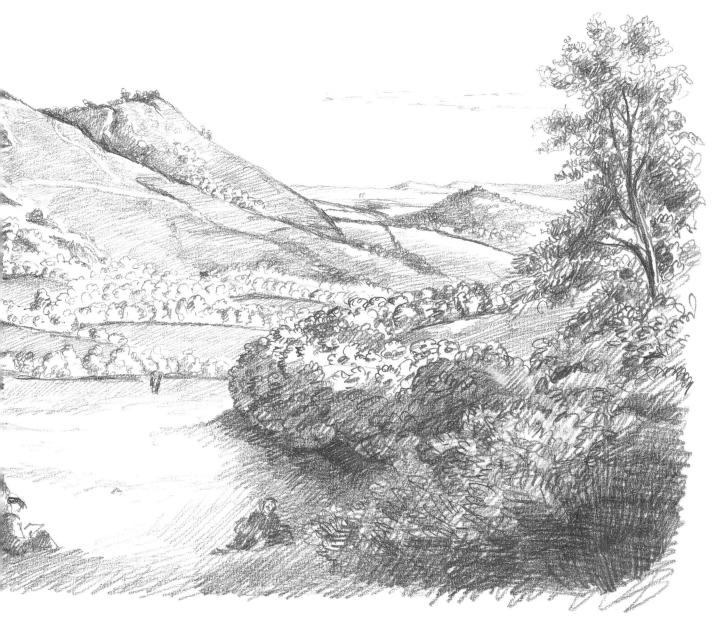

THE STRUCTURE OF LANDSCAPE

Before you start to draw a larger and more complicated landscape from life, it's advisable to consider how it can be approached schematically. The first point to realize is that in any large open landscape, there's an area of sky with the background immediately below it, then the middle ground and finally the foreground. The horizon line is the edge of the background against the sky.

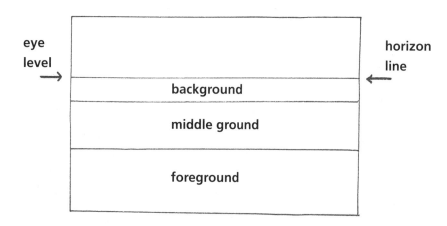

eye level →

← horizon line

background

middle ground

foreground

As in my example, parts of the foreground and middle ground will sometimes project into the areas behind, like the large tree in the middle ground that reaches up into the sky.

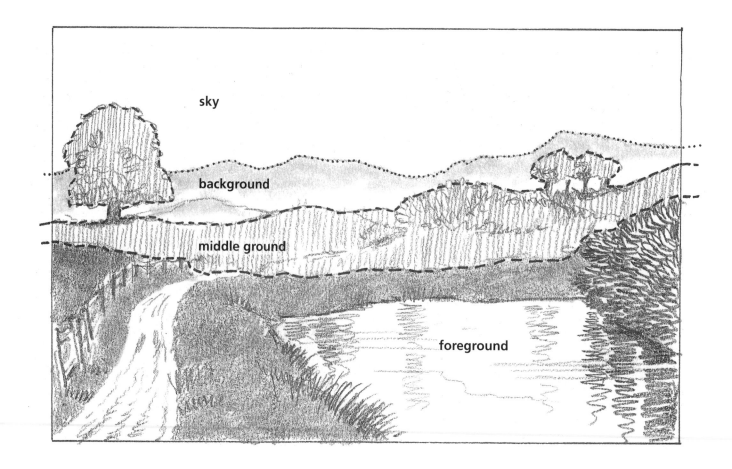

sky

background

middle ground

foreground

Sky can be considered as part of background

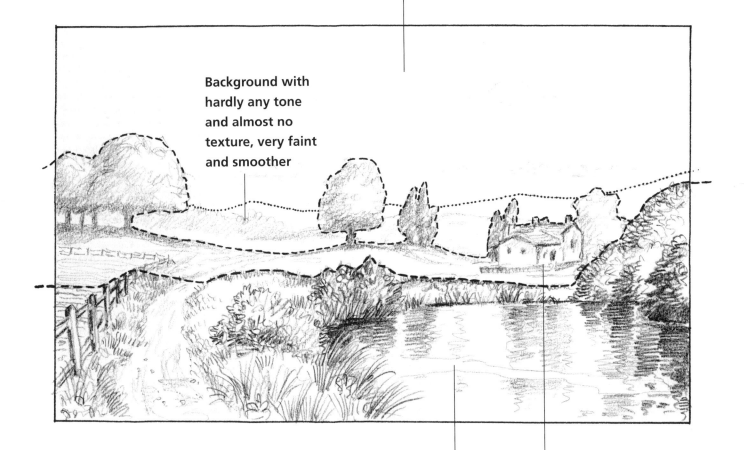

Background with hardly any tone and almost no texture, very faint and smoother

Middle ground with tone and texture but softer and less intense than the foreground

Foreground with intense tone and contrast and strong textures

In this next version of a landscape we're also aware of the fact that the background area is very faint and without detail or much texture – in fact in places it's almost as light as the sky. The middle ground has a little more definition and texture, but still not much detail. The foreground has the greatest definition and the most texture and intensity of detail. This is a result of what is known as aerial perspective, where atmospheric haze makes landscape features at a greater distance appear much less defined than those in the foreground.

TYPES OF LANDSCAPE

The never-ending interest of drawing landscapes is that there's such a variety of forms, textures and compositions encompassed by the genre. While we all have a particular type of landscape that calls to us the most, it's always possible to find a scene that sparks off a drawing. Over the next pages we'll look at various landscape compositions, one after a master artist and the others my own.

Our first example is of a large tree that dominates the foreground and in fact the whole picture. The sun is rising behind it, so bright patches of light can be seen through its very dark silhouette. The fact that this tree stretches from the top to the bottom of the picture and takes up almost half of the composition means that the rest of the landscape is subordinate to it. Indeed, the picture appears to be mostly background – though the expanse of the field behind the tree is middle ground, it's not very obvious. The row of trees in the background is not much more detailed than the sky, and here the clouds play a big part in the composition. The complexity of this composition is subtle and depends on your ability to draw the clouds interestingly enough to contrast with the dominant tree.

Here the main feature is again trees, but this time a group of them in the middle ground. A curving path extends from the forefront of the composition and swings around behind the trees, helping to pull the eye into the picture towards the main feature. Behind that is a row of low hills covered in vegetation, while in the near foreground there is a bank of bushes.

The third scene is of a mountainous landscape with rows of rocky peaks in the background, similar terrain in the middle ground and scrub-covered lumps of rock in the foreground. The great difficulty in a scene like this is to show the difference in distance between the nearest outcrops and the distant mountains. If you're lucky there'll be some light mist between the further ranges and the middle ground outcrops, as in this picture; if not, rendering the texture and detail well-defined in the foreground and lessening towards the background is the best way. Notice how in this example the view has been selected so the nearest mountains are shown to the sides of the picture, and the furthest mountains are most prominent in the centre of the composition.

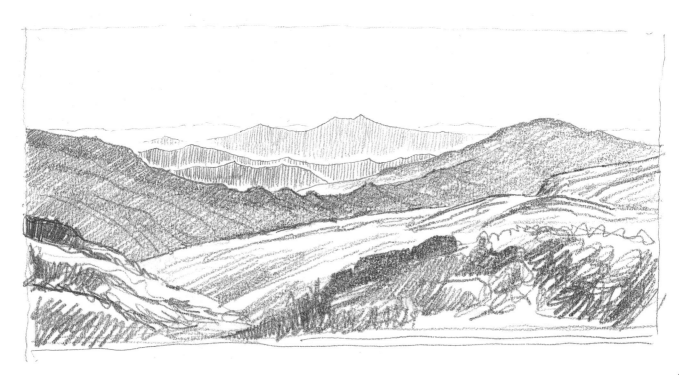

Here's a composition rather like the first example on
p.152, in which a very large tree in the foreground tends
to dominate the scene. However, unlike the first picture,
the lines of the ploughed landscape pull the eye into the
scene and lead it into the background hills and woods.
The structure of the main tree is very evident here and
becomes the most interesting part of the drawing.

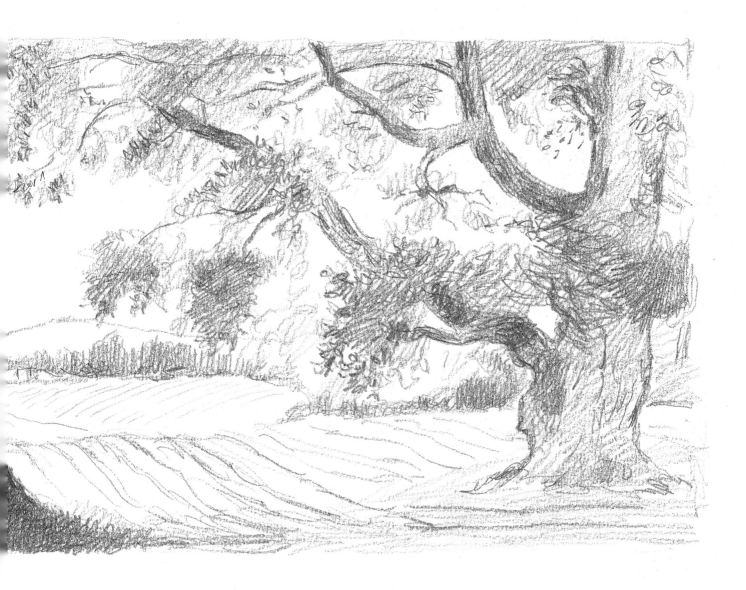

The next scene is primarily about the water in the foreground and how it reflects the rest of the scenery in the surface. The middle ground is mostly trees with a gap opening up the background to one side. As the lake takes up half of the whole composition it's quite important in the drawing and the reflections need to look convincing.

The scene on the left is another one in which water is the dominant feature, but this time it's given added depth by the device of including some ground and a small piece of fencing in the foreground. The main middle ground and background curve away on the other side of the lake, disappearing in a mass of reeds and vegetation over on the far left. Once again the reflection in the water is the key to this composition.

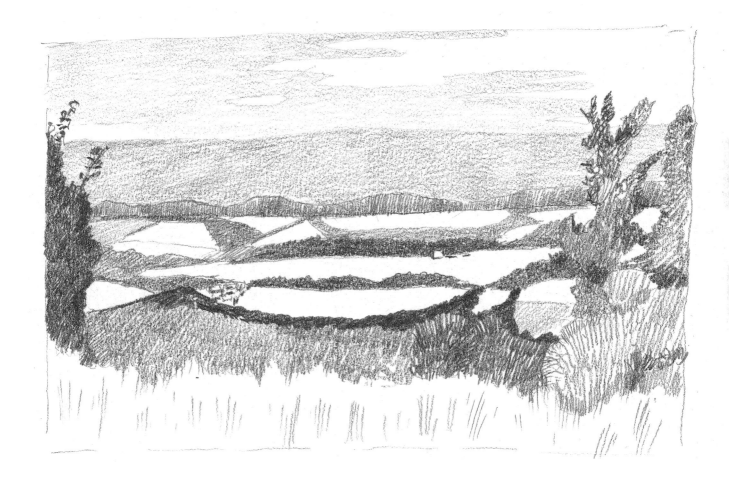

The scene above is less dramatic but, treated carefully, this kind of wide, open landscape can give a very good feel of depth in the picture. The foreground is composed of the tufts of grass and bushes on the edge of the hill that I was drawing from, which gives a good view over the fairly flat countryside stretching off into the distance. Behind that is a large area of dark cloud, above which is a lighter, more streaky sky. The texture of the bushes and grass in the foreground is important to give the right effect of space.

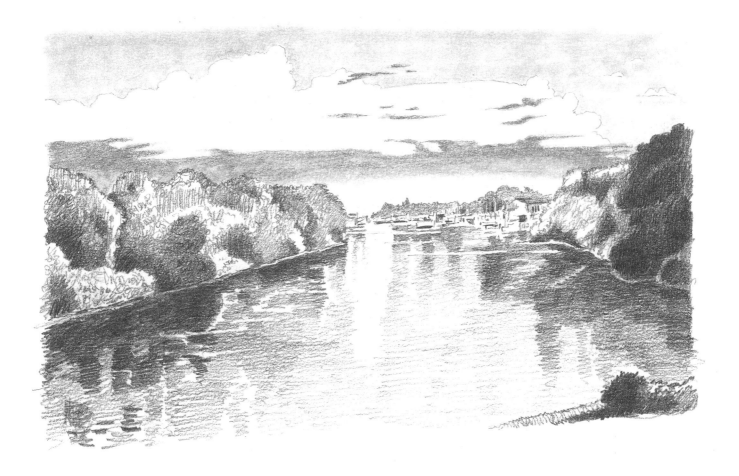

In this scene the river is pulling the eye towards the distant scenery, but the dramatic cloudy sky above seems to stretch our attention sideways to consider the breadth of the space. This sky with its reflection in the river surface is quite effective in opening up the space in the scene. The arrows in the diagram on the right show the direction the eye takes when reading the image.

The next scene, of
the dramatic coast in
Dorset, England, is more
complex. The centre of the
composition is the circular
inlet of the sea in the rocky
cliff face. All the lower
parts of the picture seem
to indicate the direction
towards this centre. The cliffs
immediately above the pool
also move the eye down
to the water. The sky, the
slanting line of the cliff top
with its row of trees and the
distant downland all move
the attention towards the
centre line of the cliff face,
which dips down towards
the edge of the pool.

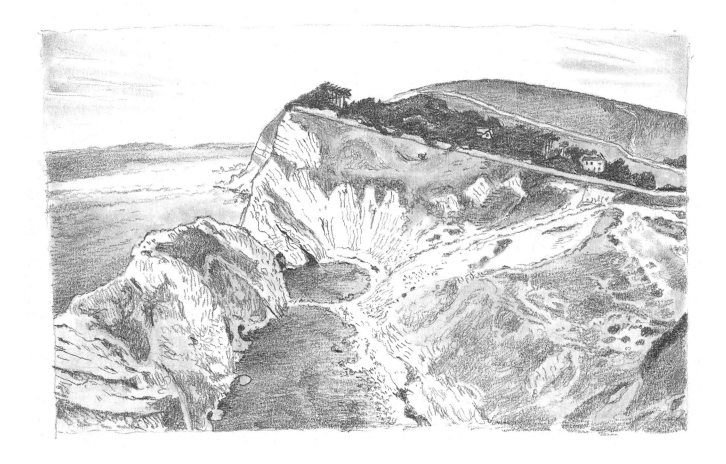

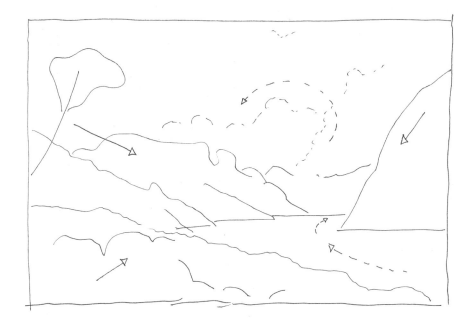

This drawing of the English Lake District has a similar effect to the coastal scene on the previous page in that the rocky edges of the lake all seem to draw our attention towards the water. The water appears to swing around the edge of the rocks, while the activity of the clouds swirls around to bring the eye back to the centre of the scene.

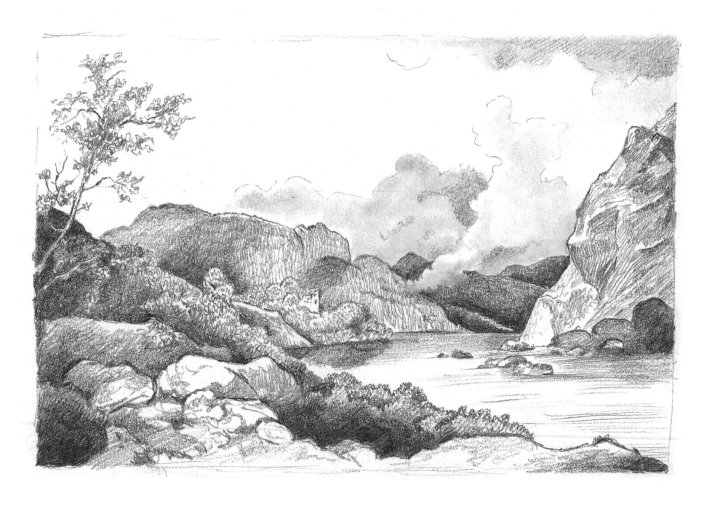

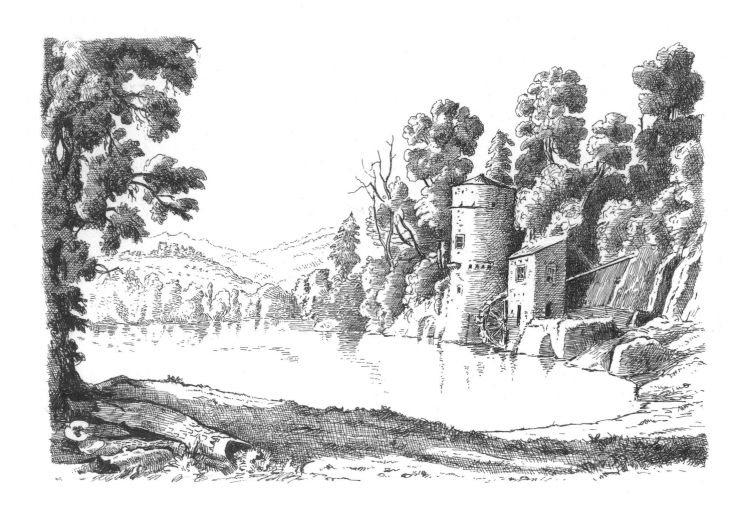

A lakeside scene after Claude Lorrain (1602–82) is slightly more complex, as you would expect from this master of landscape. The big tree on the left hems in our vision, while the foreground pulls our attention towards the area of the water. The outline of the distant landscape and the large trees sweeping down to the river on the right also concentrate the eye on the water. However, the key element is the strong vertical tower built on the riverbank which holds our attention. This is the real centre of the piece and everything else tends to pull our attention towards it or across it.

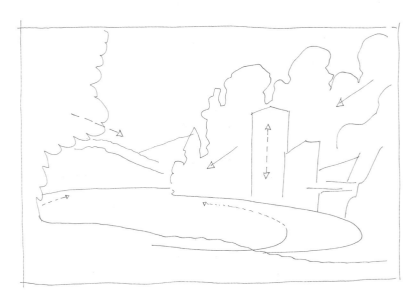

IDEAS FOR A LANDSCAPE

As I live near an urban park, this seemed to be the right place to start finding ideas for a landscape scene. Of course, if you live out in the country, perhaps by the seaside, you can take advantage of your situation to bring in the greater glories of nature.

An enclosed scene

In the park I found a group of trees near a small bridge over a stream. The trees looked interesting to draw, as they were of various sizes and types.

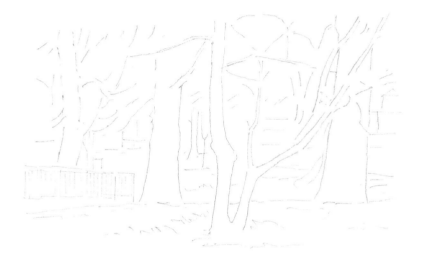

1 First I plotted out the scene, outlining the main trees and the end of the bridge and the farthest edge of the park. I had to take a bit of time over this in order to get the proportions of size and canopy of the trees accurate enough. At this stage it doesn't matter if the shapes are not quite exact, as long as they have the same look as the scene in front of you.

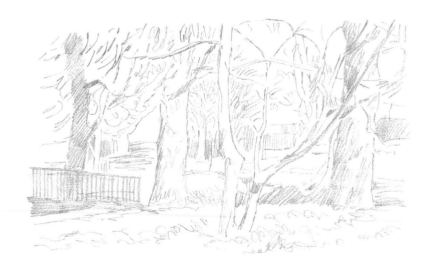

2 Next with a soft dark pencil (about 4B), I put in the tonal areas, all in the same tone at this stage. This ensured a balance between the darks and lights of the composition, and helped to give a feeling of depth.

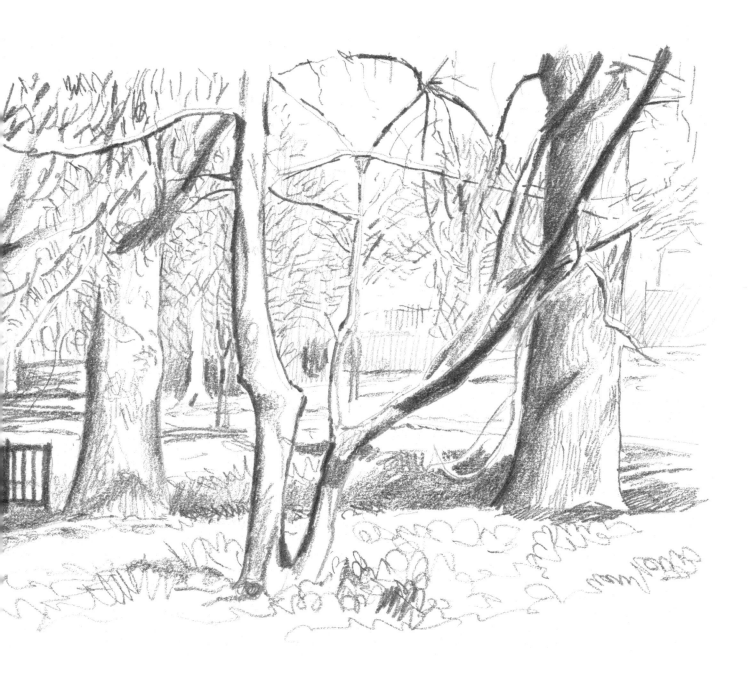

3 Now, with the same pencil, or one even darker such as a 6B, I began to build the tonal and textural qualities of the scene, to enhance the feelings of depth and substance. Some branches here looked very dark against the lighter background and some tree trunks had textured bark on them. The bridge was in deep shadow and you can see how this helps to define the space of the area. The very fine branches that criss-cross each other were put in with a sharp B pencil to maintain the feeling of a network of thin twigs.

An open scene

Next I moved into a more open part of
the park, where there was a yew tree
with typical dense foliage. All the other
trees were leafless, as it was late winter.
The contrast between the evergreen
and the other trees made an interesting
balance of textures in the scene.

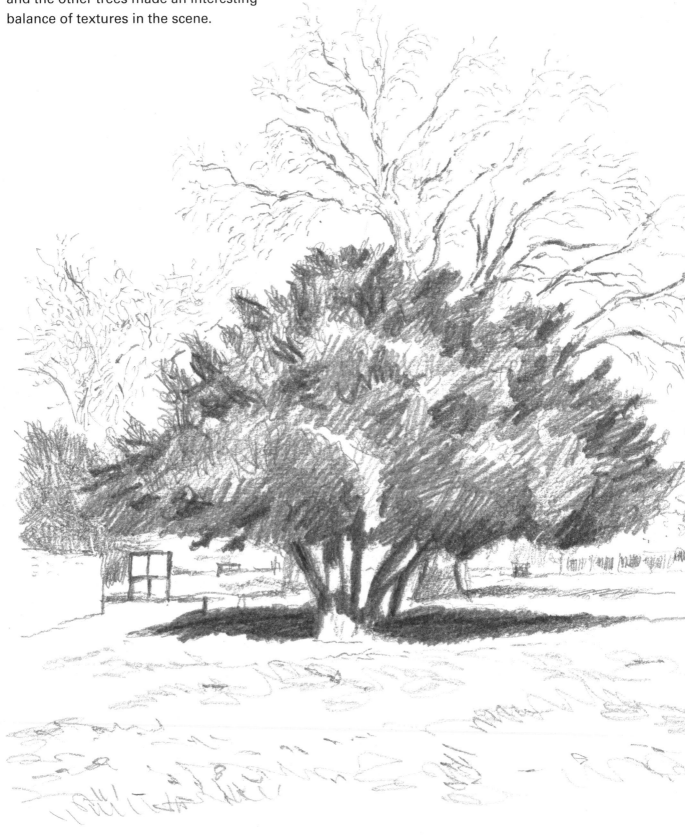

1 First I drew the outline of the main tree and then all the leafless trees further away. In the distance were some buildings, which I indicated lightly.

2 Then I put in the main areas of tone, which were mostly on the dark yew tree and its shadow. There was a little tone in the distant buildings, but it was important not to make it too heavy, or it would have looked too dominant. I then drew in the smaller branches of the leafless trees a bit more, and included the texture of the nearest grass and small objects such as the seat and its occupant.

3 Finally, with a soft, dark pencil, I built up the dark tones and textures with what might be called inspired scribbling. The nearest yew tree had to look much darker and more textured than anything else, and its shadow needed real depth. Then I put in a few other marks here and there to bring out some of the most prominent branches and features such as the park bench.

A foreground feature

Finally, I moved further into the park, where a stream runs through the landscaping.

1 Once again I began by marking in all the main features in a simple outline, indicating the line of the stream and the distant background of town houses.

3 The last stage was the dark tonal values which began to give some depth and substance to the picture – the dark bare trees against the slightly less dark buildings, and the very dark areas near to the water. The reflections were a bit tricky because of the small areas of highlight amid the dark shadows. I achieved them by drawing the darkest parts and then erasing vertical streaks with a putty eraser. This produced an interesting, slightly wintery scene.

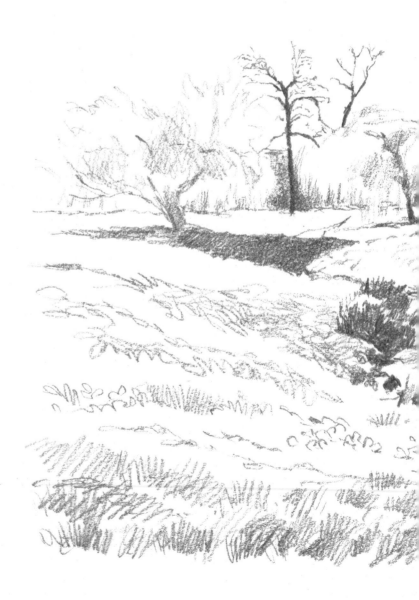

2 I then put in the main areas of tone and shadow, such as the background houses and the reflection in the stream. I also added the patches of bushy grass near the water and the shadow along the sloping bank under a tree.

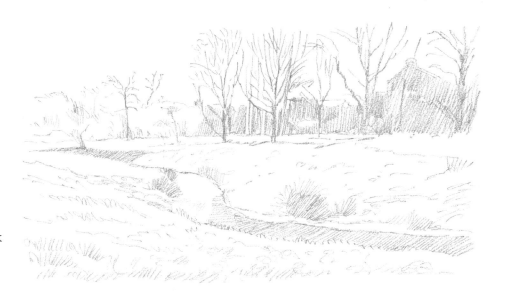

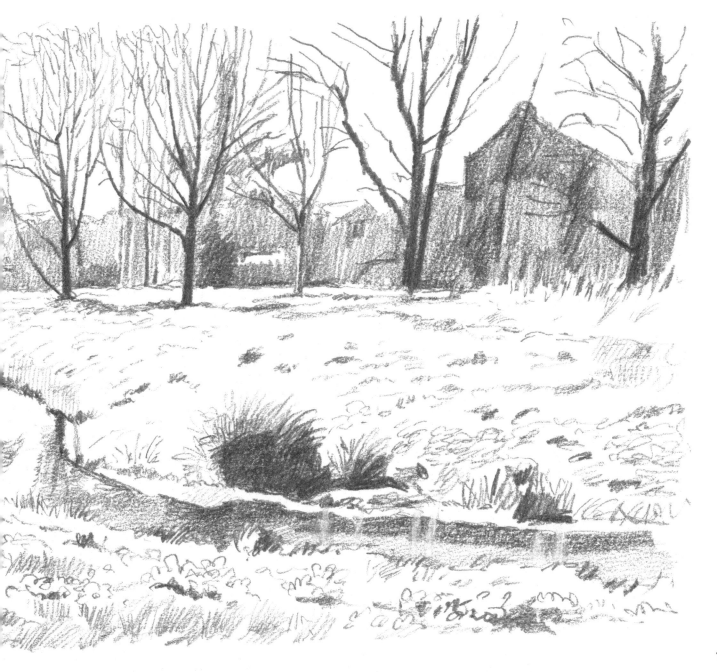

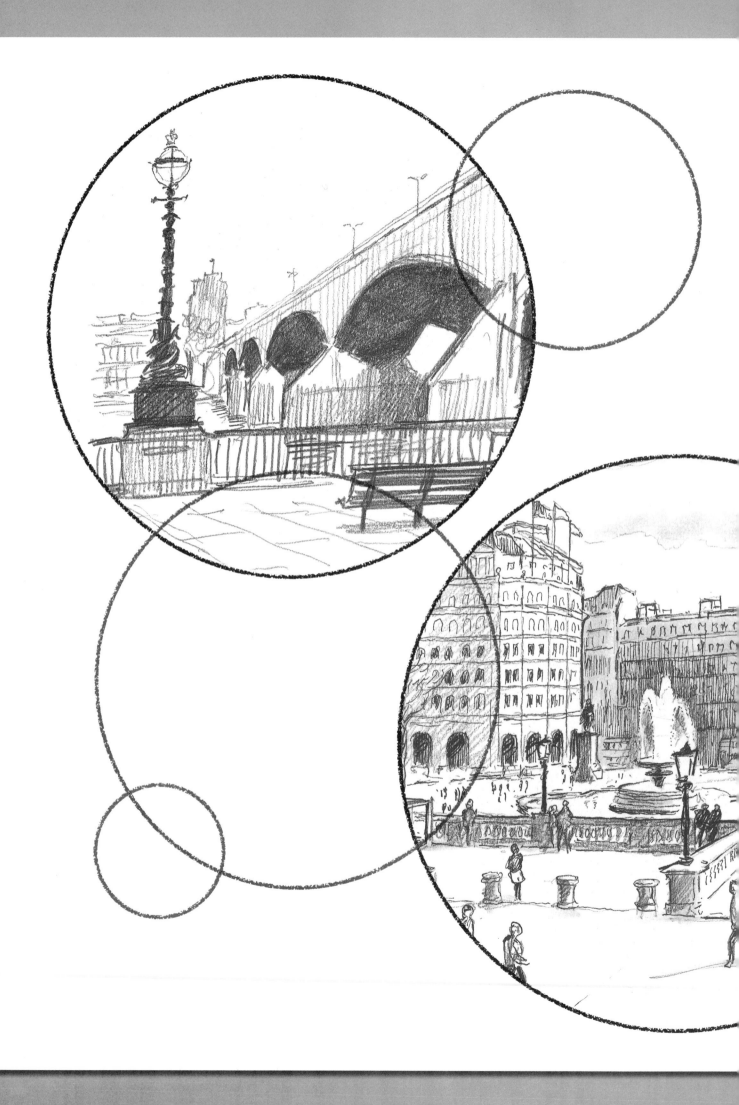

URBAN LANDSCAPES

The problem you'll find with urban scenes is that there's so much competing for your attention it can be hard to choose a subject. However, the same rules apply as in a rural landscape – select how much you are going to draw from your own viewpoint, and don't be confused by a lot of detail. Most of the scene is recorded in your mind only as a general impression, and this is the best way to show it. The details you do have to be precise about are those that are in the foreground or are points of focus.

STREET SCENES

Looking at the urban scene presents a different problem to the rural landscape because your view will often be cluttered with multiple signage, cars and so forth. For this reason, if you live in a quiet residential area it's a good idea to progress gradually from there to the centre of the town.

So our first compositions here are streets of residential housing with roadside trees, cars and minimum signage. Even so your spatial area will be rather constrained by the narrowness of the streets and the closely built houses.

This drawing is a view down a road with the houses on the opposite side jumbled together and the pollarded tree at the side of the road acting like a frame on the left of the picture. The cars alongside the kerb are significantly cutting off your view of the road, which is the largest space in the scene. You immediately see how this lacks the spacious qualities of the more open landscape of the countryside.

The next picture is of a town where the road divides, giving a concentrated view of the near side of the road and a more open view of the far side. The lamp post, road sign and parked car give you an easy introduction to the street paraphernalia that typically occur in urban scenes.

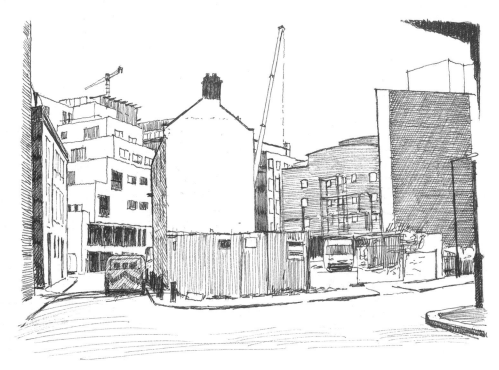

Here some building works are taking place in a city location where sheets of corrugated iron fence off the site from the pavement. The crane and scaffolding in the centre of the scene are framed by the large new buildings on each side.

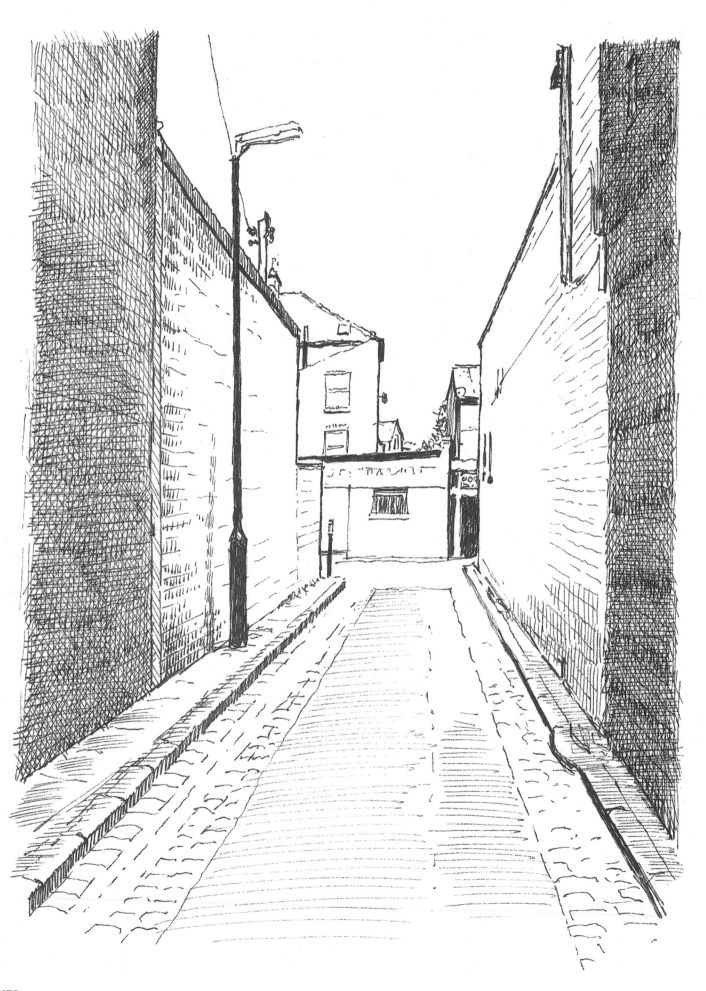

Now a couple of awkward spaces in the centre
of a town. The picture on the left shows a
narrow alleyway between rows of shops, giving
access to areas behind the commercial frontage.
It is rather like a large slot in the buildings,
showing a little sky and blank brick surfaces.

The second of these two scenes is the back of some
large buildings, where a car park is in temporary use.
Soon these spaces will be filled by new buildings, but
until then we have a view of these large blank surfaces
which indicate that these are not the main fronts of the
buildings concerned. This is really an exercise in drawing
large areas of texture and cast shadows.

URBAN DETAILS

An urban scene can be just as picturesque and interesting as the countryside. For a start, draw urban details that are easy for you to see, trying to show all the different textures and patterns that can be found in even mundane features.

I have made a selection of the upper parts of a doorway with ironwork protecting and decorating it, a set of chimneypots, and finally roof eaves with a window and drainpipes. However, you don't have to limit yourself to buildings – anything that takes your attention as you are wandering about is fair game, even if it is just a dustbin by a gate or a garden fence. You can find inspiration and interest everywhere if you look with an inquisitive eye.

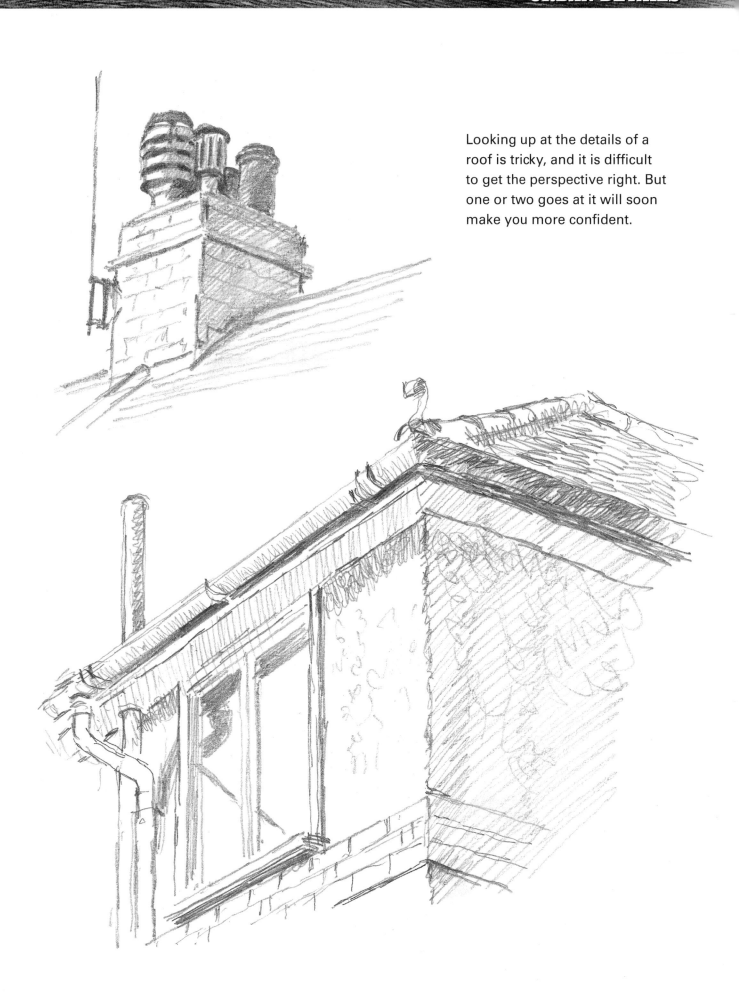

Looking up at the details of a roof is tricky, and it is difficult to get the perspective right. But one or two goes at it will soon make you more confident.

A TRIP TO THE CITY

I decided to go on a journey to get some examples of urban landscapes that had some direct significance for me, so I took the train to London's Trafalgar Square. This is one of the city's main focal points, and I thought that I would be able to find plenty of scenes that gave a good idea of the problems to be solved when drawing in a busy urban environment.

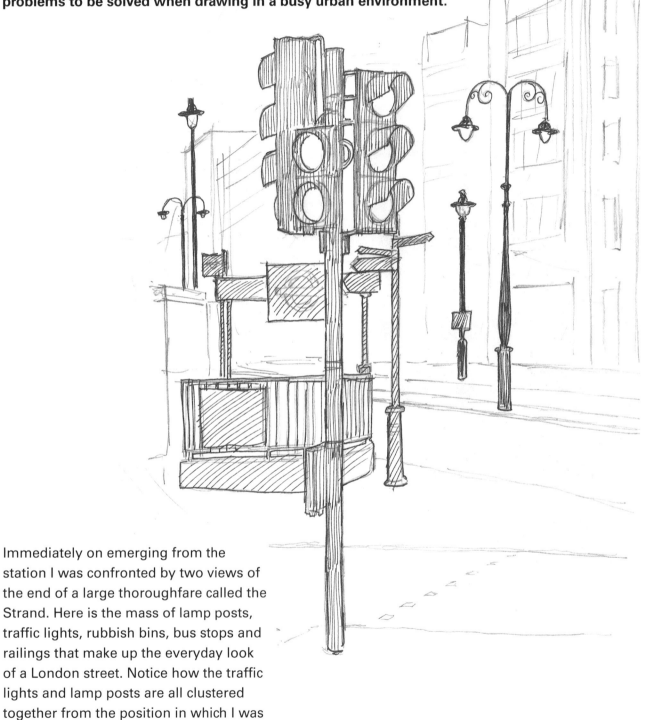

Immediately on emerging from the station I was confronted by two views of the end of a large thoroughfare called the Strand. Here is the mass of lamp posts, traffic lights, rubbish bins, bus stops and railings that make up the everyday look of a London street. Notice how the traffic lights and lamp posts are all clustered together from the position in which I was viewing the scene. I have purposely left the buildings only outlined in order to point out how much of the scene can be taken up with street furniture.

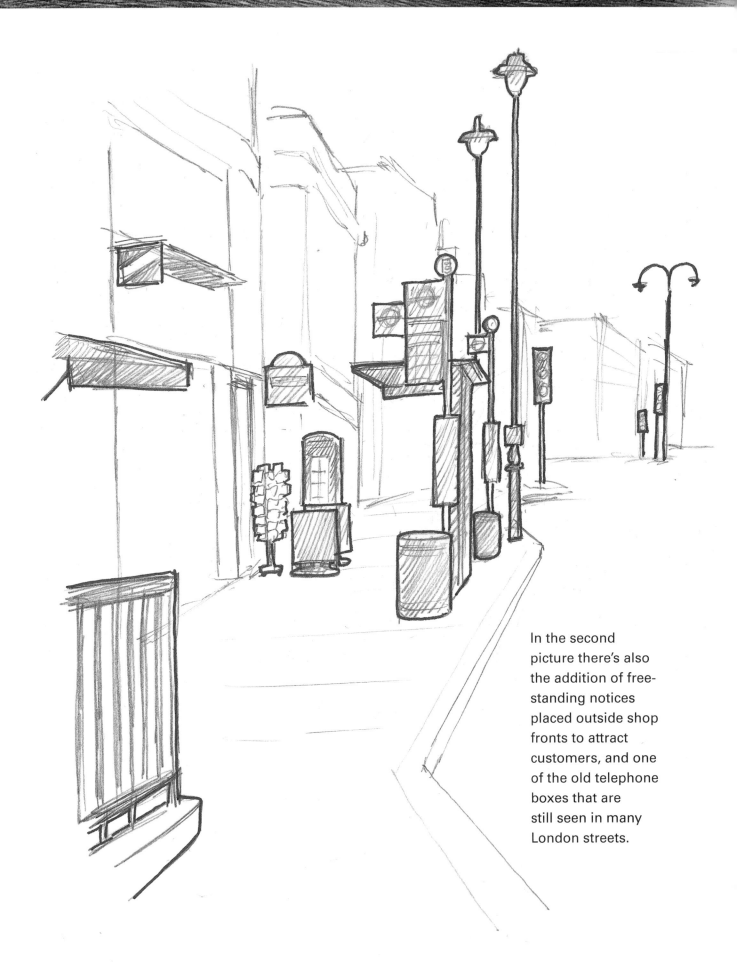

In the second picture there's also the addition of free-standing notices placed outside shop fronts to attract customers, and one of the old telephone boxes that are still seen in many London streets.

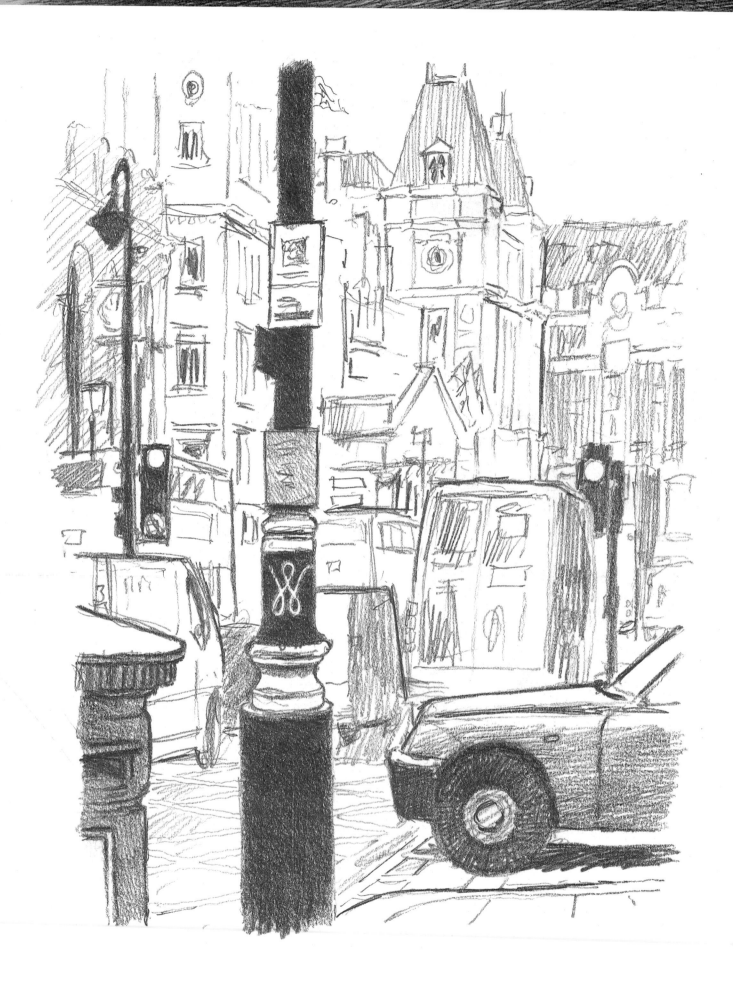

In the picture on the left you can see how the traffic jams in large towns always give a crowded look to the streets and with the lamps and other paraphernalia the whole picture can look very busy. This isn't a bad thing, because this may well be what you want to portray as typical city life.

However, you can find big spaces as well, especially if, as in London, there's a river running through the town. This view is on the south bank of the River Thames looking up at Waterloo Bridge. There are walkways along the side of the river which allow you to step back and see some very nice spaces contrasting with the solid architecture of the massive spans. The deep shadows under the bridge bring a certain drama to the scene.

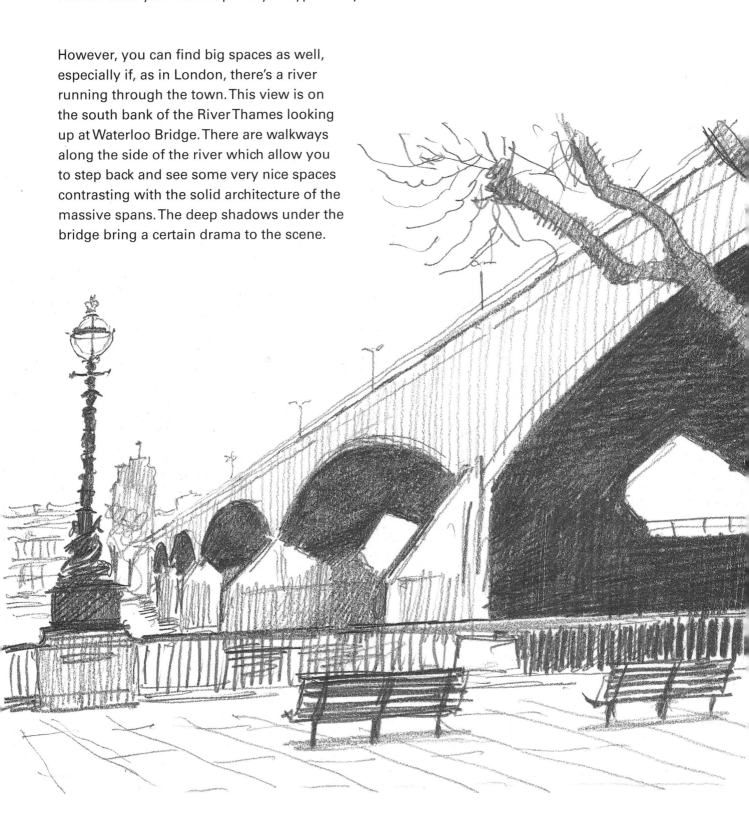

This drawing of a pedestrian walkway between shops and restaurants gives a good idea of the bright streets at night in a town. Figures walking along the street tend to look like silhouettes.

Here's a similar effect by daylight, seen from the top of the steps up to the National Gallery in Trafalgar Square. A large ornamental lamp stands in the centre of the picture, and around it can be seen a street of large classical buildings stretching off into the distance. The people dotted about help to define the space between the viewer and the buildings.

And now the view is from the lower part of Trafalgar Square, where once again the street furniture becomes a way of defining the space between the viewer and the figures and traffic. It's quite difficult to draw people as they pass by in the street, so the best way is to take photographs that incorporate the pedestrians so that you can place them in the scene afterwards. I have used ink here because I find it is sympathetic to drawing the details of buildings.

CITY PANORAMA

To make a sufficiently dramatic scene to show the most effective method of drawing in the city, I chose as large a panorama as I could of Trafalgar Square, without trying to get everything in. I placed myself in the middle of the steps of the National Gallery and looked straight across the square towards Whitehall with Nelson's Column right in the middle of the scene, but without being able to see the top, where Nelson's statue stands. This gave me a focal point for the scene without including a large expanse of sky. After all, I wanted to portray the city buildings rather than just the central column.

1 To start with I sketched in the main areas of the blocks of architecture, indicating the open space of the square where people were wandering about. I did this in pencil so that if any of the spaces were wrong I could erase them.

2 Next, still using pencil, I drew up the whole square in some detail, although the large numbers of windows visible were put in as simply as possible. At this stage I could still alter anything that didn't work, and if I decided I didn't like the position of a tree or lamp post, or even a rooftop, I could get rid of them. My aim was to maintain the overall spacious quality of the scene rather than worry about every detail.

3 Having got the whole scene drawn in I could now put in more people, and add some tone as well. I decided to mainly use ink and so the first thing was to draw the whole picture all over again with a pen. This may seem a bit tiresome, but it can often lead to a better picture. I also started to mark in the tones of the main buildings with a very soft all-over tone, which helped to show up the white splash of the fountains in the square. I did this with pencil to keep it soft at first, then I went over all the areas that I wanted to be more definite with inked-in areas of tone, which looks a lot darker than the pencil. At this stage I put in a lot of people crossing the square and looking at the fountains.

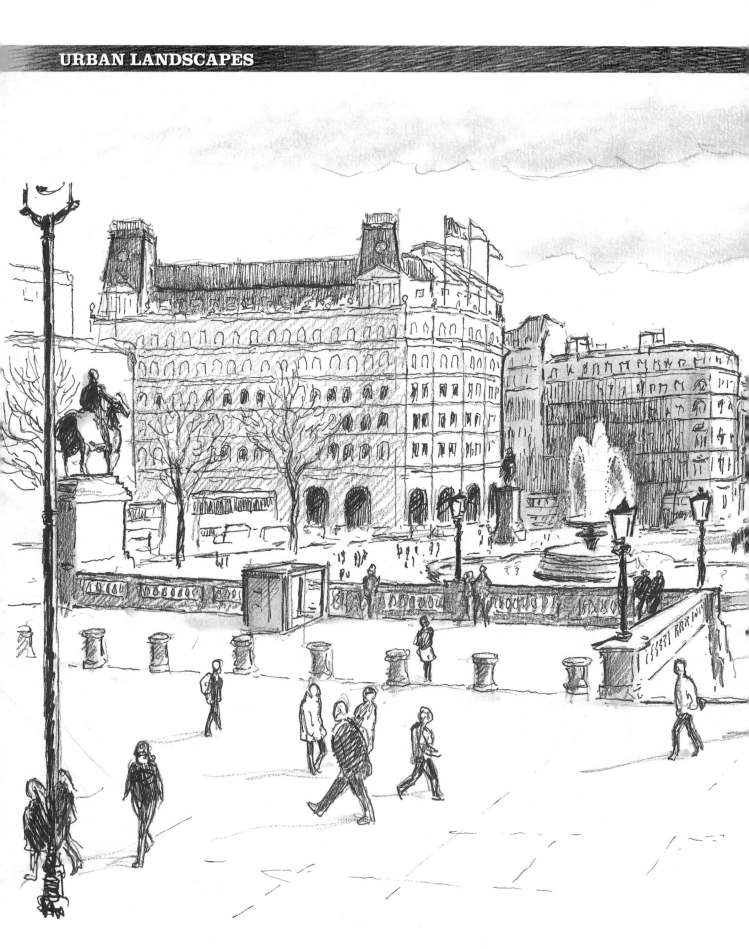

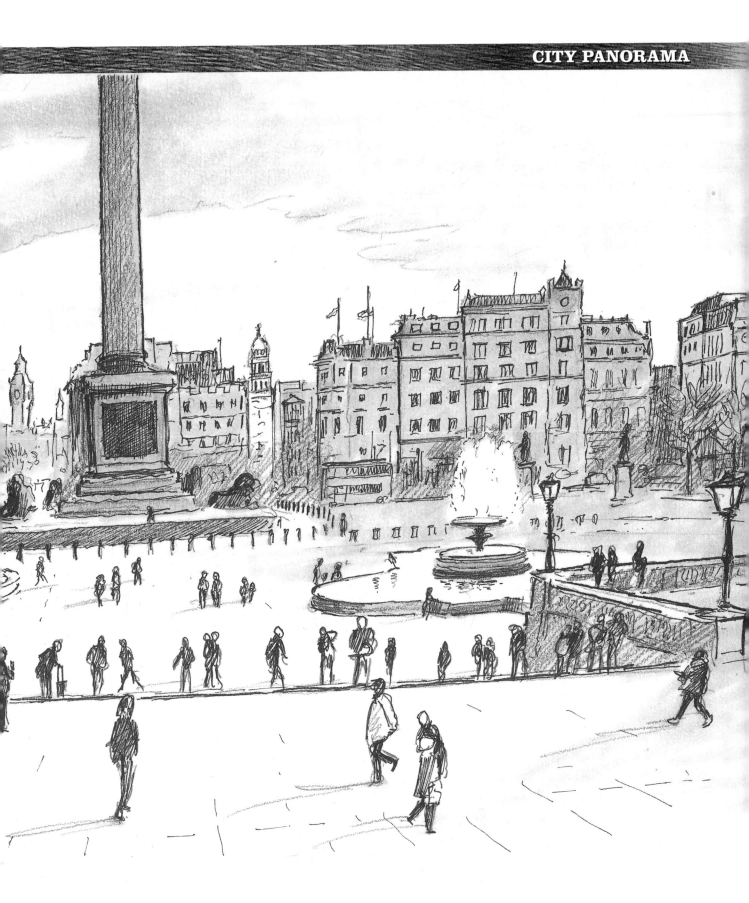

4 Finally, I strengthened parts of the buildings and figures that I wanted to be more obvious, such as the edges of the nearest structures and some of the foreground people. From here on I could add more tone bit by bit with either pencil or ink until I was quite sure that I had given the tonal values their due and made the buildings look as solid as they should. I particularly made sure that the white water of the fountains stood out against darker backgrounds. As in any landscape, the elements further away – in this case the buildings – are less defined than those closer to the foreground.

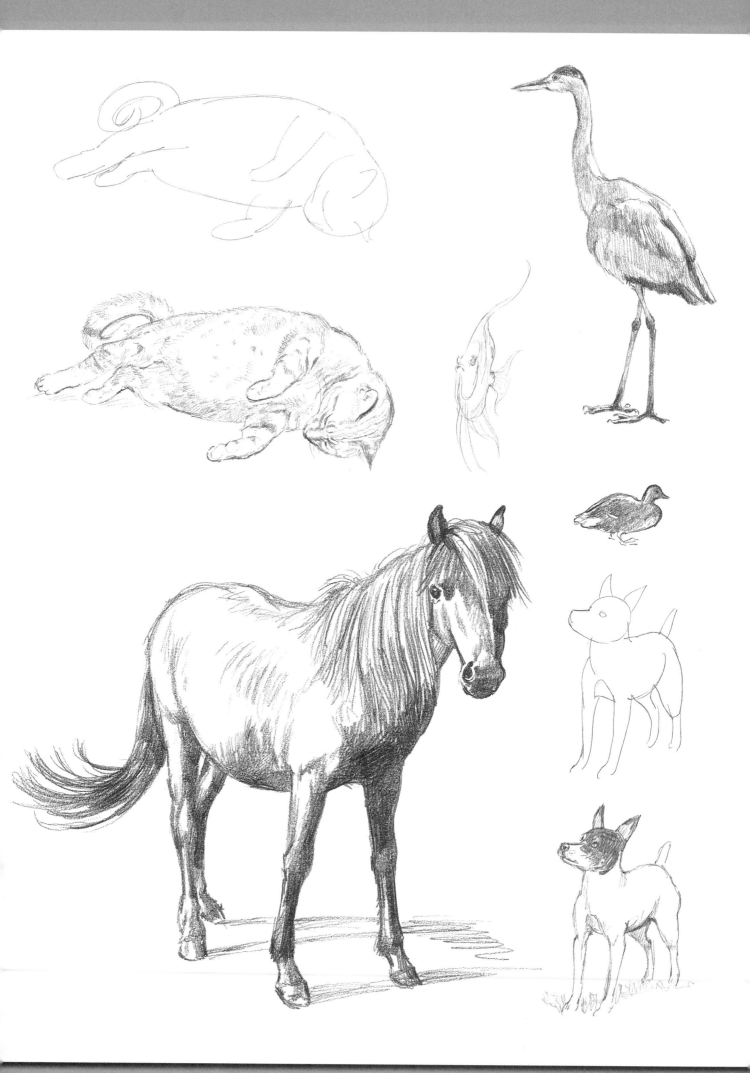

Chapter 9

ANIMALS

The main difficulty with drawing animals is that you won't be able to persuade any of them to stay patiently in a pose you choose. Indeed, many won't remain still long enough for you to manage any more than a quick sketch. This means that you have to start drawing quickly and go for only the most obvious shapes first, even in the case of a sleeping animal, as most tend to move quickly once awake. This is an area of drawing where photography is particularly useful, especially for supplementing swift sketches done at the same time.

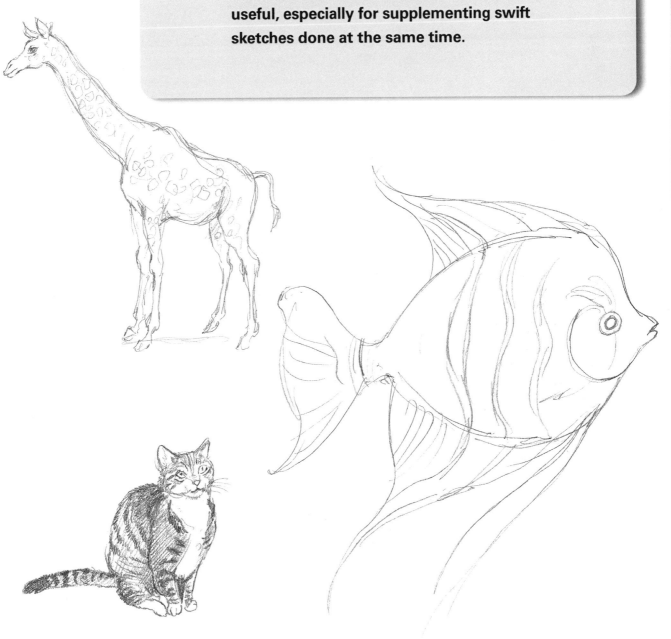

SKETCHING FROM PHOTOGRAPHS

You may have heard that artists should always draw from life rather than from photographic references, and it's true that relying entirely on photographs is not a good way to proceed. However, used judiciously, they are more of a help than a hindrance, especially where you have a constantly moving subject. The problem only comes when you slavishly copy them and produce drawings that lack the animation and freshness that comes from working from life, in the belief that exactitude is all that matters.

If you already have books with large, good-quality pictures of animals in them you are ahead of the game. If not, try your local bookstore or indeed your newsagents, which is bound to have some magazines dedicated to household pets, horses, wildlife and so on. Local museums and nature reserves often have books and magazines with animal pictures in them, too.

Choose some photographs that aren't too challenging in their angle of view and start by keeping your drawings very simple, putting in only the main shapes. These examples are just to give you an idea how that can be done. Notice how the penguin is a very simple elongated pillow shape, with a beak at the top and feet at the bottom. The owl is even simpler, characterized by its big eyes. The giraffe is an elongated angular shape, with a very long neck and legs related to the size of the body. The rhinoceros, on the contrary, is a very compact shape, with just the addition of the jutting square head and the legs.

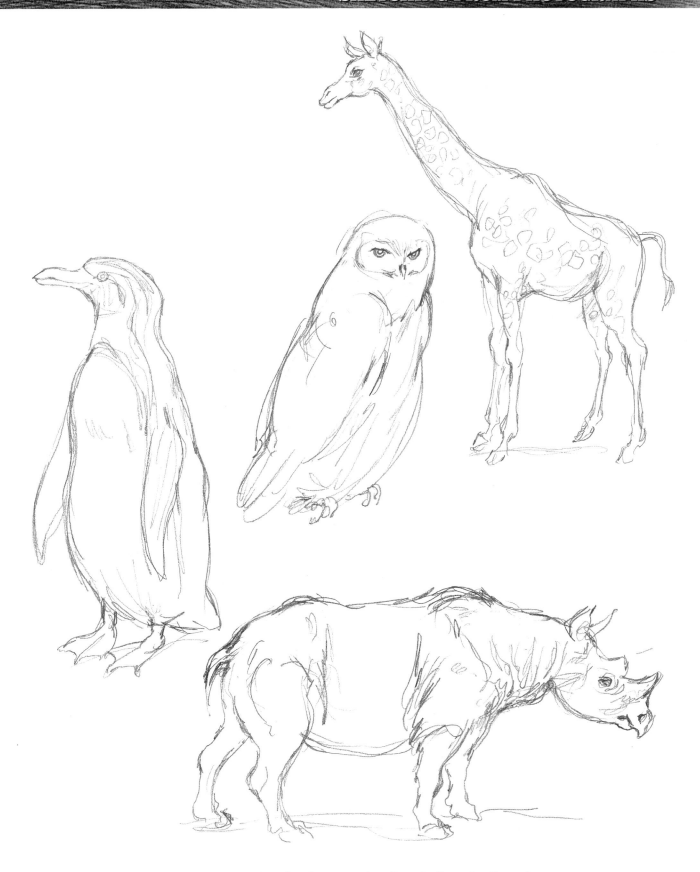

Now have a go at drawing in more detail and allow the line of your pencil to follow the obvious contours and patterns of the animals. Don't worry about a great deal of naturalism at this stage – just concentrate on getting the feel of the animal's shape in a sympathetic way, roughly indicating the texture of skin, fur and feather with your line as you do so.

Now try some fish and a snake, because these are fairly simple to draw – use mine for reference if you don't have photographs. Once again don't try to be exact on the detail but go for the main shapes and try to give them the right feel in the fluid way that you draw them. This is all very good practice, as it helps you to bring some expression to your work. The snake is a bit harder than it looks, but as long as you observe its curves and folds carefully you will soon be able to make it look convincing.

DRAWING FROM LIFE

The next step is to draw animals from life, encouraged by the confidence you've gained by working from photographs. Most of the time you won't be able to complete your drawings, not least because many animals will move away as a result of your showing too much interest in them for their comfort. However, domesticated animals can usually be observed when they are sleeping or just relaxing, and this is an ideal opportunity for you. Even so, it's a good idea to take a quick photograph so that you still have some reference if they decide to go.

Birds

I've started with birds because although they aren't often motionless, they have fairly straightforward shapes and can be drawn quickly. Once again, go for a very simplified drawing first as I've shown here, so that even if they move you have got something down on paper. Taking a quick look and remembering what you saw is a very good discipline.

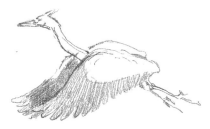

If you get the chance, put in as much detail as you can, taking your own photographs to help you remember. Tone can often be the way to help show the substance of the animal.

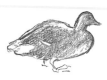

Cats

Domestic cats are very useful models as they are very somnolent – most sleep for about 16 hours a day. Consequently, you should have plenty of time for fairly detailed studies and because of their furry coat and relaxed, graceful forms they tend to present easy, fluid shapes to draw. Draw the main shape of the pose in a very simple way, as you can see in these examples, and add the heads and legs to that.

Next, show the texture of the fur with multiple strokes of the pencil. Indicating the coat markings will make the drawing look much more like a portrait of that particular animal. The eyes and nose are important, and as they are very close to each other you shouldn't find it too difficult to see the right proportions.

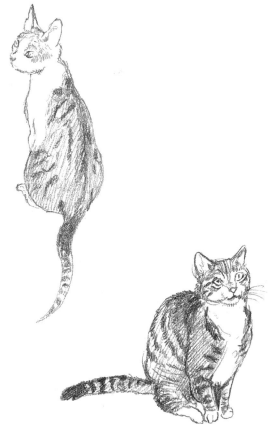

When you feel confident enough, have a
try at more active animals and see how
far you can take the drawing. Go for the
main outline first and then as much as
you can include in the time you've got.

Dogs

Dogs spend less time asleep than cats but, while awake, tend to be much more co-operative. They vary much more in appearance, so you will need to check the proportions with each new breed to make it recognizable. As before, draw the main shape simply at first and add detail in the time you are given.

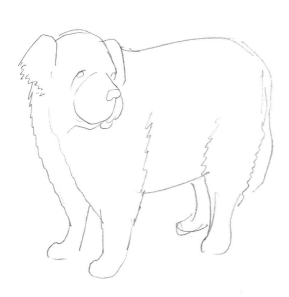

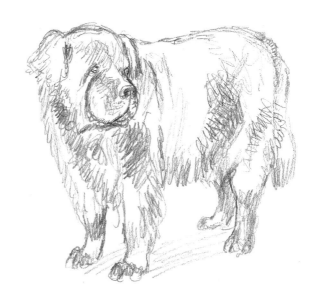

FARM ANIMALS

Have a go at drawing farm animals if you are in the countryside, or even in town if there is a city farm near by. Luckily sheep and cows don't move too fast, and they keep adopting the same poses. Again, note the different characteristics belonging to the breed rather than just reproducing your idea of what a cow or sheep should look like. Practice makes perfect, so keep your sketchbook with you wherever possible and even if you have only two or three minutes to do a thumbnail sketch it is still excellent drawing practice.

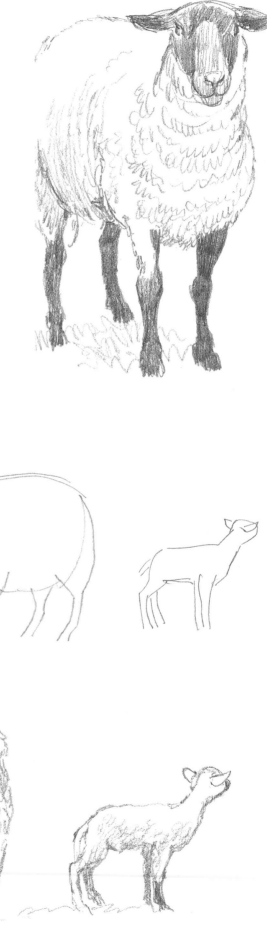

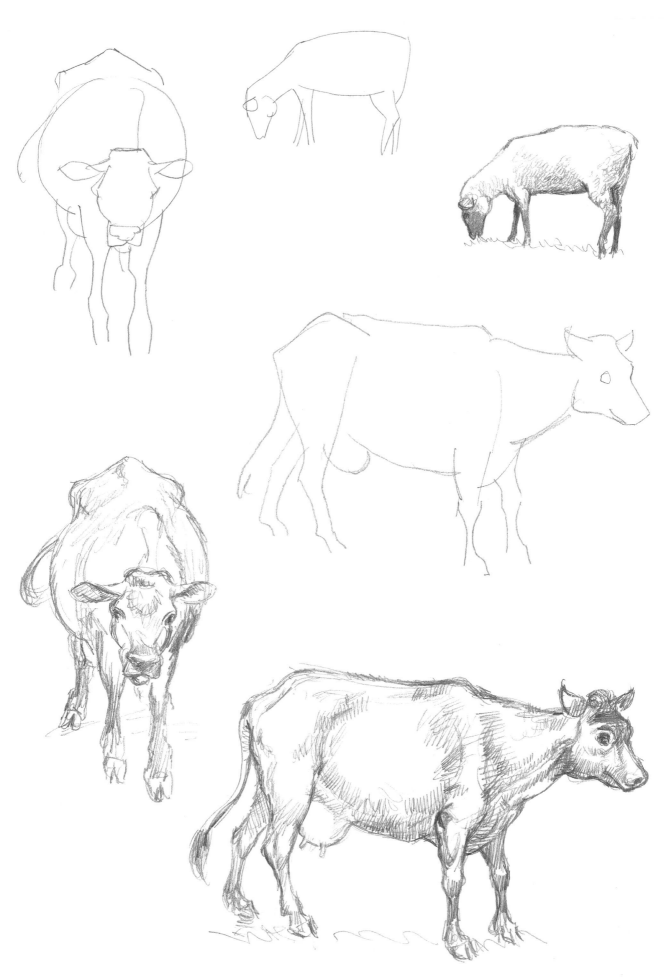

HORSES

Horses are probably one of the easiest large animals to find for drawing from life. You may have to return to using photographs for this exercise, but if you are near some stables, do take the opportunity to draw from life as much as you can. Horses are not too difficult to draw but they do gently move around, so most of your early drawings will resemble the first two sketches shown here. However, after making several sketches like these you may be able to get some more detail as the horse resumes the same positions.

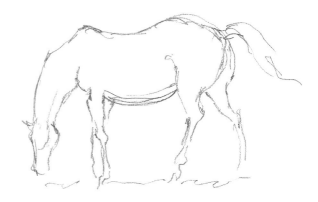

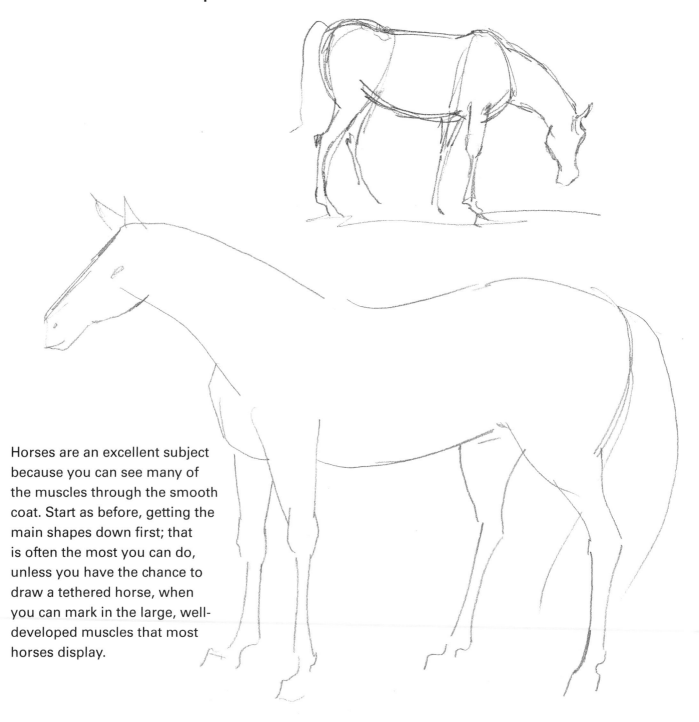

Horses are an excellent subject because you can see many of the muscles through the smooth coat. Start as before, getting the main shapes down first; that is often the most you can do, unless you have the chance to draw a tethered horse, when you can mark in the large, well-developed muscles that most horses display.

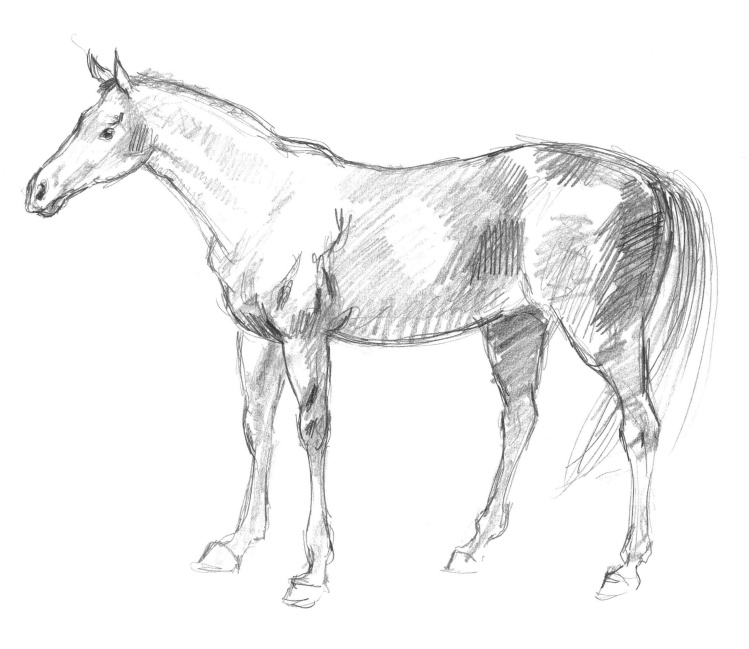

As you add detail to your drawing,
don't be afraid to mark the muscles in
strongly and quickly – you can treat
them with a greater degree of subtlety
when you are more practised.

A horse's prime motivation is to graze, so you should have no difficulty in sustained studies of them doing that – it's an alert pose with the head up that you have to be fast to capture. Photographing them at the same time gives you extra information that you can add to your drawings later.

1 First, get the main shape of the horse down, as quickly as possible.

2 Then, when you get the chance, firm up the shapes with a little more detail, particularly in the head.

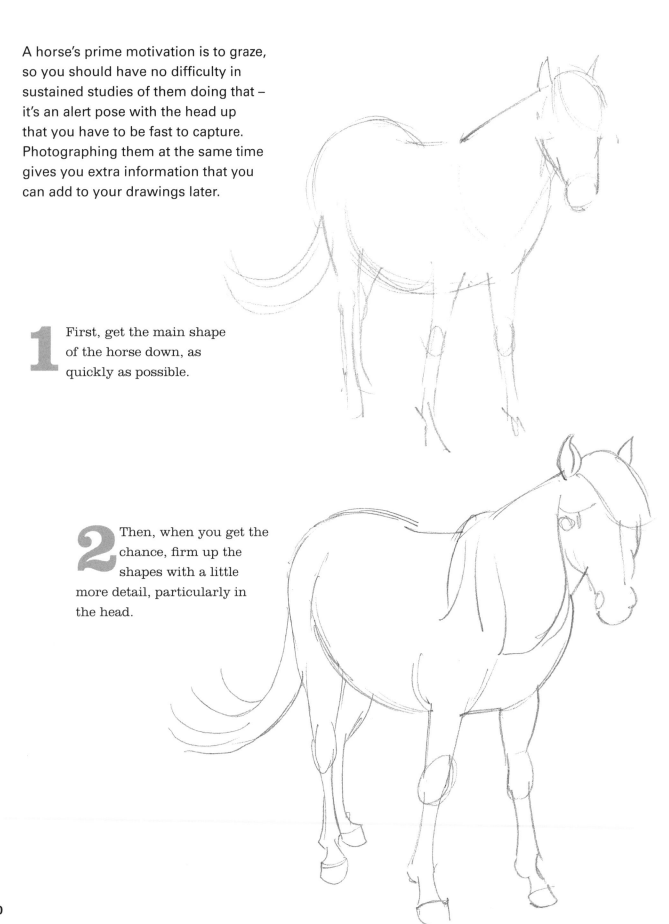

3 Finally, add some details of tone and texture to help give a more solid look. Some areas, such as between the legs near the chest and on the ears and nose here, can be put in more intensely to contrast with lighter areas.

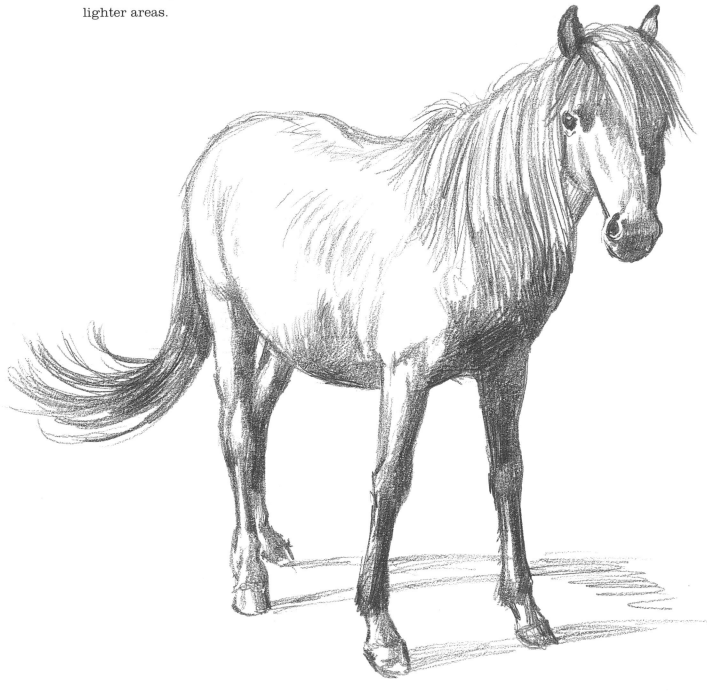

HERDS OF ANIMALS

Drawing animals in larger numbers may strike you as harder at first, but in fact it can be easier. One of the most significant things about herds and flocks is that all their members share the same habits, so when one moves out of a pose that you are drawing another will conveniently adopt a very similar position, giving you another chance to complete your work.

Here I have shown herds of deer and sheep and, to change the task slightly, a flock of seagulls. The latter group is harder in one way because of course they are in constant movement. However, their shapes are relatively simple and they all swirl around in much the same way, so that after a while you begin to see how you can draw them more easily.

Sheep are fairly slow in their movements, and among the most docile of your models. Deer, on the other hand, are rather nervous of people getting close to them, but because you will have to draw them from some way off you will more easily be able to reduce their shapes to the simplest formula.

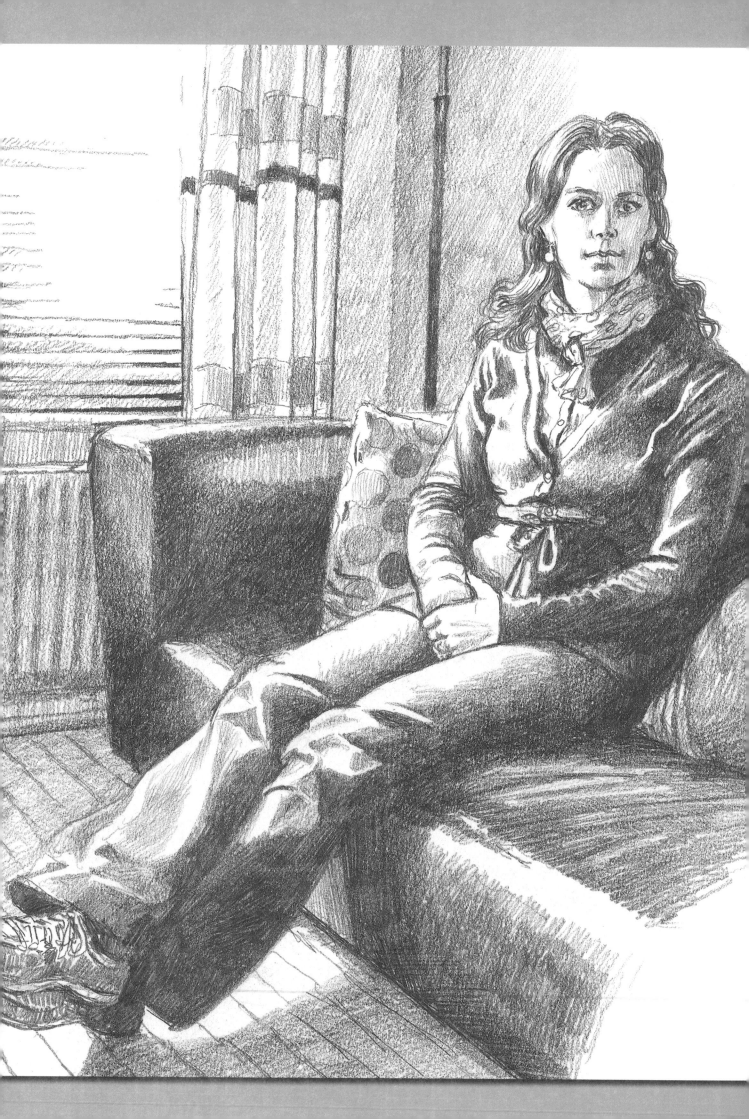

Chapter 10

PORTRAITS

Producing a good portrait of someone shows how well you are progressing; it's the hardest area in which your skills will be tested, because everyone can see at once whether you have attained a resemblance to the individual or not. However, that isn't the be all and end all of a portrait – it's also meant to be a work of art, not just an accurate record of facial features. In this lesson you'll learn how to capture likenesses of your friends and family as well as producing pictures that stand up as art in their own right.

PROPORTIONS OF THE HEAD

Profile view

This view of the head can be seen proportionately as a square which encompasses the whole head. When this square is divided across the diagonal, it can be seen immediately that the mass of the hair area is in the top part of the diagonal and takes up almost all the space, except for the ears.

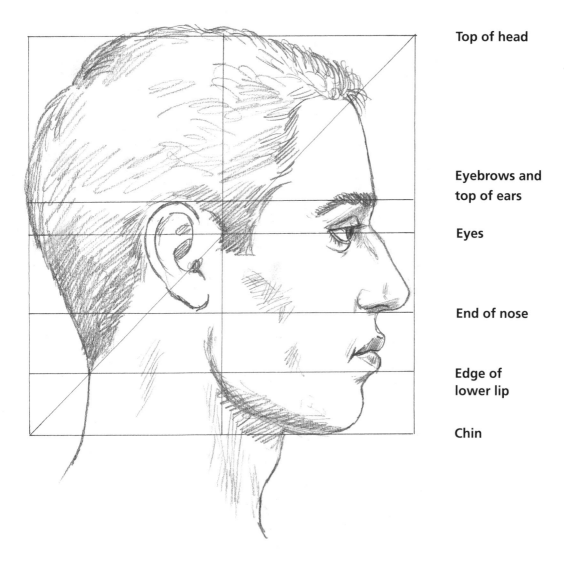

Top of head

Eyebrows and
top of ears

Eyes

End of nose

Edge of
lower lip

Chin

When the square is divided in half horizontally it's also clear that the eyes are halfway down the length of the head. Where the horizontal halfway line meets the diagonal halfway line is the centre of the square. The ears appear to be at this centre point, but just behind the vertical centre line.

A line level with the eyebrow also marks the top edge of the ear. The bottom edge of the ear is level with the end of the nose, which is halfway between the eyebrow and the chin. The bottom edge of the lower lip is about halfway between the end of the nose and the chin. While these measurements aren't exact, they are fairly accurate and will hold good for most people's heads.

Front view

From the front, as long as the head isn't tilted, it is about one and a half times as long as it is wide. The widest part is just above the ears.

As in the side view, the eyes are halfway down the length of the head and the end of the nose is halfway between the eyebrows and the chin; the bottom edge of the lip is about halfway between the end of the nose and the chin.

The space between the eyes is the same as the length of the eye. The width of the mouth is such that the corners appear to be the same distance apart as the pupils of the eyes, when looking straight ahead.

These are very simple measurements and might not be quite accurate on some heads, but as a rule you can rely on them – artists have been doing so for many centuries.

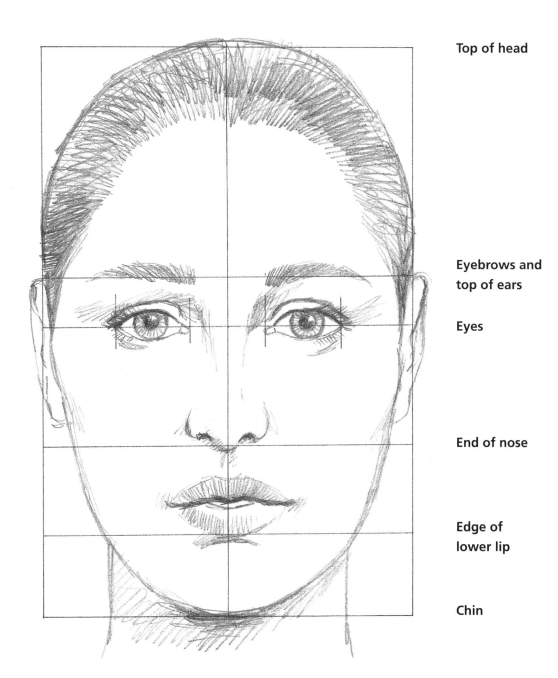

Top of head

Eyebrows and
top of ears

Eyes

End of nose

Edge of
lower lip

Chin

THE SKULL

The upper part of the human skull contains the brain and the organs of sight and hearing. The front and rear parts, where impacts are most likely to occur, consist of the thickest bone; the bone at the sides of the head is much thinner. There are various openings in the case of the skull such as the nose and ear holes, and the eye sockets, which contain smaller apertures for the passage of the optic nerves to the brain. Underneath we find the nasal cavities; also the foramen magnum, through which the spinal column passes and connections are maintained between the brain and the rest of the body.

The lower part of the skull is the mandible, which houses the lower teeth and is hinged at the sides of the upper skull just below the ears. The first (milk) teeth fall out during childhood and are replaced by much larger adult teeth, which fill out the growing jaw.

Front view

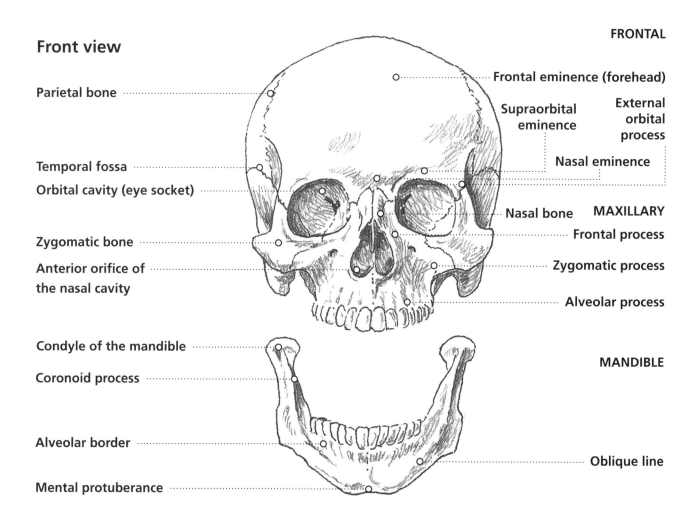

Parietal bone

Temporal fossa

Orbital cavity (eye socket)

Zygomatic bone

Anterior orifice of the nasal cavity

Condyle of the mandible

Coronoid process

Alveolar border

Mental protuberance

FRONTAL

Frontal eminence (forehead)

Supraorbital eminence

External orbital process

Nasal eminence

Nasal bone MAXILLARY

Frontal process

Zygomatic process

Alveolar process

MANDIBLE

Oblique line

Side and top view

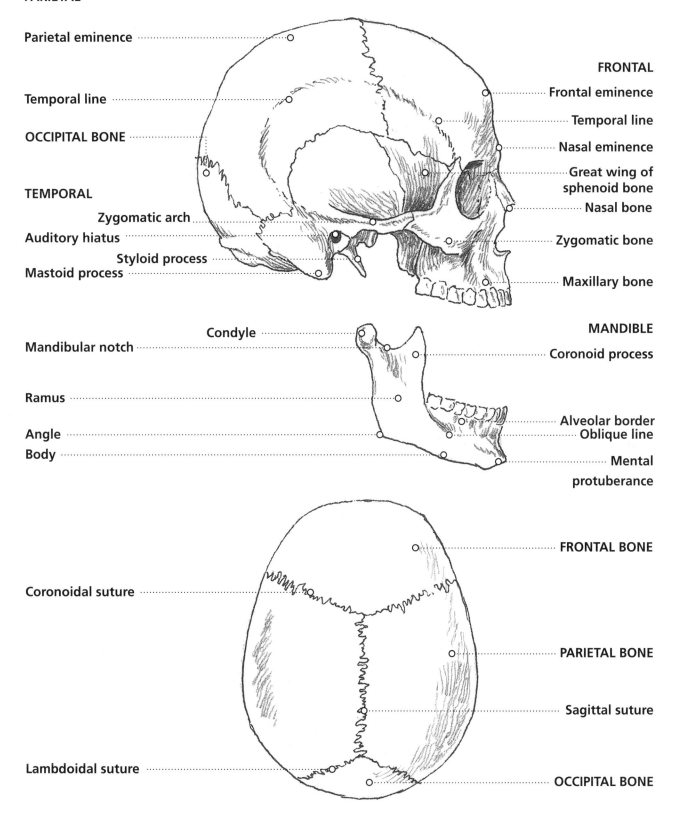

PARIETAL

Parietal eminence

Temporal line

OCCIPITAL BONE

TEMPORAL

Zygomatic arch

Auditory hiatus

Styloid process

Mastoid process

FRONTAL

Frontal eminence

Temporal line

Nasal eminence

Great wing of sphenoid bone

Nasal bone

Zygomatic bone

Maxillary bone

Condyle

Mandibular notch

Ramus

Angle

Body

MANDIBLE

Coronoid process

Alveolar border

Oblique line

Mental protuberance

Coronoidal suture

Lambdoidal suture

FRONTAL BONE

PARIETAL BONE

Sagittal suture

OCCIPITAL BONE

MUSCLES OF THE HEAD

These are the muscles that enable us to eat and drink, and of course they surround our organs of sight, sound, smell and taste. Although they don't have the physical power of the larger muscles of the limbs and trunk, they do play an important part in our lives.

Front view

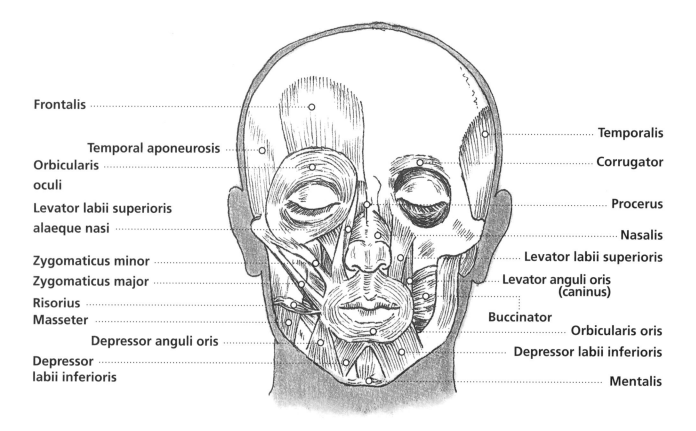

Frontalis

Temporal aponeurosis

Orbicularis oculi

Levator labii superioris alaeque nasi

Zygomaticus minor

Zygomaticus major

Risorius

Masseter

Depressor anguli oris

Depressor labii inferioris

Temporalis

Corrugator

Procerus

Nasalis

Levator labii superioris

Levator anguli oris (caninus)

Buccinator

Orbicularis oris

Depressor labii inferioris

Mentalis

Side view

DEEP LAYER

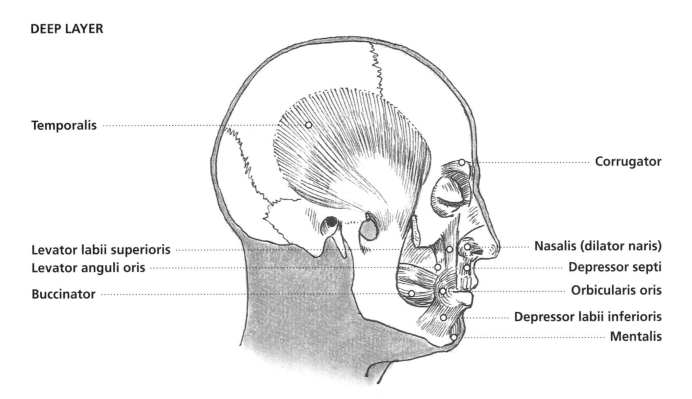

Temporalis

Corrugator

Levator labii superioris
Levator anguli oris

Nasalis (dilator naris)
Depressor septi

Buccinator

Orbicularis oris

Depressor labii inferioris

Mentalis

SUPERFICIAL LAYER

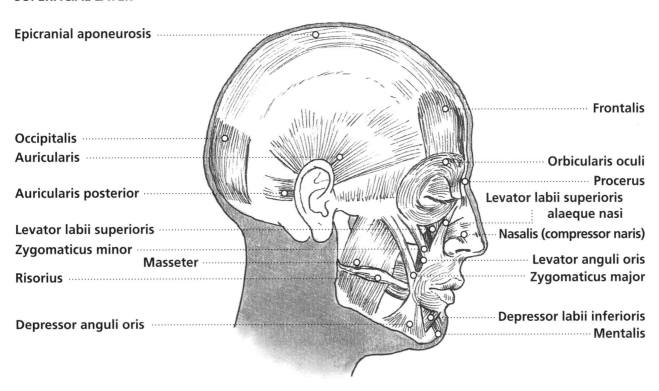

Epicranial aponeurosis

Frontalis

Occipitalis
Auricularis

Orbicularis oculi
Procerus

Auricularis posterior

Levator labii superioris
alaeque nasi

Levator labii superioris
Zygomaticus minor

Nasalis (compressor naris)

Masseter

Levator anguli oris

Risorius

Zygomaticus major

Depressor labii inferioris

Depressor anguli oris

Mentalis

211

THE HEAD DRAWN BY MASTER ARTISTS

The same groups of muscles can be seen on these drawings by
Michelangelo and Peter Paul Rubens. It is interesting to note that
as soon as you start to look for these muscles of the face, they
become clearer and it is easier to draw them correctly.

**After Michelangelo
(1475–1564)**

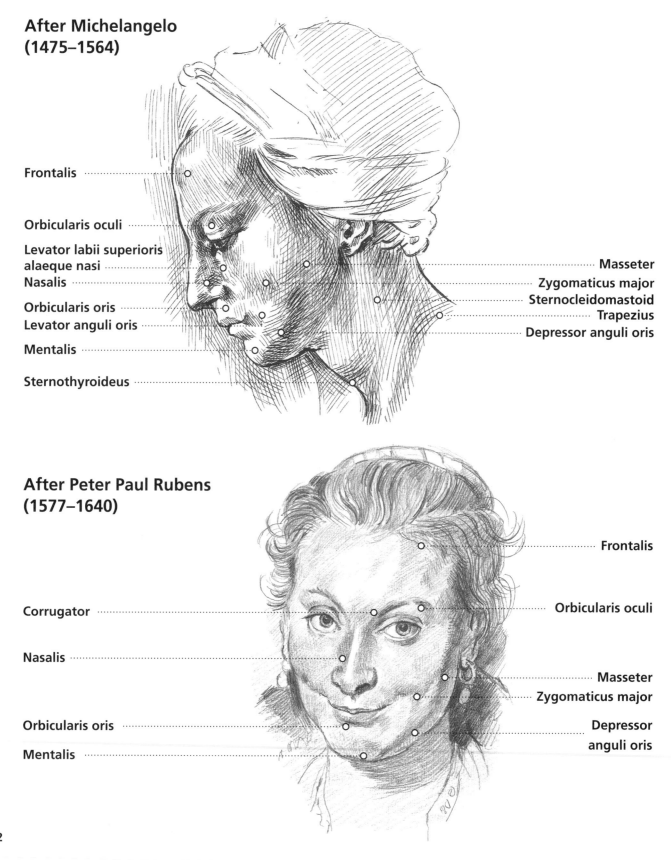

Frontalis

Orbicularis oculi

Levator labii superioris
alaeque nasi

Nasalis

Orbicularis oris

Levator anguli oris

Mentalis

Sternothyroideus

Masseter

Zygomaticus major

Sternocleidomastoid

Trapezius

Depressor anguli oris

**After Peter Paul Rubens
(1577–1640)**

Corrugator

Nasalis

Orbicularis oris

Mentalis

Frontalis

Orbicularis oculi

Masseter

Zygomaticus major

Depressor
anguli oris

212

In our last drawing, Self-portrait from 1913 after the Irish artist William Orpen, we see the main muscles of the human head again quite clearly. It is probably easier to see them on a more mature face and one that does not have too much flesh on it, because younger or more rounded faces don't show the muscles so clearly.

After William Orpen (1878–1931)

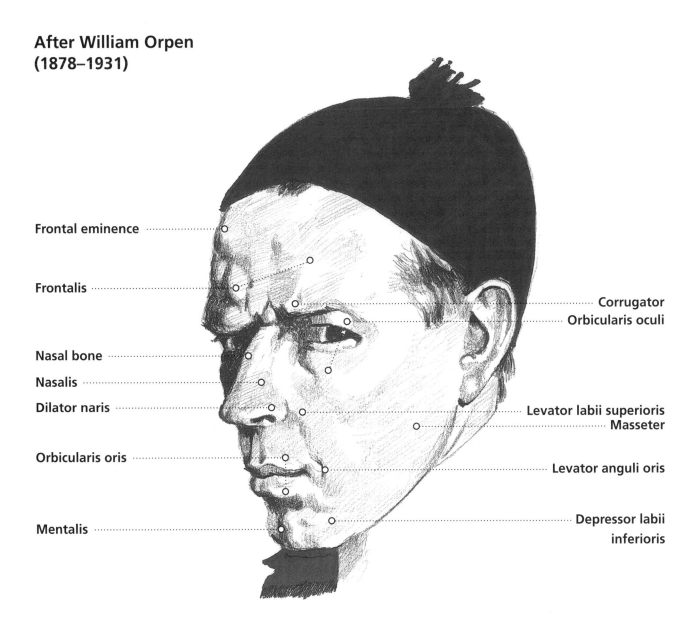

Frontal eminence

Frontalis

Nasal bone

Nasalis

Dilator naris

Orbicularis oris

Mentalis

Corrugator

Orbicularis oculi

Levator labii superioris

Masseter

Levator anguli oris

Depressor labii inferioris

SKETCHING HEADS

Here I have drawn the heads of five different people, which show how we all look very similar under the surface. Each of the initial drawings is of a skull, which only shows you the basic shape of the head.

The next stage shows the outlines of the individual heads and the placing of their features. At this stage the hair hardly registers, and although you can see that there are some differences between the faces they're still very slight.

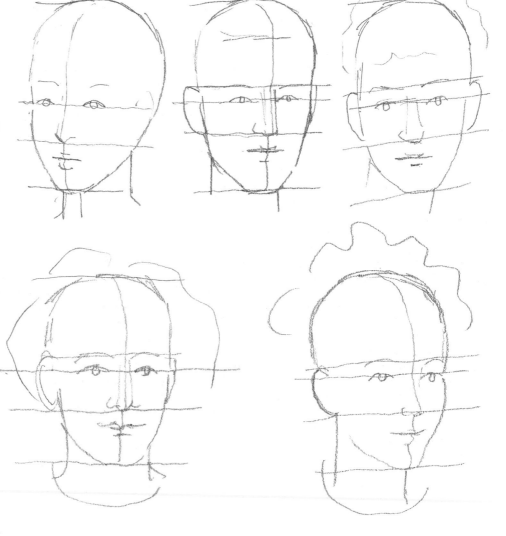

In the last stage I've put in all the particular features that turn these drawings into portraits of two young women and three young men. It's the finer features of the women and the hairstyles that create the differences between the main shapes of the male and female heads, but the details of the features make the heads more individual. If you met these people you wouldn't mistake one for the other, though you might not have spotted much difference in the skulls.

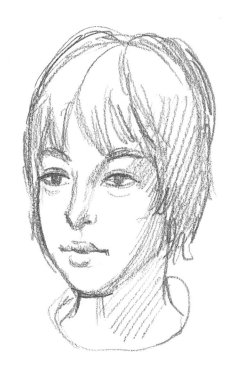

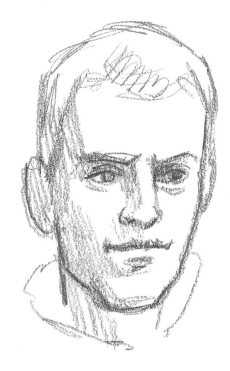

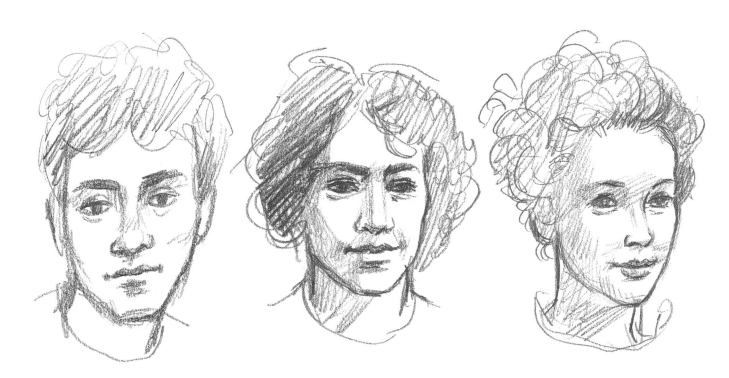

This exercise will have helped you to realize that one face isn't more difficult than another, because all faces have a basic shape so similar that it's only the final details of the features that make them distinguishable. Always draw people as though they were the same, but bring in the individuality with sensitive delineation of the final look.

215

THE HEAD FROM DIFFERENT ANGLES

The head is often observed turning from full face towards a profile view. Looking at the full face (1), both eyes are the same shape, the mouth is fully displayed, and the nose is indicated chiefly by the nostrils. As shown in our diagram, when the head turns, the features remain the same distance apart and stay in the same relationship horizontally.

However, as the head rotates away to a three-quarter view (2), we begin to see the shape of the nose becoming more evident, while the far side of the mouth compresses into a shorter line, and the eye farthest from our view appears smaller than the nearer one.

Continuing towards the profile or side view (3), the nose becomes more and more prominent, while one eye disappears completely. Only half of the mouth can now be seen and – given the perspective – this is quite short in length. Notice how the shape of the head also changes from a rather narrow shape – longer than it is broad – to quite a square one, where width and length are almost the same. We can also see the shape of the ear, which at full face was hardly noticeable.

1. 2. 3.

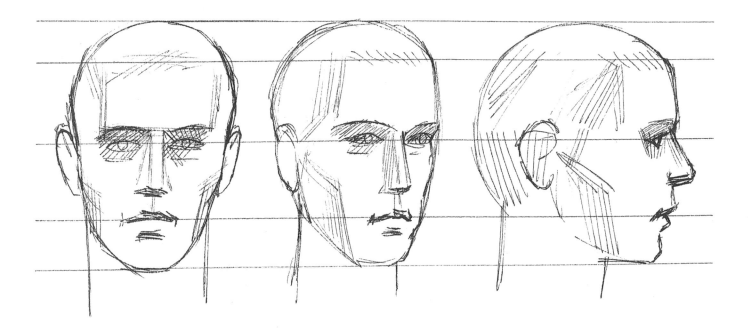

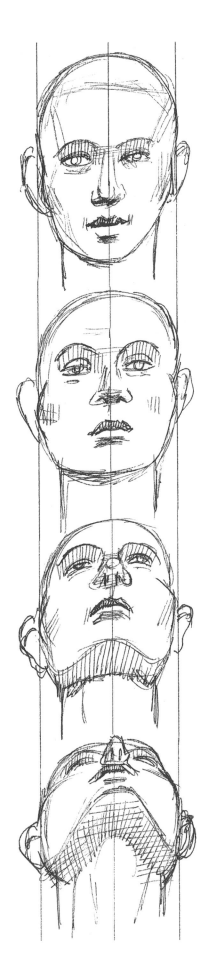

Next, we shall look at the head in another sequence that opens with the full face, but this time the head will be lifted backwards with the chin tilting up, until very little of the face is seen from below.

Note at the beginning that the front view goes from the top of the head to the tip of the chin, and the facial features are all clearly visible.

Now, as we tilt the head backwards, we see less of the forehead and start to reveal the underside of the jaw and the nose. The end of the nose now seems to be about halfway down the head instead of three-quarters, as it was in the first diagram. The eyes appear narrower and the top of the head is invisible.

One more tilt of the head shows an even larger area underneath the jaw, and the mouth seems to curve downwards. The underside of the nose, with both nostrils very clearly visible, starts to look as though it is positioned between the eyes, which are even more narrowed now. The forehead is reduced to a small crescent shape and the cheekbones stand out more sharply. The ears, meanwhile, are descending to a position level with the chin, and the neck is very prominent.

One further tilt lifts the chin so high that we can now see its complete shape, and the nose, mouth and eyebrows are all so close together that they can hardly be seen. This angle of the head is unfamiliar to us, and is only usually seen when someone is lying down and we are looking up towards their head. Note how the head looks vastly different from this angle, appearing as a much shorter, compacted shape.

These examples show variations on viewing the head from slightly unusual angles, and you can see how they all suggest different expressions of the body's movement. Although the models for these drawings were not trying to express any particular feelings, the very fact of the movement of the head lends a certain element of drama to the drawings. This is because we don't usually move our heads without meaning something, and the inclination of the head one way or another looks as though something is meant by the action.

**Leaning back
seen from below**

**Leaning forward
seen from above**

**Leaning back
seen from below**

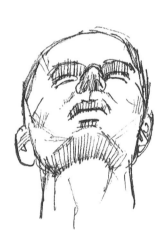

**Chin tilted up
seen in profile**

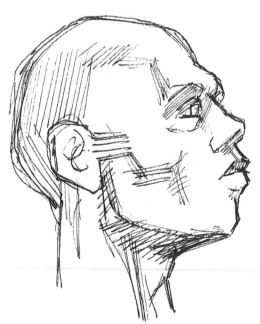

**Three-quarter view, head
tilted towards viewer**

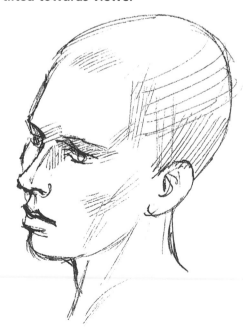

Three-quarter view seen
from below

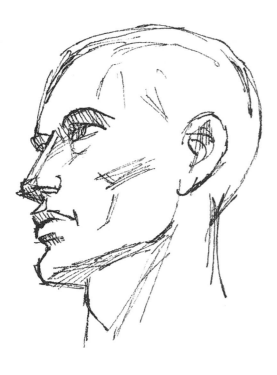

Three-quarter view
seen from same level

Three-quarter view from the front,
seen from almost the same level

Three-quarter view seen tilted
forward from above

Front view seen from above

Profile seen
from a slightly
rear view

Profile turning toward
three-quarter view

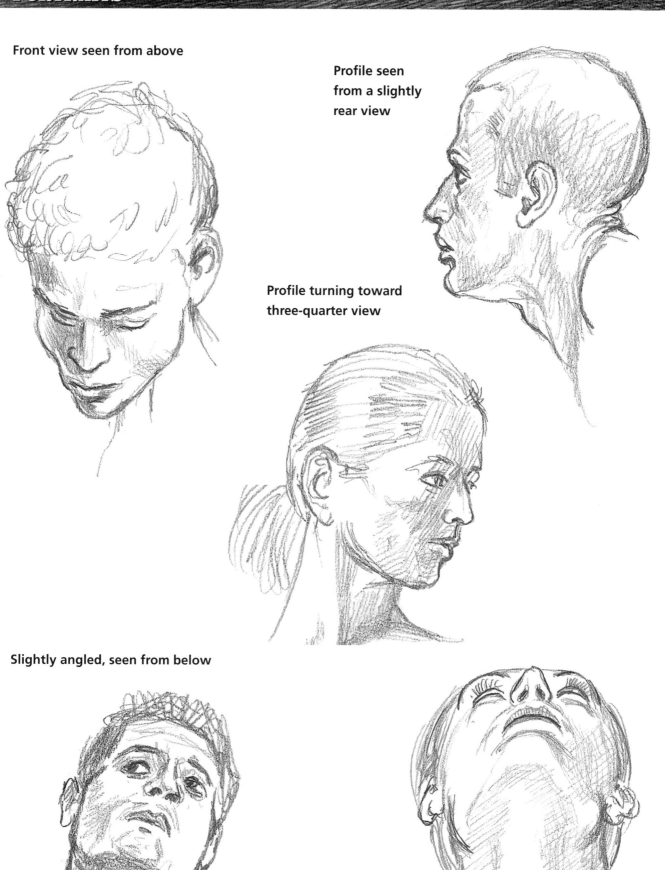

Slightly angled, seen from below

Tilted back, seen from below

FRAMING

Now you have to decide how much of the sitter you're going to include in your picture. In the first example you see only the head and neck, which is quite a good way to do a portrait because it concentrates on the face. You could draw it without much neck showing, but that gives a slightly brutal appearance.

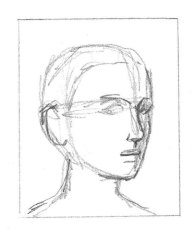

A half-length figure with the arms and hands showing is often chosen because it helps to give a little more grace to the portrait. It's especially suitable if the model is someone who has beautiful hands or uses them for their profession, such as a pianist, a surgeon or a craftsman.

A full-length portrait would include every part of your model, but because the head becomes less significant, a three-quarter length is more commonly used.

FACIAL EXPRESSIONS

Now we move on to the other great challenge of drawing the head: capturing expression. Here are a series of expressions showing the dominant muscles. Check them and then persuade your friends or family to make similar faces, and see if you can identify the muscles responsible.

MUSCLES USED WHEN SMILING, GRINNING AND LAUGHING

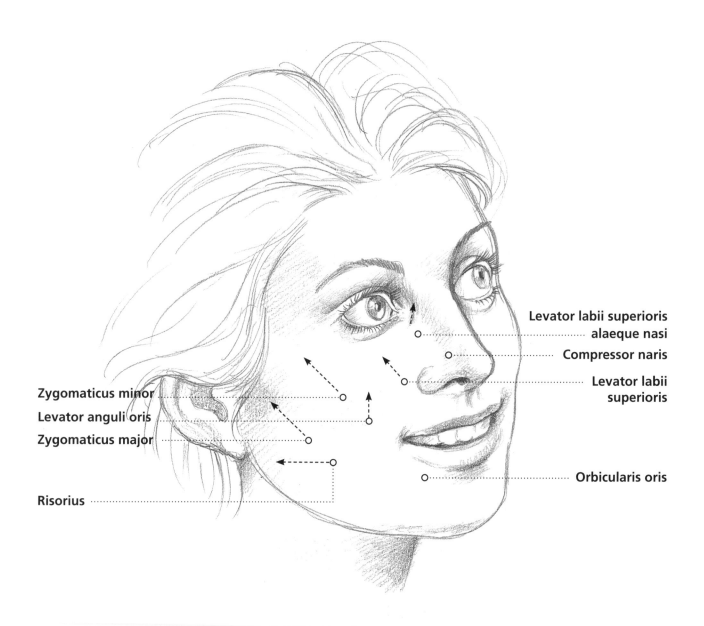

Levator labii superioris alaeque nasi

Compressor naris

Levator labii superioris

Zygomaticus minor

Levator anguli oris

Zygomaticus major

Orbicularis oris

Risorius

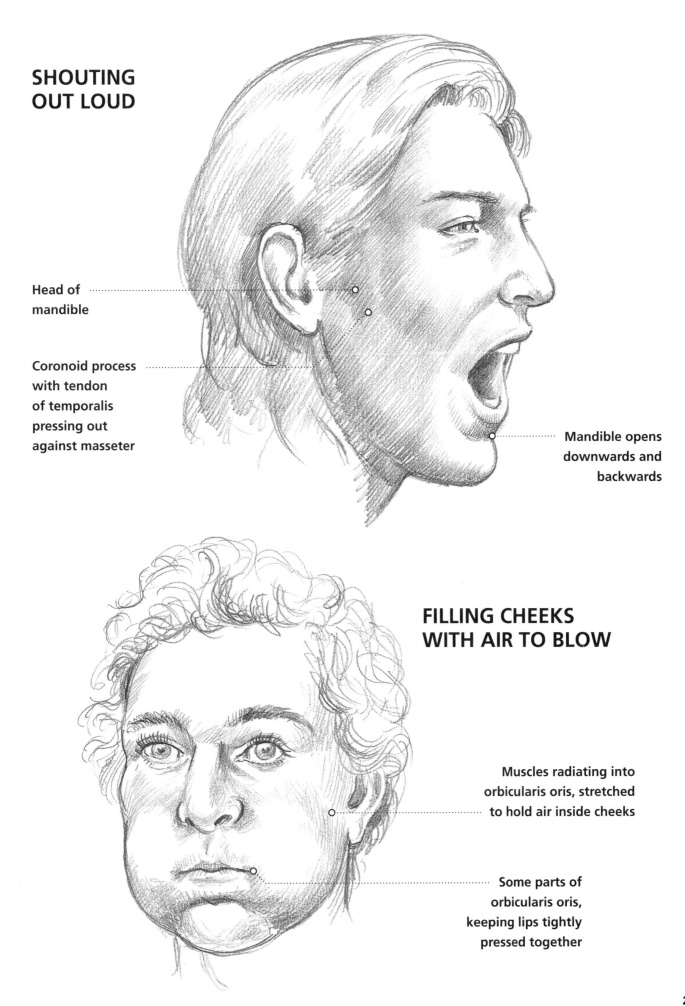

SHOUTING OUT LOUD

Head of
mandible

Coronoid process
with tendon
of temporalis
pressing out
against masseter

Mandible opens
downwards and
backwards

FILLING CHEEKS WITH AIR TO BLOW

Muscles radiating into
orbicularis oris, stretched
to hold air inside cheeks

Some parts of
orbicularis oris,
keeping lips tightly
pressed together

223

CRYING

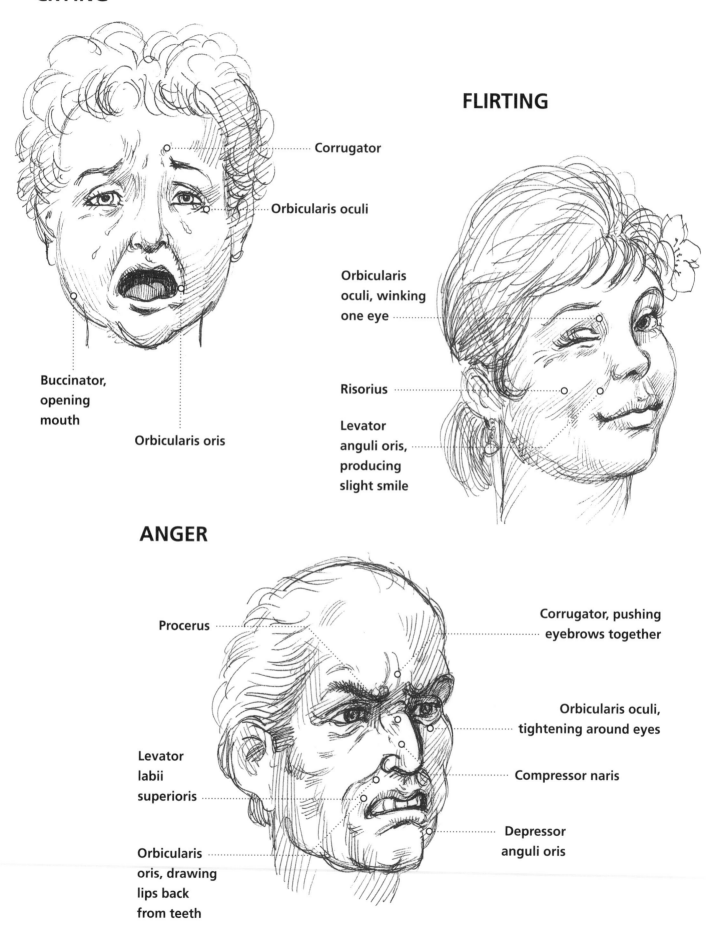

Corrugator

Orbicularis oculi

Buccinator,
opening
mouth

Orbicularis oris

FLIRTING

Orbicularis
oculi, winking
one eye

Risorius

Levator
anguli oris,
producing
slight smile

ANGER

Procerus

Corrugator, pushing
eyebrows together

Orbicularis oculi,
tightening around eyes

Compressor naris

Levator
labii
superioris

Depressor
anguli oris

Orbicularis
oris, drawing
lips back
from teeth

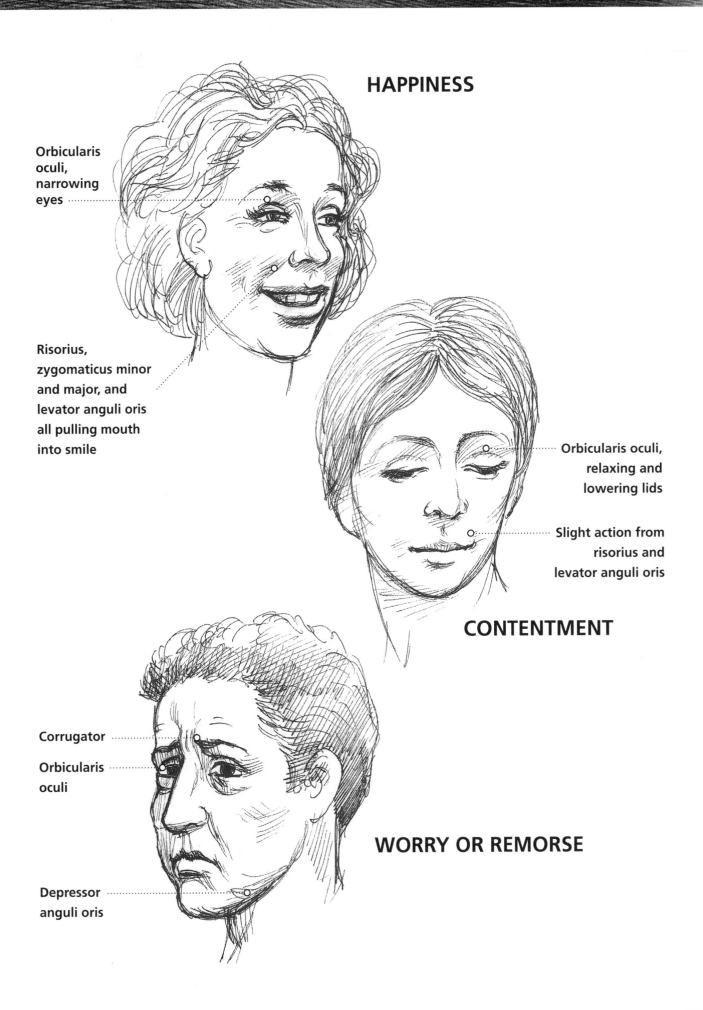

HAPPINESS

Orbicularis oculi, narrowing eyes

Risorius, zygomaticus minor and major, and levator anguli oris all pulling mouth into smile

Orbicularis oculi, relaxing and lowering lids

Slight action from risorius and levator anguli oris

CONTENTMENT

Corrugator

Orbicularis oculi

WORRY OR REMORSE

Depressor anguli oris

FEAR

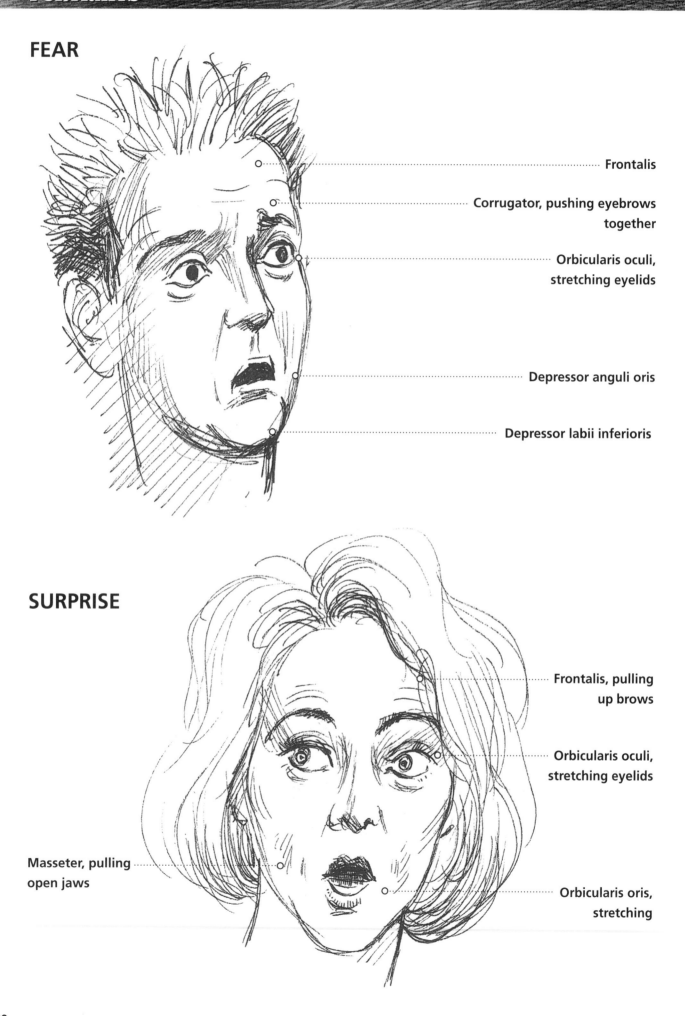

Frontalis

Corrugator, pushing eyebrows
together

Orbicularis oculi,
stretching eyelids

Depressor anguli oris

Depressor labii inferioris

SURPRISE

Frontalis, pulling
up brows

Orbicularis oculi,
stretching eyelids

Masseter, pulling
open jaws

Orbicularis oris,
stretching

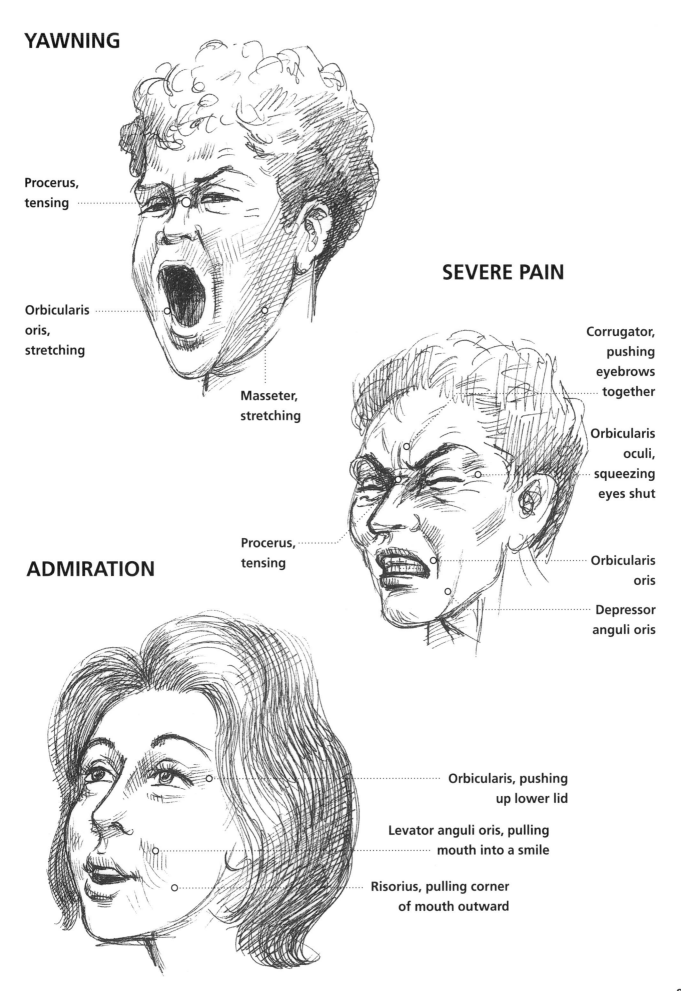

YAWNING

Procerus,
tensing

Orbicularis
oris,
stretching

Masseter,
stretching

SEVERE PAIN

Corrugator,
pushing
eyebrows
together

Orbicularis
oculi,
squeezing
eyes shut

Orbicularis
oris

Depressor
anguli oris

Procerus,
tensing

ADMIRATION

Orbicularis, pushing
up lower lid

Levator anguli oris, pulling
mouth into a smile

Risorius, pulling corner
of mouth outward

227

Various facial expressions

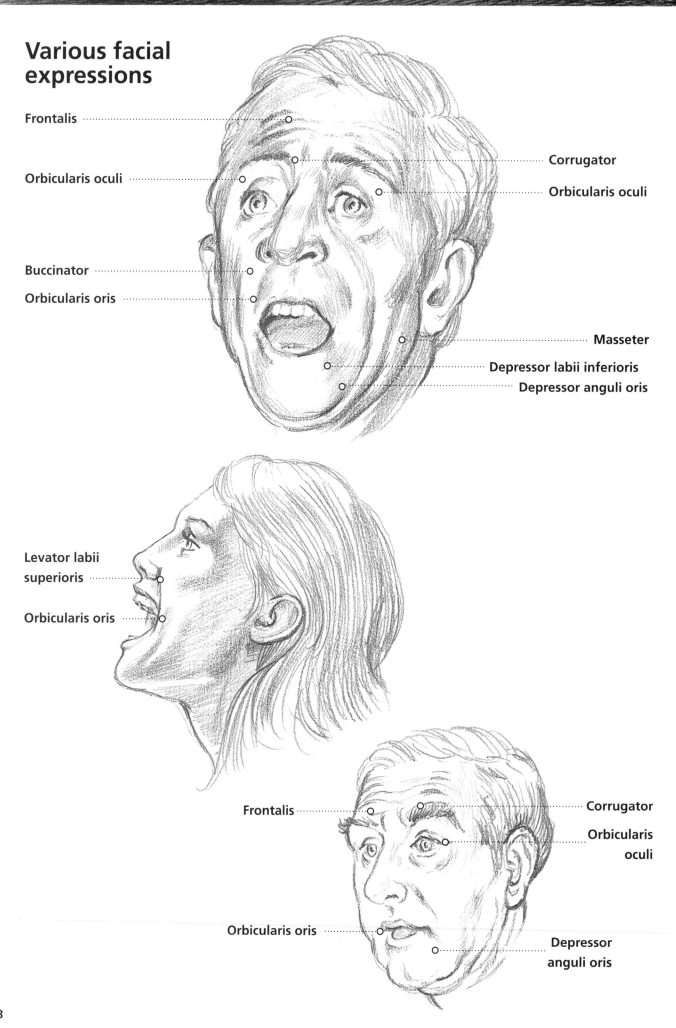

Frontalis

Orbicularis oculi

Buccinator

Orbicularis oris

Corrugator

Orbicularis oculi

Masseter

Depressor labii inferioris

Depressor anguli oris

Levator labii superioris

Orbicularis oris

Frontalis

Corrugator

Orbicularis oculi

Orbicularis oris

Depressor anguli oris

228

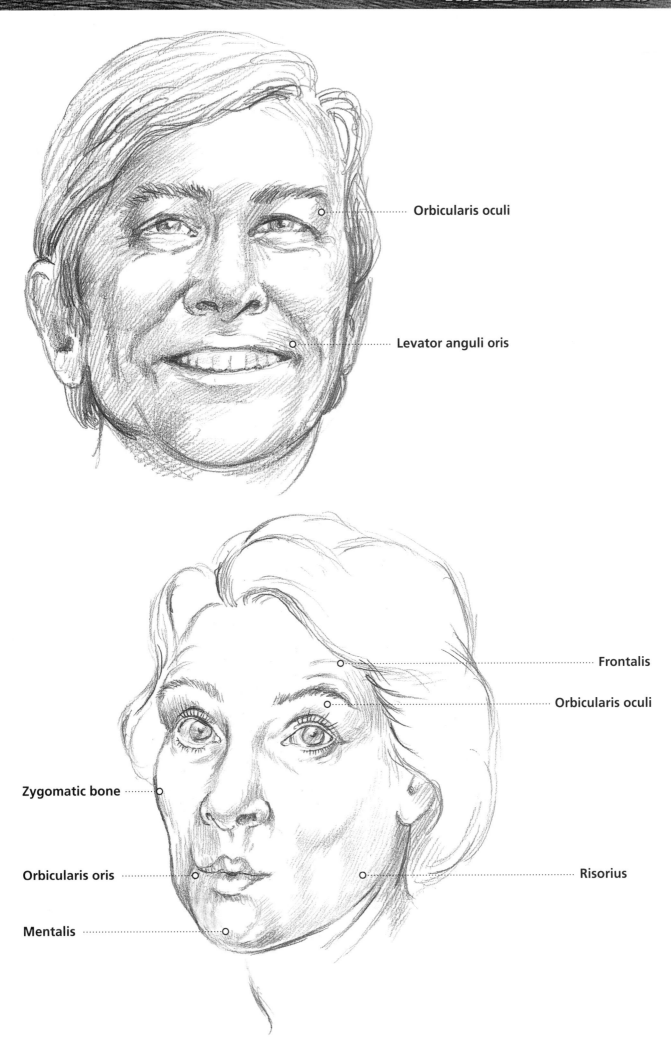

Orbicularis oculi

Levator anguli oris

Frontalis

Orbicularis oculi

Zygomatic bone

Orbicularis oris

Risorius

Mentalis

TEST YOUR KNOWLEDGE

The next six drawings are in the nature of a quiz, to try out your new-found expertise in identifying muscles of the head.

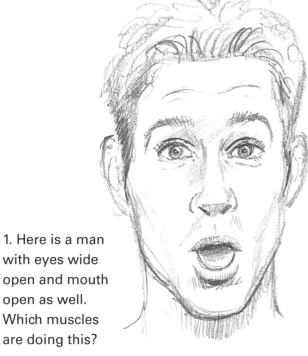

1. Here is a man with eyes wide open and mouth open as well. Which muscles are doing this?

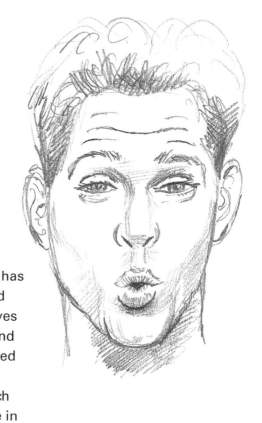

2. This man has his forehead wrinkled, eyes narrowed and mouth pursed into an 'O' shape. Which muscles are in operation here?

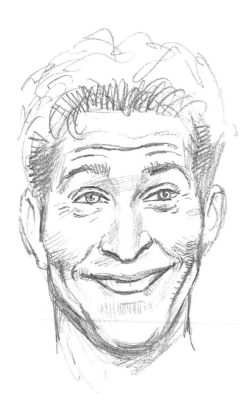

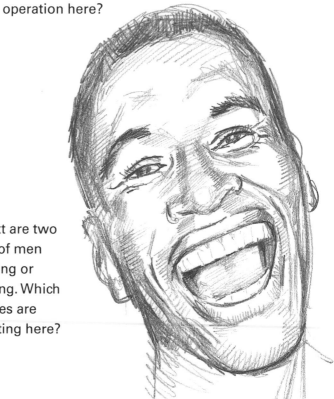

3. Next are two faces of men laughing or grinning. Which muscles are operating here?

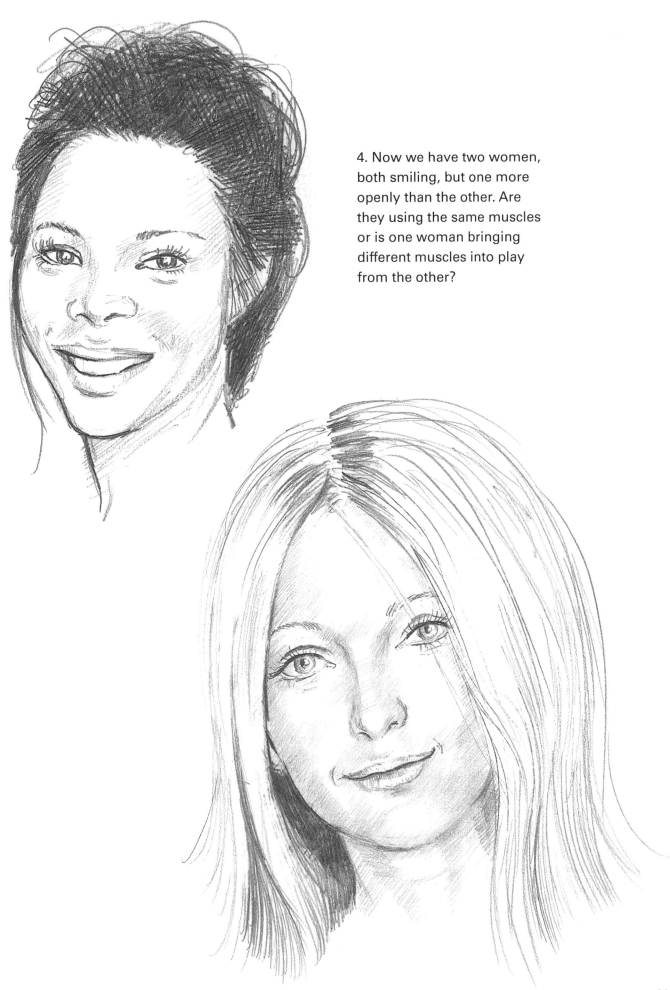

4. Now we have two women, both smiling, but one more openly than the other. Are they using the same muscles or is one woman bringing different muscles into play from the other?

TEST YOUR KNOWLEDGE: ANSWERS

These are the answers to the questions on the previous pages – but try to name the muscles before looking at them to find out how many you have remembered accurately.

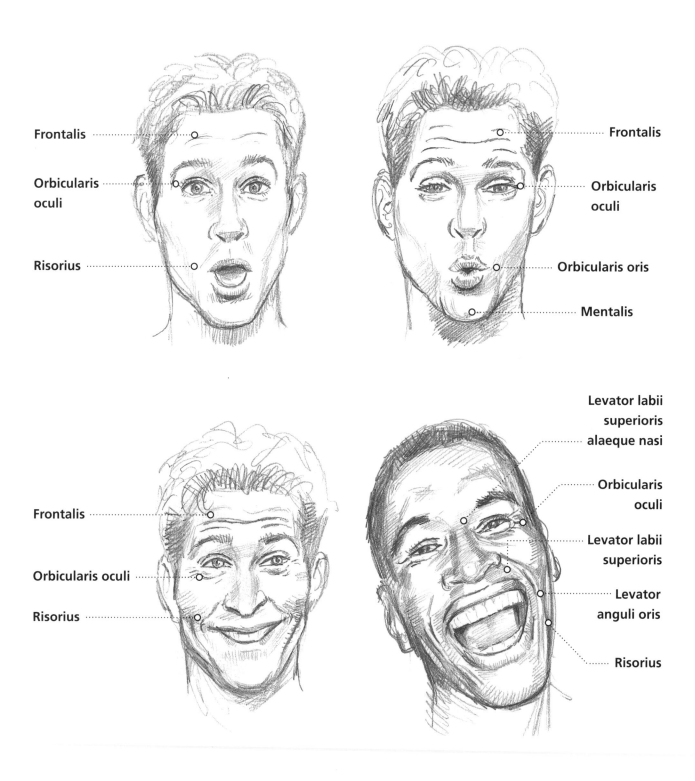

Frontalis

Orbicularis
oculi

Risorius

Frontalis

Orbicularis
oculi

Orbicularis oris

Mentalis

Frontalis

Orbicularis oculi

Risorius

Levator labii
superioris
alaeque nasi

Orbicularis
oculi

Levator labii
superioris

Levator
anguli oris

Risorius

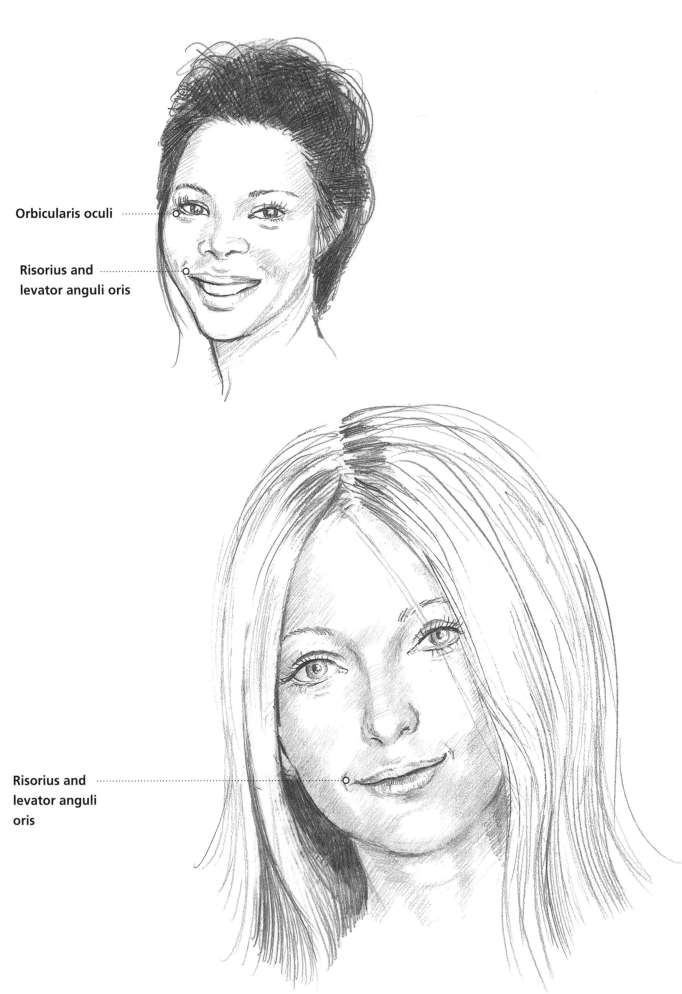

Orbicularis oculi

Risorius and
levator anguli oris

Risorius and
levator anguli
oris

FEATURES OF THE FACE IN DETAIL

Here we shall explore the individual features of the face – the eyes, the mouth, the nose and the ears – and their normal formation. The basic structure of these features and their most obvious shape are shown, but bear in mind that the features of individuals do vary quite dramatically sometimes.

Eyes

First note that the normal position of the eye, when open and looking straight ahead, has part of the iris hidden under the upper eyelid, and the lower edge of the iris just touching the lower lid.

FRONT VIEW

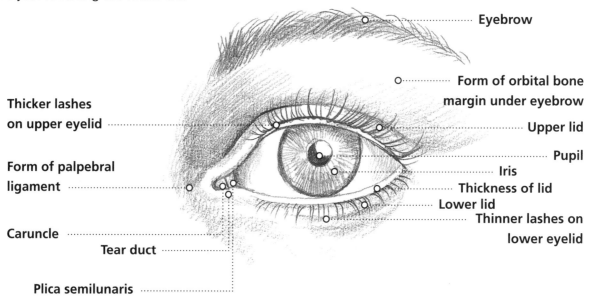

Thicker lashes on upper eyelid

Form of palpebral ligament

Caruncle

Tear duct

Plica semilunaris

Eyebrow

Form of orbital bone margin under eyebrow

Upper lid

Pupil

Iris

Thickness of lid

Lower lid

Thinner lashes on lower eyelid

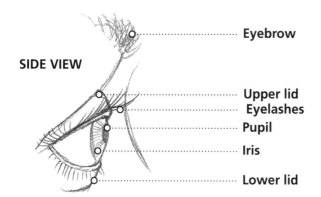

SIDE VIEW

Eyebrow

Upper lid
Eyelashes

Pupil

Iris

Lower lid

Note the tendency of the eye's inner corner (medial canthus) to be slightly lower than the outer corner (lateral canthus), to help tear drainage.

Various eye shapes

Narrow eyes

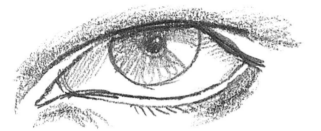

Round eyes

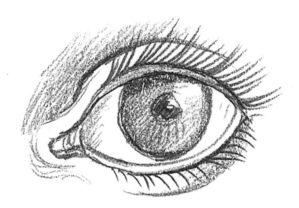

Heavy-lidded eyes

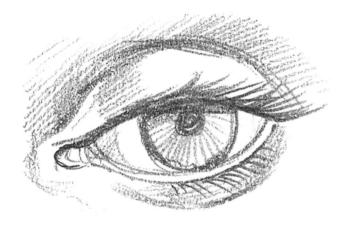

Oriental eyes

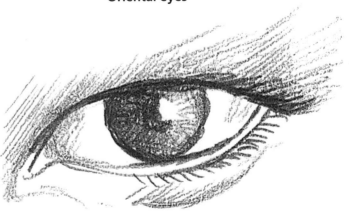

Mouth

FRONT VIEW
Normal structure of lips

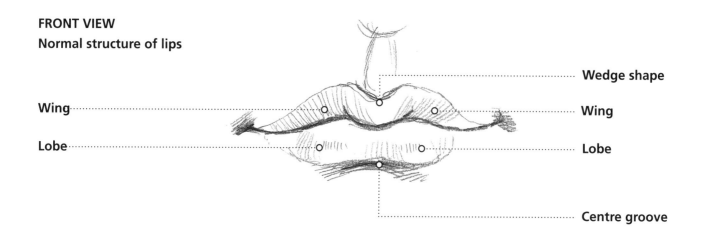

Wedge shape

Wing · Wing

Lobe · Lobe

Centre groove

Various mouth shapes

FRONT VIEWS SIDE VIEWS

Full lips

Full lips

Angled: lower lip
behind upper lip

Thin lips

Thin lips

Lower and upper lips
protrude the same
amount (pouting)

Average 'Cupid's bow' lips

Average lips

Angled: lower lip
projecting beyond
upper lip

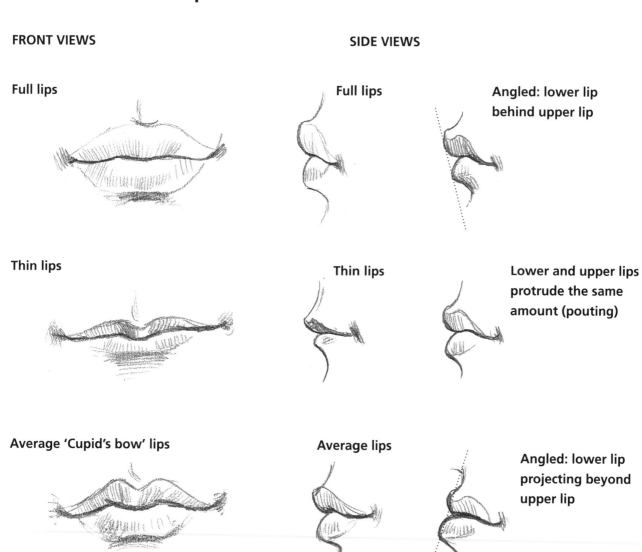

Noses

SIDE VIEWS

Long nose **Short straight nose** **Aquiline nose** **Hook nose** **Broken nose** **Retroussé or snub nose**

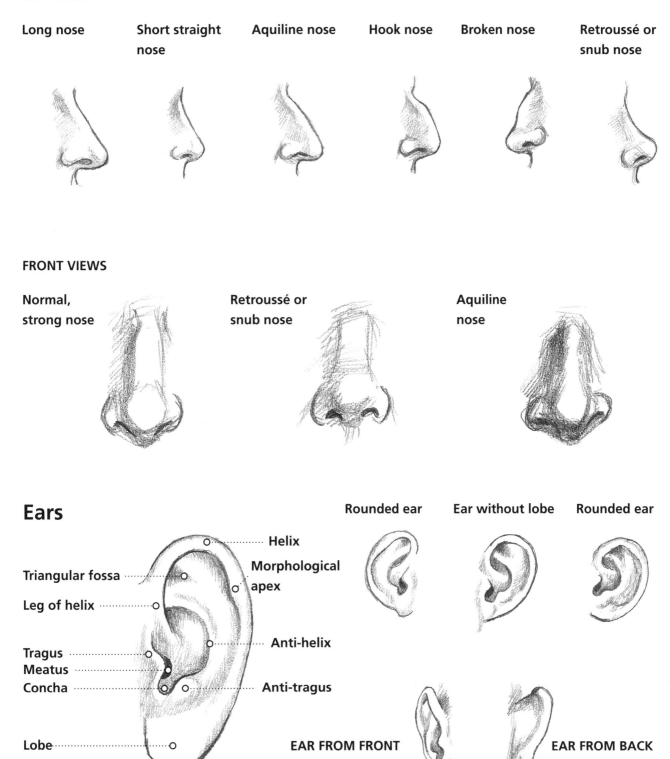

FRONT VIEWS

Normal, strong nose **Retroussé or snub nose** **Aquiline nose**

Ears

Rounded ear **Ear without lobe** **Rounded ear**

Triangular fossa ·········
Leg of helix ·············
Tragus ·············
Meatus ·············
Concha ·············
Lobe ·············

········· **Helix**
Morphological apex

········· **Anti-helix**

········· **Anti-tragus**

EAR FROM FRONT **EAR FROM BACK**

There are enormous variations in the shapes of facial features, and these pictures show only a few. However, their basic structures are the same and you need to familiarize yourself with those before exploring the detailed differences.

DRAWING A PORTRAIT

Now you have some idea of how heads are formed, try making a simple portrait. You can always do a self-portrait in the mirror if you can't find a model, but at this stage it's better to draw someone else. Alternatively, you can use a large, very good photograph as long as the subject's head isn't tilted backward or forward.

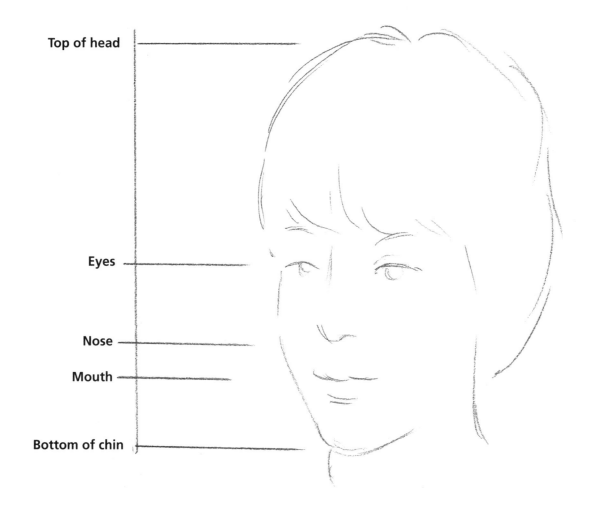

Top of head

Eyes

Nose

Mouth

Bottom of chin

1 Pose your model with the head level and facing slightly towards one side, looking past you, so that you can see all the features clearly. Make a mark which indicates the very top of the skull, and another mark to indicate the bottom of the chin. Halfway down that length mark the level of the eyes, then in the lower half make a mark about halfway down to place the tip of the nose. The mouth will be in that lowest quarter,

closer to the nose than to the bottom of the chin. See if you can judge it by eye.

Having marked up the placing of the major features, now draw a head shape that looks like your model's, keeping your line very light and loose. Then you will need to mark in the eyes, nose and mouth, still very simply. At this stage, don't attempt to achieve a likeness – your task is just to get the main shapes correct.

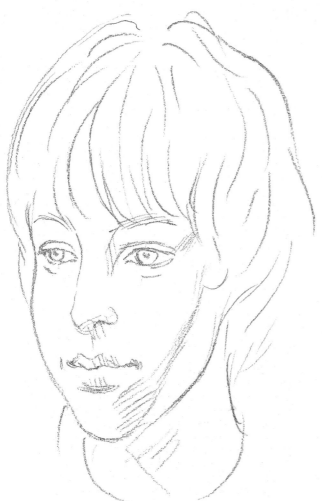

2 Having satisfied yourself that the shapes of the head and features are as they should be, you can now start to draw in the rest of the head. Make sure that everything you put down is as you see it on your model, and don't be surprised if this takes quite a long time. It's better to get everything right at this stage to avoid having to make corrections later on.

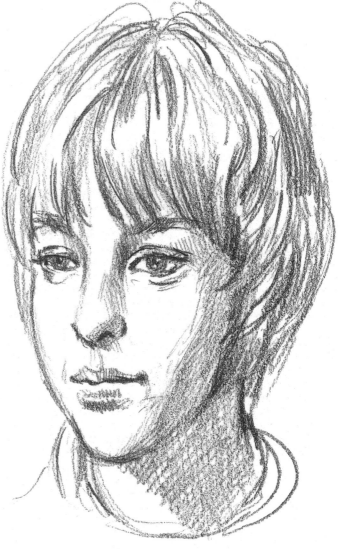

3 When everything looks as it should to you, try out a bit of tone on the head to indicate the direction of the light. As you can see, the light is falling on my model from the upper left-hand side, so all the darkest shadows are on the right of the head.

PORTRAITS: DIFFERENT APPROACHES

While a portrait should resemble the sitter in some way, that doesn't mean it must be time-consuming and full of detail. On these pages we shall consider several examples of portraits that approach the subject in different ways before embarking on a short portrait project.

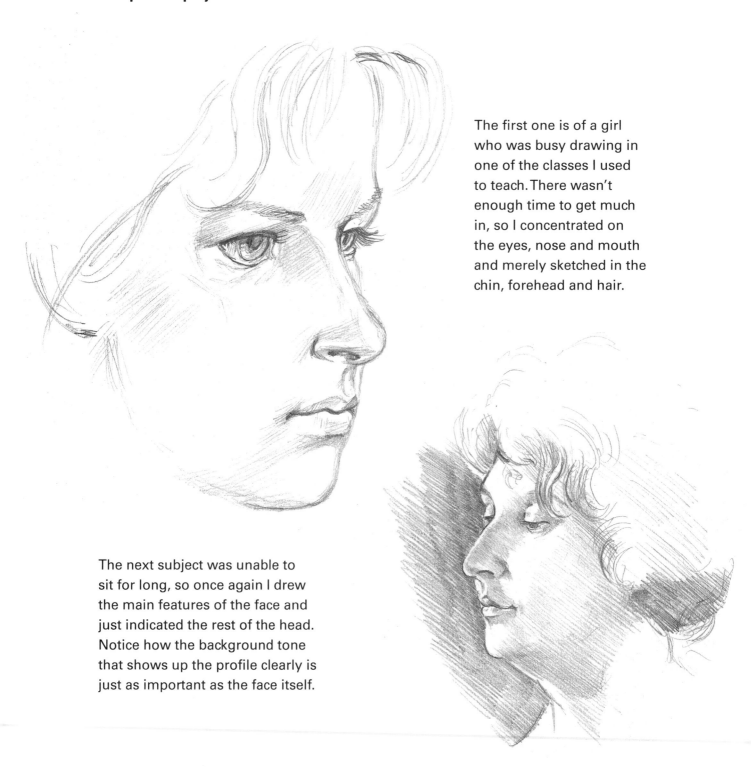

The first one is of a girl who was busy drawing in one of the classes I used to teach. There wasn't enough time to get much in, so I concentrated on the eyes, nose and mouth and merely sketched in the chin, forehead and hair.

The next subject was unable to sit for long, so once again I drew the main features of the face and just indicated the rest of the head. Notice how the background tone that shows up the profile clearly is just as important as the face itself.

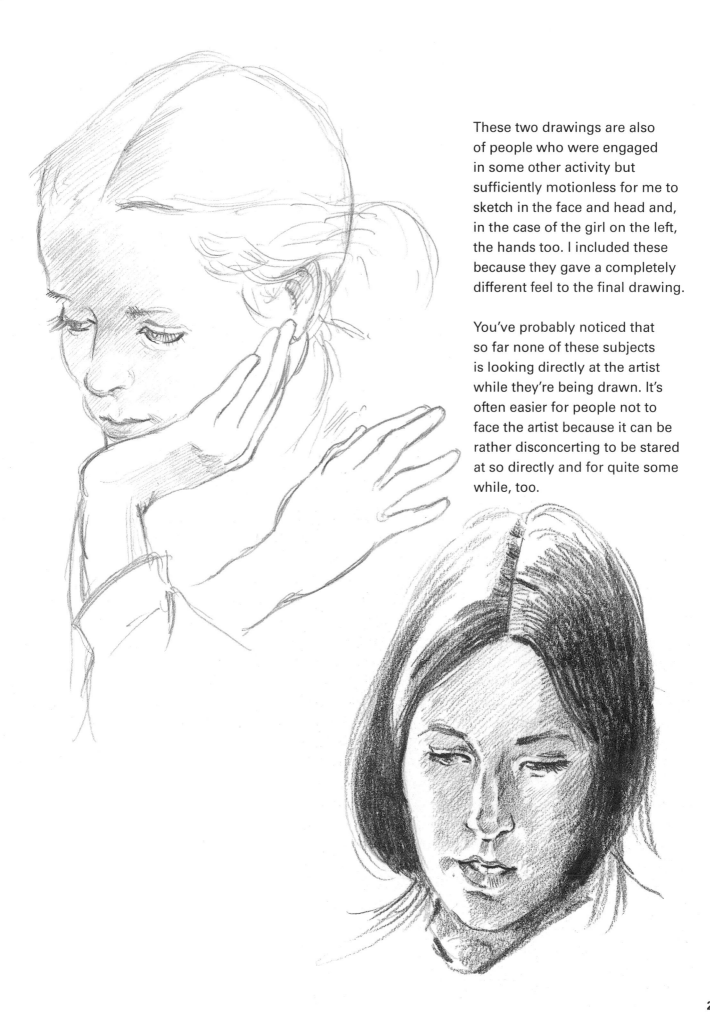

These two drawings are also of people who were engaged in some other activity but sufficiently motionless for me to sketch in the face and head and, in the case of the girl on the left, the hands too. I included these because they gave a completely different feel to the final drawing.

You've probably noticed that so far none of these subjects is looking directly at the artist while they're being drawn. It's often easier for people not to face the artist because it can be rather disconcerting to be stared at so directly and for quite some while, too.

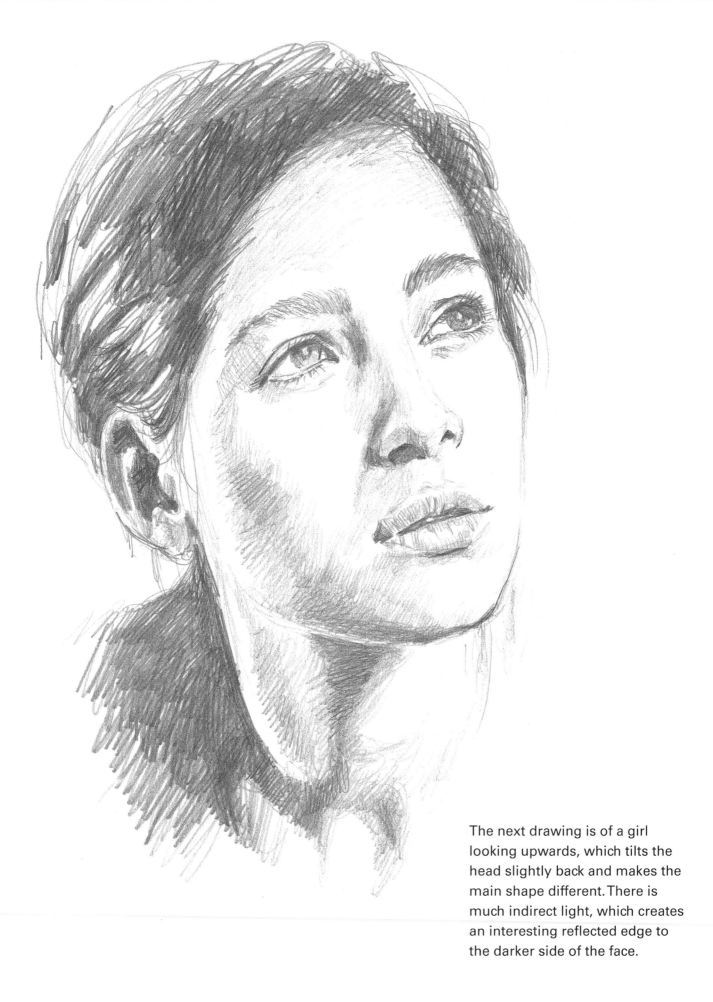

The next drawing is of a girl looking upwards, which tilts the head slightly back and makes the main shape different. There is much indirect light, which creates an interesting reflected edge to the darker side of the face.

This portrait is a complete profile view of a man's head, with a strong dark background behind the face and a lighter one behind the back of the head. Profile views were very popular in the early Renaissance period in Italy, and you might find it quite a good way to start drawing, as it seems easier to catch the exact shape of the face and head. However, it won't be the view that most people like to see in a portrait.

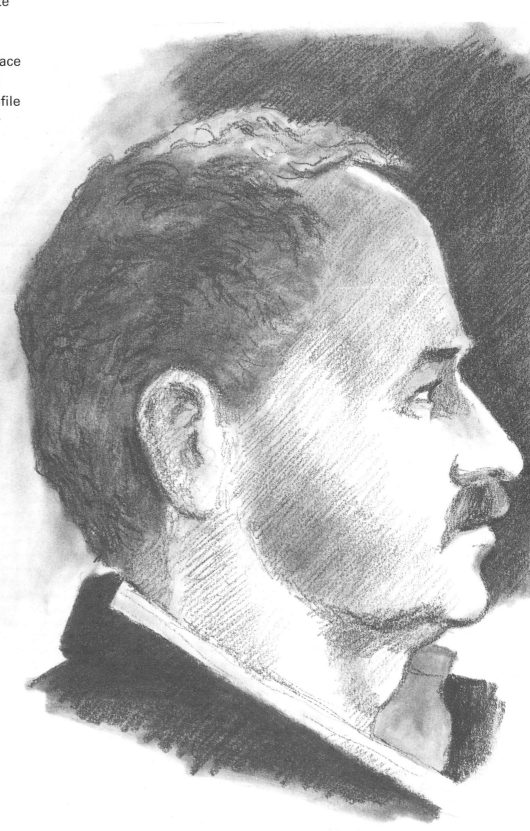

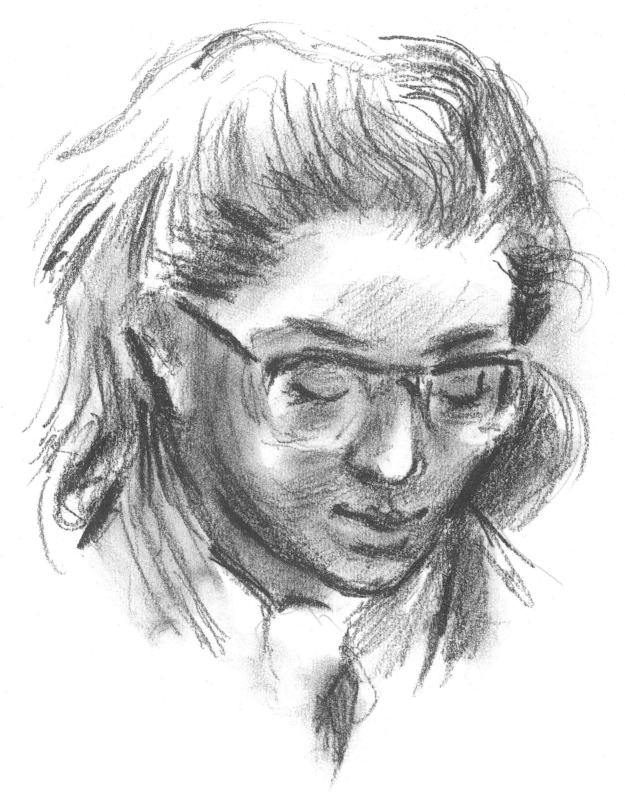

This time the model is looking downwards, and the significant thing here is the spectacles. These are often omitted from portraits as they can act as a sort of disguise to the face. Of course, if your model always wears spectacles, removing them will result in a portrait that looks less like the person that everyone is familiar with. Notice how much shadow there is on the lower half of the face, because the model's head is inclined.

The next two drawings are both of people looking directly towards the artist, and of course this is often the best way to draw someone because it's how they are most recognizable. This man is looking almost challengingly towards the artist, and you can see that he isn't afraid to meet someone's eye.

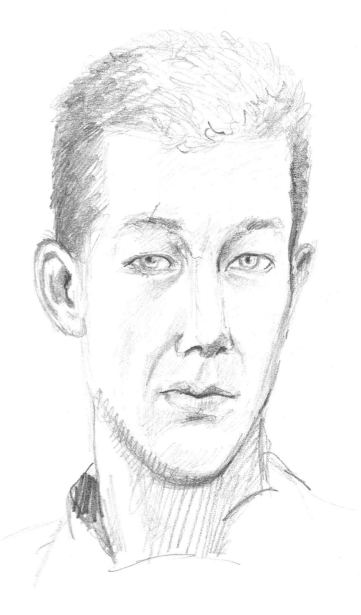

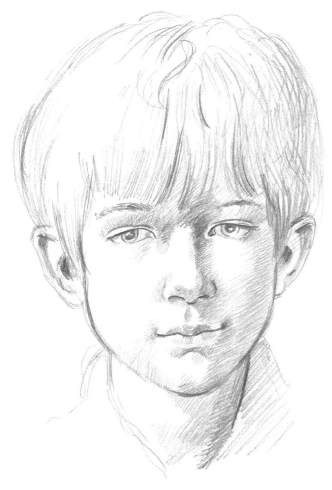

This young boy is my eldest son, drawn when he was quite young. He found it difficult to keep still long enough for me to draw much detail, but we just about managed it. It's noticeable that he didn't look directly at me as I was drawing his eyes.

245

Children

Children's heads don't match the proportions of an adult head. The greatest difference is the size of the cranium in relation to the lower jaw, but also the eyes are more widely spaced than in an adult and the cheeks are usually rounder. All the features fit into a much smaller space, and of course there are hardly any lines on the face.

These drawings of a little girl of four or five years of age, viewed from above and below, show the soft rounded cheeks and small snub nose which are fairly typical of the age group.

The little boy is a bit older but doesn't have a fully grown jaw yet, and his eyes and ears look much larger in relation to his nose and mouth than they would in an adult.

The little baby is an even more extreme shape, having a much larger cranium than face, with all her features being close together in the lower part of her head.

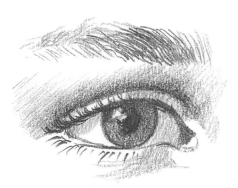

Ageing

Now let's look at the effect of age on the eye. This is quite important, because it's the eyes that mainly give us the clues as to how old someone might be. The first eye (above) is of a little boy of six and looks as big and lustrous as any young woman's might. There are hardly any lines around the eye.

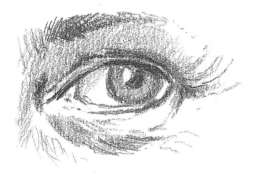

Next we have someone of middle age. Although the eye is still quite lustrous, there are lines around the eye socket that give you some idea of the age.

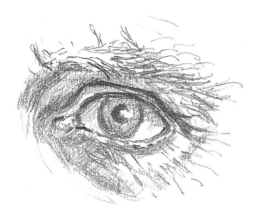

This is the eye of an elderly person, with all the multifarious lines etched into the skin and the straggly eyebrows.

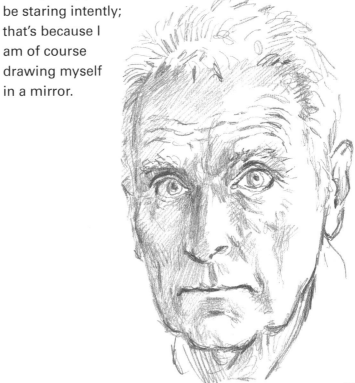

Finally, before we leave the subject of heads, I want to show you one of a young woman at her peak and one of an old man – my youngest daughter and myself. See the difference in the quality of the hair, on the one soft and shiny, the other white and sparse. Then look at the surface of the skin. Although my daughter is grinning widely she has very few lines on her face and her eyes are very clear. My own skin is furrowed with lines of all kinds, especially around the eyes and on the forehead. The cheeks look more hollow and the mouth is defined only by its edge. I appear to be staring intently; that's because I am of course drawing myself in a mirror.

247

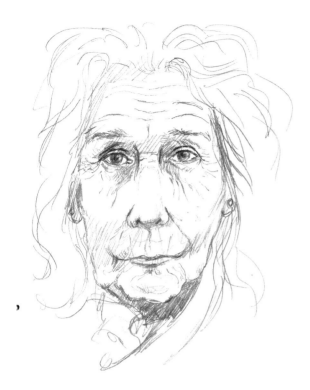

AN INDIVIDUAL PORTRAIT

Drawing a portrait is an interesting project, for not only should the finished work look like the subject, it must also have some artistic quality that takes it further than being just a good resemblance. An elderly person's face is a real challenge, because the sitter will not be pleased if the only quality that stands out is the aged features, with their lines and loose skin. My sitter didn't expect a flattering portrait, but I felt I must not emphasize her advanced years rather than her character.

First I did a couple of drawings to acquaint myself with the forms of the face. Drawing profile, full-face and three-quarter views gave me a good knowledge of all the features that would serve me well no matter which angle I decided upon for the finished portrait.

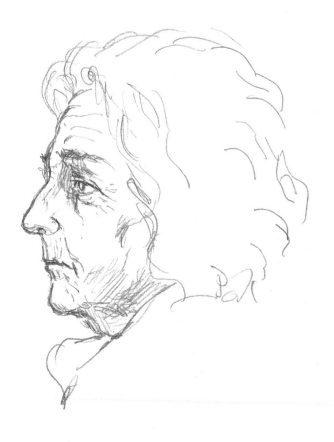

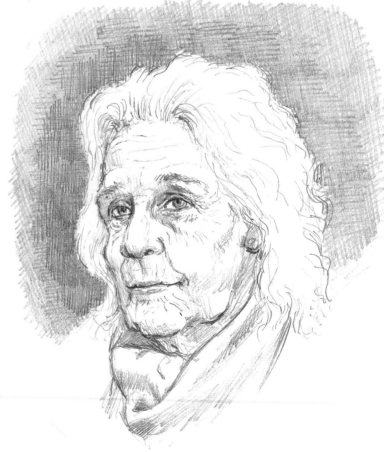

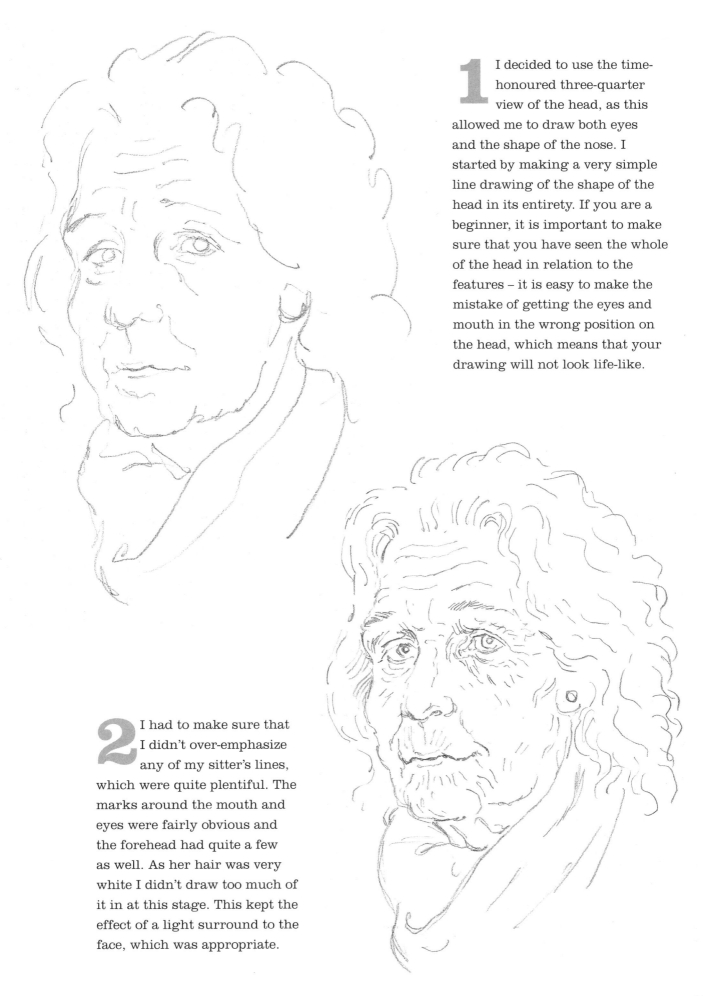

1 I decided to use the time-honoured three-quarter view of the head, as this allowed me to draw both eyes and the shape of the nose. I started by making a very simple line drawing of the shape of the head in its entirety. If you are a beginner, it is important to make sure that you have seen the whole of the head in relation to the features – it is easy to make the mistake of getting the eyes and mouth in the wrong position on the head, which means that your drawing will not look life-like.

2 I had to make sure that I didn't over-emphasize any of my sitter's lines, which were quite plentiful. The marks around the mouth and eyes were fairly obvious and the forehead had quite a few as well. As her hair was very white I didn't draw too much of it in at this stage. This kept the effect of a light surround to the face, which was appropriate.

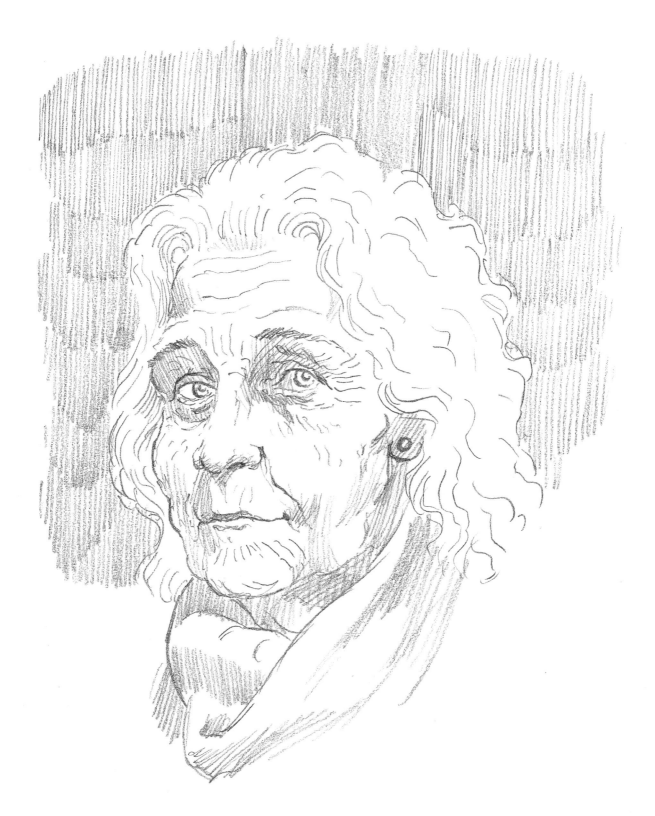

3 Having built the defining lines of the face, I now put in the tonal value of all the parts that were in shadow. All around the white hair, I made a shadow which helped to emphasize its pallor, while the shadows around the eyes and under the chin gave a more three-dimensional form to the head. At this stage, I kept the tone light.

When drawing elderly people you may find it useful to reduce the intensity of the marks – it helps to make the form of the features look more convincing, because with age the definitions fade. This particular subject had lived a long, interesting life, so indicating her character required many subtle touches that tested my ability.

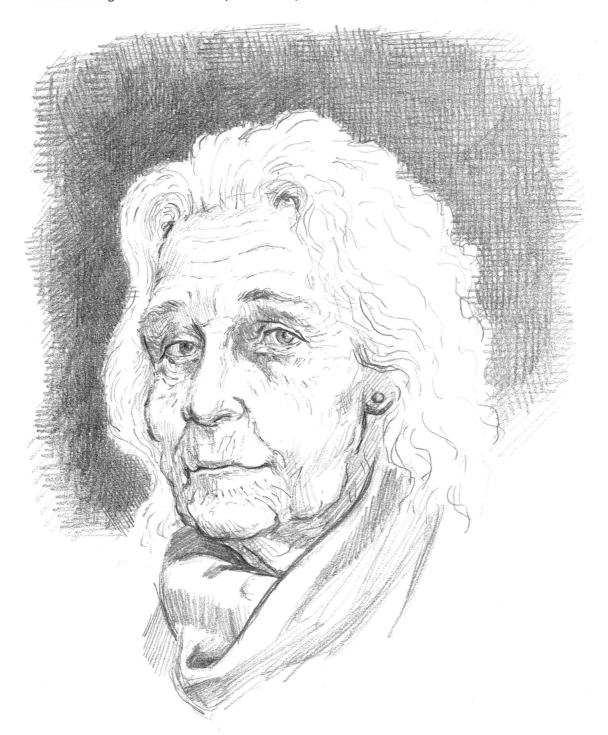

4 Next came the last stage, in which all the final subtleties were worked into the drawing to give it conviction as a living form. At this stage it is sometimes necessary to reduce the sharpness of some of the lines on a face so that the deeper lines will contrast with the fainter ones; it is easy to overdo facial marks, which will have the effect of making the sitter look like a piece of carved wood or stone. Try softening any that you are not sure about, as you will often find it immediately improves the verisimilitude of the portrait.

DRAWING YOUR FAMILY

Now let's look at what happens when we choose our nearest and dearest for our portrait sitters. Most of us have enough family and friends to practise our drawing skills on, and it is of great benefit to draw the people you have easiest access to and whom you know very well. This in-depth knowledge can help to give your portraits more power.

I decided to have a go at drawing most of the members of my family who were in the house one Christmas, and I started with my grandchildren. Of course young children and babies will not sit still for you much, so this is probably an occasion when photography can come to your aid. It does help to have the originals around as well, though, because this helps to inform your drawings from photographs that you have taken yourself.

Here is my youngest grandson, caught in his mother's arms and laughing at the camera. As you can see, his round, open eyes and nose and mouth are all set neatly in the centre of the rounded form of his head and face.

Next my granddaughter lounging on the floor, kicking her legs and giggling. Here, I concentrated on her gleeful expression.

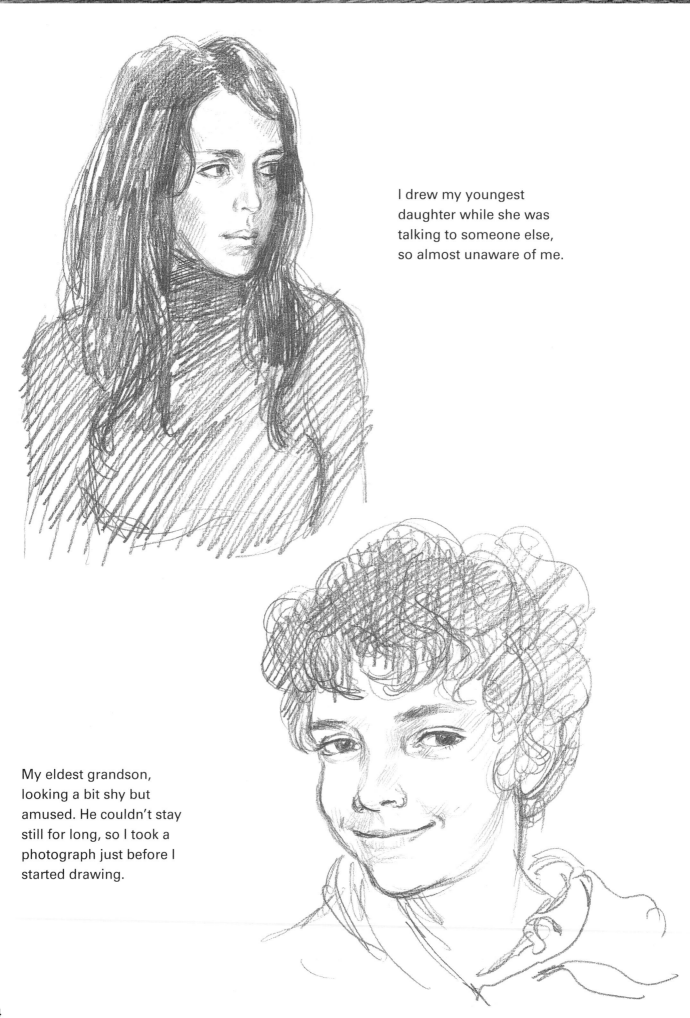

I drew my youngest daughter while she was talking to someone else, so almost unaware of me.

My eldest grandson, looking a bit shy but amused. He couldn't stay still for long, so I took a photograph just before I started drawing.

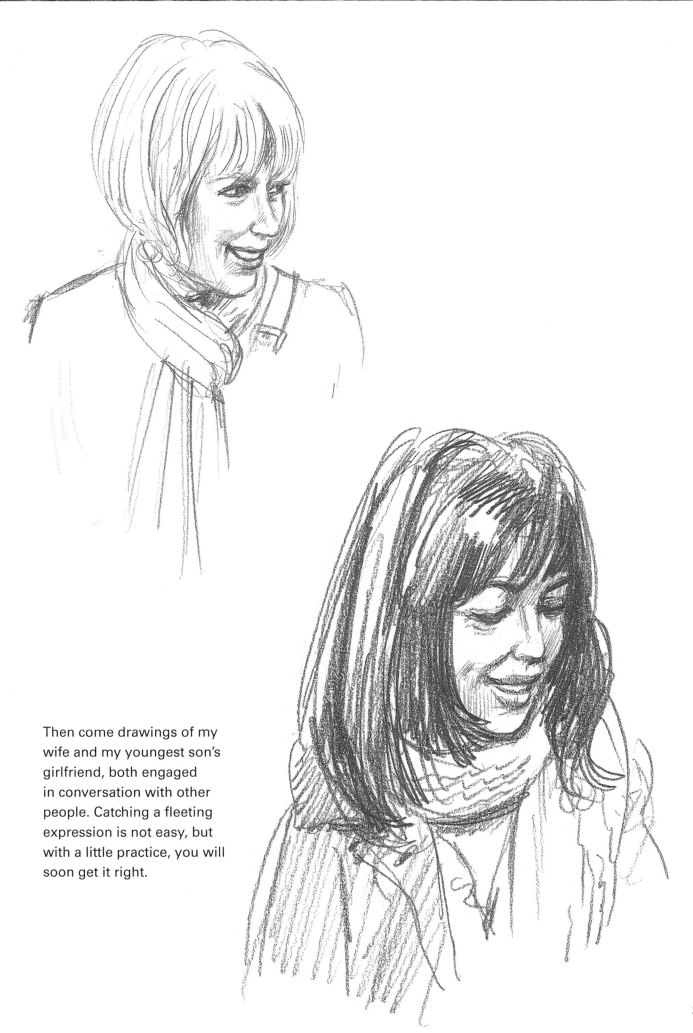

Then come drawings of my wife and my youngest son's girlfriend, both engaged in conversation with other people. Catching a fleeting expression is not easy, but with a little practice, you will soon get it right.

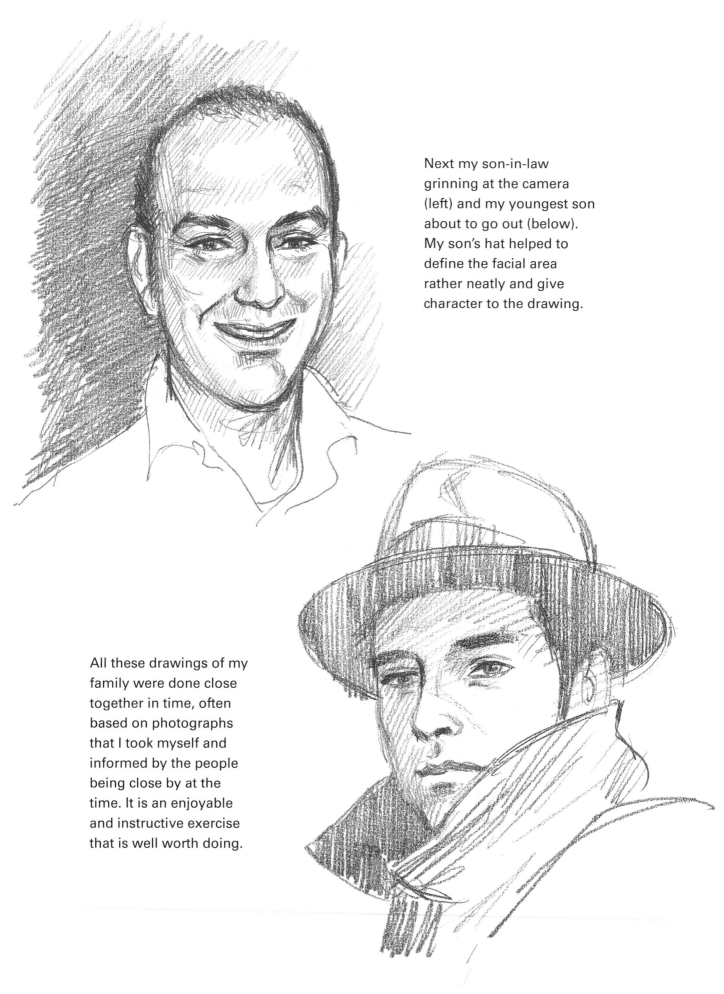

Next my son-in-law grinning at the camera (left) and my youngest son about to go out (below). My son's hat helped to define the facial area rather neatly and give character to the drawing.

All these drawings of my family were done close together in time, often based on photographs that I took myself and informed by the people being close by at the time. It is an enjoyable and instructive exercise that is well worth doing.

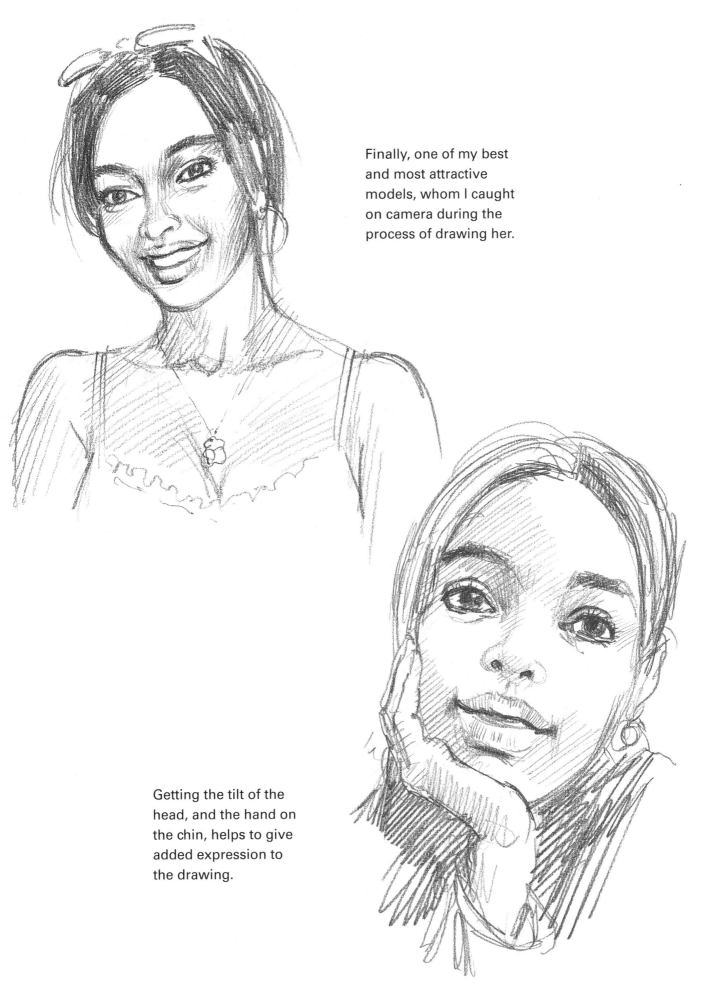

Finally, one of my best and most attractive models, whom I caught on camera during the process of drawing her.

Getting the tilt of the head, and the hand on the chin, helps to give added expression to the drawing.

A PORTRAIT PROJECT

This exercise entails quite a bit of drawing and you will learn a lot about your model's appearance by spending a whole session drawing and redrawing him or her from as many different angles as you think would be useful.

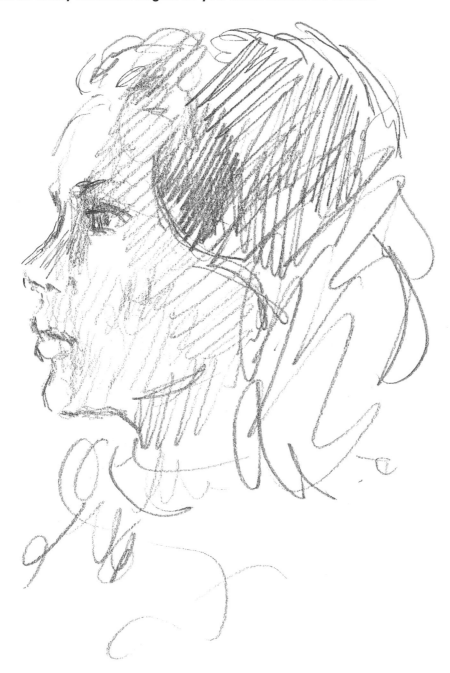

Sketches of the head

I chose as my sitter my eldest daughter, who has sat for me often, like all of my family. Not only that, she is an accomplished artist herself, so she knows the problems of drawing from life. This sympathy with your endeavours is useful, as models do get bored with sitting still for too long.

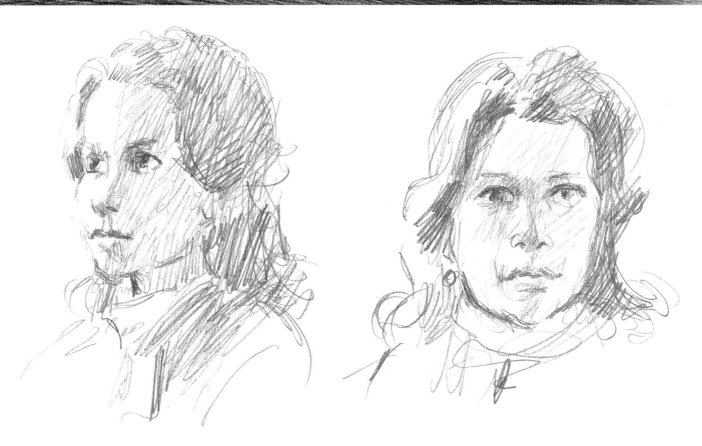

I worked my way round my sitter's head by drawing her first from the side or profile view, then from a more three-quarters view and finally full face. I now had a good idea as to the physiognomy of her face.

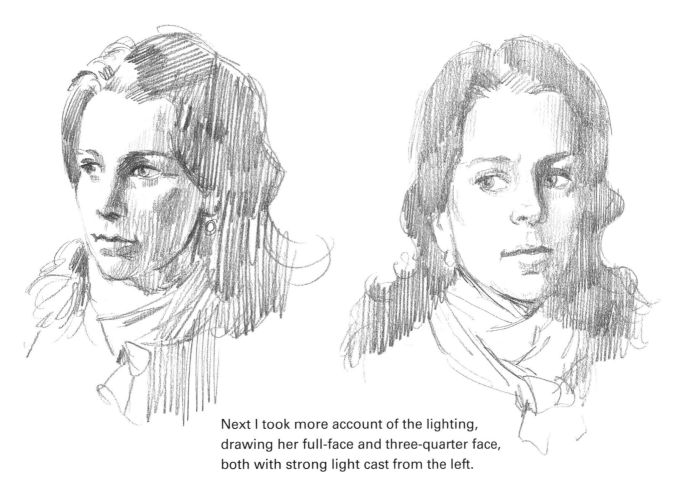

Next I took more account of the lighting, drawing her full-face and three-quarter face, both with strong light cast from the left.

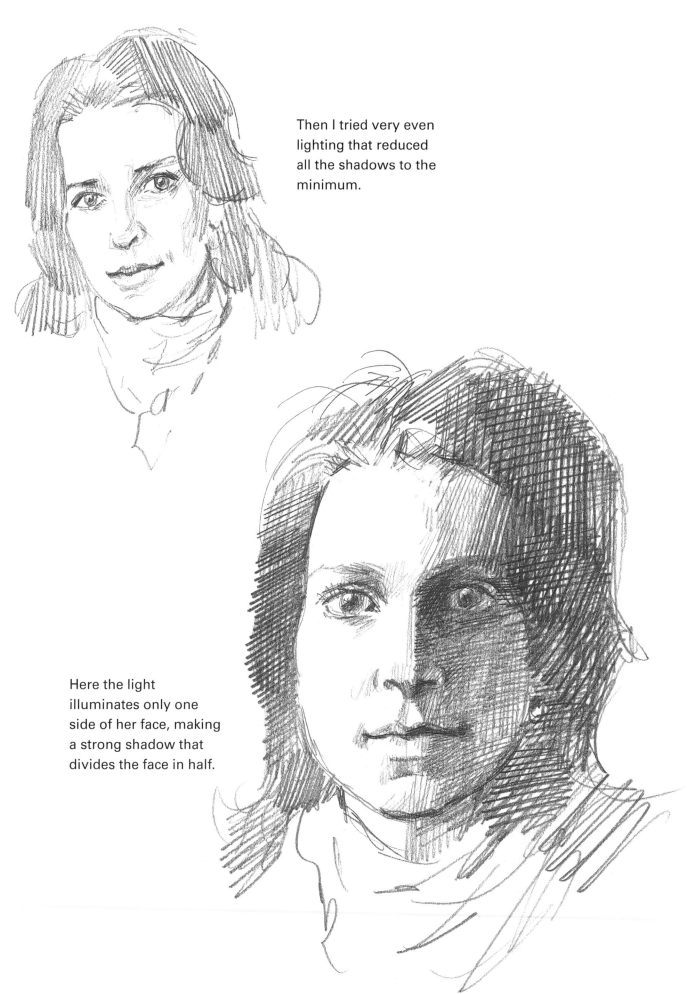

Then I tried very even lighting that reduced all the shadows to the minimum.

Here the light illuminates only one side of her face, making a strong shadow that divides the face in half.

A portrait project

Now you need to spend some time drawing the sitter full or three-quarter length in order to decide how much of the pose you might want to draw.

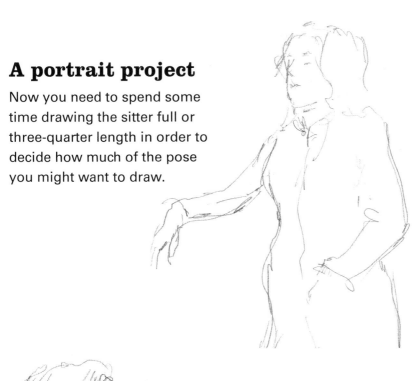

First I drew my daughter standing, with her arm draped across a mantelpiece, which gave me a three-quarter figure.

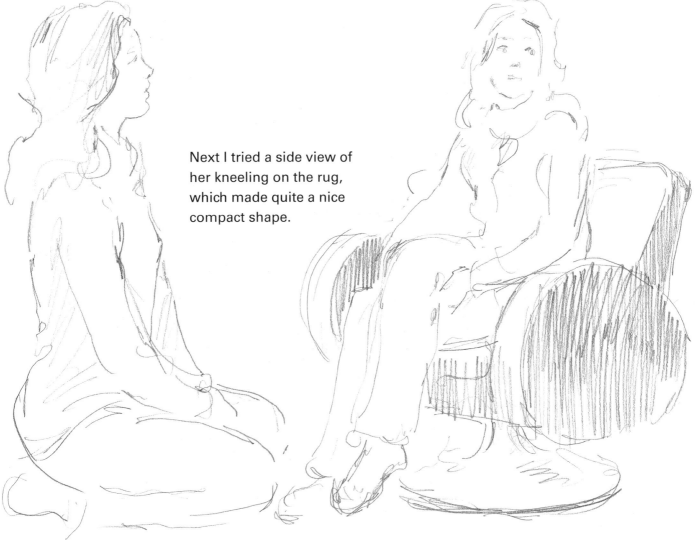

Next I tried a side view of her kneeling on the rug, which made quite a nice compact shape.

Then I asked her to sit in a big easy chair with her legs crossed. Notice how she is looking out of the picture.

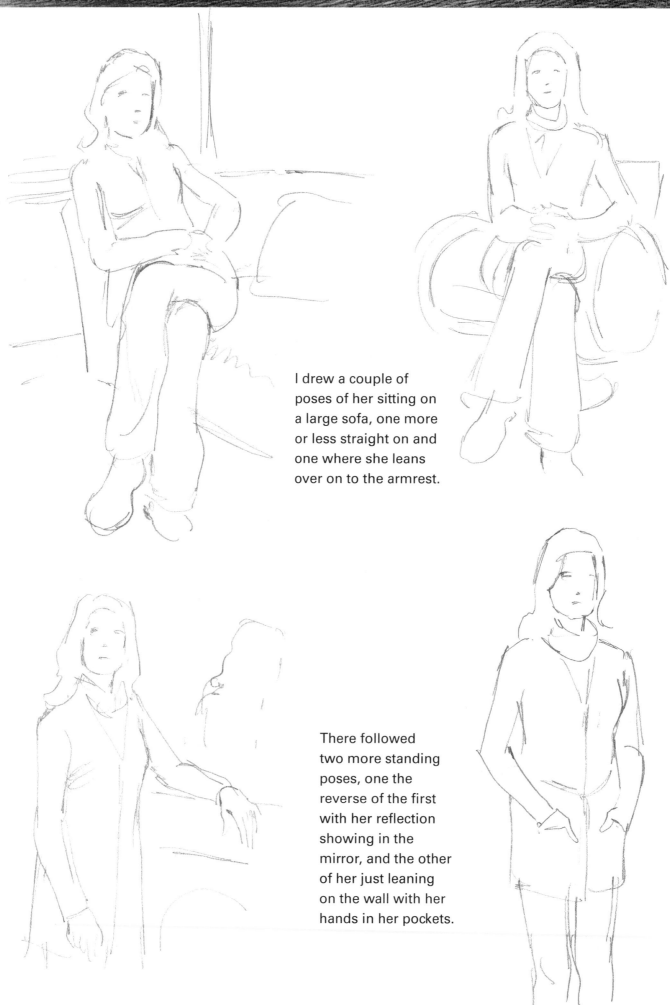

I drew a couple of poses of her sitting on a large sofa, one more or less straight on and one where she leans over on to the armrest.

There followed two more standing poses, one the reverse of the first with her reflection showing in the mirror, and the other of her just leaning on the wall with her hands in her pockets.

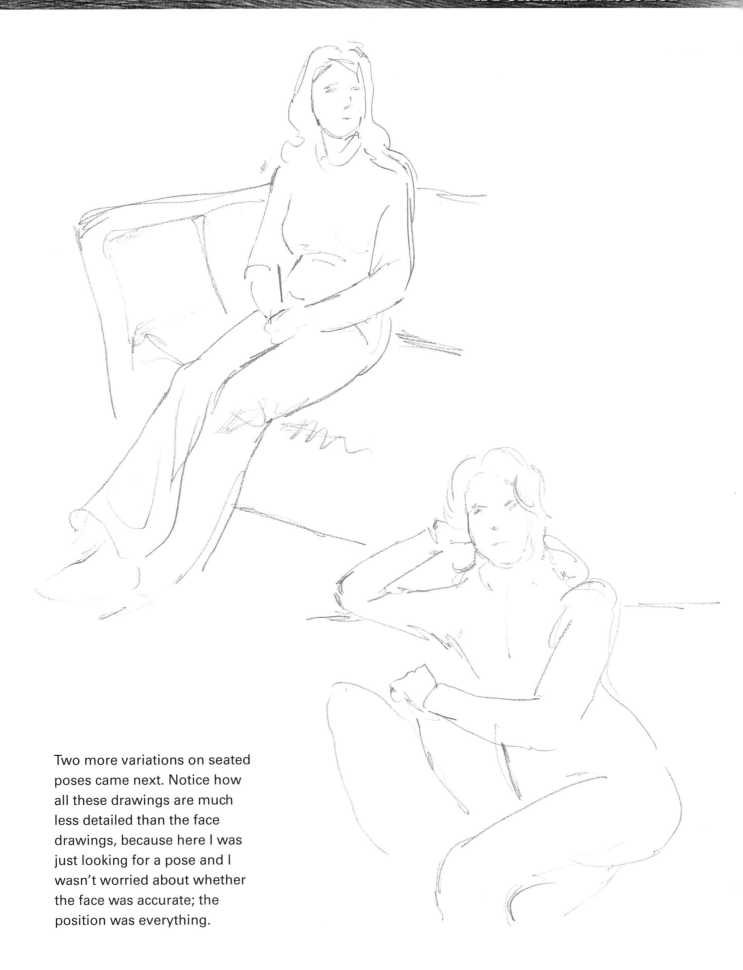

Two more variations on seated poses came next. Notice how all these drawings are much less detailed than the face drawings, because here I was just looking for a pose and I wasn't worried about whether the face was accurate; the position was everything.

Drawing the features in detail

Once you've decided upon the pose you need to turn your attention to the details of the sitter's face, taking each of the features and making detailed drawings of them.

I started by drawing just one eye. This is a difficult thing to do, as the model will find your concentrated stare a little daunting. However, it's also very revealing as to how carefully you have observed the eye. Having drawn my daughter's eye directly facing me, I then drew it from a slight angle so that I got a side view of it. I did this with both eyes, then drew them as a pair to see how they looked together, as well as the space between them.

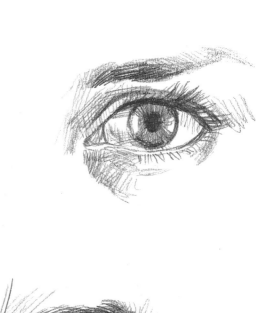

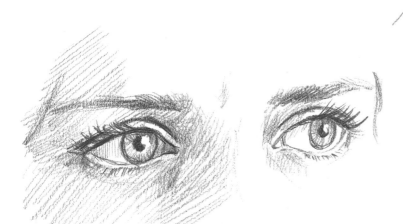

Next I moved on to the mouth and drew it two or three times, exploring the front, side and three-quarter view.

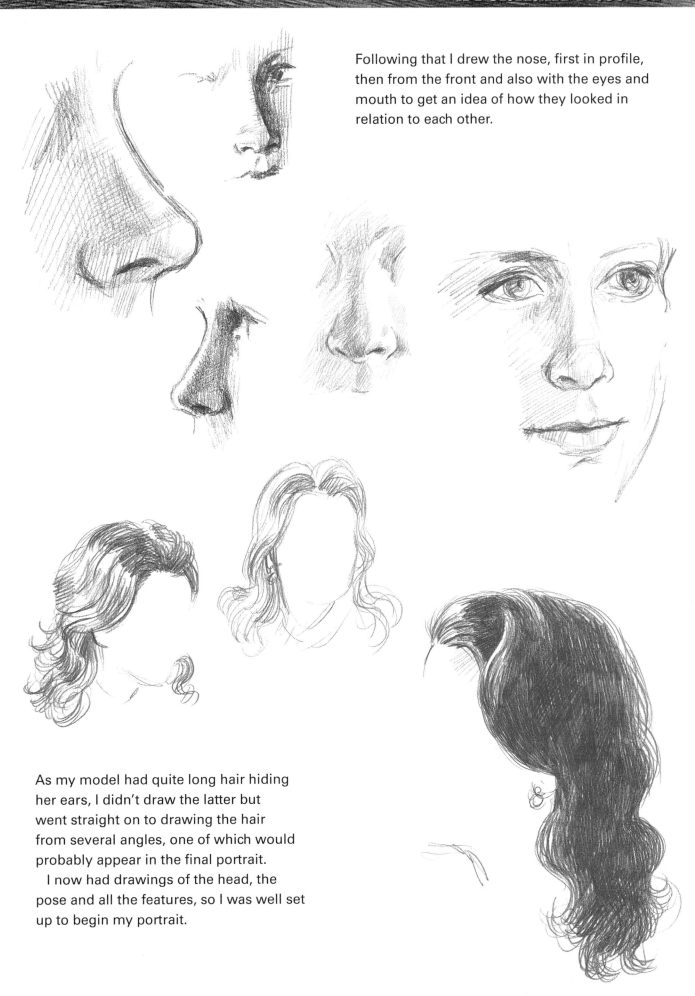

Following that I drew the nose, first in profile, then from the front and also with the eyes and mouth to get an idea of how they looked in relation to each other.

As my model had quite long hair hiding her ears, I didn't draw the latter but went straight on to drawing the hair from several angles, one of which would probably appear in the final portrait.

I now had drawings of the head, the pose and all the features, so I was well set up to begin my portrait.

Choosing the composition

With my drawings gathered together and my model refreshed and ready to sit for me again, I first had to choose the pose and then draw it up in as simple a way as possible but with all the information I needed to proceed to the finished portrait. I decided to place her on a large sofa, legs stretched out and hands in her lap, with her head slightly turned to look directly at me. The light was all derived from the large window to the left and so half of her face was in soft shadow.

I then spent time drawing her in some detail, but without any shading, to create my cartoon. I tried to make it as correct as I could, but it didn't yet matter if the drawing was not quite as I wanted it because the purpose of the cartoon was to inform me as to what I needed to do to make the final piece of work the best possible portrait that I could manage. When artists in traditional ateliers were painting a large commission, they often drew up the whole thing full-size in an outline state from which to produce their final painting.

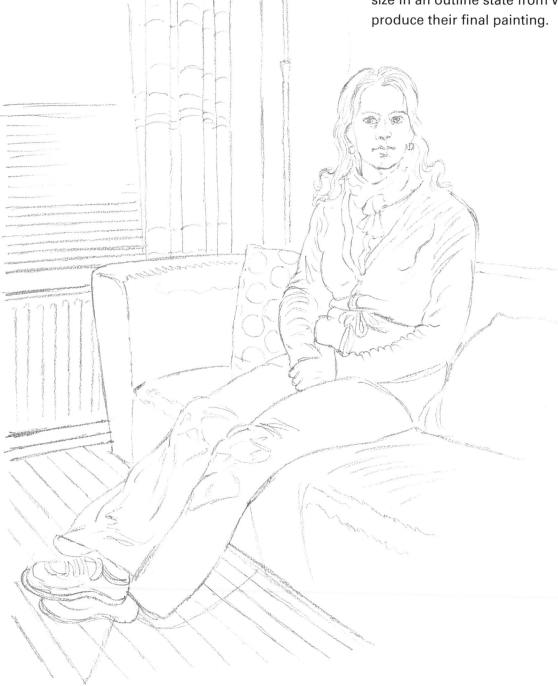

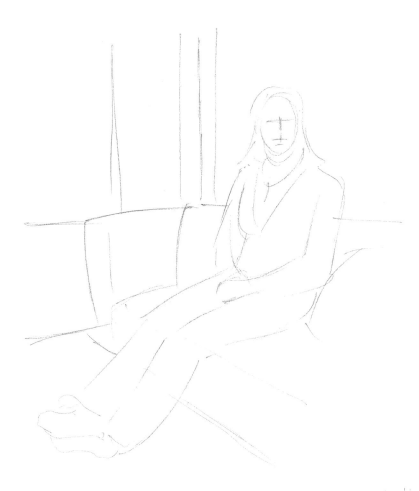

1 First I drew up a quick sketch that told me where everything would be placed. This almost exactly echoed the shape of my cartoon, which I had in front of me.

2 Then, still using my cartoon as a guide, I drew up a careful outline drawing of the whole figure and the background setting in some detail. This was the last stage at which I could introduce any changes if they were necessary.

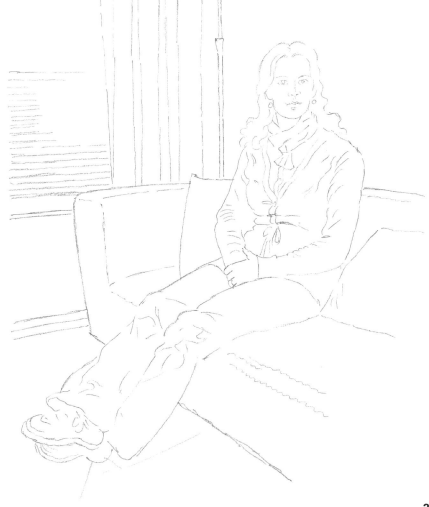

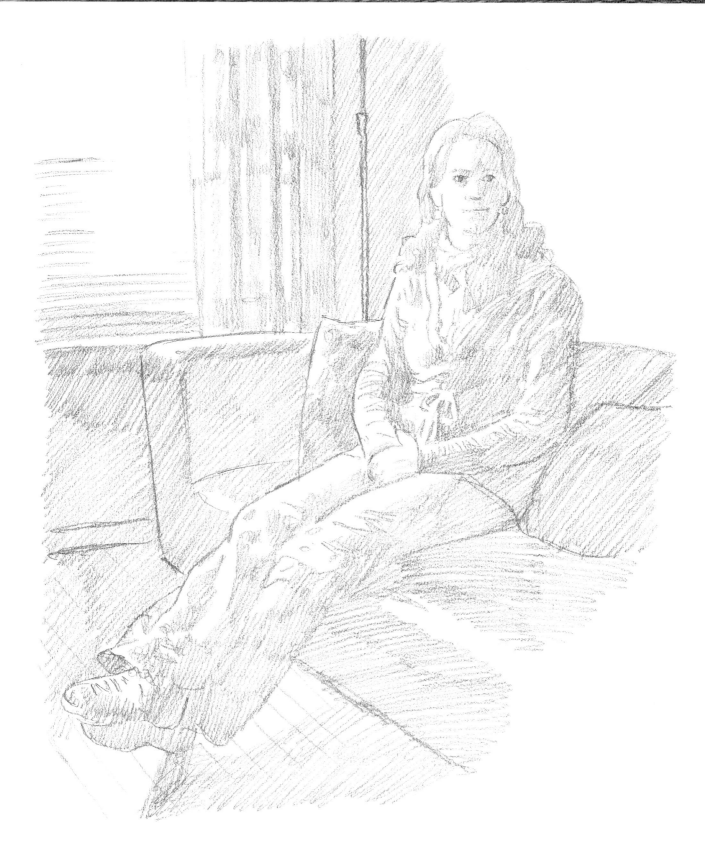

3 Next I began to put in the main area of tone evenly, using the lightest tone that would appear on the finished article.

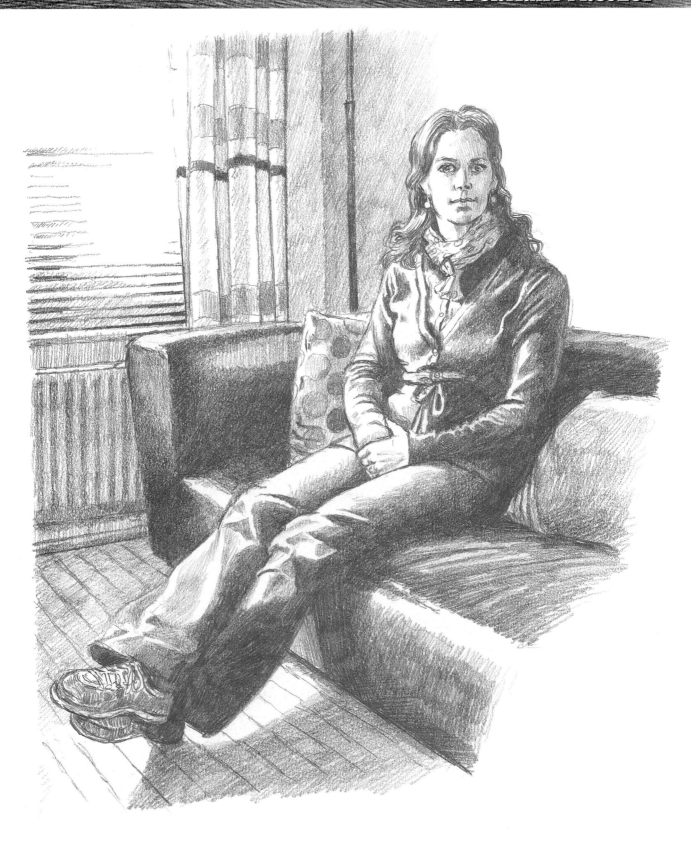

4 I could now build up all the different tones until I had produced a convincing three-dimensional portrait that looked like my sitter. This may have struck you as quite a long process, but if you take all this trouble to make your own portrait the chances are that not only will the sitter be pleased with the result, so will you.

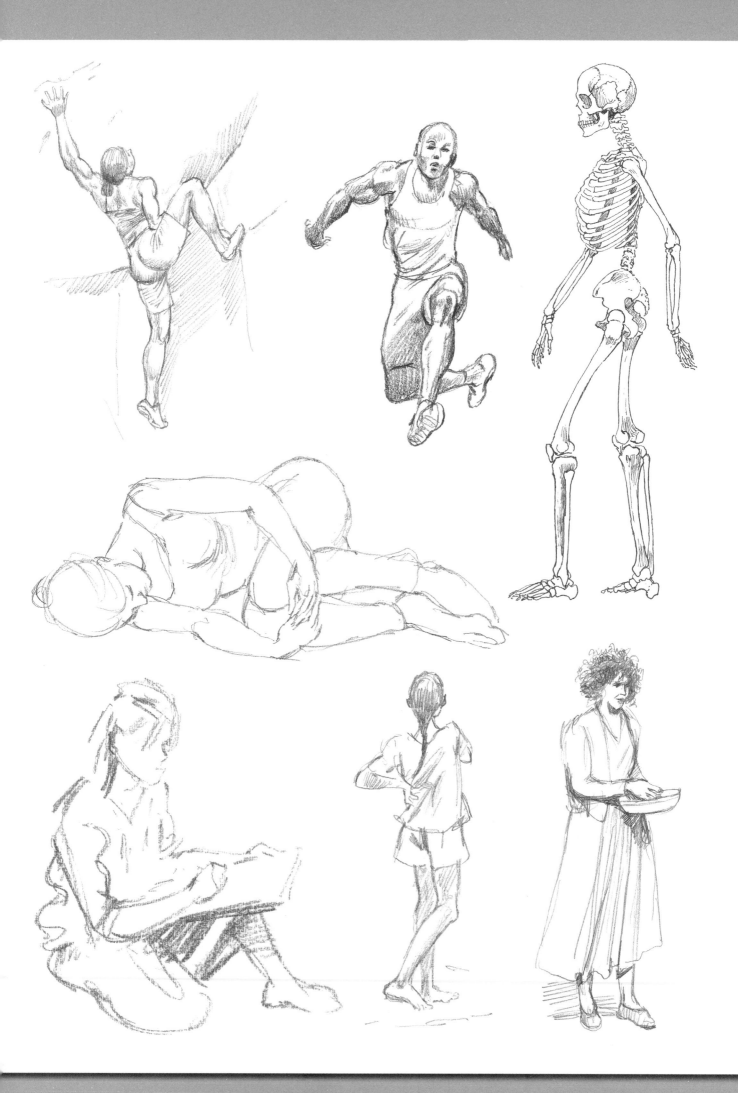

Chapter 11

THE HUMAN FIGURE

In this chapter we come to one of the most interesting, subtle and taxing of our drawing challenges. The human figure is the one subject that we all think we know about, because we are humans ourselves. However, because of our close connection with the subject, it's easier not only to follow our preconceptions rather than relying on observation, but also then to realize we have got things wrong. It's consequently harder to satisfy our own demands of our skill – but that's no bad thing because it makes us strive harder.

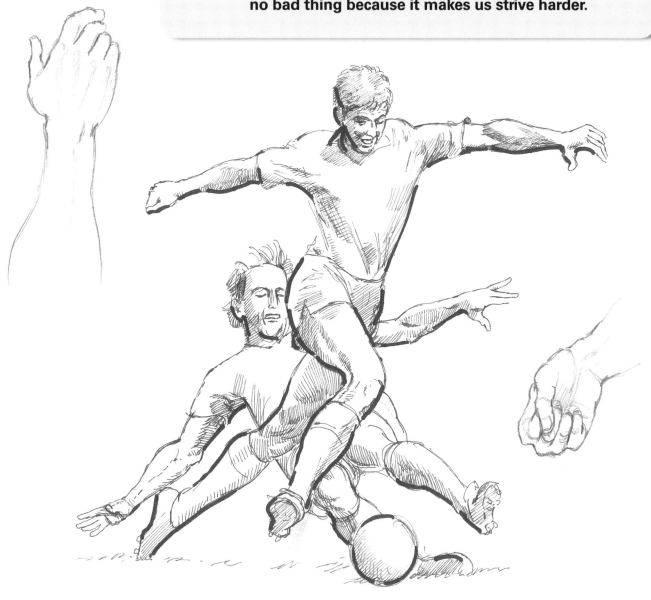

FULL-FIGURE SKELETON

Here we show three simple views of the skeleton, the front, the back and the side view (also called the anterior, the posterior and the lateral views). I have kept the number of bones named here to a minimum, but if you wish to do extensive life drawing it's a good idea to study the skeleton in full detail.

SKULL

Frontal bone

Zygomatic bone (cheekbone)

Maxilla

Mandible (jawbone)

7 cervical vertebrae

TORSO

Clavicle (collarbone)

Coracoid process

Scapula
(shoulder blade)

Manubrium

Sternum (breastbone)

Costae (12 pairs of ribs)

ARM AND HAND
(upper limb)

Humerus

5 lumbar vertebrae

Anterior superior iliac spine

Ilium

Radius

Ulna

Pubis (pubic bone)

Symphysis pubis

Carpus (wrist
bones)

Metacarpus

LEG AND FOOT (lower limb)

Head of femur

Lesser trochanter

Greater trochanter

Patella (kneecap)

Phalanges
(14 finger bones)

Fibula

Tibia (shin bone)

Tarsus

Metatarsus

Phalanges (14 toe bones)

Back view

SKULL

Parietal bone

Occipital bone

7 cervical vertebrae

TORSO

Scapula (shoulder blade)

12 thoracic or dorsal vertebrae

Costae (12 pairs of ribs)

ARM AND HAND (upper limb)

Humerus

Radius

Ulna

Carpus (wrist bones)

Metacarpus

Phalanges
(14 finger bones)

Iliac crest

Posterior superior iliac spine

Sacrum

Coccyx

Ischium

LEG AND HAND (lower limb)

Femur

Fibula

Tibia

Calcaneus
(heel bone)

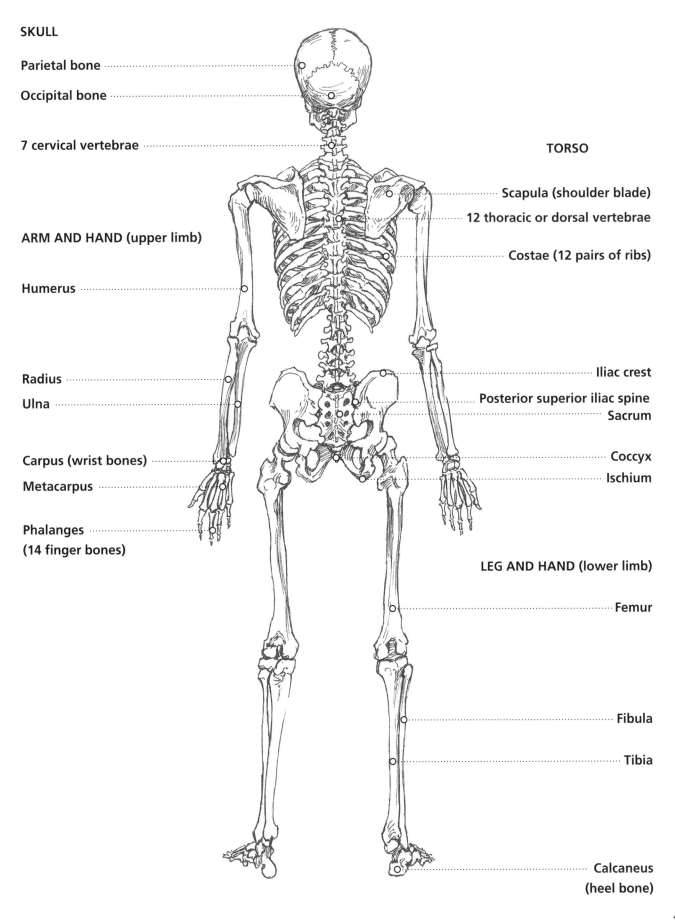

Side view

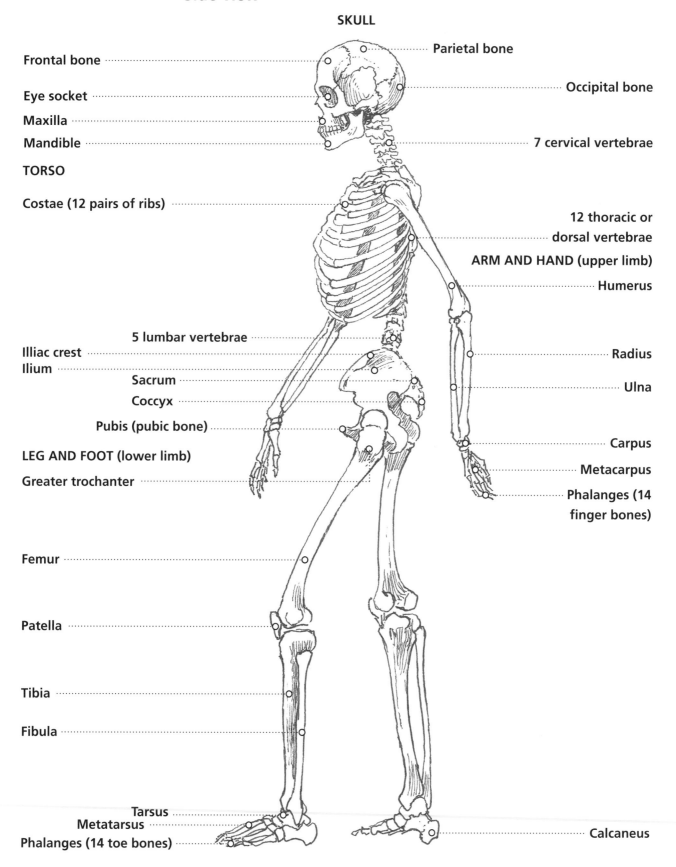

SKULL

Frontal bone

Parietal bone

Eye socket

Occipital bone

Maxilla

Mandible

7 cervical vertebrae

TORSO

Costae (12 pairs of ribs)

12 thoracic or
dorsal vertebrae

ARM AND HAND (upper limb)

Humerus

5 lumbar vertebrae

Illiac crest
Ilium

Radius

Sacrum

Ulna

Coccyx

Pubis (pubic bone)

Carpus

LEG AND FOOT (lower limb)

Metacarpus

Greater trochanter

Phalanges (14
finger bones)

Femur

Patella

Tibia

Fibula

Tarsus

Metatarsus

Phalanges (14 toe bones)

Calcaneus

FULL FIGURE SHOWING THE MUSCLES

Front view

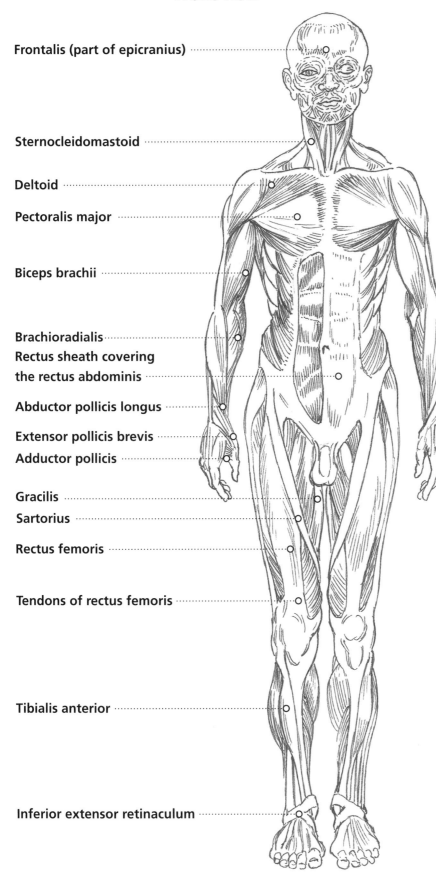

Frontalis (part of epicranius)

Sternocleidomastoid

Deltoid

Pectoralis major

Biceps brachii

Brachioradialis
Rectus sheath covering
the rectus abdominis

Abductor pollicis longus

Extensor pollicis brevis

Adductor pollicis

Gracilis

Sartorius

Rectus femoris

Tendons of rectus femoris

Tibialis anterior

Inferior extensor retinaculum

We show here the musculature of the whole body, so as to give some idea of the complexity of the sheaths of muscles over the bone structure. There are many deeper muscles in the body – only the more superficial muscles are on show here.

The drawings are based on a male body. Of course there are slight differences between the male and female musculature, but not much in the underlying structure. The main differences are in the chest area and the pubic area. There are also slight proportional differences, but this complete figure of the muscles of a human being will give you a good idea as to how the muscles are placed over the body.

Back view

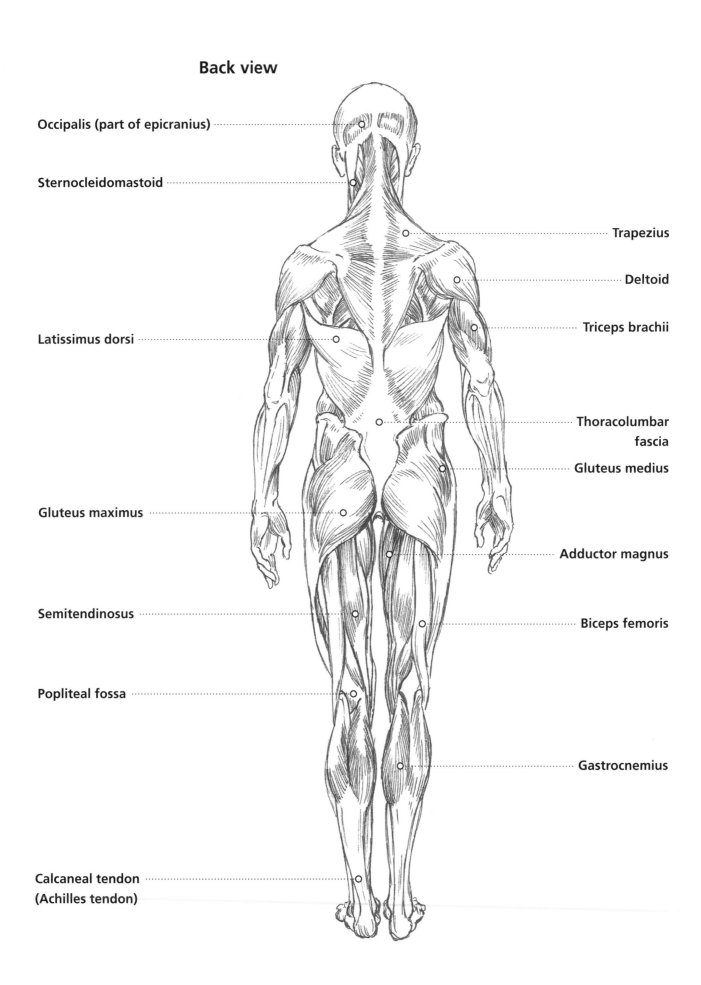

Occipalis (part of epicranius)

Sternocleidomastoid

Trapezius

Deltoid

Triceps brachii

Latissimus dorsi

Thoracolumbar fascia

Gluteus medius

Gluteus maximus

Adductor magnus

Semitendinosus

Biceps femoris

Popliteal fossa

Gastrocnemius

Calcaneal tendon (Achilles tendon)

Side view

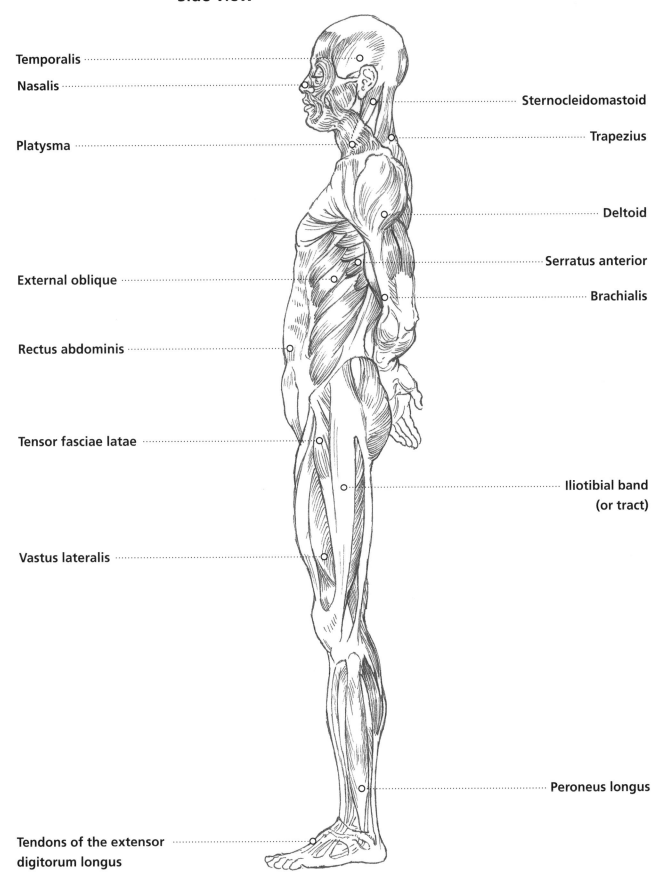

Temporalis

Nasalis

Platysma

External oblique

Rectus abdominis

Tensor fasciae latae

Vastus lateralis

Tendons of the extensor
digitorum longus

Sternocleidomastoid

Trapezius

Deltoid

Serratus anterior

Brachialis

Iliotibial band
(or tract)

Peroneus longus

THE PROPORTIONS OF THE HUMAN FIGURE

The male and female hardly differ at all in their height proportions, but there is a difference in width; the male figure is wider at the shoulders, the female wider at the hips.

Male figure: front view

In these diagrams, the basic unit of measurement is the length of the head, from the highest point on the top of the skull to the bottom of the chin. The length of the body, from the top of the head to the soles of the feet, is subdivided by the length of the head.

Shown here is the male figure in the scale of classical proportion, which makes the head go into the length of the body eight times. This isn't quite accurate, although there may be some tall people with small heads who could fit the scale. It was considered ideal at one time because, drawn like that, the figure had a certain grandeur about it, so it was used for the proportions of heroic and god-like figures.

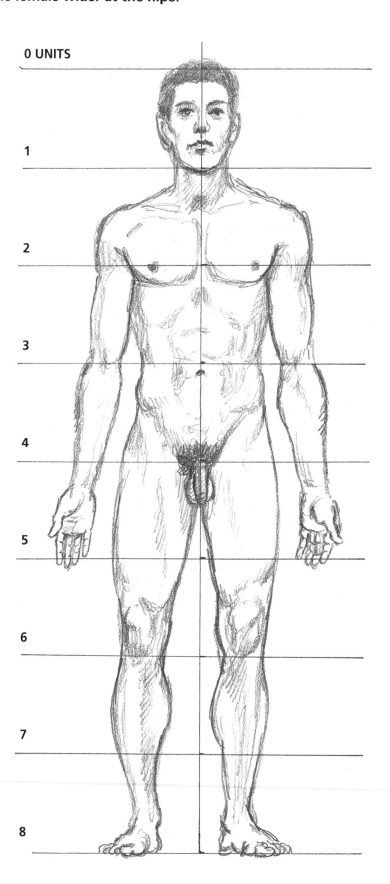

0 UNITS

1

2

3

4

5

6

7

8

Female figure: side view

In fact, most human beings are closer to one head going seven and a half times into the body length. Even this is an approximation, because not everyone fits the proportion quite so neatly, and most drawings and paintings of human beings can be drawn more simply as if eight units made up the height. What this proportion shows is that two units down from the top of the head marks the position of the nipples on the chest. Three units down from the top marks the position of the navel. Four units down marks the point where the legs divide.

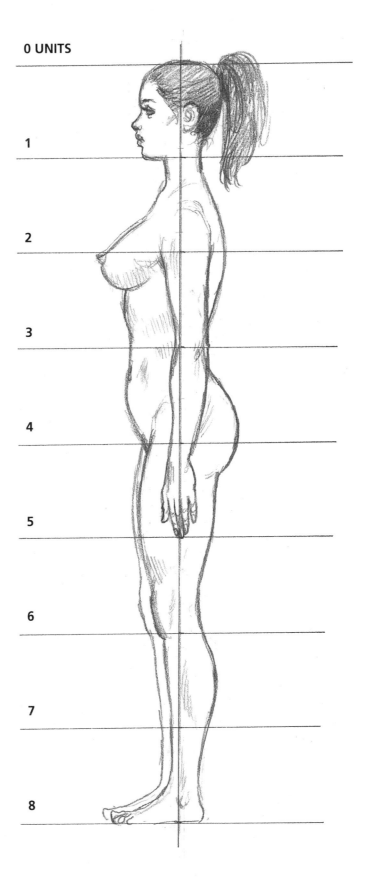

0 UNITS

1

2

3

4

5

6

7

8

PROPORTIONS AT DIFFERENT AGES FROM 1 TO 25 YEARS

These drawings show the changes in proportion of the human body (male) at different ages. At one year old, only four head lengths fit into the full height of the body, whereas at almost 25 years old, the head will go into the length of the body about seven and a half times.

1 Year

4 Years

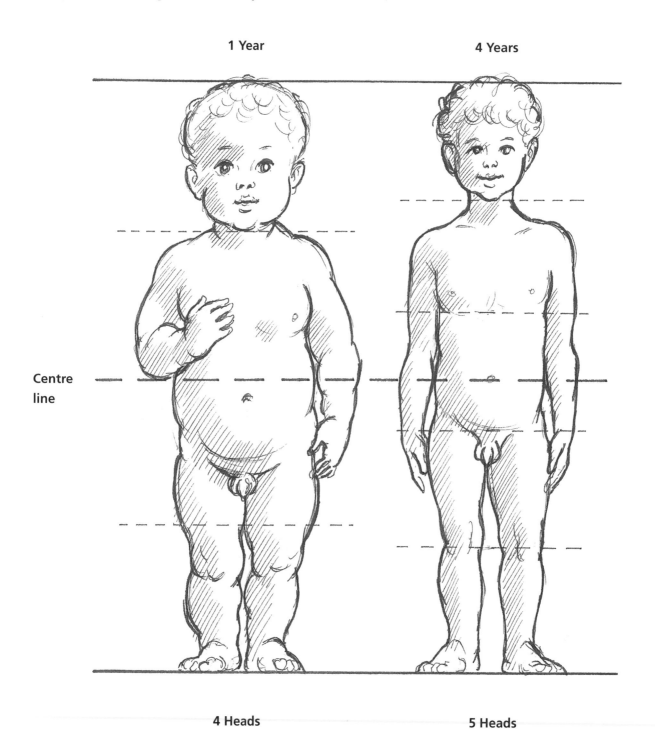

Centre line

4 Heads

5 Heads

9 Years

16 Years

25 Years

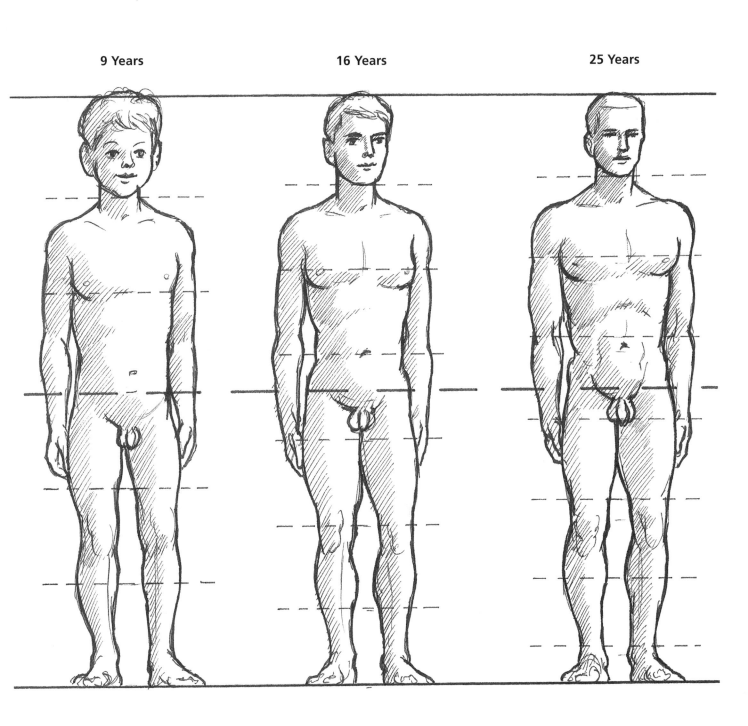

6 Heads

7 Heads

7¹/₂ Heads

THE FULL FIGURE DRAWN BY MASTER ARTISTS

Here we show drawings after two of the great masters of the human form, Michelangelo Buonarroti (1475–1564) and Jean-Auguste Dominique Ingres (1780–1867). These artists made many studies of the human body, both adopting very different approaches.

Michelangelo drew almost every muscle that could be shown in his drawings. As well as being an artist, he was also a great sculptor, fascinated by the way the shape of the figure was built up, with muscle forms clearly shown on the surface of the body. His approach was influenced by the relatively new science of dissection, which the Renaissance artists were beginning to explore.

By the time we get to the 19th century, however, the French master Ingres was endeavouring to show how subtle his depictions of the human form could be, with all the musculature very softly indicated and tones graduated from one place to the next on the form. This slightly more cosmetic approach was, in a way, a move away from the overtly dramatic methods of showing the human form after the age of Michelangelo. Nowadays, we tend to use both approaches to our advantage.

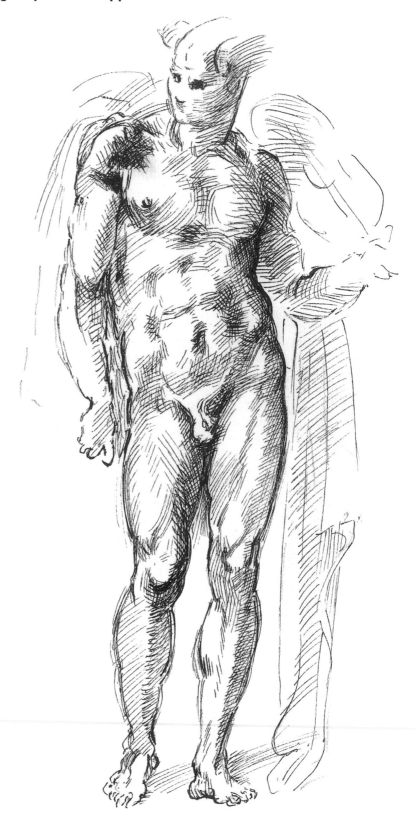

after Michelangelo (1475–1564)

after Ingres
(1780–1867)

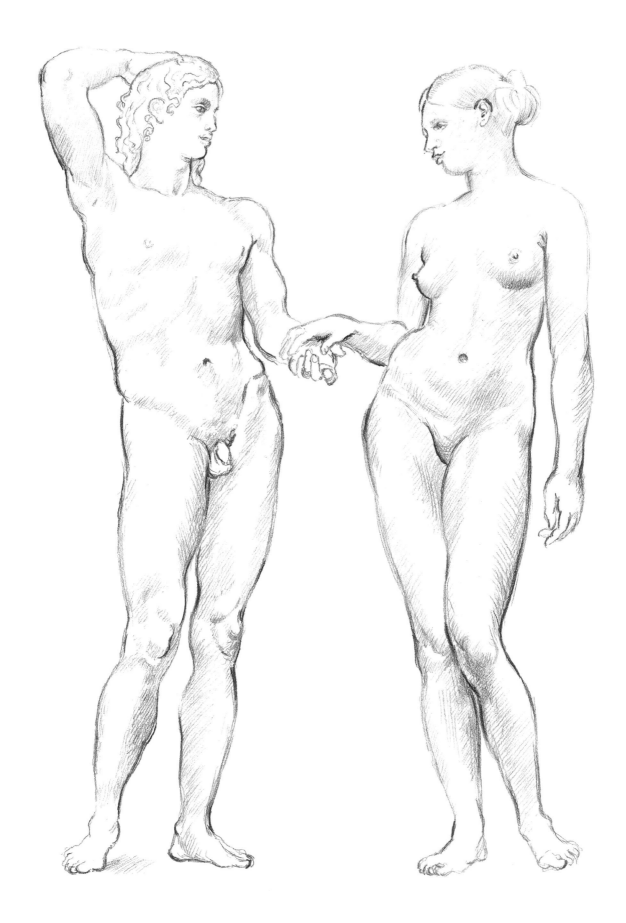

THE LIMBS AND EXTREMITIES

On these pages, we'll look at the limbs, hands and feet. You won't necessarily draw all these particular poses, but try as many as you can before moving on to the next stage. Again it is of more benefit if you can draw from life, and in most cases you could be your own model with the use of a large mirror.

Arms and hands

First, draw some arms from different angles. Those that I've drawn are both feminine and masculine, but if you are drawing your own arms, that doesn't matter at the moment; male and female arms look different, but the basic anatomy is the same.

In my drawings I've shown both the use of tone and a more linear approach to define the form. No matter how many arms you draw, there will always be more to discover about their formation in different positions.

The hand is a study in itself. Tracing round your own hand will remind you of its basic shape.

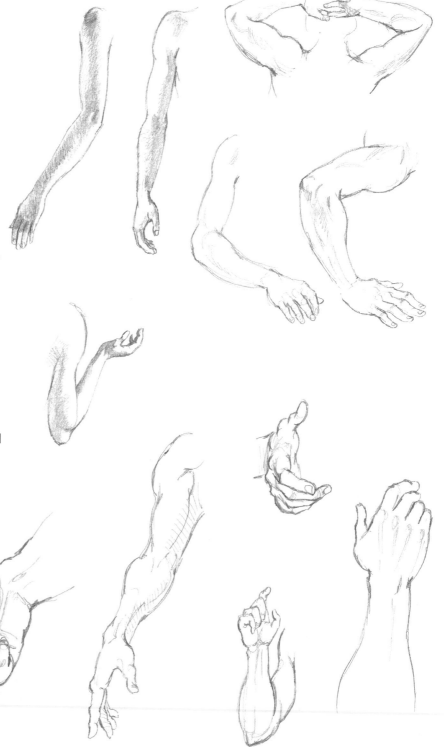

Legs and feet

To draw the legs and feet, again you can use your own seen in a mirror or ask people to pose for you. You will need to show the difference between female and male legs, which is evident in the softer, rounder forms of the former and the harder lines of the latter. However, the difference may not be so obvious on the legs of a female athlete compared to the legs of a sedentary male. The hardest part is to get the proportion between the upper and lower leg correct, and the drawings of the knee and ankle joints.

Draw the legs from various angles: front, back, side and crossed over each other. This helps you to see how the various groups of muscles behave from different angles. When the legs are under more tension the muscles will appear more prominent. The knee joint and the area where the foot joins the leg are quite tricky to get right and it is worth making several studies of them.

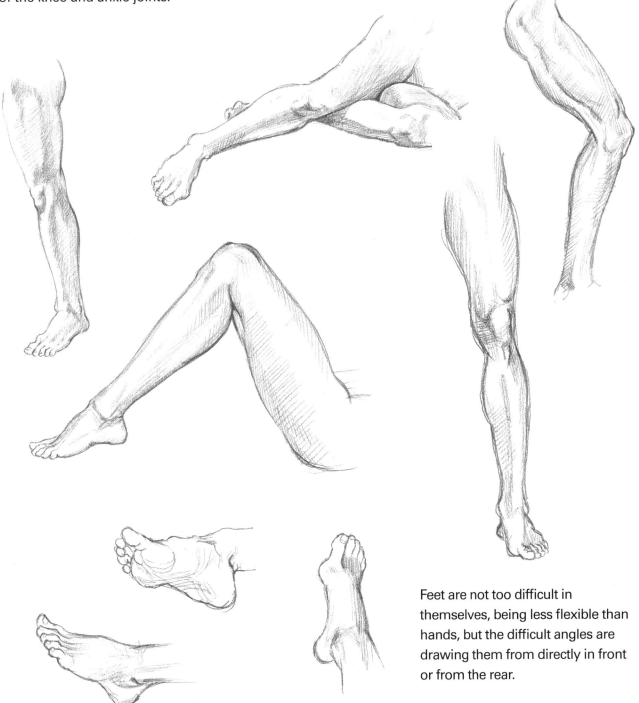

Feet are not too difficult in themselves, being less flexible than hands, but the difficult angles are drawing them from directly in front or from the rear.

285

DRAWING SIMPLE FIGURES

For looking at the human figure more extensively, you will find that a good supply of photographs of people in action can be very useful. While the best drawings are done only from life, using photographs, especially if you have taken them yourself, is not a bad substitute.

First of all, limit yourself strictly to the simplest way of showing the figure, which is almost like a blocked shape with a line through its length. In these figures the movement is not great, as befits a first attempt, and two of them were taken from photographs. However, simplify all the time when drawing figures because the movement is so difficult to catch that you don't have time for details. Try to do a few drawings like this, spending just 3–4 minutes on each one and making your lines fluid and spontaneous, even if at first the results look terrible. All artists start like that, and only time and repeated practice effect a change.

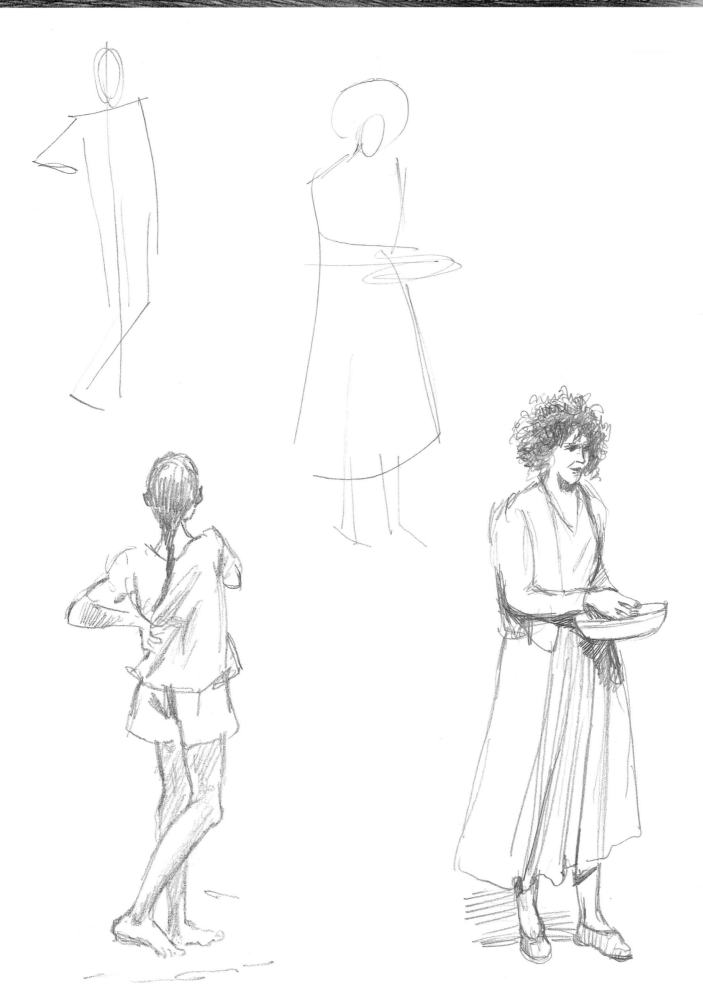

Line of movement

In the drawings on this page I have used the stick drawing technique, drawing only the line through the movement of the shape first, in order to get the feel of the flexibility of the human form.

Have a go at this first before you draw the figure more solidly, keeping the stick drawings at the side of your more considered drawings to guide you. Put in the figures as simply as you can, leaving out all details and limiting yourself to about 10 minutes per drawing.

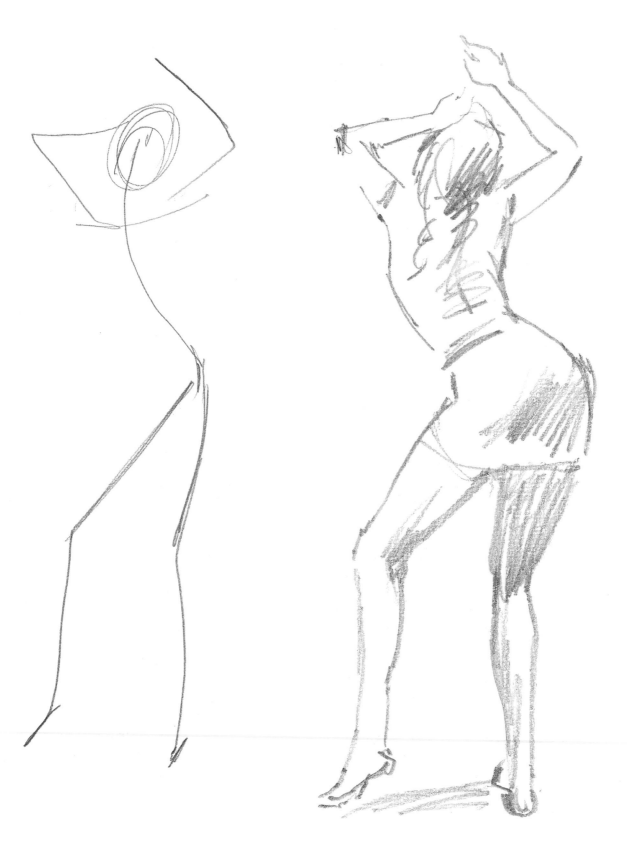

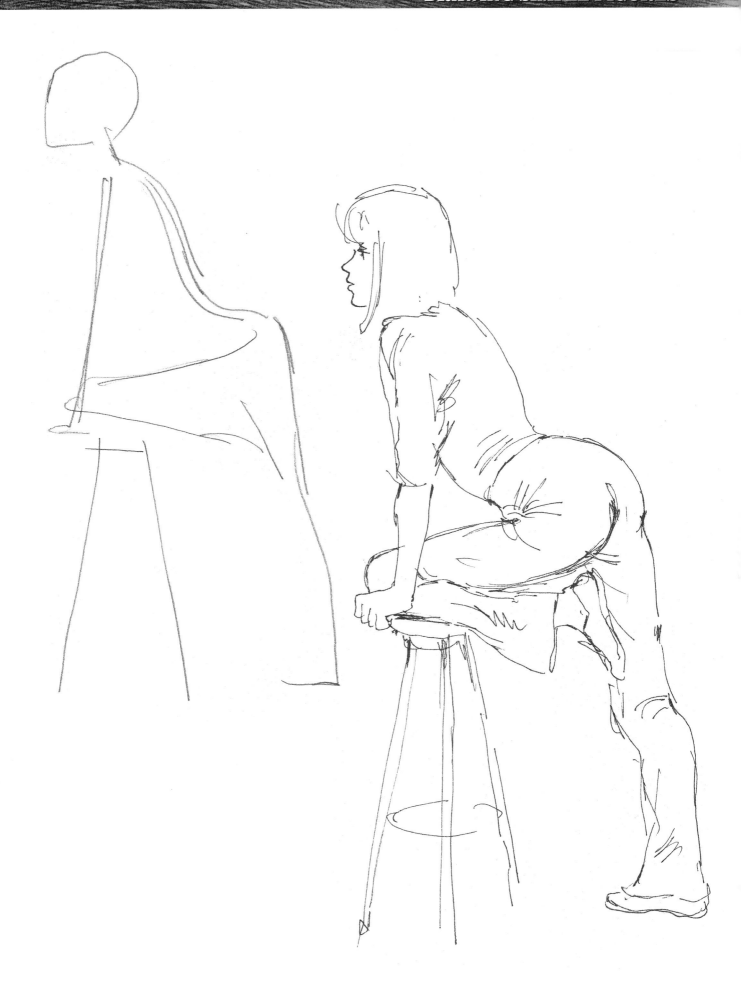

BLOCKING IN THE SHAPE

Here we look at the figure as a whole and try to simplify the drawing by blocking in the main area as a simple geometric shape before engaging with the detail. You won't always have to do this, as once you are more proficient you'll be able to project it as a mental image. However, at the beginning it's sensible to draw the main shapes so that you're aware of the space that the figure occupies.

In the first figure treated thus (below), I've drawn a large triangle that is taller than it is wide and then marked places where I think that the shoulders, breasts and hips appear on that triangle. Putting a vertical through the centre also helps to get the feeling of the body's position.

In the second drawing (above) the model is half reclining and she more or less fits into a large right-angled triangle with the base larger than the upright. Again I have marked in where the breasts, hips and knees should appear on this triangle to act as a check to my drawing.

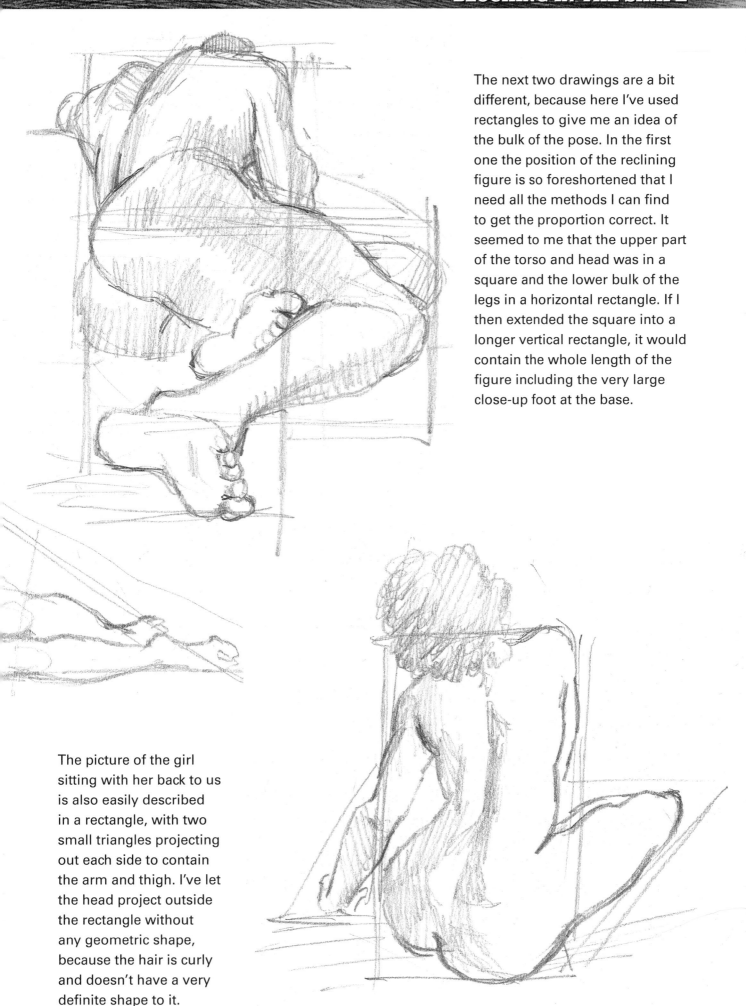

The next two drawings are a bit different, because here I've used rectangles to give me an idea of the bulk of the pose. In the first one the position of the reclining figure is so foreshortened that I need all the methods I can find to get the proportion correct. It seemed to me that the upper part of the torso and head was in a square and the lower bulk of the legs in a horizontal rectangle. If I then extended the square into a longer vertical rectangle, it would contain the whole length of the figure including the very large close-up foot at the base.

The picture of the girl sitting with her back to us is also easily described in a rectangle, with two small triangles projecting out each side to contain the arm and thigh. I've let the head project outside the rectangle without any geometric shape, because the hair is curly and doesn't have a very definite shape to it.

In this drawing I've shown a figure in an unusual position, stretching down to touch a toe. Again I've indicated the blocked-out mass of the form with geometric lines that encompass the shape made by the active figure.

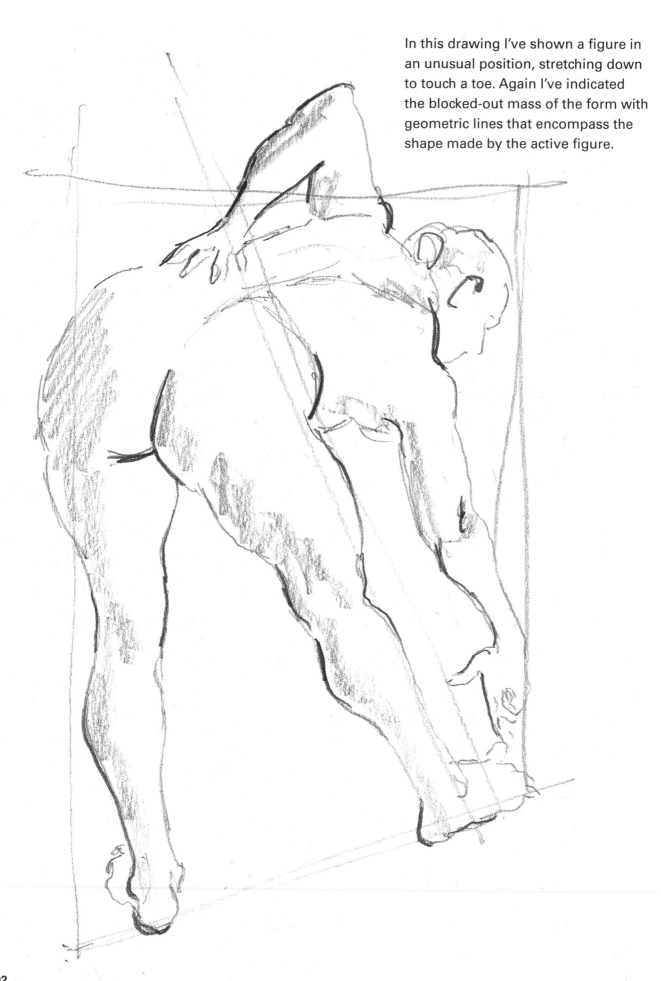

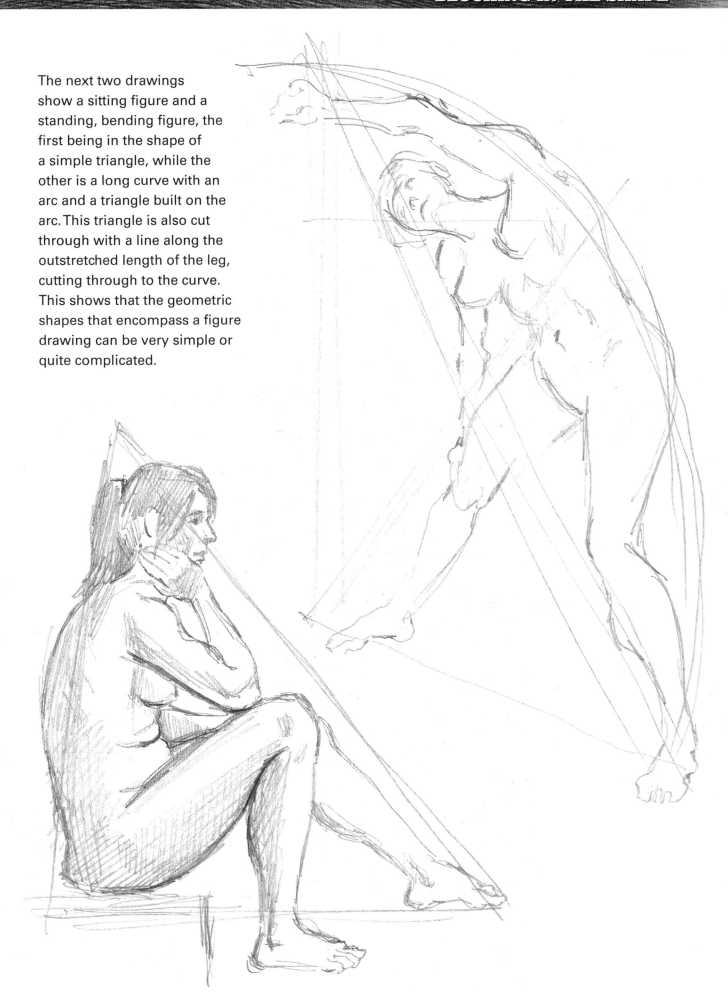

The next two drawings show a sitting figure and a standing, bending figure, the first being in the shape of a simple triangle, while the other is a long curve with an arc and a triangle built on the arc. This triangle is also cut through with a line along the outstretched length of the leg, cutting through to the curve. This shows that the geometric shapes that encompass a figure drawing can be very simple or quite complicated.

EXPRESSIVE FIGURES

Here we are still looking at the human form, but in poses that are less formal and more expressive. The four figures on this spread are not even shown in full, because my interest is in the gesticulating hands. Once again these might be easier for you to draw from photographs that have frozen the moment.

Block these in to start with as you did before, but pay particular attention to the position of the hands. One girl looks as if she is ticking off points on her fingers, one man is gesturing to draw attention to something, the other girl is in the process of combing her hair and the last man is sitting down to draw something . . . perhaps you!

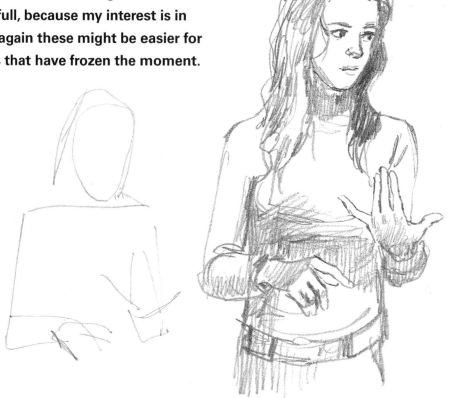

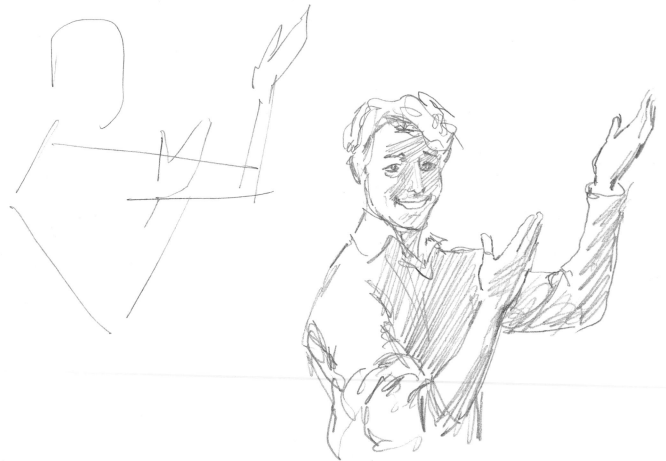

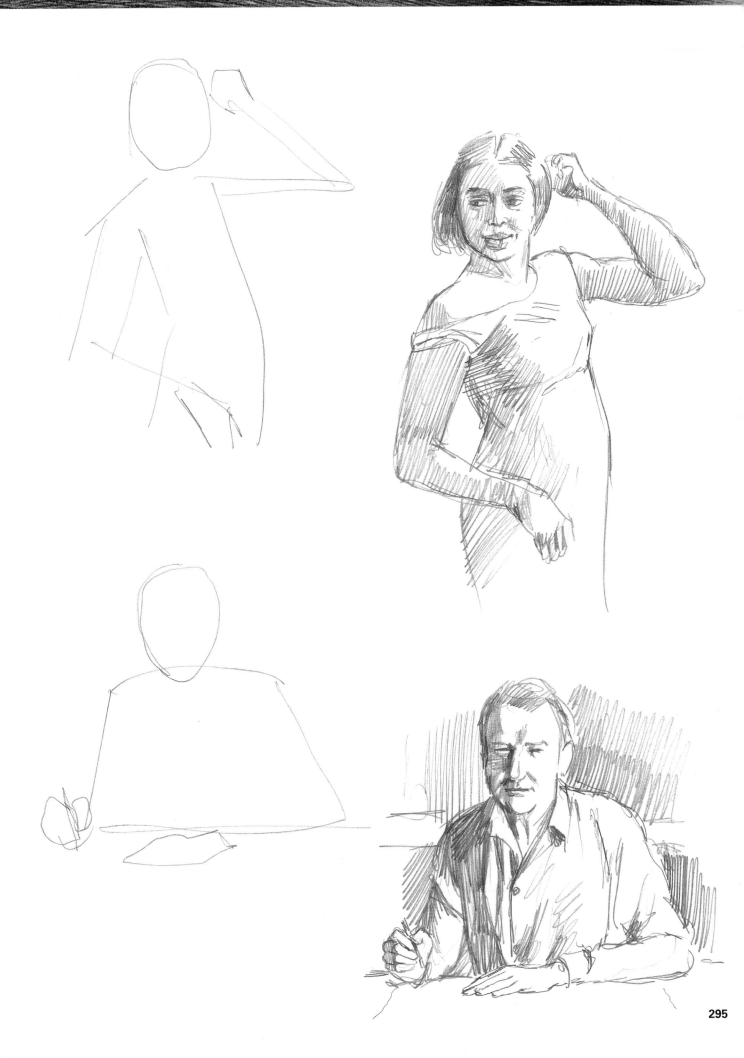

FORESHORTENED FIGURES

The next drawings look at figures which are lying and sitting in such a way that some of their limbs are foreshortened, making your task more difficult. You will have to look carefully at how the proportions of the limbs differ from how they would appear if the same figures were standing up.

Here, the first girl sits with her legs folded under her, supporting herself with her hands. Her feet and knees project forwards from her trunk and are shown proportionately larger.

The girl lying down holding her knees creates the problem of working out the proportion of both the arms and legs because of the angle we see them from.

In the case of the girl lying down with her head towards us, the legs appear much shorter and the head correspondingly larger than we tend to expect. Expectations are always a distraction in art, and it's better to try to reject them. Instead, remember to observe closely and draw what you can really see, not your assumptions about a subject.

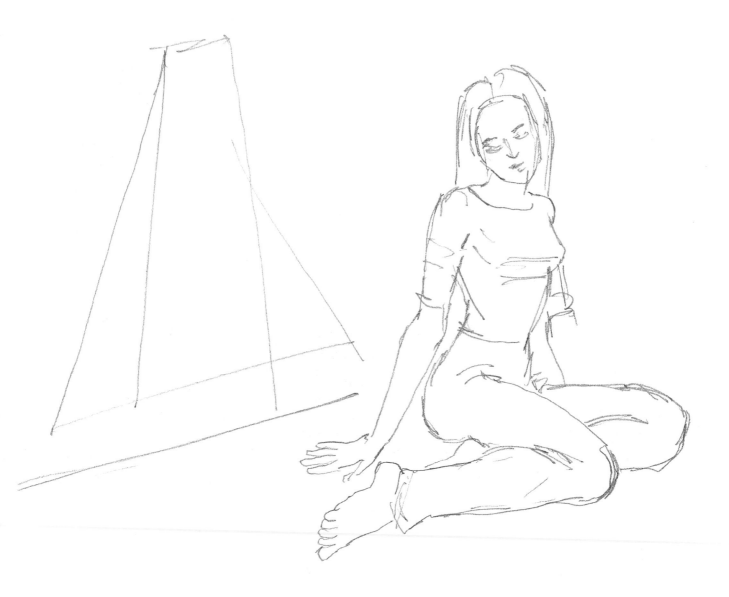

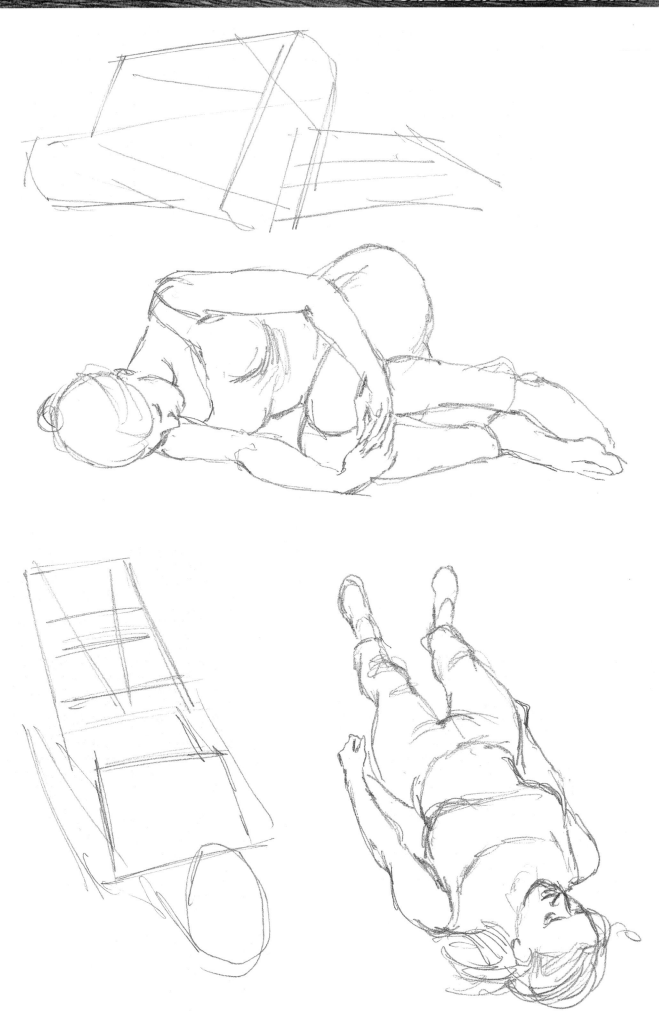

More foreshortened figures

Finally we have three male figures in poses where the foreshortening of the limbs needs to be noticed as you draw them. When you ask your friends or family to pose for you, make sure that sometimes they sit with their limbs advancing or receding to create this opportunity for you to draw in perspective.

The first figure, sitting on a stool, is relatively straightforward where the legs are concerned, but the folded arms pose a foreshortening problem. The second man is seen almost from above, so that the arm he is resting on half disappears, and the bent lower leg is almost hidden from our sight.

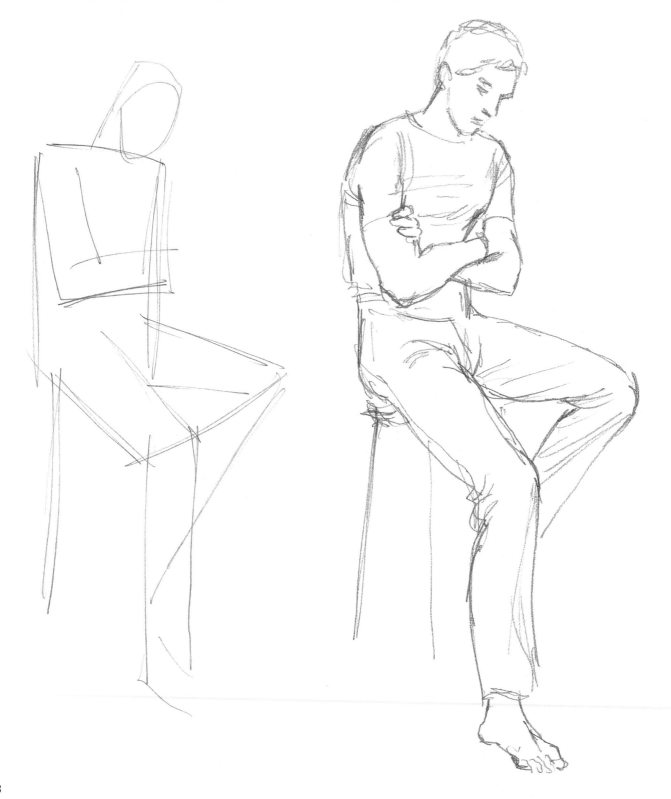

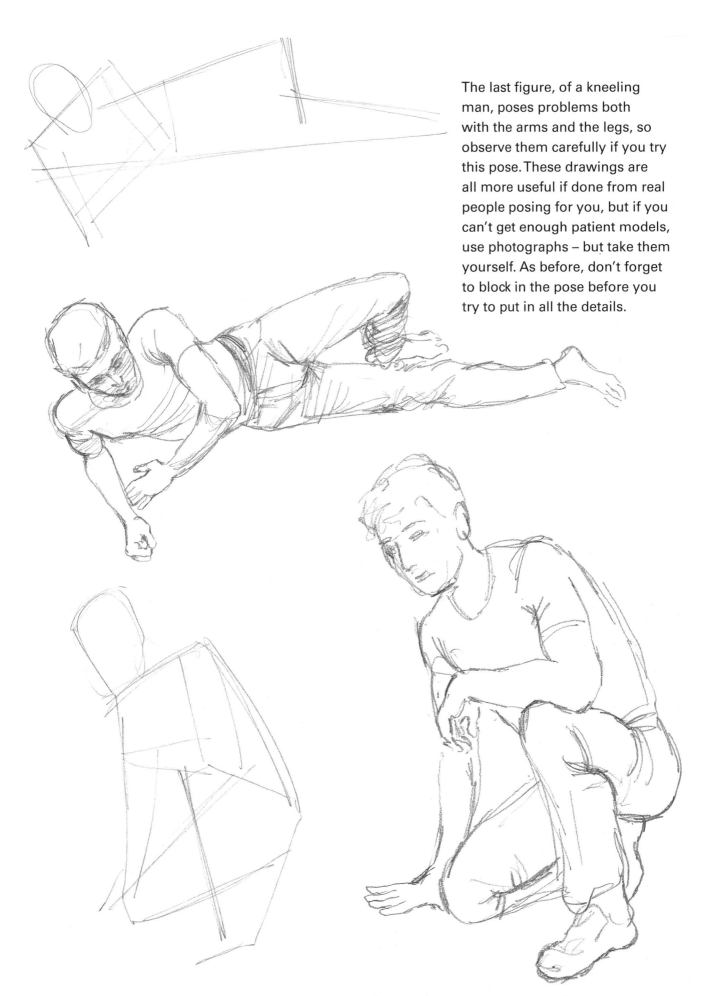

The last figure, of a kneeling man, poses problems both with the arms and the legs, so observe them carefully if you try this pose. These drawings are all more useful if done from real people posing for you, but if you can't get enough patient models, use photographs – but take them yourself. As before, don't forget to block in the pose before you try to put in all the details.

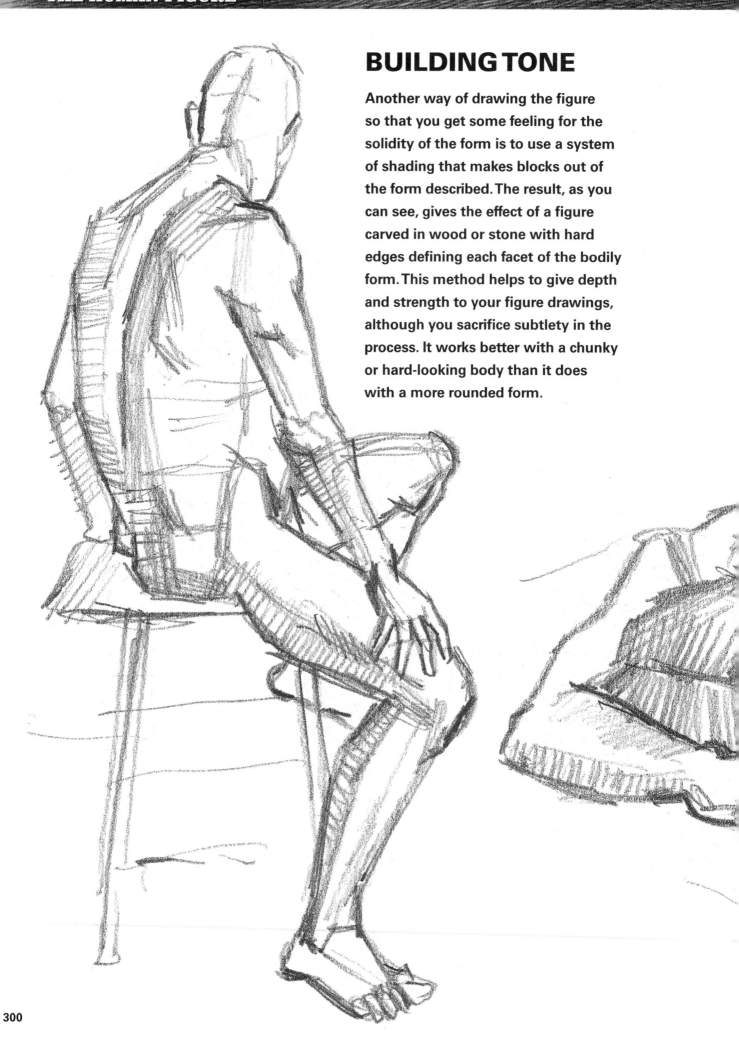

BUILDING TONE

Another way of drawing the figure so that you get some feeling for the solidity of the form is to use a system of shading that makes blocks out of the form described. The result, as you can see, gives the effect of a figure carved in wood or stone with hard edges defining each facet of the bodily form. This method helps to give depth and strength to your figure drawings, although you sacrifice subtlety in the process. It works better with a chunky or hard-looking body than it does with a more rounded form.

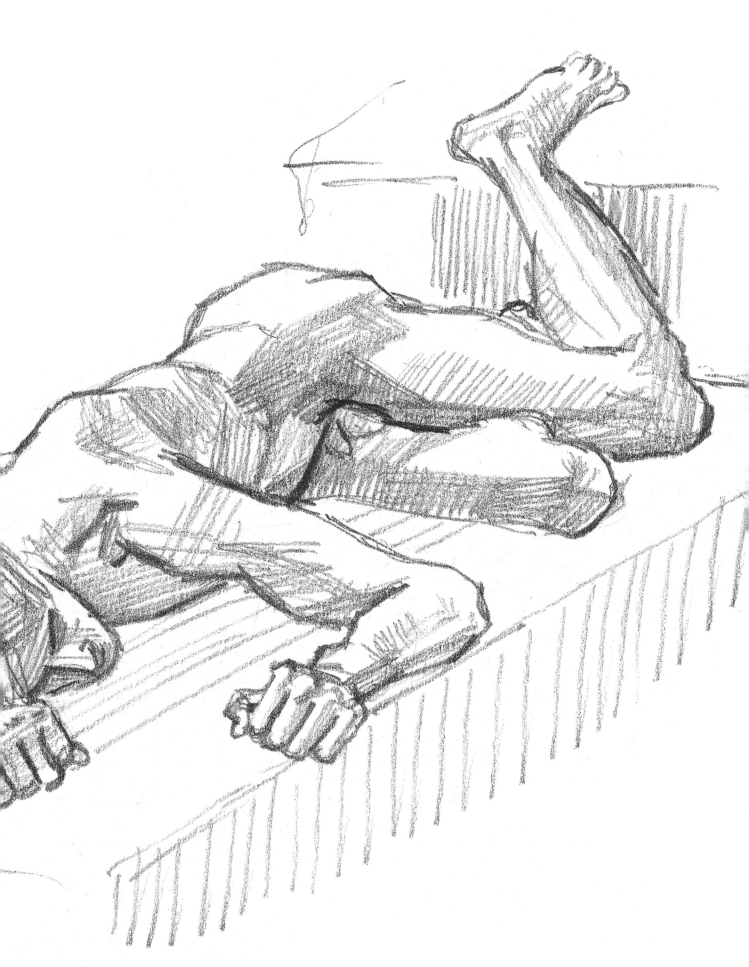

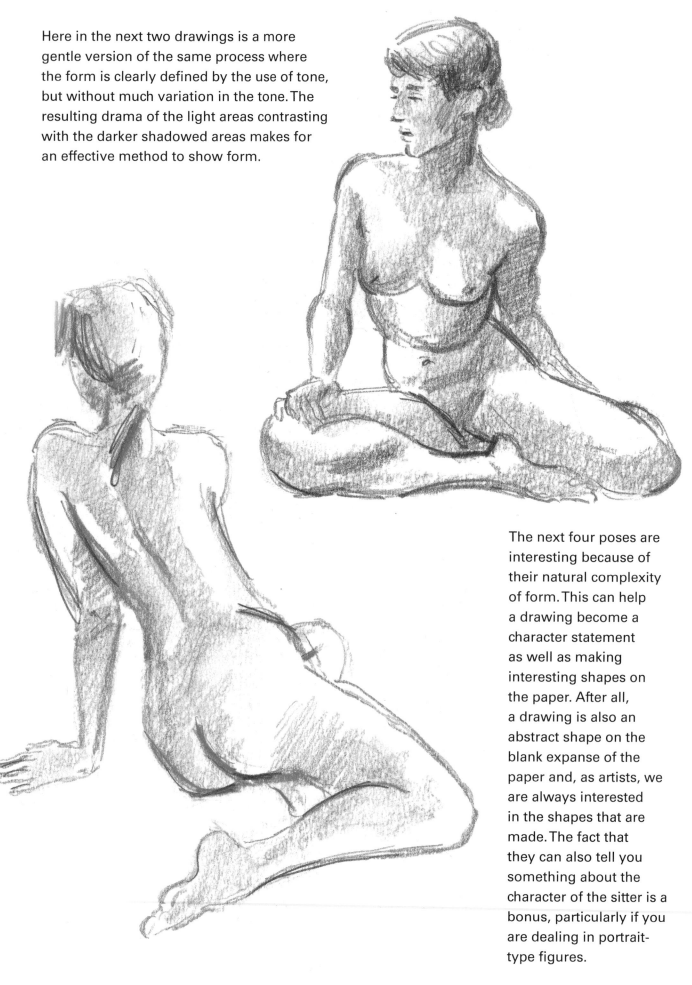

Here in the next two drawings is a more gentle version of the same process where the form is clearly defined by the use of tone, but without much variation in the tone. The resulting drama of the light areas contrasting with the darker shadowed areas makes for an effective method to show form.

The next four poses are interesting because of their natural complexity of form. This can help a drawing become a character statement as well as making interesting shapes on the paper. After all, a drawing is also an abstract shape on the blank expanse of the paper and, as artists, we are always interested in the shapes that are made. The fact that they can also tell you something about the character of the sitter is a bonus, particularly if you are dealing in portrait-type figures.

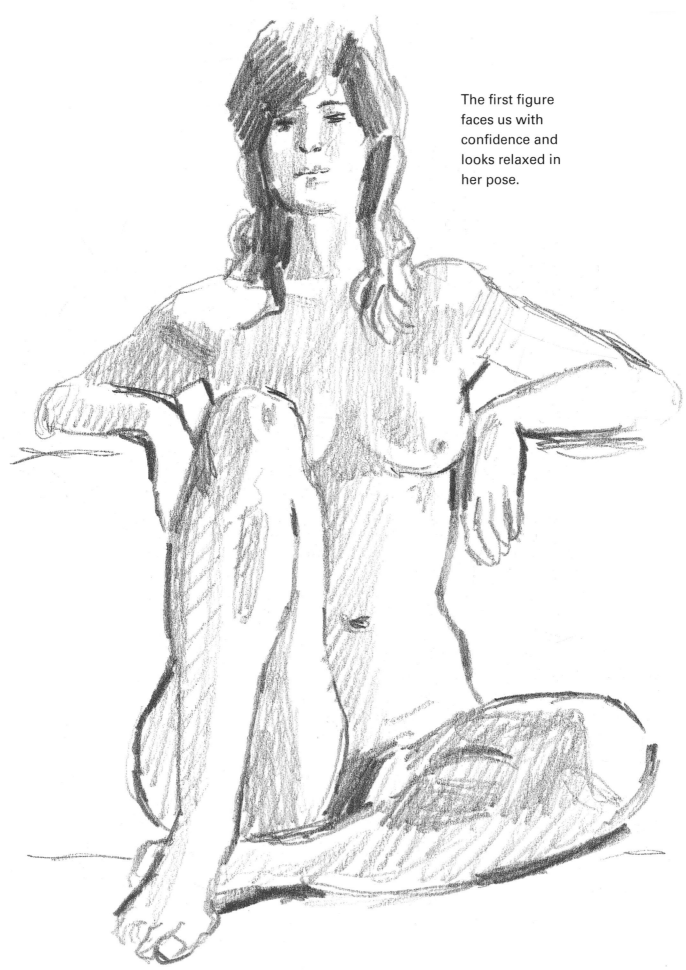

The first figure
faces us with
confidence and
looks relaxed in
her pose.

The second figure looks slightly bored with the whole proceeding, as if she can't wait for the drawing session to be finished.

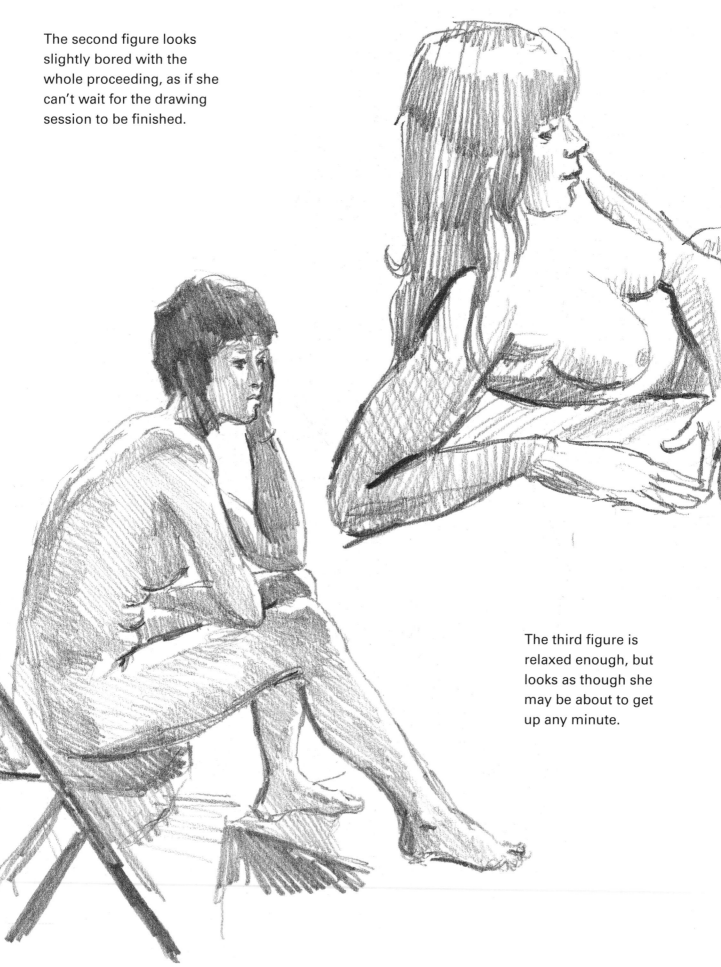

The third figure is relaxed enough, but looks as though she may be about to get up any minute.

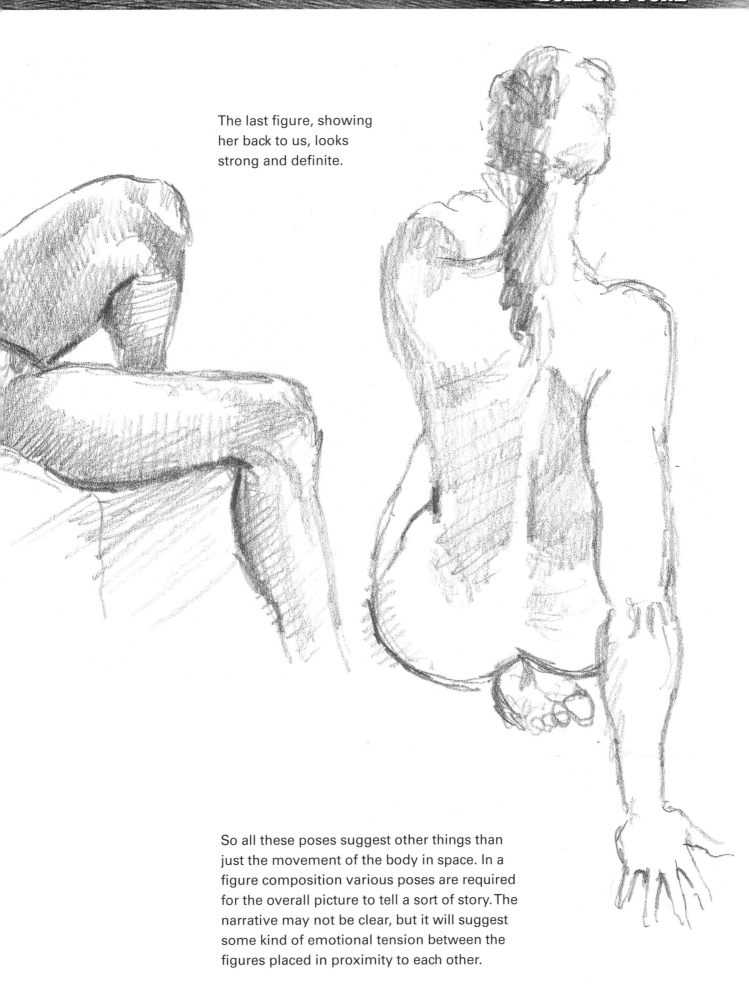

The last figure, showing her back to us, looks strong and definite.

So all these poses suggest other things than just the movement of the body in space. In a figure composition various poses are required for the overall picture to tell a sort of story. The narrative may not be clear, but it will suggest some kind of emotional tension between the figures placed in proximity to each other.

THE WHOLE BODY IN MOVEMENT

First, we look at the body leaping through the air, an action which involves all the limbs and the head as well as the torso. Everything is adjusted to keep the balance and make sure that when the body lands back on the ground it will not damage itself.

This girl is leaping through the air in a forward spring and has the grace of a dancer; many of these figures have been drawn from photographs specially taken to help artists and illustrators to render bodies in motion. The muscles most clearly seen in this drawing are those in the upper legs and across the chest and rib cage.

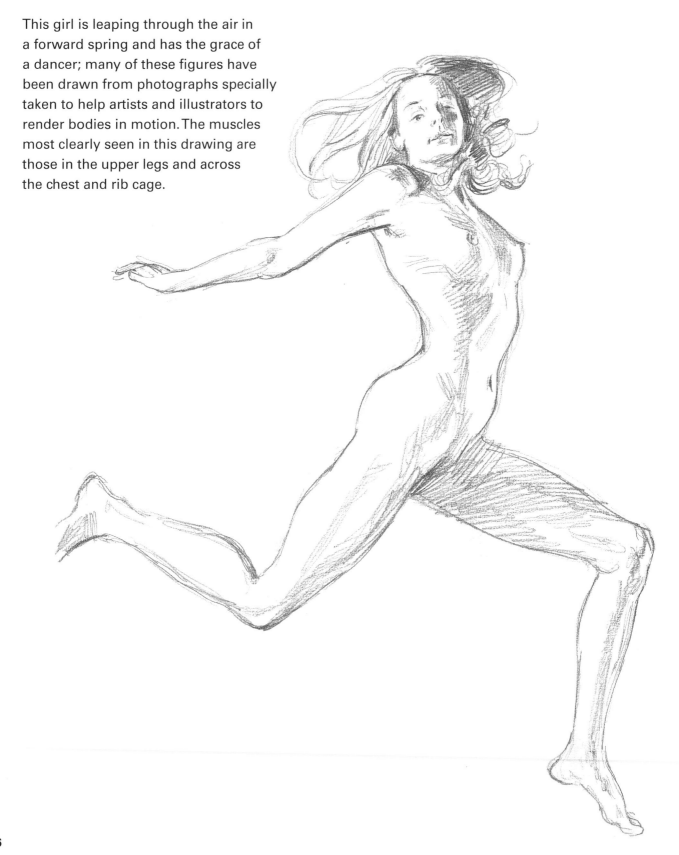

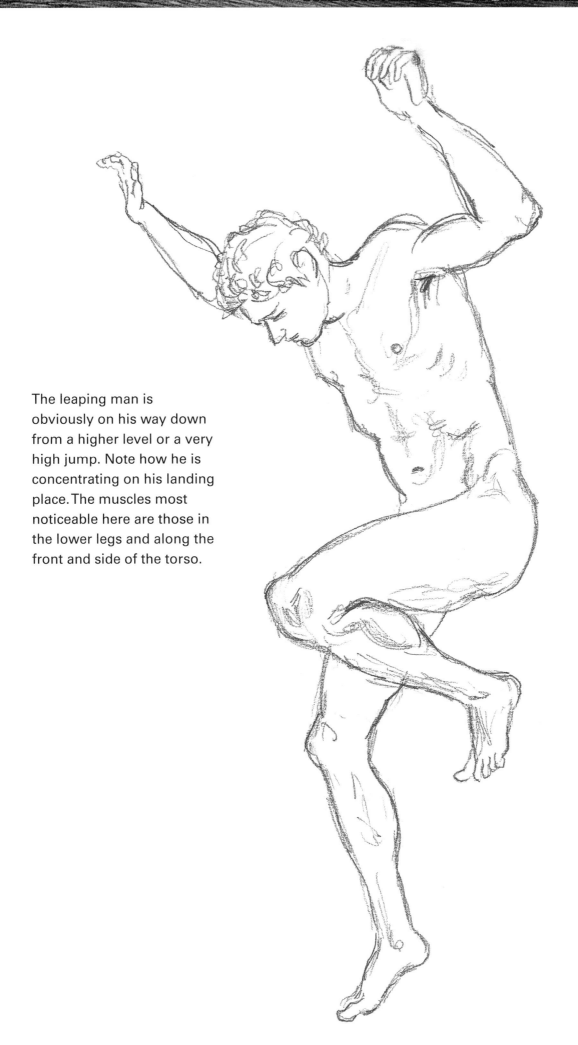

The leaping man is obviously on his way down from a higher level or a very high jump. Note how he is concentrating on his landing place. The muscles most noticeable here are those in the lower legs and along the front and side of the torso.

Bending and stretching

The next drawings show models bending and stretching, which, although not a very energetic movement, does bring many of the muscles into play. The girl bending sideways is stretching her thigh muscles as well as all the muscles down one side of her torso.

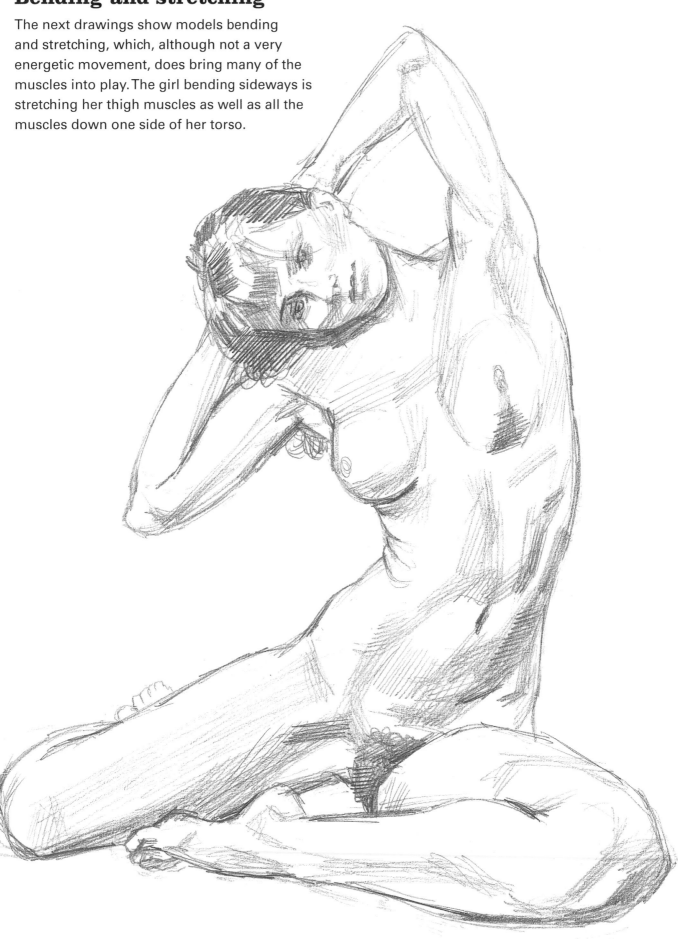

The girl bending over to touch the floor at her feet is stretching both her leg muscles and those of her back.

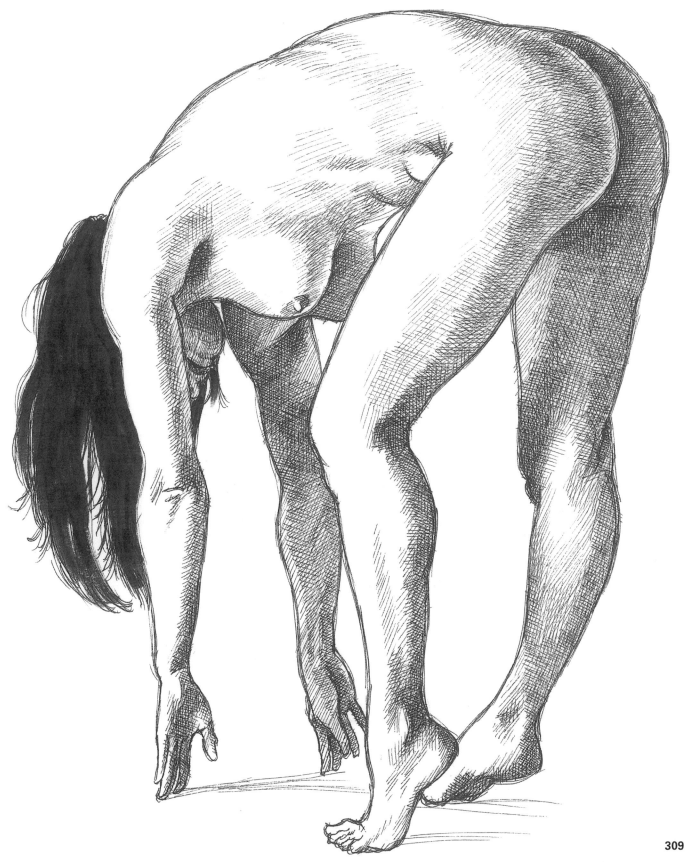

The standing model is stretching her torso down one side and has placed her feet in such a way as to make her legs point in different directions. Note the different muscles being used in the arms.

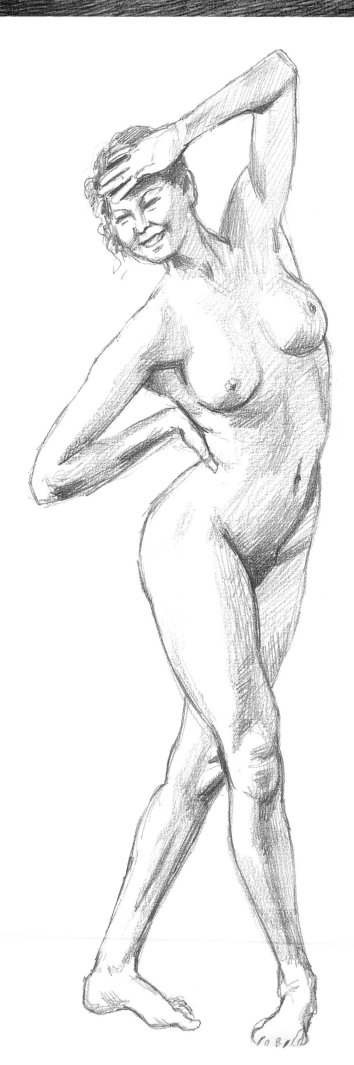

The model sitting cross-legged and stretching her arms above her head is showing very clearly the bony ribcage and her knee joints.

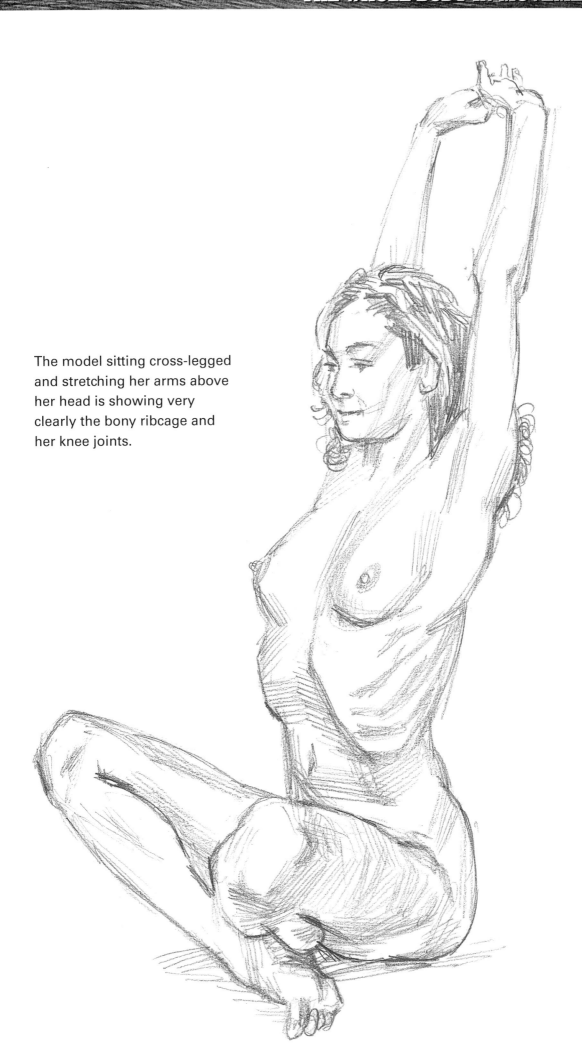

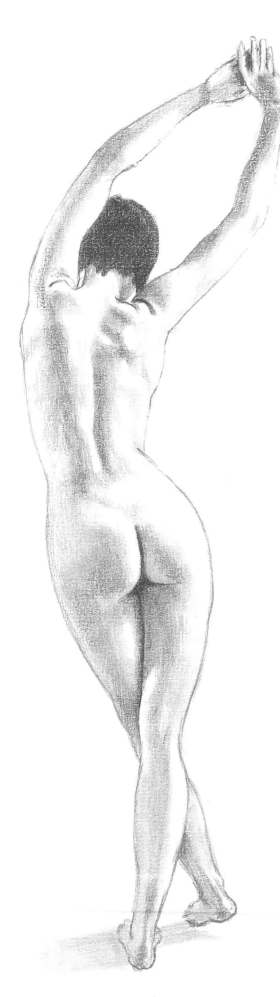

Dancing and posing

The next three poses make it look as if the models are dancing, using their bodies in a way that makes the most of the opposition of the arms and legs. Their torsos are also turned to show how the muscles are being used. Like sport, dance employs exaggerated movement. Normally the body wouldn't be worked as thoroughly as this.

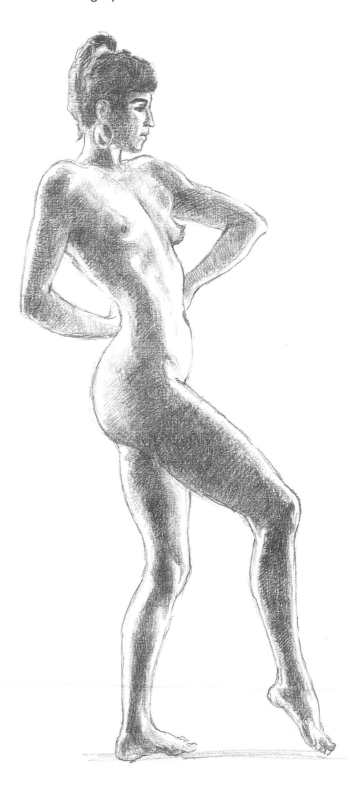

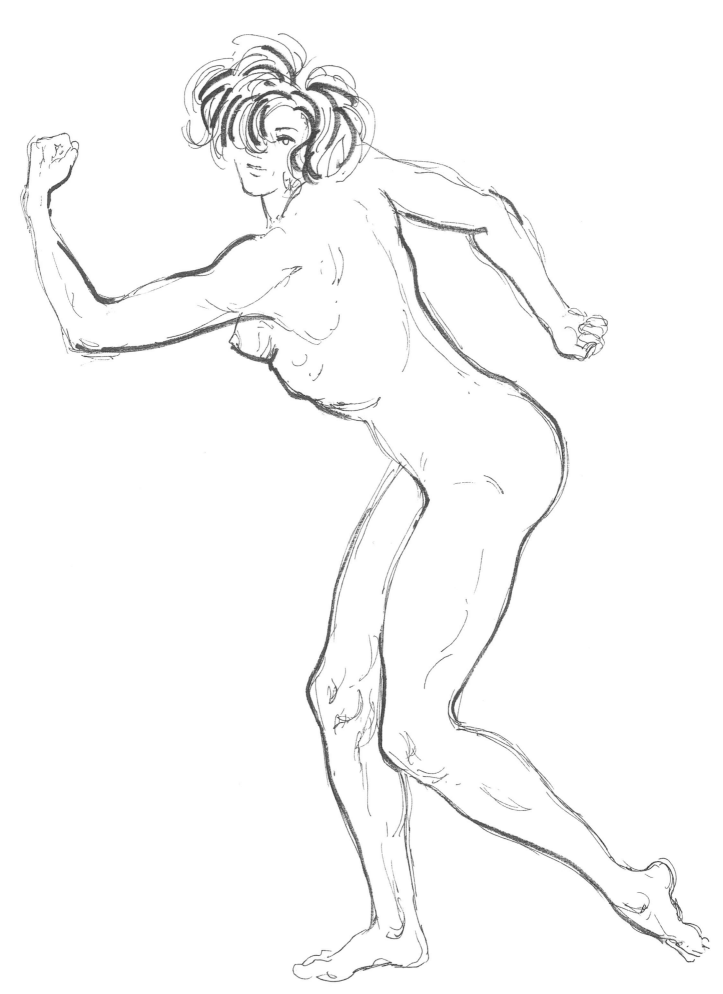

Climbing

Now we come to climbing, one of the more extreme sports, which relies on tremendous muscle co-ordination. It is also the sport which calls most upon your sense of balance and the ability to grip well with your hands and feet. Observe the great tension shown in the body when it is clinging to a difficult rock-face; notice the muscles in the arms and back.

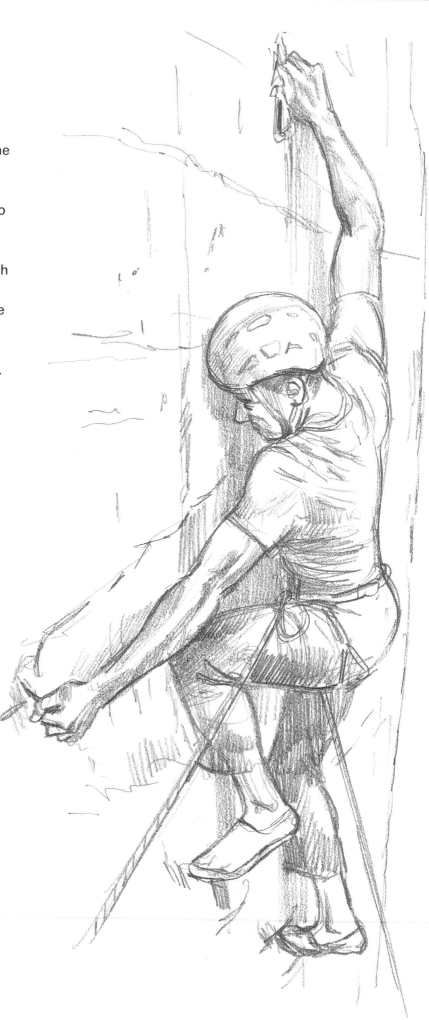

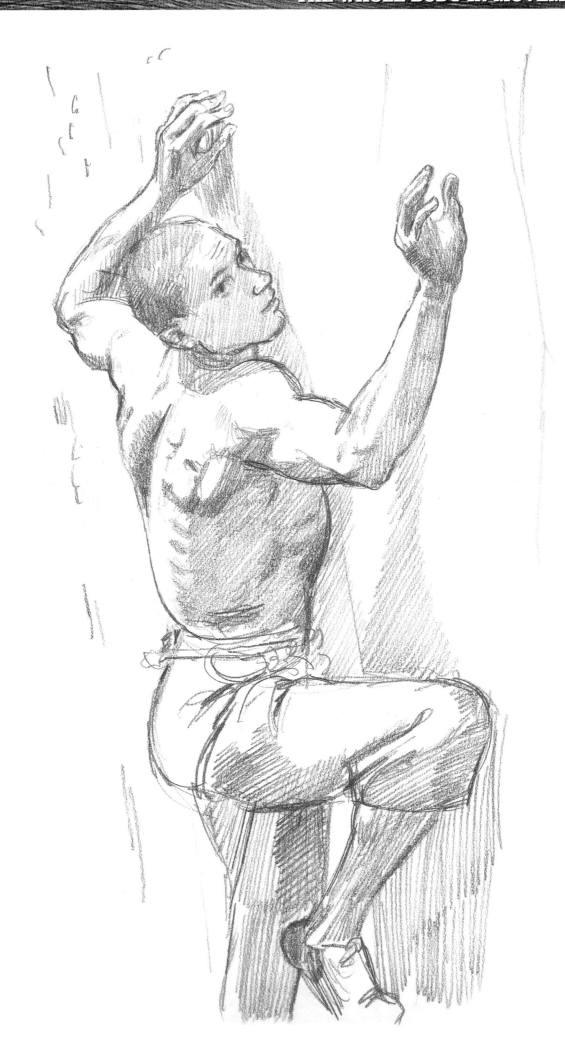

Here are three more climbers, with their legs stretching out to encompass the space between footholds. In the first female climber, it is possible to see how the legs, arms and back muscles are being worked.

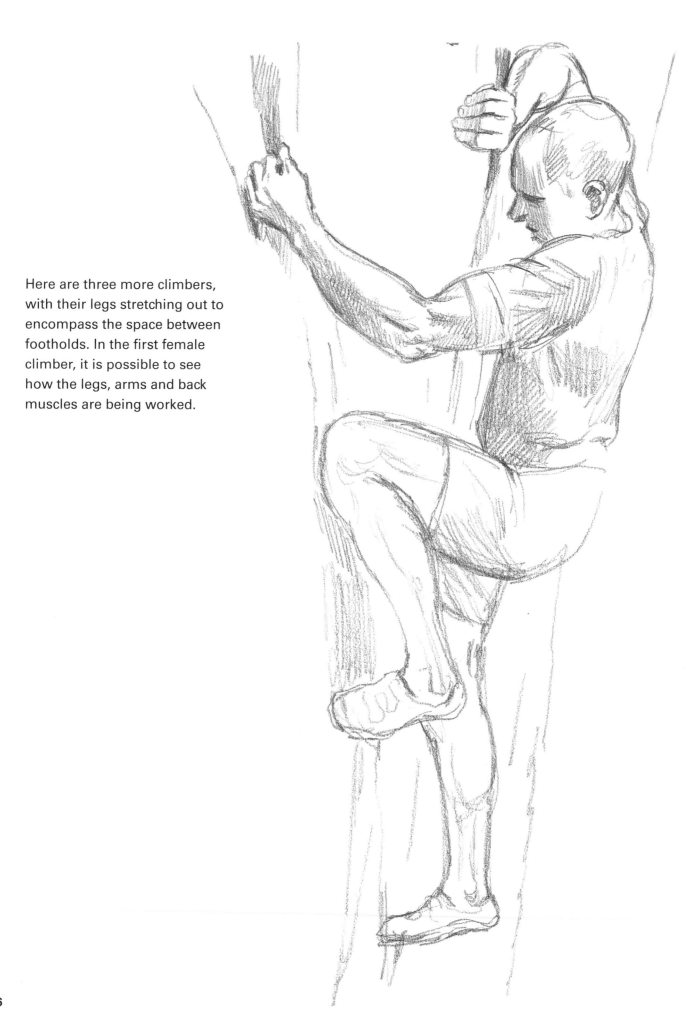

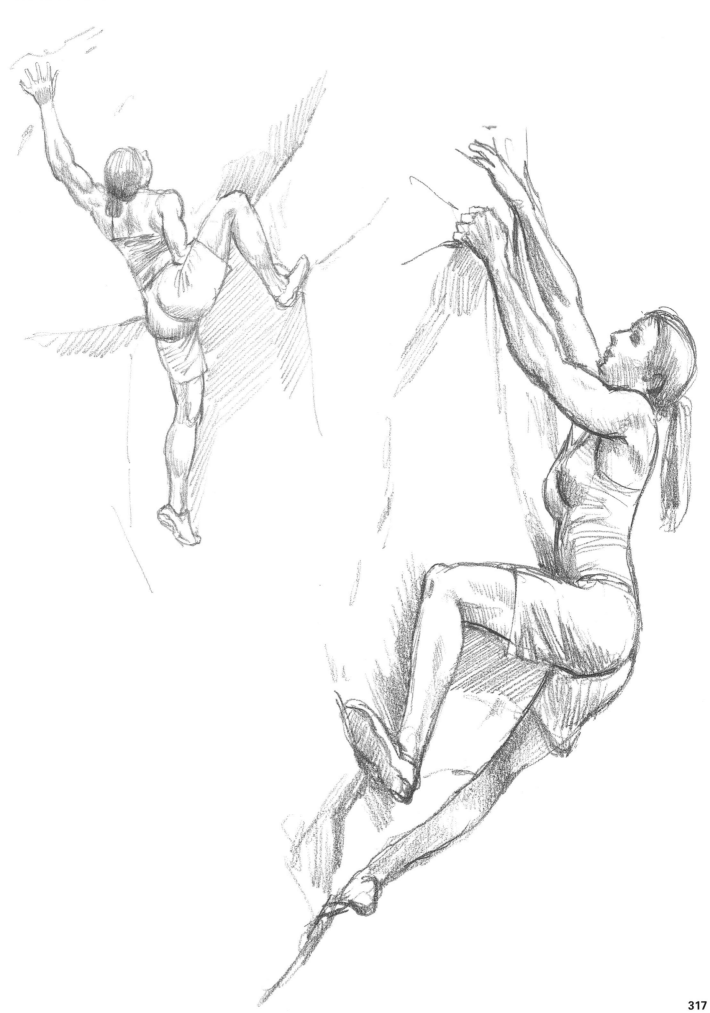

Football

The popular sport of football provides us with many examples of energetic movement, although the players' sporting strip only reveals the muscles in the legs and arms. The first two players, one tackling the other, demonstrate how powerful the action can be in competitive sports.

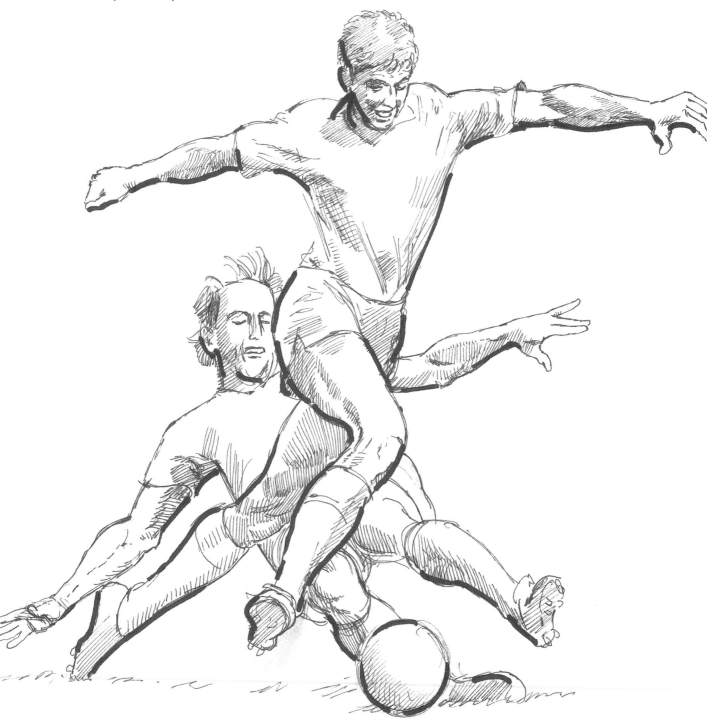

The next three footballers show the movements involved in kicking a ball when in play. The movement of the player at the bottom right is very controlled and almost acrobatic.

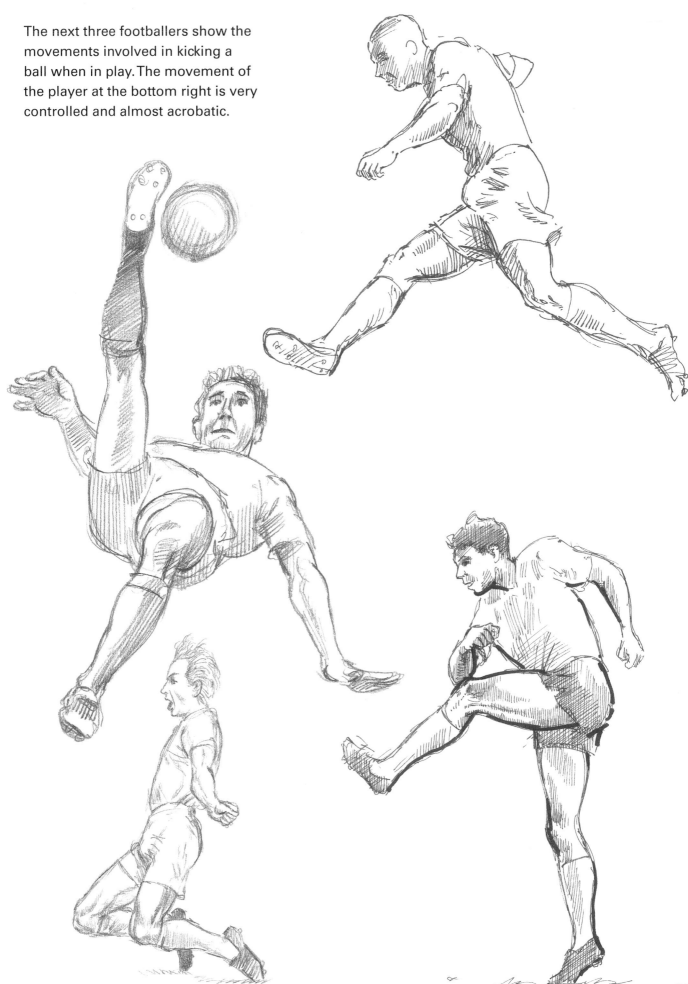

The next four pictures show the balance
and effort required when moving fast
and trying to control a ball with your
feet at the same time. Notice how, in
every case, the players are using their
limbs to keep the body in movement
and balanced at the same time.

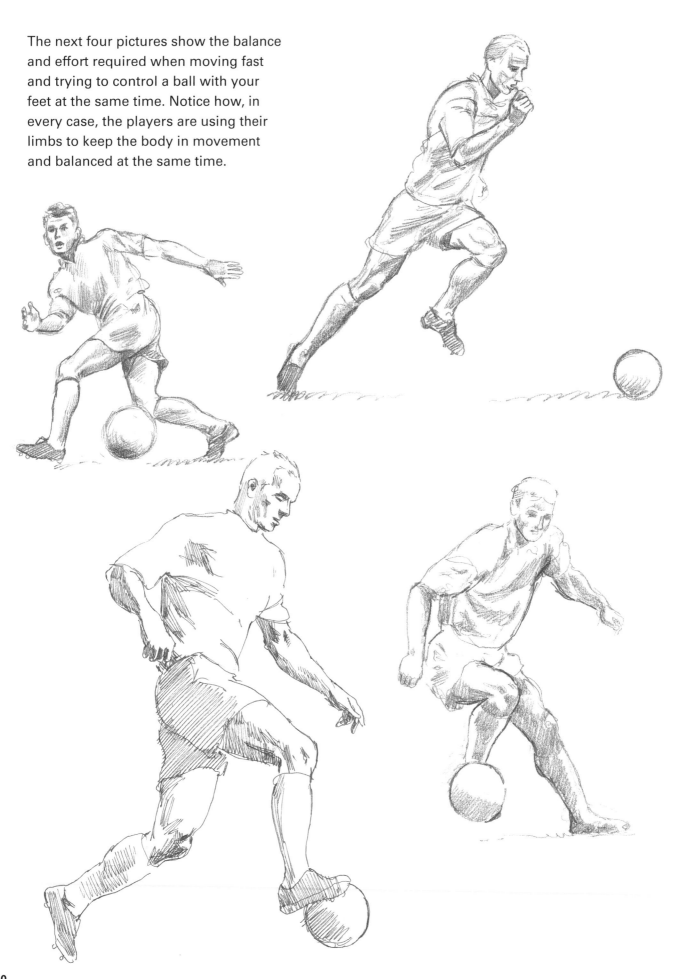

The last football picture is of two
players falling after a collision on the
field, and it is clear that their balance
has gone and their bodies are trying
desperately to counter this somehow
with the movements of the limbs.

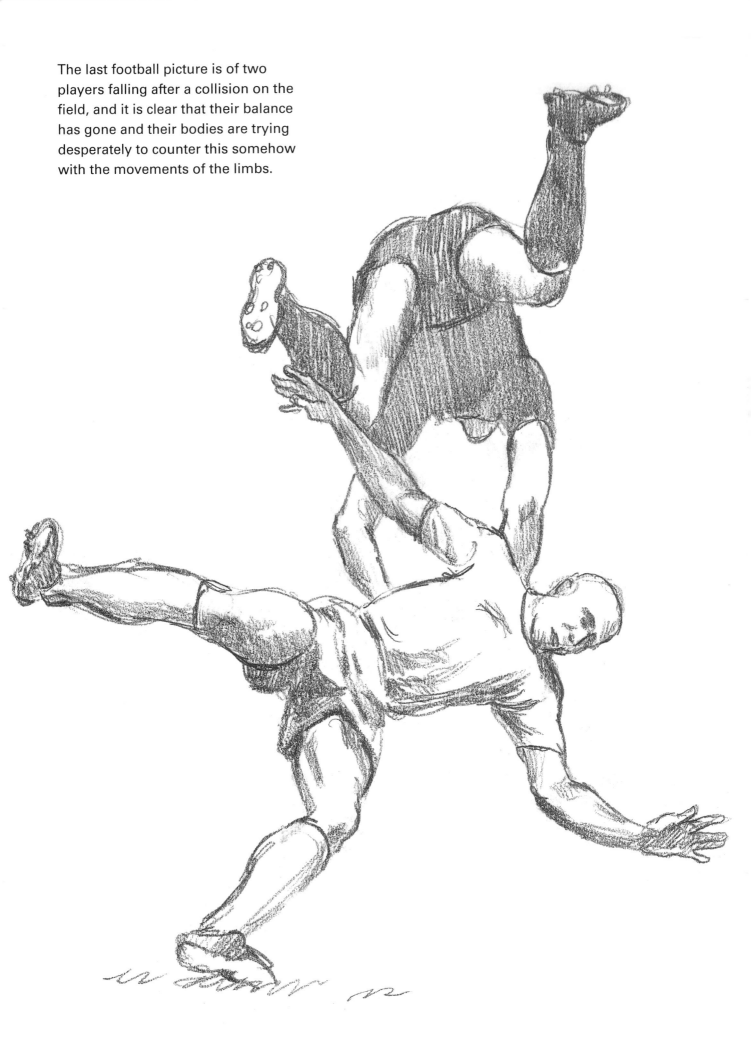

Jumping

We now examine athletes
jumping as high, as far and
as fast as they can. Note
how the body performs to
match and counterbalance
the efforts of leaping.

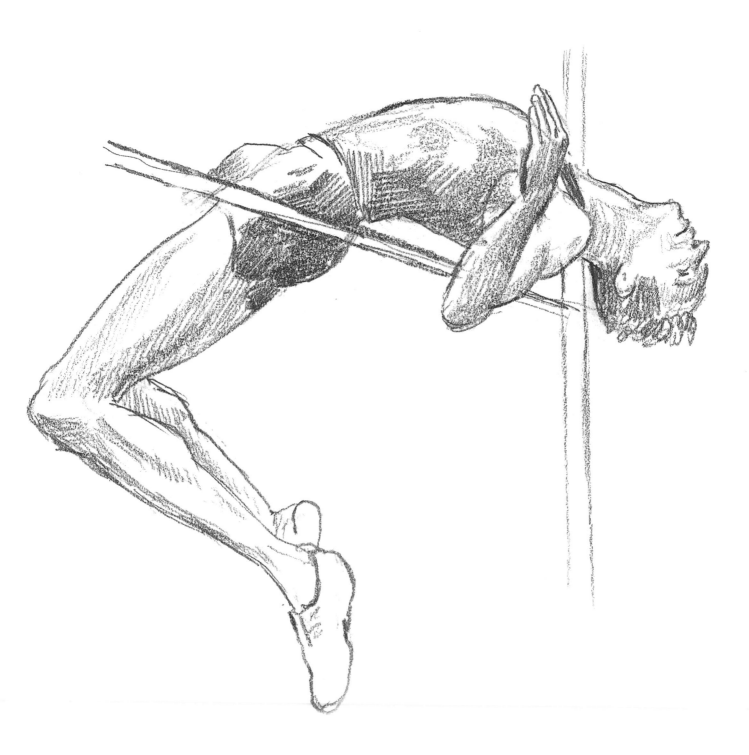

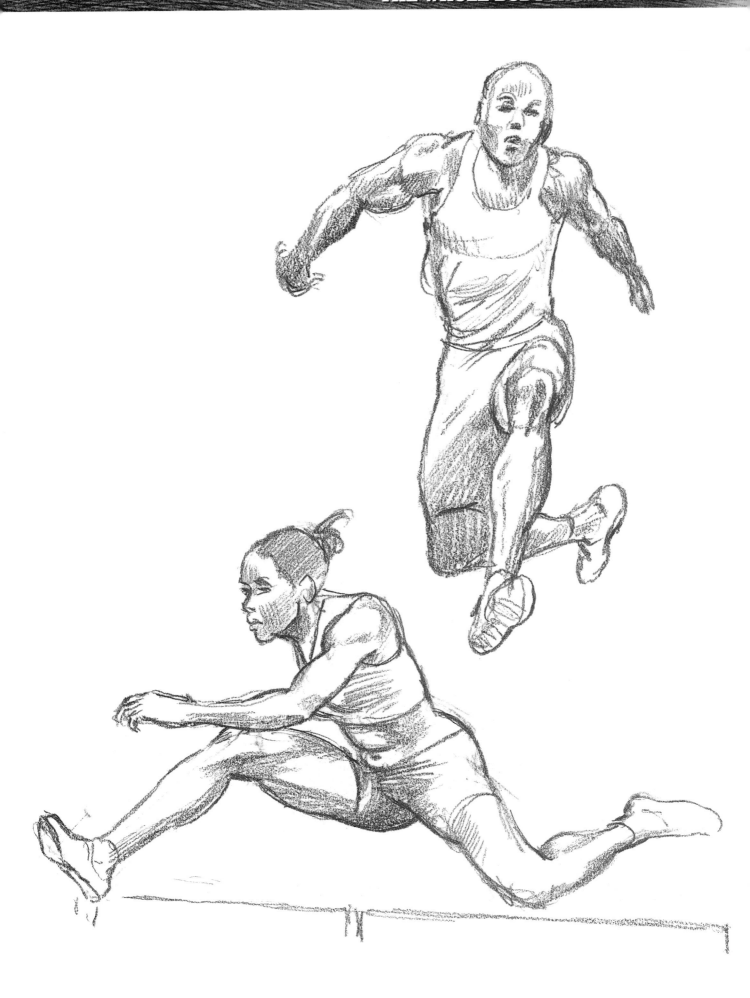

Throwing

The athlete throwing the
discus twists his body and
swings his arms in order
to get maximum power
into his throw.

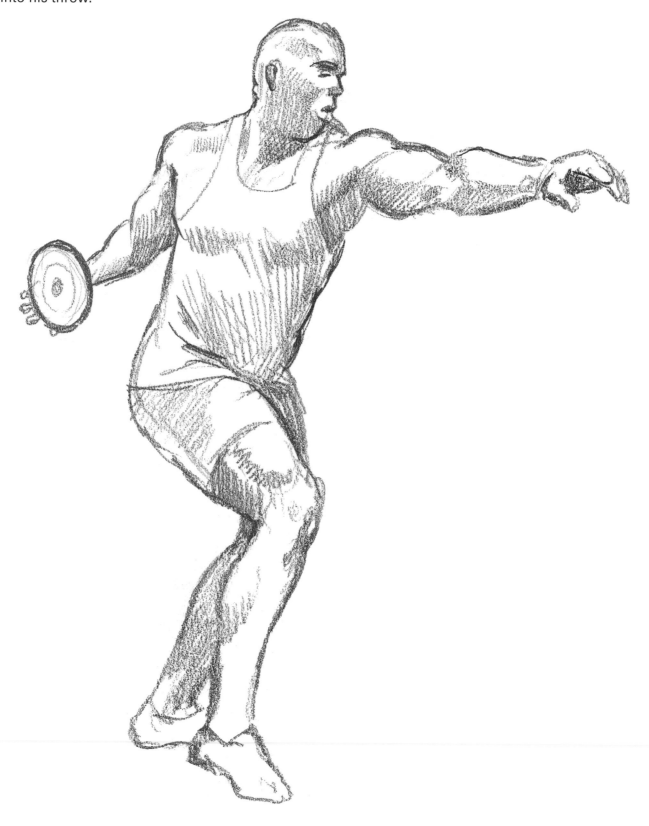

Running

The four runners illustrate the body's efforts to gain speed along a level surface, pumping the arms and legs to keep them moving as fast as possible while remaining balanced and controlled.

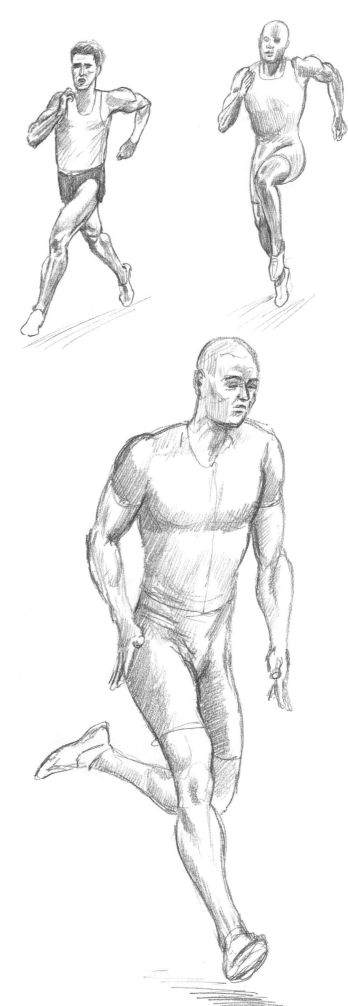

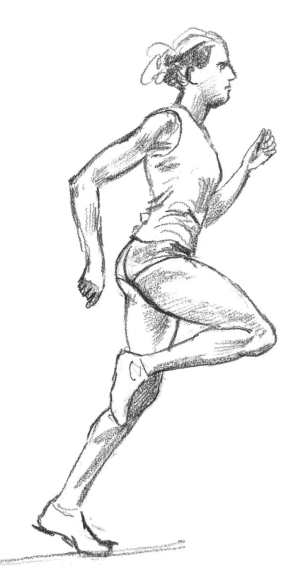

Wrestling

Next we see a pair of wrestlers, straining
to upset their opponent without losing
their own balance.

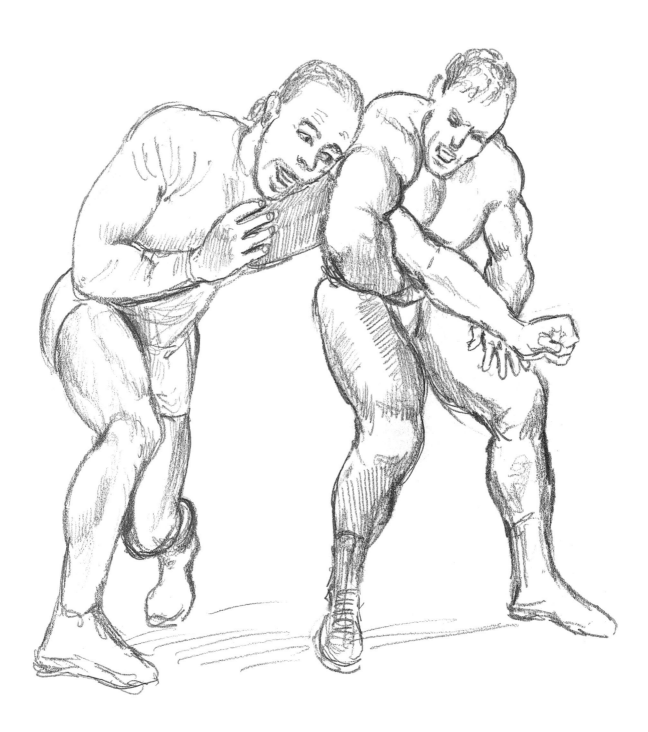

Weightlifting

This weightlifter is a good example of muscle performance under pressure. Note how the facial muscles come into play too. Watching weightlifting is one of the best ways to see clearly how the muscles behave when activated in extreme situations.

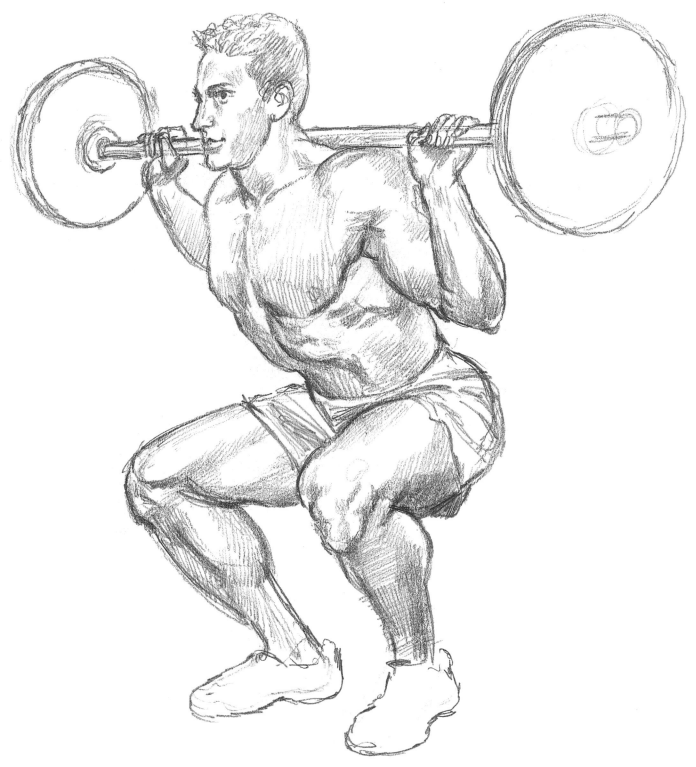

DRAWINGS OF THE WHOLE BODY IN MOVEMENT BY MASTER ARTISTS

This picture of a smith wielding a sledgehammer shows Otto Greiner's thoroughness in informing himself of the muscle movements in the body. A study like this is very informative and would be most useful in producing a finished painting.

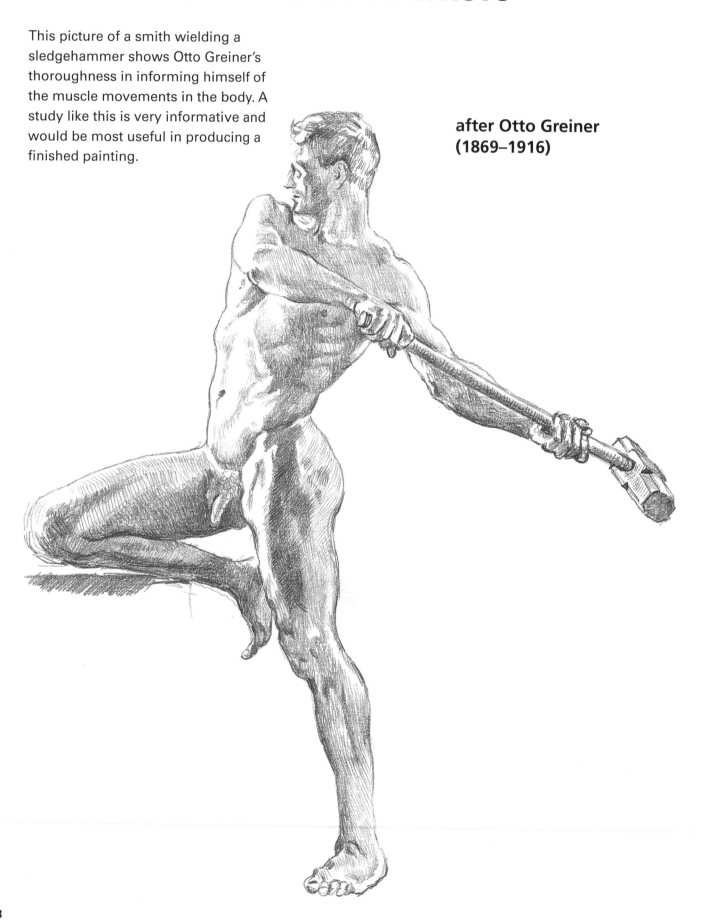

after Otto Greiner (1869–1916)

after Otto Greiner

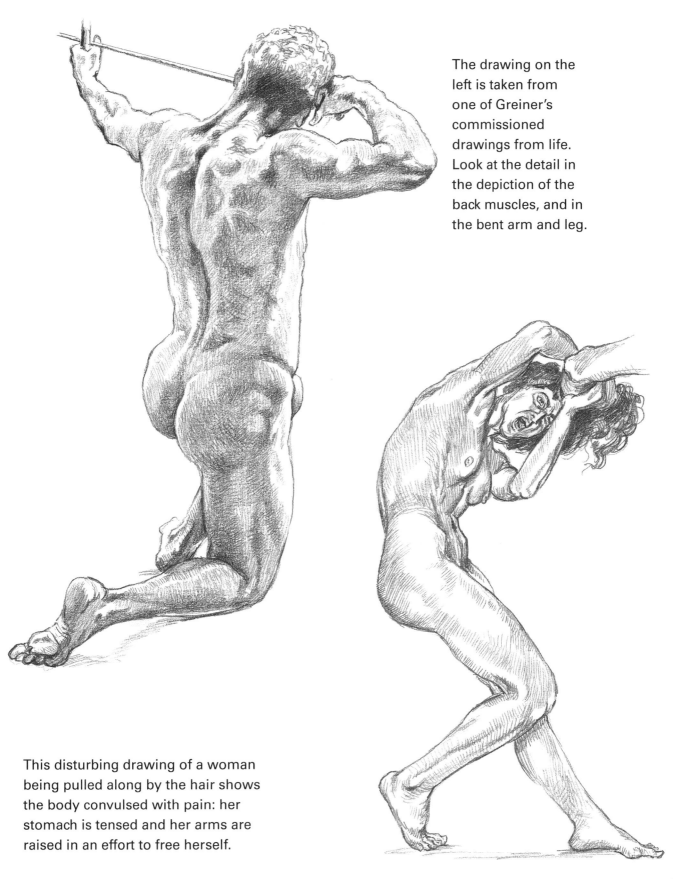

The drawing on the left is taken from one of Greiner's commissioned drawings from life. Look at the detail in the depiction of the back muscles, and in the bent arm and leg.

This disturbing drawing of a woman being pulled along by the hair shows the body convulsed with pain: her stomach is tensed and her arms are raised in an effort to free herself.

329

The first drawing by Ingres is of a
young man bending dramatically
down to gather something up,
while looking backwards.

**after Ingres
(1780–1867)**

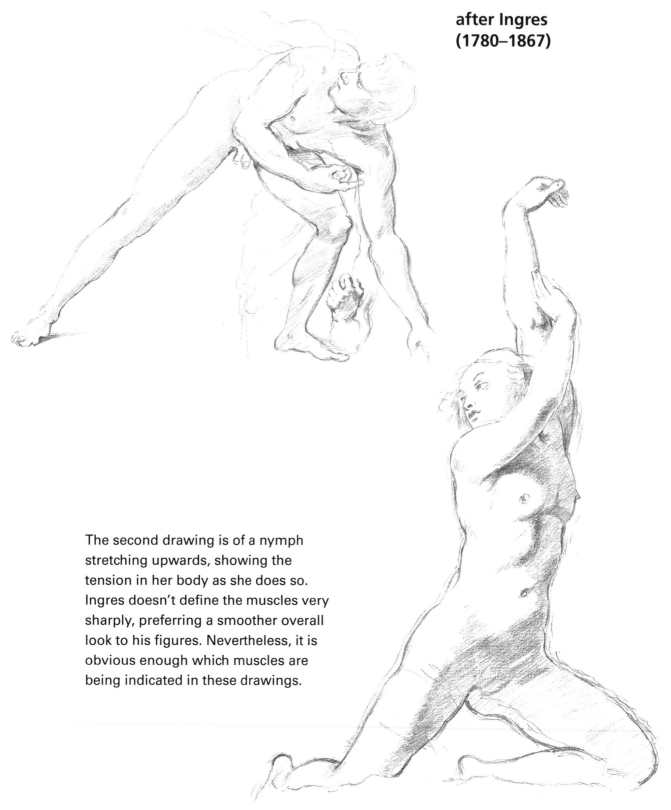

The second drawing is of a nymph
stretching upwards, showing the
tension in her body as she does so.
Ingres doesn't define the muscles very
sharply, preferring a smoother overall
look to his figures. Nevertheless, it is
obvious enough which muscles are
being indicated in these drawings.

The next drawing shows a man lifting a chair above his shoulder as he walks forward. The arm muscles are particularly obvious.

The final Ingres life study shows a man reaching down to lift something from the ground. The stretching of the legs and arms brings into play all the muscles of the limbs.

As happens in many life drawings by accomplished artists, Ingres has drawn extra definitions of the feet in the standing pose and the stretched arm in the drawing below. These workings help to clarify what is actually happening in a complex part of the pose.

after Ingres

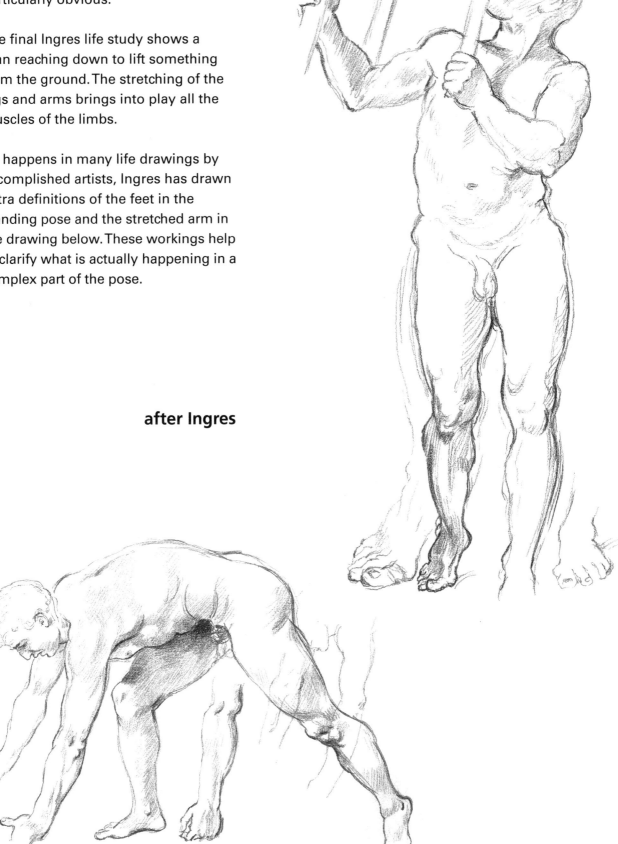

331

FIGURE COMPOSITION

Drawing a figure composition is quite a test of your abilities, and it is helpful to have a theme that makes it easy to assemble a cohesive group. An interesting combination of people can be brought together at an open-air gathering, so here I have chosen the subject of a picnic.

1 First, to develop an idea as to what I might do, I made a rough drawing of a group relaxing around a cloth spread on the ground with items of food and drink on it.

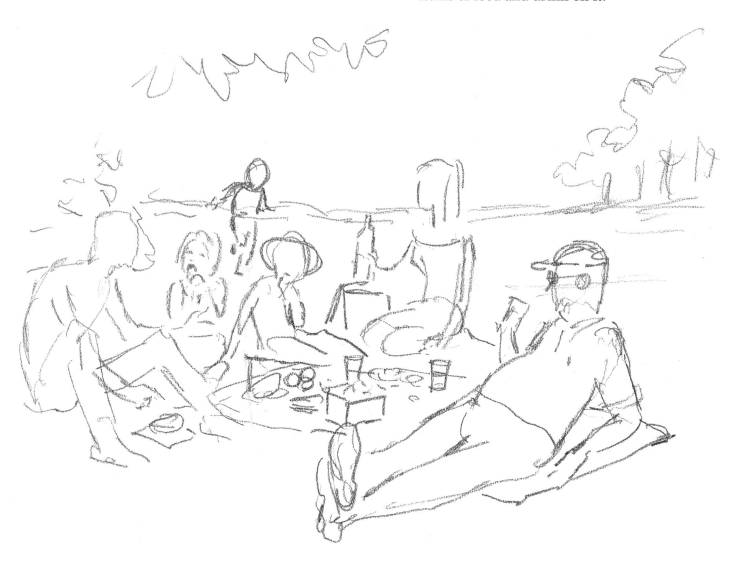

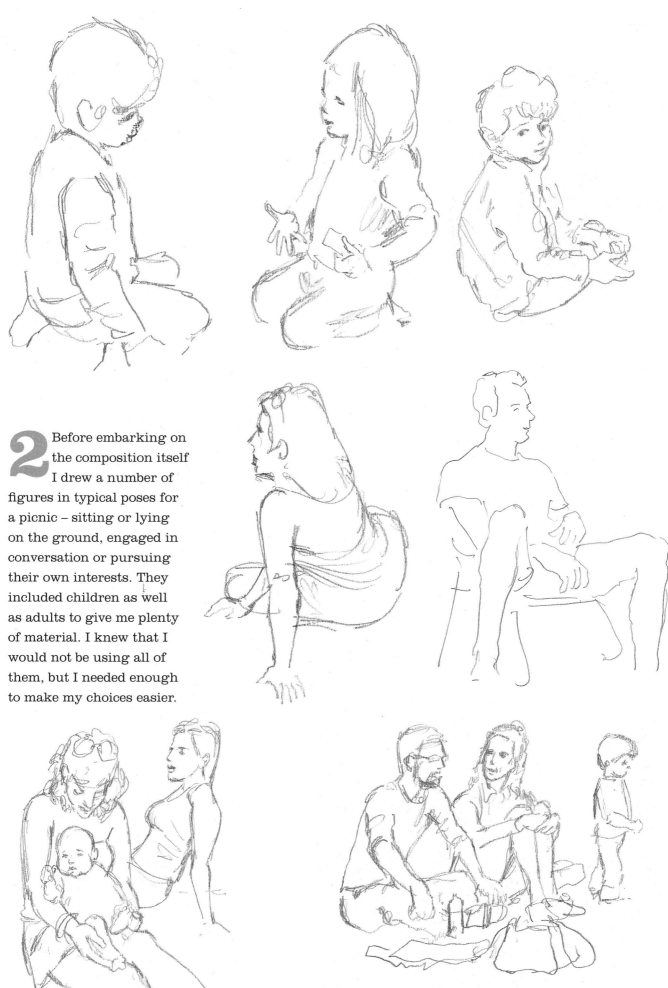

2 Before embarking on the composition itself I drew a number of figures in typical poses for a picnic – sitting or lying on the ground, engaged in conversation or pursuing their own interests. They included children as well as adults to give me plenty of material. I knew that I would not be using all of them, but I needed enough to make my choices easier.

3 Next I scribbled out a preliminary composition that spread out the figures across a space in a garden or park. This seemed a pleasingly tight arrangement and although I eventually moved everything along a bit the composition remained very much the same.

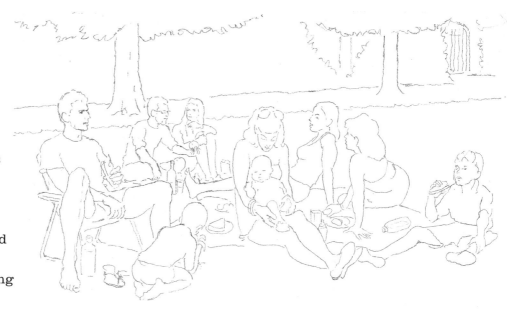

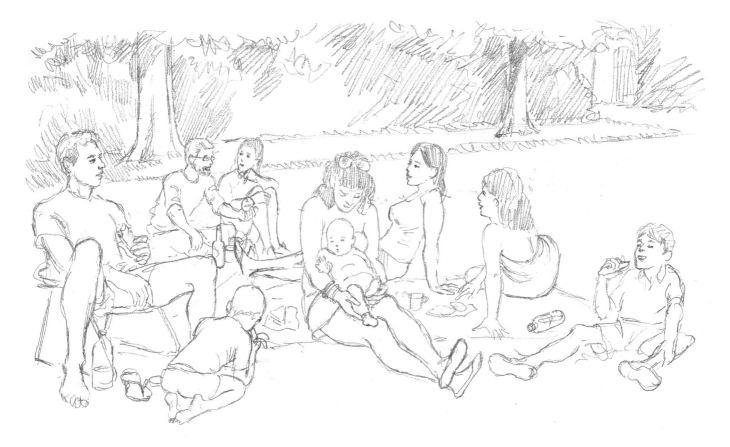

4 Once the picture was clearly drawn up I began to put in tone to show where the sun gave shadows to the figures. I kept the tone as light as possible as I didn't want heavy tones until I was sure that the light tone worked as a whole.

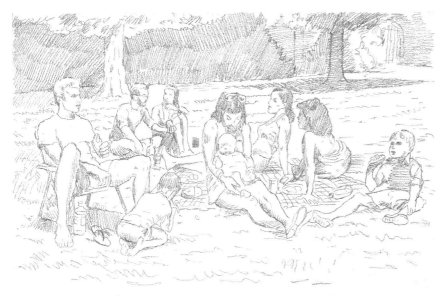

5 The next step was to give more dimension to the scene by putting a layer of tone over all the areas where there is some shadow. This includes the background with its trees in shadow as well as the figures in the foreground.

6 In the final stage, I defined all the subtleties of the picture so that everything started to relate in both space and form, building up the dark tones to get the most effective composition. The texture of the grass on which the figures are sitting was important in order to anchor them to the ground. This process of figure composition from separate drawings is a tough test of your abilities and you may not always get it quite right. That is what makes it so interesting, because you always have another chance to improve your skills.

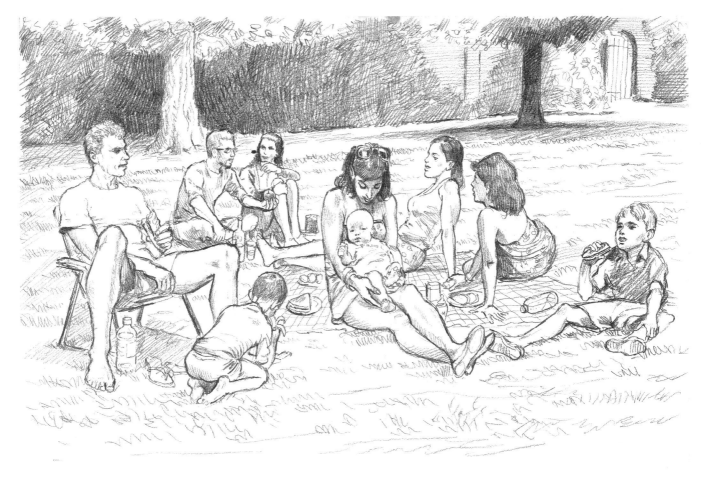

Chapter 12

PRACTICES AND PROJECTS

In this chapter I have detailed some practices that are useful for any aspiring artist. They are very general and are here to encourage you to draw as often as possible, as well as helping to make the whole process of learning easier. Where there are ways of simplifying your efforts to draw well you should always take advantage of them, since the faster you improve, the more confident, experimental and enjoyable your drawing will become.

USING PHOTOGRAPHS

Although drawing outside is very good practice, when the weather is cold or wet it's not easy to do. At times like these it's useful to take photographs of the scene that you wish to draw and use these to work from. Take several shots from slightly different angles and also with different exposures to ensure that you get several versions of the scene; not only does it give you more information, it often helps to revive your memory of the occasion, which usually means that you get a better drawing. Print the photographs as near to the size of your drawing as possible.

When you're drawing a portrait of someone it's practical to photograph them before you start, so that if they get tired of posing before you have finished you still have the pose to refer to. You can also use the photographs to choose exactly which pose you want them to hold, trying out several shots before you decide which is the best one. When you look at the pictures on the camera, you'll be able see which positions aren't successful in terms of lighting or composition. See overleaf (p.340) for more on portrait photography.

KEEPING A SKETCHBOOK

If you want to be a serious artist, you should carry a small sketchbook with you as often as you can – a small one is easy to put in a pocket or bag, which means you'll be more likely to take it along with you. Use it as often as you can to draw anything that catches your fancy. As it's a sketchbook it doesn't matter if the drawings don't work brilliantly; the mere repetition of drawing things each day will enormously increase your skill. Drawing in a train carriage, especially on a long journey, gives you a range of models and I've found most people don't mind an artist sketching them – just don't make them feel awkward by staring too hard. You can often get quite good drawings down without anyone even noticing what you're doing.

When you have moments of quiet by yourself you can draw the everyday objects around you in your sketchbook, trying to make your drawings more and more accurate. However, the sketchbook isn't meant to be filled with perfect drawings of major subjects – it's your notebook, to remind you of things that you might want to draw in more formal ways later.

PORTRAIT HINTS

I like to use every means possible to help me to get a good likeness, and I often take a photograph of the model in the pose I've chosen so I can refer to it to correct the proportions in my drawing if necessary. To do this, take your photograph from exactly the same viewpoint you will use when you're drawing.

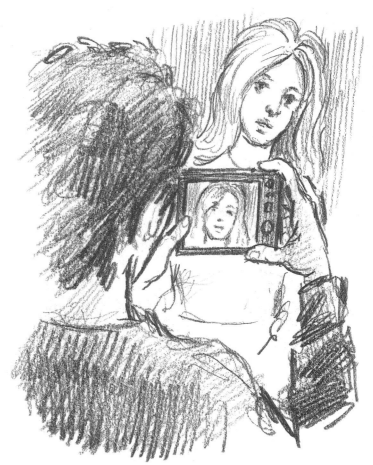

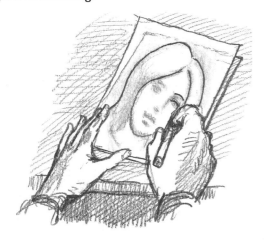

Make a print of your photograph as close to the size of your drawing as possible, then trace it so that you have a simple outline drawing to give you the right proportions of the head. Once you have the tracing, copy it on to your paper by placing the paper over the tracing on a window or a lightbox.

Now you have the correct proportions already mapped out, and sitting in front of your model you can continue to draw and get a much better likeness. If you think this is cheating you're right – but all art is cheating, really, and artists have always used as many methods as possible to improve their drawings.

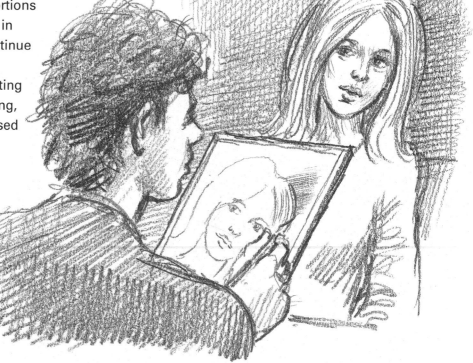

COPYING PRACTICE

It's good practice to copy other artists' work in order to increase your technical skills – a traditional method of learning to draw well. If you want to know how Leonardo drew, for example, try copying one of his drawings from a print or a book and see how close you can get to reproducing it. Draw with your print as close to your own drawing as you can, because this increases your chances of being accurate.

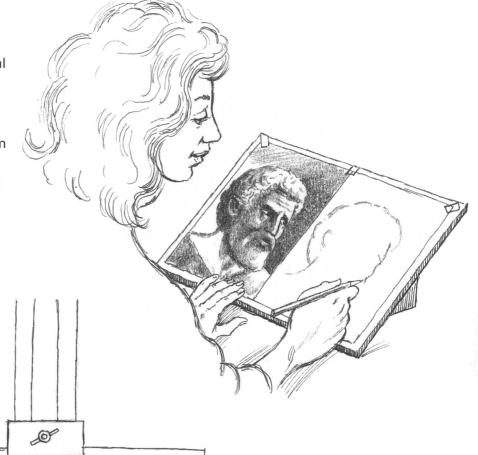

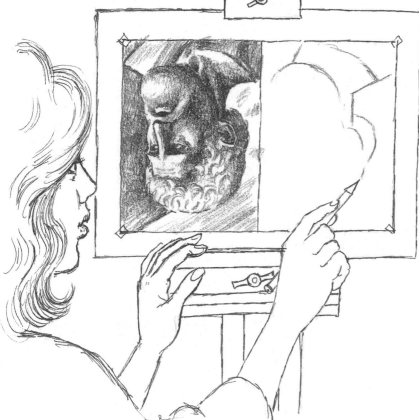

Another time-honoured method to improve drawing skills is to place your print upside down next to your paper and carefully copy it in that position. What this helps you to do is see that you are just drawing shapes rather than faces (or indeed objects), and once you begin to see just shapes and lines you'll find it easier to analyse what you are drawing.

DRAWING ON THE MOVE

For this exercise I decided to walk into and round a room in my house and draw any view that caught my interest, just letting my impulses take over. This is a useful exercise because it takes a lot of the decision-making out of a scene and results in a variety of drawing problems for you to solve immediately, without any forethought. The exercise could just as well be more concise than I have shown here, drawing only one or two objects at a time.

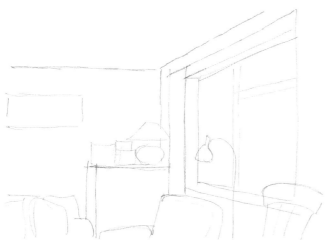

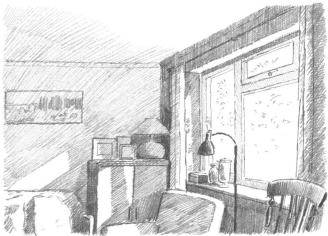

As I entered the room from the garden door I looked across to the far end and the corner of the window. On a small drawing pad, I began to draw what I could see, still standing up, and including whatever would fit into the shape and size of the page. I wasn't concerned about how much I could include, nor the composition – I simply drew the ceiling, cupboard, armchairs and so on as I could see them. The light shining through the window created strong shadows.

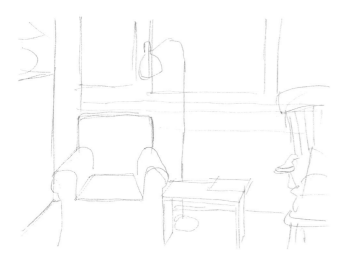

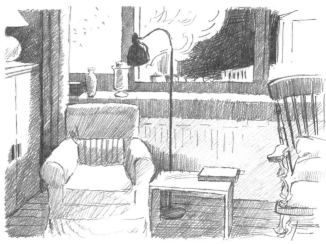

Then I turned and looked towards the window. Lowering my viewpoint a bit, I could see all of the armchair and the small table next to it, and the edge of the rocking chair to my right. Because I was now facing the light the shadows were darker. The objects were much the same as in the first drawing, but seen from a different angle and from slightly closer, so less of the room is visible.

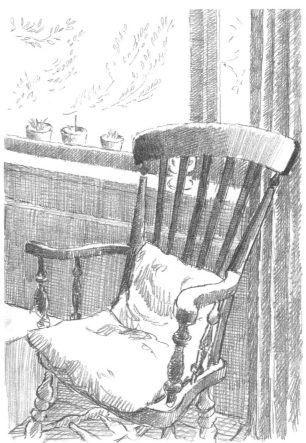

I now looked more closely at the rocking chair, which so far had been peripheral. It's sharply defined because most of it is dark against the background, and the highlighted parts are in strong contrast. The background is merely the windowsill and a curtain edge, so this picture is mainly about one object.

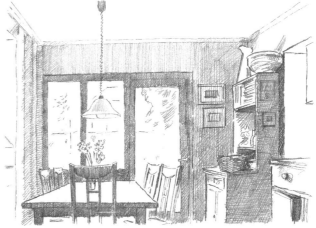

Next I turned round and faced the garden door that I had come in through. The window and door are dark frames for the light coming from the garden, and this reflects off the top of the dining table that is at that end of the room. To the right is a dresser with various objects on it, and some pictures on the wall. The chair backs frame the table top and the main light is positioned in the centre above it. Enough of the ceiling is visible to give an idea of the perspective of the view.

At this point I sat down so that I could get a slightly different view of the room. I looked up at another dresser, which is laden with cups, jugs and other paraphernalia, and because it's tall I turned my sketchbook around so that I could include the full height. This is quite a challenging view of the dresser from a low level, so I had to be careful with the perspective. I got most of the upper part in with a standing lamp at one side and a painting at the other. Because the dresser is so cluttered, I reduced all the objects on it to their simplest shapes. Again the shadows are quite strong to one side of the piece of furniture.

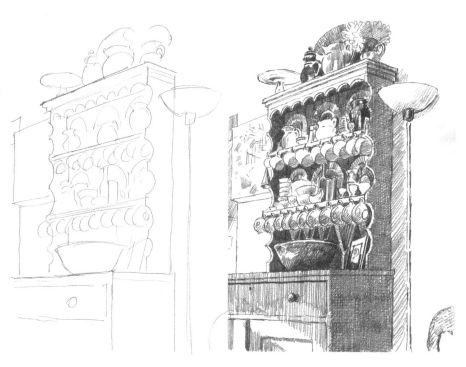

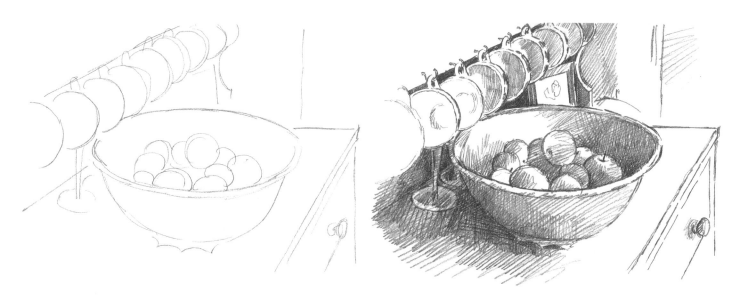

I stood up again and looked at the large earthenware bowl on the dresser, which had some apples in it. I drew this and included the row of cups hanging just above the bowl and a bit of the edge of the dresser. This is more like a simple still life drawing.

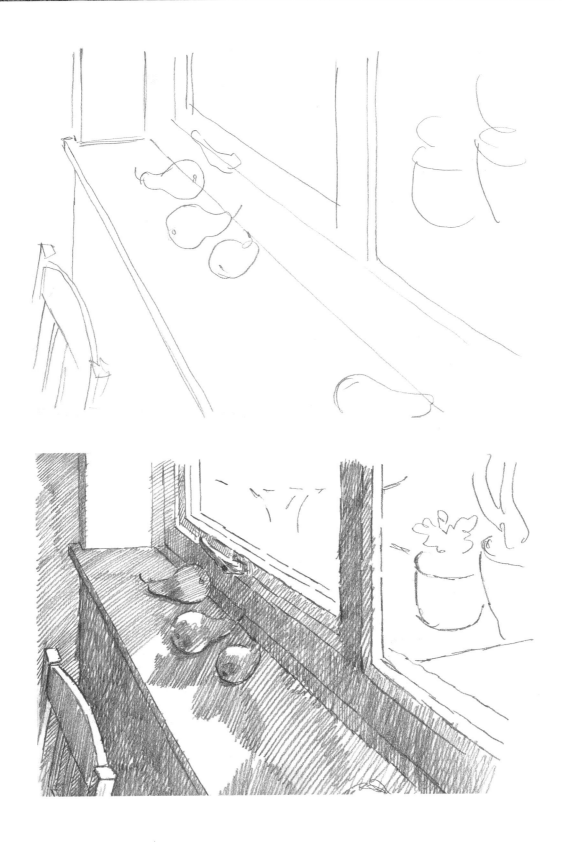

The last drawing that I made from this tour round a room is of another still-life detail. On the windowsill by the door a group of pears was ripening, caught in the shadow cast by the window frame. Because of the strong shadow, they largely melted into the background. So now I had gone around the room, drawing as I went and returning to the point where I had started, without thinking too much about what I should draw but just allowing my attention to wander to one thing and then another.

CONCENTRATING ON ONE THING

For this test of your drawing practice, concentrate on one thing for a certain period of time – that is, you don't have to do all the drawing in one go, but spread it out over two or three days. Take a mundane object which has a little complexity about it, such as a shoe – familiar enough and very basic, but also quite a strange shape once you begin to study it.

First of all, draw the shoe from a side view. Notice the proportion of length to height and rough out your drawing in order to get this right. Then draw it with as much detail as you can, ignoring nothing about the texture and shape of it. Keep correcting as you go along and take the drawing as far as you can in the time available.

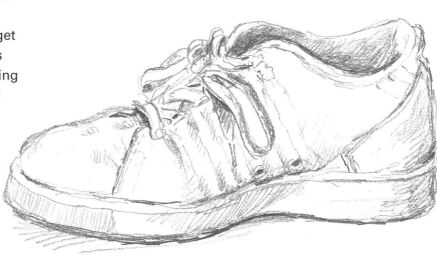

When the first drawing is complete, draw the shoe with the toe pointing towards you. Once again rough out the main shape, getting the proportions right. If there are shoelaces, tie them in a bow to keep them within the main shape. Once again, draw every detail, making corrections as you go. When your drawing is as good as you can get it, put it away until you are ready to draw again.

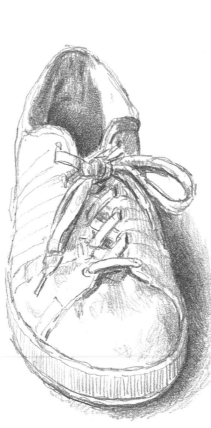

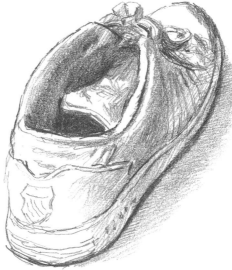

Now have another go at the shoe, this time with the heel towards you, and proceed just as you did before. This may seem a bit obsessive, but it's the easiest way to improve your drawing abilities.

Before you make the next drawing, compare the three you've already done as you'll spot what has worked well and what you should avoid repeating in the next drawing; this process also helps you to judge your own work more objectively. Now place the shoe so that you can look straight down into it. It doesn't matter whether you have the toe towards you or not – the main thing is to be able to see the whole shape of the shoe from above. Draw it as before, working towards the best result you can get.

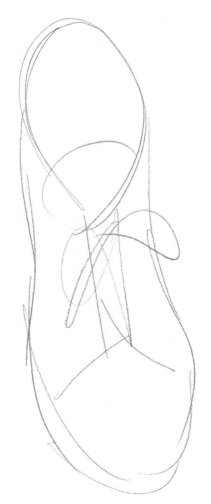

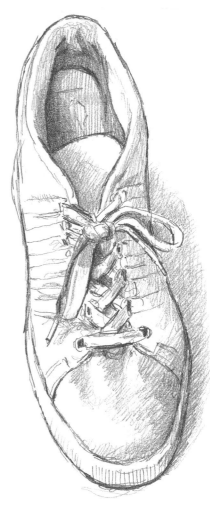

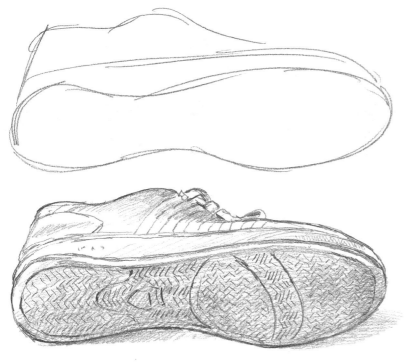

Finally, draw the shoe with the sole towards you, which is quite challenging. It's the least obvious way to draw a shoe, so you'll have to be on the alert for unusual angles. When you're satisfied, spread the drawings out so that you can see them all together. You'll now know that you're capable of a body of work that exhausts all the possibilities of drawing a shoe. This is good for your artistic memory, because although you may not come to draw a shoe for some time, the memory will help you whenever you do have to draw one. All the drawing that you spend concentrated time on will help to inform your later work.

TESTING YOURSELF

Keep testing your ability as you go along, and once you're drawing things that you seem to be getting along quite well with, strike out with something more difficult. Only you will know just what that is in your case, but let's look now at some objects that do have a certain challenge to them. It is necessary to draw the main shape of your object carefully, but don't worry about every tiny detail.

A bicycle is a good test of your drawing ability because the shape is straightforward and easy to understand but the details are quite complex. Don't get too caught up in them, but do your best to get the main shape right.

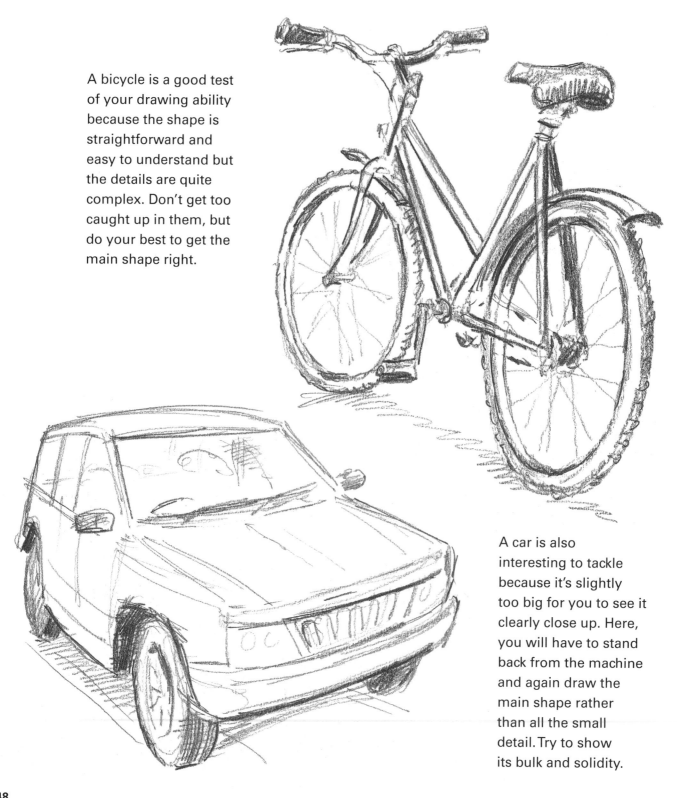

A car is also interesting to tackle because it's slightly too big for you to see it clearly close up. Here, you will have to stand back from the machine and again draw the main shape rather than all the small detail. Try to show its bulk and solidity.

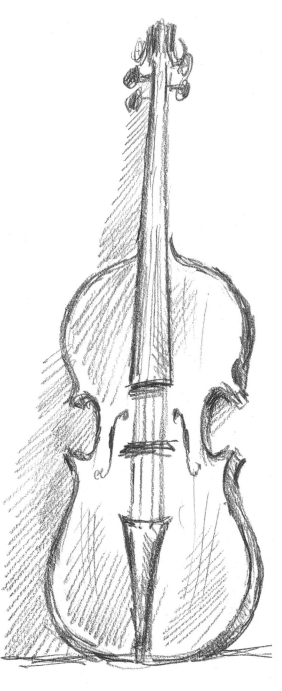

A very good test of skill is to choose a musical instrument, which is usually a very precise shape and needs to be observed carefully if you are to get a convincing drawing. I have shown a violin, which is quite tricky because of the subtlety of the shape – but any well-made instrument will do to test your abilities.

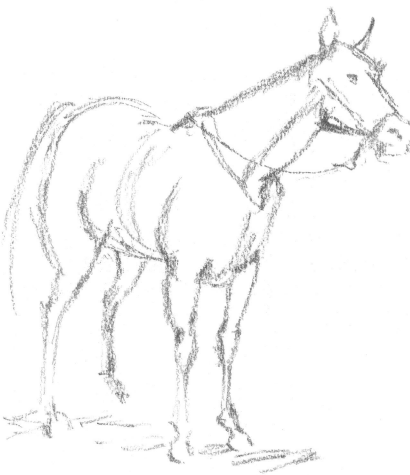

Drawing an animal such as a horse is a challenging subject, because it won't stand completely still. Sometimes you just have to draw as much as you can in the time that the animal is relatively motionless and then start a fresh drawing next time it stops for a while. This is useful in that it stops you worrying about how well you're doing; you just concentrate on getting anything down, and whatever you end up with, the action will enable you to practise looking and drawing without thinking about it.

NEGATIVE SHAPES

In a drawing there are no spaces as such – the shapes between and around objects are just as important as the shapes of the objects themselves. These 'spaces between' are called negative shapes, and observing them will help you to draw more accurately and make more interesting compositions.

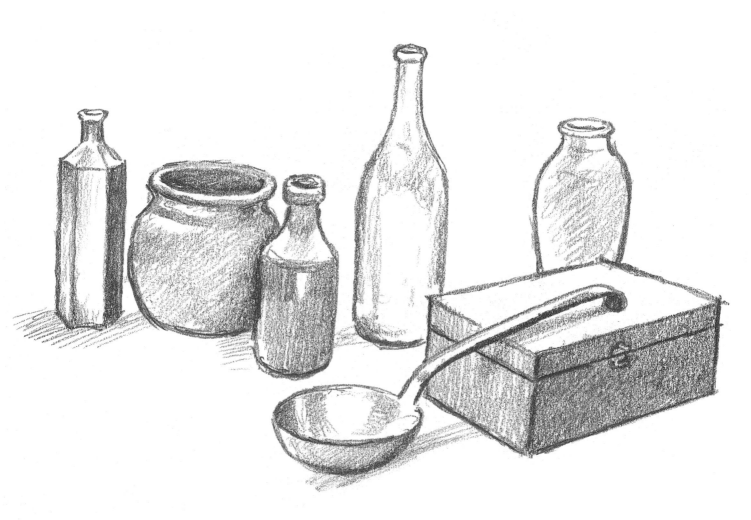

Here's a still life group, which you may want to draw. Your first instinct will probably be to try to draw it object by object, hoping that they will relate to each other correctly.

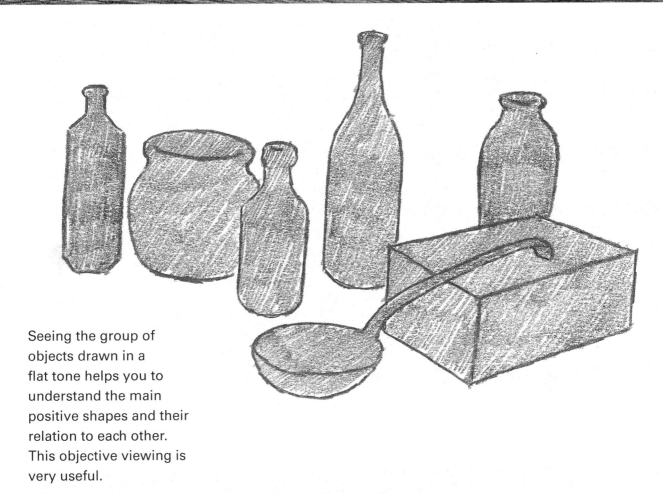

Seeing the group of objects drawn in a flat tone helps you to understand the main positive shapes and their relation to each other. This objective viewing is very useful.

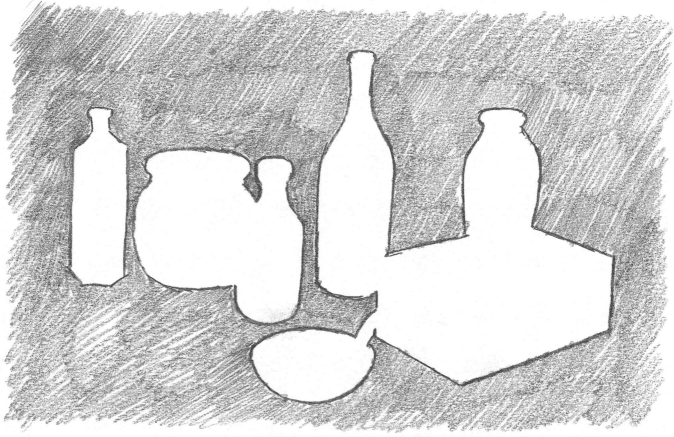

Here you can see how drawing the negative shapes describes the forms of the objects and how they overlap. In art, every mark and every shape you make is significant – and that is what makes it endlessly challenging and fulfilling.

INDEX